UTILITY REASSESSED

MANCHESTER
UNIVERSITY PRESS

STUDIES IN
DESIGN
AND
MATERIAL
CULTURE

general editor:
CHRISTOPHER BREWARD

Utility reassessed

THE ROLE OF ETHICS
IN THE PRACTICE OF DESIGN

edited by Judy Attfield

Manchester University Press

Manchester and New York

distributed exclusively in the USA by St. Martin's Press

Published by Manchester University Press
Oxford Road, Manchester M13 9NR, UK
and Room 400, 175 Fifth Avenue, New York, NY 10010, USA
http://www.man.ac.uk/mup

Distributed exclusively in the USA by
St. Martin's Press, Inc., 175 Fifth Avenue, New York,
NY 10010, USA

Distributed exclusively in Canada by
UBC Press, University of British Columbia, 6344 Memorial Road,
Vancouver, BC, Canada V6T 1Z2

British Library Cataloguing-in-Publication Data
A catalogue record for this book is available from the British Library

Library of Congress Cataloging-in-Publication Data applied for

ISBN 0 7190 5277 7 *hardback*
 0 7190 5844 9 *paperback*

First published 1999

06 05 04 03 02 01 00 99 10 9 8 7 6 5 4 3 2 1

Typeset in ITC Giovanni
by Carnegie Publishing, Lancaster
Printed in Great Britain
by Bookcraft (Bath) Ltd, Midsomer Norton

Contents

Figures

Notes on contributors

Judy Attfield is Course Convener of the MA in Design History and Material Culture at Winchester School of Art, University of Southampton. She has published widely on design history, specialising in furniture and interiors of the twentieth century, gender issues and the material culture of everyday things. She is a member of the editorial board of the *Journal of Design History* and co-editor with Pat Kirkham of *A View From the Interior: Women and Design* ([1989] 1995).

Jonathan Bell completed the MA in Design History and Material Culture at Winchester School of Art in 1996. He works for a small London firm of modern architects. His research interests include inter-war British architecture and he is currently a member of the Twentieth Century Society's Casework Committee.

Linda Coleing is a Senior Lecturer in Design History at Staffordshire University. She completed her postgraduate studies at Keele University in 1991. Her research interests are in Arts and Crafts textiles and wallpaper.

David Crowley is a Lecturer in the History of Design at the University of Brighton. He is the author of *National Style and Nation-state: Design in Poland from the Vernacular Revival* (1992), and co-author of *Graphic Design: Reproduction and Representation since 1800* (1996).

Matthew Denney is Lecturer in Design History and Valuation practice and Course Leader of the BA (Hons) Fine Arts Valuation Studies course at Southampton Institute. He specialises in furniture history, having completed his PhD, 'Arts and Crafts Furniture and Vernacular Furniture', in 1997.

Pat Kirkham is Professor at the Bard Graduate Center for Studies in the Decorative Arts, New York and was formerly Professor of Design History and Cultural Studies at De Montfort University, Leicester. She is a member of the editorial board of the *Journal of Design History*. She has published widely on design, particularly furniture and interior design, gender studies and film. Her major recent publications include *Charles and Ray Eames: Designers of the Twentieth Century* (1995). She is currently preparing a book and exhibition on women designers working in the USA 1900–2000.

Susie McKellar is a Research Assistant in the History of Design at the Royal College of Art where she is also completing her doctoral thesis on rational consumption. Specialising in product design, she has taught at several colleges and universities, including the University of Central Lancashire and the Royal College of Art. Her publications include an essay on handguns in *The Gendered Object*, edited by Pat Kirkham (1996).

Graham McLaren is a Senior Lecturer in the History of Art and Design at Staffordshire University. A specialist in the history of ceramics and glass, he is Award Leader of the MA in the History of Ceramics and has contributed to a number of books and journals. Currently he is completing *The Culture of Ceramics* for Manchester University Press.

Patrick J. Maguire is Head of the School of Historical and Critical Studies at Brighton University, Chair of The History Workshop Trust and Conference Secretary of the Labour History Society. He specialises in social, economic and labour history and his most recent publication, co-edited and authored with Jonathan Woodham, is *Design and Cultural Politics in Postwar Britain: the Britain Can Make It Exhibition of 1946* (1997).

Helen Reynolds graduated from the MA in the History of Textiles and Dress at Winchester School of Art in 1995. She is a Researcher at the London College of Fashion, author of *Couture or Trade* (1997) and is currently working on her doctoral thesis on women, training and London's luxury dress trades.

Cynthia Weaver is a Senior Lecturer in the History and Theory of Dress and Textiles at the University of Central England in Birmingham. She has contributed to *Enid Marx and her Circle* (catalogue at the exhibition held at Sally Hunter Fine Art, London, 1992), *The Dictionary of Women Artists* (1997), *English Church Embroidery* (1998), and to periodicals including *Antique Collecting*, *Journal of Design History* and *Crafts*.

Nigel Whiteley is professor in the Department of Art at Lancaster University and has been visiting professor at the National Institute of Design in Ahmedabad, the Indian Institute of Technology in Bombay and the Central Academy of Art and Design in Beijing. His books include *Pop Design – Modernism to Mod* (1987), *Design For Society* (1991), and he was joint editor of *The Lamp of Memory: Ruskin, Tradition and Architecture* (1992) and *The Authority of the Consumer* (1993). Having Guest-edited a special number of *Design Issues* on design criticism (1997), he is now working on a book about the theories and criticism of Reyner Banham.

Marjo Wiberg is a textile designer who completed her doctoral studies at the University of Art and Design, Helsinki. She was formerly Associate Professor in textile design at the University of Lapland and has taught the history and theory of textile design at these two universities.

Jonathan Woodham is Professor in the history of Design and Director of the Design History Research Centre at the University of Brighton, former Chair of the Design History Society, a member of the editorial board of the *Journal of Design History* and the author of numerous publications. His most recent title, *Twentieth Century Design* (1997), was for the Oxford History of Art series.

For Leah and Jack

Preface

Utility reassessed started life as a modest one-day seminar I ran at Winchester School of Art in association with the Design History Society in July 1994. I did not expect much interest in the subject of Utility, by then discredited along with other utopian design ideals as one of the lesser instances of the 'failure of Modernism'. In a period emerging from the glossy 'designer' 1980s, the drab greyness of Second-World-War austerity that tried unsuccessfully to champion the brave make-do-and-mend shabbiness of Utility had nothing to commend it in the way of good looks. I was therefore pleasantly surprised when the call for papers generated a remarkable amount of interest, drawing contributors and delegates from all over the United Kingdom, Scandinavia and the USA, and producing the fresh research into the Utility concept which is presented in this volume.

My early enthusiasm was tempered by the suspicion that the turn of interest towards a 'back to basics' type of design might be confused with John Major's use of the term in his campaign to continue the Thatcherist theme of Victorian values – a world in which there was no such thing as 'society', only consumers. With hindsight it is significant that the popular interpretation of the Conservative-inspired version of 'back to basics' did not relate to use-values but to the critique of moral values which highlighted the corruption within the party that proved its own downfall. Nor is it any accident that stylists and fashion leaders, always hungry to latch on to the latest resonant themes and 'story-lines', have already grabbed on to the fecundity of meaning embodied in the concept of 'Utility chic'.

My hope is that this reconsideration of the history of Utility will offer a new take on the role of ethics and downgrade the importance of aesthetics in the pursuit of a practice of design appropriate to today's world. Since the short-lived heroic phase that celebrated the history of Utility, it has been represented as a singularly unsuccessful example of Modernism, variously dismissed as unrealistic, ugly, mechanistic, boring, insignificant, dictatorial and outdated. But if Utility design is not regarded as the poor product of a wartime economy in dire straits, but as a common-sense practice that engaged actively with the conditions of the time, it is more

possible to understand the importance of finding ways to take command of the creative sense of agency that makes it possible to effect change.

Judy Attfield

Introduction ✧ Utility reassessed

Judy Attfield

A s we approach the millennium and survey the physical remains of the twentieth century which will soon lie behind us, there is a threatening sense that the detritus and contamination from mounting piles of product clutter might engulf the planet. While revolutionary communication technology has made it possible for us to look at previously unseen views of the earth from space, it can also invade our mental landscapes with uninvited visions of virtual worlds. The impulse that drives contemporary thinkers to try to take stock of the confused morass of ideas and goods that have multiplied over the last hundred years culminated in what has come to be recognised within the last third of the twentieth century as the 'postmodern' condition.[1]

The questioning of meanings and values, engendered by such a post-modern sensibility, would seem only to increase the sense of uncertainty in what appears to be a fragmented world with no fixed points of reference. At the same time the gains to be made from resistance to the rigidity of modernist 'correct' thinking that requires an unconsidered adherence to pre-set rules and definitions encourage a climate in which re-evaluations and reassessments can flourish. Yet where postmodern awareness can only critique, complicate and unsettle, a modernist stance, with its call on rational response, is still valid when it comes to problems that can only effectively be confronted by a resolve for change.[2] But a third way is suggested by Latour's challenging assertion that 'No one has ever been modern'.[3] His observation that the modern world is 'becoming susceptible to anthropological treatment' proposes theoretical explorations across the borders of 'the great fiefdoms of criticism'. It invites a step beyond the fetishisation of abstract critical theory created by 'pure disciplines' that do not allow the 'mix up of knowledge, interest, justice and power'.[4]

This book accepts Latour's challenge in seeking to uncouple the history of Utility as part of a general modernising impetus, from the so-called 'failure' to materialise the principles of modern design which required a pure and beneficent aesthetic product of mass production. The focus on the material

productions and practices of the Utility project dares to refer to the reality which did not conform to the instrumental problem-solving approach of modernist design theory. The intention is to reconsider Utility in broad terms referring to 'useful' design generally, mainly focused on the specific historical case-study of the British Utility Scheme (1942–52). This particular instance highlights the hybrid forms and practices in which various versions of Utility were made manifest at a particular historical moment. The term Utility here, therefore, stands for both that short period between 1942 and 1952 while the Scheme was in force and a more general set of design principles with a much longer history referred to here as 'Good Design'.

But as the book illustrates, the British Utility Scheme is just one among a number of other strategies that sought to adapt to modernisation and ensure well-designed goods in terms of a balance between degree of quality and the management of resources to achieve minimum price, and to promote the fair distribution to all sectors of the population. These Utility strategies ranged from state-imposed regulation to indirect control through fiscal measures, critical writings, watchdog monitoring institutions and consumer education.

The British Utility Design Scheme was introduced during the Second World War to ensure the elimination of unnecessary waste of resources during a period of national emergency. Brought in by the Board of Trade, the scheme was only a small part of the plans for the rationalisation of production envisaged by the state to control materials, labour and the production of goods that were deemed essential so that resources could be redirected to give priority to the war effort. The Utility Scheme was seized upon by a number of design reformers at the time as an opportunity to instil an appreciation of Good Design in the general population. But the fact that it fell short of those utopian intentions does not disqualify it from examination.

The Utility Scheme provided guidelines for the design of products for home consumption, made from scarce materials such as textiles and timber, with particular application to clothing and furniture. Under the Utility regime, producers were severely restricted in the manufacture and distribution of goods through government licensing, the regulation of tax, price and profit ceilings, and through the rationing of materials and labour. The population had to wait until the second half of the 1950s to benefit from wider home distribution of consumer goods. Significantly, it was critics and designers concerned with architecture who, a quarter of a century later, were among the first to embrace Postmodernism as a welcome move away from the unpopular strictures of Modernism and take a more consciously perspectival view that allowed for difference and cultural diversity.[5]

One of the pleasures in the study of history is discovering the vast

differences that comparisons across time can reveal and thus illuminate the present by a better understanding of the past. It is unwise, not to say unfashionable, to claim a definitive account of any period or aspect of history. In presenting a retrospective collection of essays on design centred around the Utility period when there was such a strong emphasis on developing and applying ethical principles, it is only by taking a historical perspective that it is possible to reconcile the degree of optimism, almost bordering on blind faith, felt by those mid-twentieth-century design reformers relying on the miraculous properties of Good Design. The mention of 'fashion' is quite deliberate here and not meant to be read in a derogatory tone. Its inclusion is intended to signal the centrality of consumption as an ineluctable ingredient in any account of the history of design,[6] even when considering Utility – a high point of the Good Design movement when the exigencies of war justified overt anti-consumerist principles.

The authoritarian tendencies of Modernism have in the main assumed Good Design[7] to be self-explanatory. Accordingly, the only legitimate industrially produced objects worthy of study in such a history of design were those considered to be aesthetically acceptable within the standards of Modernism. In the light of current critical commentary to which this book is intended as a contribution, it is therefore necessary to define 'Good Design' – both its products and its practice – in historiographical terms. Until fairly recently Good Design has been almost exclusively the main focus of attention in design history, derived from connoisseurial conventions inherited from art history in which industrial design was deemed to be 'the art of the twentieth century'.[8] But since then, changes of approach have located the history of design within the larger contexts of social, political and economic history and within material and visual cultural studies which also consider the transformation of products into the stuff of the everyday lives of people.[9] More specifically, Good Design has increasingly come to refer to utopian design reform initiatives based on the Modernist assumption that industrialisation and mass production automatically brings progress, theorised in the inter-war period and applied in the Reconstruction period.[10] The search for an intellectual rational design process derived from first principles coincided with the mid-twentieth-century development of design as a profession. This contrasted quite dramatically with the pragmatic, common-sense practice of designing-while-making, prevalent in the traditional trades and taught through craft apprenticeship. Good Design theory aimed at a classic (meaning timeless and therefore not subject to fashion) standard universal product in a 'styleless' aesthetic, resulting from the most appropriate method of production and use of materials to deliver the best quality at the most economic price for the maximum benefit of a universal consumer.

While Good Design has lost credibility and been criticised for representing the taste preferences of a small coterie of the 'metropolitan elite'[11] it can also be seen as part of a long and continuing concern for socially responsible rational design that prioritises integrity above commercial expediency. The ethics of design were a matter of popular concern in the nineteenth century as in the late twentieth century, though such concerns are now described in different terms, such as sustainability, fair trading and ecologically sound or green design.[12] Indeed, many of the themes that emerge in these chapters reiterate concerns that have assailed every modernised society since the introduction of industrialisation that depends on an economy with a tendency to overproduce and then dump.

The different, sometimes even contradictory, points of view contributed by the various authors belie any hidden agenda to offer a view that privileges Utility and, by association, Good Design and Modernism. Reassessing Utility as an instance when design was subordinated to ethical principles in an attempt to achieve 'fair shares for all' provides an opportunity to discuss the role of ethics in the practice of design at a more general level. Because the Utility Scheme rationalised design as a functional practice which attributed a natural correlation between beauty and use, it locates many of the issues which arise out of current concerns in the study of design as a practice, its history and the aspirations of those working as practitioners in the design industry, in art and design education or as critics and commentators.

The main aims of this project to resurrect Utility as a valid concept worth revisiting are twofold. The first is to contextualise its ethical design concerns and main proponents within a very specific historical period that turned optimistically to the future. It was a time when designers felt a real sense of agency – that it was possible to effect progress through Good Design. And the second is to theorise Utility principles within and against contemporary cultural debates, at a particular moment when there appear to be signs of resurgent interest in the sparse back-to-basics quality of the Utility[13] concept, following the profligate 'designer' rhetoric of the 1980s. The purpose of invoking Utility, however, is not in order to celebrate its emergence as an outstanding achievement, but to see it as a seminal moment when design became part of a national policy with social goals. The research represented in this volume suggests that there never was, nor is there now, a consensus on what constitutes 'Good Design'[14] except as a striving for progress in a positive sense. Nor can design any longer be seen as artwork – a concept emanating from a single designer's mind. What this book illustrates is how design can be viewed as both a process and a physical entity, consisting of a much more complex and circumstantial amalgam of factors and meanings coming together in physical form at a

particular place and point in time. And as such, the material object provides a distinct point of entry at the physical level where the clash between theory and practice actually meet. In locating design as part of a technical, commercial, professional and political process, the focus of study can range from design theories to the manufacturing and distributing industries, to institutions of design such as trade organisations, educational establishments, government-funded advisory bodies, private and public consumer protection societies, to the lived experience of individual designers, manufacturers and consumers.[15]

The maturation of studies in the history of design has taught us that the relations between art and industry, or – to put it another way – aesthetics and engineering, was often more about cross purposes than co-operation between different individuals, interest groups and institutions.[16] Therefore this book is presented as a group of studies with a common subject but taken from a variety of points of view which show more often than not vast unbridged gaps between would-be design reformers, producers, engineers and consumers, during a period when there was a concerted campaign to institute design reform.

The book is divided into three parts – the first, 'Defining Utility design', offers various definitions of Utility through case-studies of different applications of ethical principles to the process of designing and making everyday things. Linda Coleing's chapter on Ruskin (Chapter 1) reviews his profoundly influential nineteenth-century utopian beliefs that still manage to survive in St George's Mill, a textile workshop based directly on his ideal of an alternative society and, at the time of writing (1998), still in operation on the Isle of Man. In spite of his feudal views the ethical ideas the Mill embodied have echoes with radical current debates. The case of inter-war Finnish textile design education by Marjo Wiberg (Chapter 2) shows how Utility principles were defined in terms of creating 'more beautiful everyday things', but refused when it came to adopting modern techniques of mass production. The Finnish theme is echoed in the chapter by David Crowley on Poland's ideal of 'Beauty, everyday and for all' (Chapter 4), which in this case turned design to propagandising use under Stalinist rule. Jonathan Woodham's account of the Co-operative Wholesale Society's attempt to produce a range of furniture defined along Utility lines after the industry was freed from regulation (Chapter 3) shows up the difficulties of reconciling Good Design ideals with popular taste. Susie McKellar's chapter (Chapter 5) defines Utility in terms of rational consumption in the United States and shows the conflict between ethical concerns for the protection of consumers and the American enterprise culture entirely based on fomenting consumerism. The chapters in Part I discuss contributions to the ethical design debate by several generations of personalities and

institutions, under both communist and capitalist systems of government. The common concern in an ethical approach to design in each of the five chapters manifested itself in a variety of ways according to the diverse historical, political and geographical contexts within which Utility principles were applied.

Part II, 'Reassessing the history of Utility design', homes in on a group of case-studies that focus in particular on the Utility Design Scheme that operated during and just following the Second World War in Britain. The chapters give accounts of the impact of the Utility regulations on the automotive, pottery, clothing, furniture and textiles industries. Jonathan Bell's chapter on the background discussions around the unrealised design for a Utility vehicle (Chapter 6) gives an insight into the political climate of the Reconstruction planning period in Britain and shows up the clash between the engineering and the nascent industrial design profession. Matthew Denney's analysis of the 'myth' of Utility with particular reference to furniture production, suggesting that it has been perpetuated by over-simplified historical accounts (Chapter 7), is set against the reality of an industry curtailed by complex ever-changing legislation, forced to adapt to acute shortages of materials and labour. 'The Utility Garment' by Helen Reynolds (Chapter 8) also challenges assumptions about the degree of effect the Utility design scheme actually had on the mass market. Her research shows that too much emphasis has been placed on the importance of the Couturier Pattern Scheme. The female fashion consumer's perspective is provided by Chapter 9, in which Pat Kirkham asserts that fashion did not disappear during the years of war and austerity; and conversely, that Utility principles were already part of the fashion vocabulary before 1939. The fact that glamorous items like hats and cosmetics were spared or relieved from government restriction during the Utility period attests to the qualitative definition of 'necessary' during a period to which unadult-erated functionalism has been attributed.

In 'Utility Forgot' (Chapter 10) Graham McLaren questions the reason for the neglect accorded to Utility ceramics by design historians, proposing that discussing ceramics as one of the 'decorative arts' confers too much importance on surface decoration. His chapter also seeks to redress the balance from the generally held opinion that Gordon Russell was the sole 'creator' of the Utility aesthetic, to make a place for two major figures in the development of Good Design in the pottery industry – Gordon Forsythe and Harry Trethowan. Whereas Denney and McLaren both imply that Gordon Russell has been given too much credit for Utility design, in Chapter 11 Cynthia Weaver recounts Enid Marx's own positive account of her involvement as a designer working with Russell on the Utility Furniture Design Advisory Panel, describing it as a rewarding collaborative experience.

Weaver cites a number of Marx's contemporary fellow-designers who also recognised Russell as a charismatic and inspirational figure, admired for his reforming campaign to improve design while managing to maintain an uneasy position 'between the frying pan and the fire'.

Part III, 'Theorising the ethics of Utility design', deals more discursively with some of the themes and debates which arise out of the history and theory of Utility. In Chaper 12 Nigel Whiteley takes a long look at the tradition of ethical design theory that arose in nineteenth-century Britain with Ruskin. He tracks the change of focus from the virtue of the maker and the aesthetic of the object to the active role of the designer, producer, distributor and consumer in addressing the ethics of design. A number of 'hidden from history' themes with regard to Utility and Good Design are also raised in Part III. 'Freedom of Design' (Chapter 13) deals with the rarely discussed years when British furniture design was deregulated while still under the Utility Scheme. Thus so-called 'choice' in furniture consumption was introduced at a time when Modernist reformers were still struggling to retain control over design. The shift of emphasis, even while the Utility regime was still in force, from the 'concentration' [17] of industry and the standardisation of design to the more consumer-orientated phase of the Utility Scheme after 1945, is also discussed by Patrick Maguire in Chapter 14, on 'Utility and the Politics of Consumption'. 'Fascinating Fitness' (Chapter 15) takes a look at the dark side of Utility by looking at the dangers of attempting to aestheticise ethical design in the context of the continuing fascination with the astringent quality of stark bareness. In Chapter 16 Jonathan Woodham reviews the public role of design by the state in Britain from Attlee's Labour government to Blair's New Labour.

Although the distinctiveness of the historical period in which the Utility Scheme arose is quite specific and some of the uses to which its moral economy were applied are questionable from today's perspective, there are nevertheless certain broad parallels that can be drawn with current concerns for an ethical design practice. These ideals are part of a longer history of Good Design that can be traced much further back than the twentieth century. The economic management, use and consumption of materials has echoes in current global concerns over the depletion of natural resources expressed in a growing 'green' consciousness. Some governments have taken on longer-term environmental views on pollution such as the economic disposal of waste through recycling. Many current concerns also echo past critiques of consumerism which would have looked to rationalised production and the control of profit margins to benefit the general consumer.

There is a growing awareness that designers, producers, distributors and consumers all have a share in the responsibility to maintain ethical principles. Today these are discussed in terms of sustainable production,

ecological concern in the management of the earth's resources and the development of fair trading practices to stop the exploitation of labour. Apart from global issues, much of the 'design for society' movement has concentrated on locale, cultural difference and special client groups – such as design for children, the elderly and the disabled.[18] Though still only a minority concern, the signs are that ethical products and practices are increasingly becoming a major issue.

One of the more popular phenomena in the pursuit of the ideal, the good and the beautiful is evident in the movement for the conservation and preservation of the past. The heritage movement is criticised as much for its retrospection, elitism and the corrupting effect it has on history by creating sentimental reconstructions of the past, as welcomed for allowing the entry of hidden histories from below, unearthed from unofficial sources.[19] This reassessment of Utility from within the disciplinary context of design history is not intended as a heroic reconstruction, but a recognition that the past is not necessarily a foreign country and that the initiatives and ideas which gave impetus to useful design are still evolving today.

Conclusion

The cost of travelling from the search for the paradigm to postmodern critiques that has given Modernism and Good Design a position in history, has by the same token discredited design as a practice with any power or agency. So, for example, planning, architecture, clothing and furniture, seen in the Reconstruction period as the social responsibility of designers and the state, is more likely to be discussed retrospectively as the 'failure of Modernism'. And from past interest in the pathology of 'bad' design (in order to highlight the Good) debates now seem to turn on dystopias. In reassessing Utility in an unheroic light it is possible to change focus from the iconic classics of the Modern Movement to the imperfect hybrid reality of ordinary things. Design improvements to the work environments, transport systems, the homes, cups, socks and chairs which make up the fabric of people's everyday lives are not effected by means of a stylistic aesthetic.

This book reveals the impossibility of realising ethical solutions by means of a design theory that can only produce an ideal aesthetic. Latour's challenge suggests that taking an anthropological stance recognises that we have more connection with our pasts than conventional attitudes to modernity acknowledge. A longer perspective places the Utility phenomenon as representative of an ongoing search for a design practice that does not prioritise the visual at the expense of ethical concerns but is animated by a sense of purpose which does not require a beautiful solution.

Notes

1 For definitions of modernity/postmodernity, modernisation/postmodernisation and Modernism/Postmodernism see M. Featherstone, *Consumer Culture and Postmodernism*, Sage, 1991, pp. 1–12.

2 See, for example, R. Boyne and A. Rattansi (eds), *Postmodernism and Society*, Macmillan, 1990; J. Habermas, *The Philosophical Discourse of Modernity* (translated by Frederick G. Lawrence), Polity Press, 1987; K. Jenkins, *Re-thinking History*, Routledge, 1991; J. O'Neill, *The Poverty of Postmodernism*, Routledge, 1995; D. Miller, *Modernity: An Ethnographic Approach*, Berg, 1994, chapter 2: 'Modernity as a General Property', pp. 58–81.

3 B. Latour, *We Have Never Been Modern*, Harvester Wheatsheaf, 1993, p. 47. I am grateful to Daniel Miller for introducing me to this text.

4 Latour, *We Have Never Been Modern*, p. 3.

5 See, for example, R. Venturi, *Complexity and Contradiction in Architecture*, The Architectural Press, [1966] 1977; C. Jencks, *The Language of Postmodern Architecture*, Academy, 1977.

6 Belatedly recognised as a central feature of cultural history and theory; see, for example, D. Miller, *Acknowledging Consumption: a Review of New Studies*, Routledge, 1995.

7 Ironically, it is quite difficult to ascertain how 'Good Design' was actually defined by the experts at different times, suggesting serious rifts and disagreement between various factions and interest groups, as J. Woodham's essay, 'An Episode in Post-war Utility Management' (Chapter 3) testifies. See also, for example, J. Attfield, 'Good Design By Law: Adapting Utility Furniture to Peacetime Production: Domestic Furniture in the Reconstruction Period 1946–1956', in P.J. Maguire and J.M. Woodham (eds), *Design and Cultural Politics in Post-war Britain: the Britain Can Make It Exhibition of 1946*, Leicester University Press, 1997, p. 99–109; J.M. Woodham, 'Managing British Design Reform II: the film *Deadly Nightshade* – An ill-fated episode in the politics of "Good Taste"', in *Journal of Design History*, Vol. 9, No. 2, pp. 101–15.

8 See, for example, A. Forty, *Objects of Desire*, Thames and Hudson, 1986, p. 7.

9 For example, J. Attfield, 'Design as a Practice of Modernity: a Case for the Study of the Coffee Table', in *Journal of Material Culture*, Vol. 2, No. 3, 1997, pp. 267–89; A.J. Clarke, 'Tupperware: Suburbia, Sociality and Mass Consumption', in R. Silverstone (ed), *Visions of Suburbia*, Routledge, 1997, pp. 132–60.

10 G. Julier, *Twentieth-Century Design and Designers*, Thames and Hudson, 1993, pp. 93–4.

11 Woodham, 'Managing British Design Reform II: the film *Deadly Nightshade*', p. 101.

12 J. Attfield, '"Give 'em something dark and heavy": the Role of Design in the Material Culture of Popular British Furniture 1939–1965', in *Journal of Design History*, Vol. 9, No. 3, 1996, p. 199, n. 3.

13 In the last few years the style pages of the colour supplements have been announcing a revival of interest in 1940s-style furnishings and fashion. See, for example, C. Williams, 'Back to Basics with Forties Utility Chic', the *Independent on Sunday*, 12 October 1997, p. 12.

14 See, for example, J.M. Woodham, 'Putting the Industrial into Design: the Problems facing the Council of Industrial Design', in P.J. Maguire and J.M. Woodham (eds),

Design and Cultural Politics in Post-war Britain: the Britain Can Make It Exhibition of 1946, Leicester University Press, 1997, pp. 131–2.

15 This is in no way intended to be construed as making a new claim for the research methods of design history, which just a cursory enquiry into its literature would soon dispel. See, for example, J.A. Walker, *Design History and the History of Design*, Pluto Press, 1989, Chapter 5: 'Production–Consumption Model', pp. 68–73.

16 See, for example, Maguire and Woodham, *Design and Cultural Politics*.

17 The term 'concentration' refers to the process of rationalisation the state attempted to impose on industries during the war in order to maximise production.

18 N. Whiteley, *Design for Society*, Reaktion, 1993.

19 See, for example, R. Samuel, *Theatres of Memory*, Verso, 1994 and P. Thompson, *The Voice of the Past*, Oxford University Press, 1988.

I

DEFINING UTILITY DESIGN

1 ✧ Utility prefigured: Ruskin and St George's Mill

Linda Coleing

Most of the literature from the last fifty years would have us suppose that the main function of design is to make things beautiful ... Particularly in Britain, the study of design and its history has suffered from a form of cultural lobotomy which has left design connected only to the eye, and severed its connection to the brain and the pocket.[1]

SINCE ADRIAN FORTY wrote those words in *Objects of Desire* in 1986, his criticism has been redressed to a certain extent within British design history,[2] but there still remain some important omissions. Although much has been written about John Ruskin's utopian ideas, and accounts of the Guild of St George exist in published sources,[3] there is very little published material about Ruskin's practical venture – St George's Mill in Laxey, Isle of Man. Anthea Callen refers to it briefly in her study of women and the Arts and Crafts Movement, *Angel in the Studio*, acknowledging its importance as a response to the plight of female hand-spinners on the Isle of Man.[4] The lack of interest in the mill so far may be explained by its focus on the production of hard-wearing 'honest' woven woollen cloth rather than 'pretty' decorative designs. Nor was the venture enough of a commercial success to attract economists to analyse it. In her thesis, 'Ruskin's Late Works. c. 1870–90', Catherine Morley has suggested that the taint of his mental illness has coloured serious study of his later work.[5]

A study of St George's Mill based on Ruskin's utopian aspirations of establishing a congenial workplace in idyllic surroundings provides a good example of ethical design practice that resonates with the ideals still sought today by many designer/makers. The mill's ultimate success lay in its responsiveness to the broader community's needs rather than commercial profit gains. This study suggests that Ruskin's mill represents a much nearer approximation to William Morris's 'A Factory as it Might Be'[6] than Morris himself was ever able to achieve. It was not until a time of national crisis, during the Second World War, that a similar experiment in ethical design

and production was implemented with the introduction of the Utility Scheme.

The origins of the Guild of St George

The mill was established through the finance and support of Ruskin and the Guild of St George in 1881.[7] The origins of the Guild lay in the earlier establishment of St George's Fund in 1871,[8] which became St George's Company in 1875,[9] finally changing its name to 'Guild' after registering with the Companies Act in 1878.[10] Ruskin's plans for the Guild were first presented to the public through the publication of *Fors Clavigera: Letters to the Workmen of Great Britain.*[11]

The Guild of St George represented Ruskin's vision of a humanitarian society as an alternative to what he considered a decadent and uncaring industrialised culture. The organisation of the Guild was based on his research into Italian free states of the thirteenth and fourteenth centuries which were governed by a family or individual as constitutional leader supported by representatives of various guilds and companies who were subject to election and rotation. He cited Florence as a significant role-model for the development of a just constitution.[12] Ruskin even designed some gold ducats based on Florentine examples as an alternative currency, though the coinage was never struck.[13]

The structure of the Guild was rigidly hierarchical, with the Master at its head given absolute and unquestioned authority. The Master was to be elected by the company, but during his active life Ruskin was unchallenged as Master. The layers below the Master consisted of Marshals (persons of independent means), Landlords and Militants (the rank and file working on the company's lands) and land-agents, tenant-farmers, hired labourers or tradesmen. Last of all were the Friends in Council – sympathisers called Companions, pledged to St George's Vow and to giving one-tenth of their income, but not living on St George's lands and following their own pursuits.[14] The original roll of the Guild had the Master and 32 members, which had increased to 57 by 1884, of whom 30 were women.[15] The requirement for members to donate one-tenth of their income was reduced to £5 per year in 1885 because of a lack of supporters.[16]

The money raised was intended for the purchase of land to set up self-sufficient communities which would eschew the typical industrial and technological systems of the age. It was Ruskin's original intention that only wind, water, animal and human power were to be used for Guild ventures.[17] This specifically excluded steam power on two grounds – firstly social – 'Machinery enables no more of us to live; it only enables more of us to live idle on other's misery'[18] – and secondly pollution – 'Most

assuredly, the soot and stench of your steam engine will make your crop *less* next year.'[19]

Because of Ruskin's interest in the environment, he is now recognised as a forerunner of the ecology movement.[20] His attitude to trade and fair wages further reinforces that pioneering connection with ethical issues. In Ruskin's ideal community wages were intended to be based on production rather than any intellectual or occupational hierarchy:

> The price of every other article will be founded on the price of food. The price of what it takes a day to produce, will be a day's maintenance; of what it takes a week to produce, a week's maintenance, such maintenance being calculated according to the requirements of the occupation, and always with a proportional surplus for saving.[21]

Exploitation of the working classes through the artificial inflation of food prices particularly enraged Ruskin. To cite one example, in a letter in *Fors Clavigera*, Ruskin quoted from legislation in the Florentine archives: 'No person whatsoever shall buy fish, to sell it again, either in the market of Florence, or in any markets in the state of Florence.'[22] The middleman was abolished in Florence. Ruskin followed this by an account of the suffering of fishermen at Yarmouth, forced to sell their entire catch to middlemen who dumped or converted a large part of the catch into manure to inflate prices artificially. It is from anger at examples like this and research into more ethically sound policies in fourteenth-century Florence and Venice that Ruskin formulated his policy for trade. In the Guild of St George communities, food was only to be sold when there was no one going hungry in the district.[23] A barter economy was to be used within and between Guild ventures as far as possible.[24] All articles produced by Guild employees were to have the profit margins clearly marked for public display.[25]

Where Ruskin was more in tune with the consensus of his age was in his patriarchal attitude towards the working classes. His anxiety to control access of his charges to intellectual materials was demonstrated in his proposal that every Guild member tenant's

> household will have its library, given it from the fund, and consisting of a fixed number of volumes, – some constant, the others chosen by each family out of a list of permitted books, from which they afterwards may increase their library if they choose. The formation of this library for choice, by a repub- lication of classical authors in standard forms, has long been a main object with me. No newspapers, nor any books but those named in the annually renewed lists, are to be allowed in any household. In time I hope to get a journal published, containing notice of any really important matters taking place in this or other countries, in the closely sifted truth of them.[26]

The intention to censor and control reading material has echoes of the anxiety that prompted organisers of the Great Exhibition of 1851 to create separate viewing days for the working classes in case they rioted because of the sight of luxury. Ruskin wanted to educate and improve the lot of the working classes, but only within tightly controlled parameters. Each tenant family was to be put on trial for a year without a lease of land to ensure that it conformed to the regulations and behaved well. This was to be followed by a three-year lease and, if officers were satisfied, a lifelong lease.[27]

Ruskin also had a conventional attitude to the role of women; he was opposed to women's suffrage and saw their place as being within the home, in keeping with the Victorian notion of the domestic angel in the house. In the proposed schools for the Guild (which never came into existence) Ruskin specified a curriculum in which 'the boys learn either to ride or to sail; the girls to spin, weave, and sew, and at a proper age to cook all ordinary food exquisitely'.[28] Despite this, Ruskin did attract to his sphere of influence a number of women who were anything but conventional in their achievements. These included Mrs Fanny Talbot, a benefactor of the Guild, Octavia Hill, who campaigned for better housing for the working classes, and Kate Greenaway, the water-colourist and children's book illustrator. They became friends of Ruskin as well as supporters.

Because of the clash between idealism and reality, it is perhaps not surprising that the Guild's actual achievements during Ruskin's lifetime were somewhat less than he had hoped. Some land was purchased and other estates were donated and managed by the Guild. The Walkley estate in Sheffield (including an acre of land) was purchased, which enabled the establishment of a small museum.[29] St George's Farm was set up at Totley, 6 miles from Sheffield on 13 acres of poor land,[30] bought in response to requests from Sheffield workers for land to work in their spare time. The growing of fruit-trees, strawberries and gooseberries was attempted on this land, a purpose to which it was totally unsuited.[31] The Cloughton estate near Scarborough, of about 2 acres and with one cottage, was purchased to be worked by John Guy, a Guild member and a family man, who had been sacked from a farm for following Ruskin's principle of refusing to operate and maintain a steam engine.[32] Although Ruskin was able to demonstrate successfully that, with his recommended agricultural methods, poor land could be made to produce food, it was hard physical labour and was achieved with great difficulty. The land purchased for John Guy was rocky, with poor soil. Acquiring fuel was also a serious problem for him, since he had no peat-cutting rights like the other villagers.[33] He could grow food for his family but did not have sufficient surplus to sell to buy

fuel. Yet he still made his donation of one-tenth of his income, and from the tone of his letters was extremely grateful for Ruskin's support. John Guy's case demonstrates Ruskin's compassion and willingness to take direct action on an individual scale.

Ruskin's charisma and energy attracted a small number of influential followers who were able to donate land to the Guild. George Baker (one-time mayor of Birmingham) donated the Bewdley estate,[34] about 20 acres of land in Worcestershire where Ruskin wished to build a museum for books, art objects and minerals,[35] but this project was never completed. The estate was later used as a tenant farm.[36] Baker became a trustee of the Guild and its second Master (1901–10) after Ruskin's death. Mrs Fanny Talbot read about the Guild in *Fors Clavigera* and became a lifelong friend of Ruskin after he helped her 18-year-old son with his drawing by correspondence.[37] As a trustee of the Guild, she took an active role and donated the Barmouth estate of 1 acre of land and eight cottages to the Guild.[38] In 1885 Ruskin identified Baker and Talbot as his chief supporters and collaborators.[39]

In his Master's Report of 1884, Ruskin acknowledged his inability to act as a manager of land and regretted that appropriate people had not come forward to help.[40] He reinforced the shift of emphasis for the Guild from the establishment of a self-sufficient peasantry to a more educational role.[41] He explained that the museum containing books, manuscripts, minerals and other objects was intended for the use of working people. Ruskin considered it fortunate that it was outside Sheffield on top of a steep hill, so that working people would have to take a bracing country walk to reach it, suggesting that 'the approach to it (the museum) may be at once symbolically instructive, and practically sanitary'.[42] To further its educational role, the Guild dispatched books, prints and collections of minerals to schools, for example, in the Shetland Isles.[43]

Through the Guild Ruskin paid a number of young artists a wage that he considered to be slightly above subsistence of £120–£160 per annum [44] to make paintings and drawings of beautiful buildings and copies of important paintings selected by Ruskin. The wage was an example of the important principle that everyone was to be treated equally in the Guild; in theory the labourer and the manager receiving a similar wage. He disapproved of the elevation of the artist to a higher status than that of the artisan, a situation which was widely accepted in the nineteenth century.

The Guild's textile projects

Ruskin's frustration and disappointment at his failure to enlist his friends and the broader public in support of the Guild was evident in his Master's

Report of 1885, which expressed his disillusionment because of the lack of assistance.[45] While it is true that he did not attract as wide a range of wealthy, experienced and influential collaborators as he had hoped, the textile projects associated with the Guild were an exception in their loyal and competent supporters. For example, Albert Fleming, a Companion of the Guild, revived handloom weaving in the Lake District, following Ruskin's principles, setting up an organisation known as the Langdale linen industry.[46] Ruskin had been campaigning for many years to re-educate the public to accept the irregularities of production in handmade articles as signs of individual creativity and the passage of the worker's hand. He had exhorted all true Englishwomen to learn to spin and weave. When the first piece of linen was woven by the Langdale linen industry, Fleming was initially dismayed by the coarseness of the cloth, but was encouraged by remembering Ruskin's writing about handcraftsmanship: 'the *Seven Lamps* ... convinced us that these little irregularities were really the honourable badges of all true hand work'.[47]

The hand-woven linen found a market among female philanthropists who were campaigning to save crafts and particularly to help the female rural poor in the 1880s. Ruskin lent his support to another Lake District organisation, the Ruskin Lace and Linen Industry, which embroidered hand-woven linen with cutwork and insertion stitches, made clothing and household items, and was run by Miss Twelves, a trusted friend of Ruskin. She organised a number of women to do the embroidery, some of them in a workshop and sales outlet at St George's Cottage, Keswick, others in their homes as part of a cottage industry. Exhibitions and sales of work were held in London. Although Ruskin gave his support and his name to the Lace and Linen Industry, it was not formally adopted by the Guild until 1902, after Ruskin's death.[48] The embroidery techniques begun at that time have continued in the Lake District. In the summer of 1995 embroiderers were working at Ruskin's house, Brantwood, which is open to the public, thus demonstrating the living tradition.

Another committed supporter, George Thomson, the proprietor of a woollen mill in Huddersfield, reorganised his mill to function as a worker's co-operative, following Ruskinian principles.[49] Thomson became a trustee of the Guild, and after Ruskin's death served as its Master. The textile projects appear to have been extraordinarily successful in Guild terms, that is, in giving the opportunity for improved social conditions for the work-force, the creation of a practical and beautiful product and in developing a market for handicraft production. In my view, a significant reason for this is that Ruskin did manage to attract competent managers for these ventures. He acknowledged his own inexperience in land-management and regretted that knowledgeable people in that area had not

come forward to help. He used his own expertise to purchase and commission art, to buy books and manuscripts and to develop a minerals collection, thereby creating a museum and teaching collection of lasting benefit.

St George's Mill

When I visited St George's Mill in 1994, it was still producing hand-woven cloth, representing about 50 per cent of its annual output. The history of the mill reflects what Ruskin had hoped to achieve with Guild projects, in that it was managed by Egbert Rydings, who was working-class in origin and had come to know Ruskin by reading *Munera Pulveris* and *Fors Clavigera* and through corresponding with him. Knowing Ruskin's concern to conserve and promote the skills of handicrafts, Rydings originally wrote to him about the plight of handspinners on the Isle of Man. Many of the women of his village, Laxey, were elderly, in poverty and forced, despite their spinning and weaving skills, to seek work in the leadmines. He wrote compassionately of 'beclogged and bejacketed village women who were forced from 7 o'clock in the morning to 6 at night out in the open ... pushing, pulling and trundling heavy wheelbarrows filled with lead ore'.[50] At the same time there were no young girls coming forward to learn spinning because they saw no future income from it. Ruskin was quoted in the *Pall Mall Gazette* as seeing this as 'a last effort to save ... the venerable art' that was being so remorselessly 'torn from the poor'.[51] He responded immediately with money from the Guild to support the women[52] and thereafter worked with Rydings to establish a spinning and weaving business. The Guild can in this context be seen as directly practical

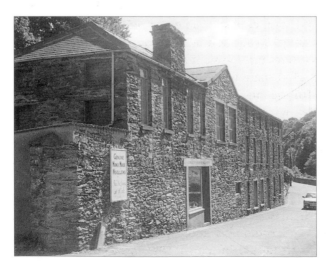

1 St George's Mill, Laxey, Isle of Man, 1994

on an individual scale. More importantly it was used to safeguard future prospects by financing a spinning school and a spinning and weaving mill. This action is in keeping with what is currently termed 'sustainability'.

When Rydings wrote to Ruskin in March 1876 to apply to become 'a companion of the lowest order',[53] he was careful to explain his working-class origins [54] and how he had been able to better himself through hard work, education and careful saving by frugal living. In his application he wrote

> I was brought to the trade of silk hand-loom-weaving and followed it faithfully from my 10th year until I was 20. During these 10 years of work I gained a thorough practical knowledge of my trade and worked some of the finest sorts of hand-loom work – velvet, satins, ottomans figured – brocades, gros-grain etc., etc., – being intended for an 'overlooker' I was put to these various classes of work to fit me for the possition [*sic*].[55]

Rydings also commented on an area dear to Ruskin's heart – the dying out of handloom weaving as a craft and on the low status accorded to handloom weavers among the working classes:

> There is one question here that arises in my mind that has always puzzled me and perhaps you can throw some light on it. How is it that hand-loom weaving is always looked upon as the most degraded trade a person can follow ... I remember the colliers of Oldham used to look with a sort of disdain upon us 'poor mean Failsworth weavers' as they used to call us. And it is not alone the workers in other trades that look upon hand-loom weaving as a degraded occupation, but the weavers themselves consider it a low trade.[56]

It is rare to find a direct comment on occupational hierarchy from a member of the working classes. Rydings could be said to have changed class through his own efforts, having progressed from weaver to designer, then to general assistant, bookkeeper and cashier responsible for 450 workers in the silk-warehouse. Through frugal living he was able to save £350, which he invested in an iron-works. After three years it burnt down, causing Rydings to lose the whole of his £500 share in the firm, as it was not insured. He left Manchester to live with the family of his wife, who came from the Isle of Man. After a year, they were able to set up a draper's shop in Laxey which his wife managed, while he became secretary and manager of a co-operative society selling groceries. He gave up his job and the shop to nurse his wife through a long illness culminating in her death in April 1876. He was left with the care of his two young sons, aged 5 and 13. After his wife's death, Rydings became more actively involved with the Guild, becoming its accountant in May 1876.[57] Rydings's family connections must have helped when he set up a spinning school with money from the Guild in 1877.[58] Rydings's letter to Ruskin in March 1876 described the family

involvement with self-sufficiency in textile production: 'All our blankets, sheets, flannels, skirts, jacket cloth, stockings, and yarns, have been spun by my wife and her mother before her.'[59] In Rydings's application to become a Guild member he pointed out that 'I have been ernestly [*sic*] endeavouring to live up to your teachings for a long time now.' His commitment was evident in how he educated his pupils at the spinning school in the aims of the Guild and formed a spinning co-operative in 1879.[60] He was able to generate enough enthusiasm and expertise to merit setting up a spinning and weaving mill, which opened in 1881.

The Guild of St George was again able to be of practical and immediate help with an interest-free loan for the rental and fitting of a water-mill and store at Laxey. The rental was £20 and the fitments £500. Rydings personally provided one-third of the £500.[61] The mill at Laxey was fitted with machinery for carding and spinning the wool and washing the cloth, and with handlooms. It also operated as a store and a shop with direct sales and bartering. Rydings described a visit that he made to Ruskin at Brantwood to discuss the mill:

> He [Ruskin] entered with enthusiasm and spirit into all the details of this the first venture of 'St George's Guild' as manufacturers. The fundamental rules were that all materials used in the manufacture must be of the best and purest, and that the goods when made were to be as perfect as fingers could make them; an open market to all; if a girl wanted a new frock, or a young man cloth for a new suit of clothes, they should be able to buy direct from the mill, and have the Guild's guarantee that they were getting honest woollen cloth.
>
> 'No credit,' – as he quaintly put it, – 'this will save sleepless nights.'[62]

His description of the cloth as 'honest' related to Ruskin's long-term concern about shoddy, a cheap reconstituted cloth often used in clothing for the working classes[63] that wore badly and often fell apart on washing. Engels had described it as 'Devil's Dust' in 1845.[64] Ruskin considered that 'honest' pure and unadulterated woollen cloth, manufactured without profit as the key motivation, thereby making it reasonably priced, was a viable alternative for the working classes. He specified the ideal form of dress for Guild members to be plain and of sound cloth. Only ornaments of gold and uncut gems were allowed. Second-hand clothes and selling or pawning their clothes were forbidden to Guild members. In Ruskin's *Letter to Young Girls* (1876) he dispensed advice to those interested in following the principles of St George's Company, including the following comments on dress:

> Dress as plainly as your parents will allow you: but in bright colours (if they become you), and in the best materials – that is to say, in those which

will wear longest. When you are really in want of a new dress, buy it (or make it) in the fashion: but never quit an old one because it has become unfashionable.[65]

Knots and flounces were to be absolutely avoided. The dressmaker to be used had to be

a poor person, living in the country; not a rich person living in a large house in London. 'There are no good dressmakers in the country'? No: but there soon will be if you obey St George's orders, which are very strict indeed, about never buying dresses in London.[66]

Despite the somewhat dictatorial tone, the letter, which was eventually produced as a pamphlet, proved very popular, and 75,000 copies had been published by 1907.[67]

The St George's Mill homespun was used for dress fabrics and men's suiting. It came in varying shades of grey and brown from the undyed wool of the native Loaghtan sheep blended with white. Farmers brought wool to the mill, for which they could be paid in finished cloth, yarn for home-knitting or occasionally carded wool for home-spinning. Finished cloth was available for sale. A yard of homespun cloth was intended to be used as a unit of currency in Guild ventures.[68] A small amount of dyeing was done using vegetable dyes native to the island. The cloth was guaranteed not to shrink or change colour.[69] These were important considerations in the 1880s, when clothing could be positively dangerous to health. The trade press was full of reports of sores caused on the skin by dyes or finishing processes.[70] In the 1880s Dr Jaeger promoted the wearing of undyed wool with its oil left in next to the skin as having positive health benefits.[71] So it was a good time to market a safe, durable and beautiful fabric. Grey was a popular colour in the 1880s.

Egbert Rydings was paid by the Guild as manager of the venture; for example, in 1882 he received £105,[72] a reasonable salary, given the size of the concern. The passage of Ruskin's which had first influenced Rydings not to want a large salary was from *Munera Pulveris*, published in 1872:

That the law of life is, that a man should fix the sum he desires to make annually, as the food he desires to eat daily, and stay when he has reached the limit, refusing increase of business, and leaving it to others, so obtaining due freedom of time for better thoughts.[73]

Rydings strove to live according to these principles; he was an idealist and gave his wholehearted commitment to the Guild, including 10 per cent of his earnings.

Rydings did his utmost to make the mill successful within the ethical guidelines that he had established in his meeting with Ruskin at Brantwood.

In 1882 Rydings produced a flysheet to advertise the St George's Mill products, a range of mail-order goods, carriage-free. It included 'a stock of Cloth [presumably plain weave], Tweeds, Home-spun Serges, Flannels, Blankets, Yarns, Stockings',[74] with patterns available for inspection.

In 1882 the report of the Manchester Ruskin Society (the Society of the Rose) commented on the Laxey venture and noted that patterns of the goods were about to be sent to the secretaries of all the various societies associated with Ruskin.[75] Rydings had expressed his concern as early as 1876 that the long-lasting nature of Manx cloth made it unpopular, as it did not give 'young women a chance of having four or five new dresses in the year'.[76] Despite the lack of response to Ruskin's advice to dress plainly and the continuing desire for novelty, the mill flourished. A Guild trustee, Mr George Thomson, a manufacturer of woollen and worsted cloth in Huddersfield, took over Ruskin's involvement from c. 1884.[77] The mill expanded in 1891, since despite working overtime workers were unable to fill more than half of the orders received. It operated an open-market principle, charging the same rate for cloth to the Duchess of Westminster as to a worker at the mill. Apparently much of the heavy woollen cloth was bought by Savile Row tailors.[78]

In terms of its success as a community venture, workers previously employed in shiftwork at the mines were able to enjoy regular daytime shifts which left them leisure for gardening and fishing, and they were able to help farmers with the harvesting. In winter they gathered at mountain farms for evenings of singing, dancing and story-telling. This made a real change in the communal lives and working conditions of all at St George's Mill. In keeping with Guild philosophy, Rydings became fully integrated in the social and cultural life of the island.

In comparison with the success of the mill on social and communal grounds, its success as a commercial venture was not quite so straightforward. After Ruskin's death, Fanny Talbot, one of the trustees and by all accounts a very practical woman, was strongly in favour of removing the mill from Guild influence because of its lack of financial viability. Although Rydings agreed with Mrs Talbot about the lack of commercial viability, he was clearly more personally engaged with the social and spiritual goals of the Guild, and wrote to her on 10 December 1900:

> I am quite of your opinion 'that the whole concern is a total failure' ... I have worked the mill on the lines laid down by Mr Ruskin when the mill started 20 years ago and I find myself at least £200 poorer than I was when I commenced the business. Of course I must confess it has been a great blessing for the poor people who have been working in the mill – most of them having been with me from 15 to 20 years – been getting good wages all the time. It has always been considered here that St George's Mill has

been a sort of hospice for the poor widdows [*sic*], orphans deaf & dumb & cripples in the parish & have no doubt I have been the means of saving the poor rates of our parish. This of course is the great consolation to me that if I am poorer materially I hope I am richer spiritually.[79]

Holroyd and Son of Huddersfield took over the running of the mill in 1901[80] when it was sold by Rydings, ending Guild involvement. Some difficulty was experienced in redeeming the Guild mortgage of about £275. It was noted in the Minutes of the Guild on 2 September 1903 that 'with regard to the woollen mill at Laxey, Mr Baker mentioned that tho' Mr Rydings had sold the mill only £30 has been rec'd since the last meeting towards the balance of the mortgage'.[81] The situation was not resolved until 1907, when it was recorded that 'A satisfactory settlement of the claim against Mr Egbert Rydings had been effected £203 paid in settlement.'[82]

This seems to suggest a rather sorry end to the idealistic involvement of Rydings with the Guild, which did attempt to operate on a sounder business footing after Ruskin's death. I found no mention of Rydings's death on 12 April 1912 in the minutes of Guild meetings, although it was common practice to acknowledge members' deaths.[83]

St George's Mill today

St George's Mill is still in operation at Laxey, producing cloth and selling other goods and textiles not manufactured at the mill. In 1947 the mill was taken over by a co-operative of islanders who employed Robert Wood, an energetic young graduate from Galashiels, to become mill manager.[84] He was still working in the mill in 1994, operating it as a family concern, with his wife selling cloth, his son weaving on the handloom and local people employed according to demand. Wood was very knowledgeable about the background history of the mill and its Ruskinian origins. He was responsible for reintroducing handloom weaving during the 1960s, when it was becoming increasingly difficult to compete commercially in the world market as a small-scale producer. Much of the business was with Canada, where there was a market for heavier-weight woollen cloth. Lucrative contracts were also made with Dormeuil Bros. at the top end of the market. Wood estimated that in 1994 at least half of the mill's production was hand-woven. The tourist trade on the island also provided an important outlet for sales. The range of colours and textures was quite breathtaking and fully in line with the idea of producing a beautiful but utilitarian cloth embodied in Ruskin's original concept.

Although plant-derived dyes are no longer used at the mill, the link with nineteenth-century production is still maintained by the use of the

undyed fleece of the Loaghtan Sheep, a breed native to the island since Celtic times.[85] The fleece has varying shades of brown and produces an exceptionally soft but hard-wearing yarn. The mill no longer has a right to a share of the Manx clip (the fleece shorn from sheep on the Isle of Man), since its spinning facility was destroyed by fire.[86] Manx wool has to be purchased by the mill, and apart from the Loaghtan product is mixed with cheaper imported wool.

The Guild of St George could be deemed to have failed in its initial aim of setting up a viable alternative to industrial society, but even for its age it was a rather unrealistic proposal, with a structure that was too dogmatic and rigidly hierarchical. The principles underlying the ideas, however, are still valid and relevant, and have left a lasting influence on the Isle of Man. The Green movement is exploring issues of relevance to Ruskin's philosophy. For example, the use of wind and water power, the wearing of natural undyed materials, buying locally, wearing simple classic designs to avoid discarding clothes for fashion trends, growing food organically and many examples of barter economies have been introduced, such as Local Exchange Trading Systems (LETS) [87] and Angel credits in the Findhorn community.

Being dependent on personal choice (apart from anti-pollution legislation), the ecology movement, in my view, marks a progression from the government-legislated 'applied democracy' as practised through the Utility Scheme. The agenda for the Scheme went beyond the immediate need for defence measures in terms of defining an aesthetic that had its origins in values expressed in the nineteenth-century Arts and Crafts Movement. There was also a social agenda as expressed by Hugh Dalton, President of the Board of Trade in 1942, who wrote in his memoirs of working with manufacturers to locate industry in the countryside not just as a protection from bombing but to take industry to economically depressed areas and because he considered it to be environmentally healthier for the work-force, cutting down on transport pollution in cities and providing a pleasanter environment for workers' families.[88] This philosophy has parallels with Ruskin's environmental concerns and the notion of the country village providing a kind of utopia for the work-force also evident in William Morris's writings. Another precedent for moves away from the cities to rural locations was Ashbee's Guild of Handicraft, which relocated from London to Chipping Campden in the Cotswolds in 1902.

T.D. Barlow, the implementer of the Utility Scheme for clothing and textiles and negotiator with businesses under the Control of Premises Act, was allegedly able to cut down clothing production from 25,000 companies to 2,000 while retaining a good relationship with manufacturers and retailers. A textile manufacturer himself, of high standing within the trade,

he demonstrated his aesthetic concerns by setting up a specialist individual weaving branch, Helios, which was run by the Swiss designer Marianne Straub within the parent company of Barlow and Jones. His desire to use the Utility Scheme to promote simple, well-designed clothing with high production standards in terms of manufacture and cloth specification is evident in statements to the press and in reportage of the scheme.[89]

Implementers of the Utility Scheme were concerned with extending the customer base of well-designed good-quality clothing and textiles. Price-control measures were used in an attempt to limit profit levels and thereby increase value for money in Utility cloth and clothing production. The Utility Apparel (Maximum Prices and Charges) Order came into force on 2 February 1942, under which 'The maker-up is not allowed to make more than a limited percentage of profit, and the items he can take into account as costs are strictly defined. In no circumstances may the garments be sold at a price higher than the 'ceiling', or over-riding maximum, fixed for each garment.'[90]

Ruskin had a highly developed notion of the importance of fair trade and had attempted to implement a fair policy in the pricing of goods made by members of the Guild of St George. The cost of the production of items, for example, of a length of cloth, was to be clearly displayed along with the amount that was added as profit. He encouraged the use of a barter economy in Guild ventures and intended a yard of Laxey homespun cloth to serve as a unit of currency.

From the tone of Ruskin's writings I am sure that he would have welcomed the opportunity to stamp his convictions on social policy and design production. Evidence suggests that he always intended the Guild of St George to operate on a large, international scale.[91] His initial desire to run the Guild with total authority, requiring all decisions to be subject to his mandate, is a trifle alarming, but he did envisage a system of managers/administrators with a degree of local autonomy reporting to him.

It is evident that there were many shared concerns between Ruskin's philosophy and Arts and Crafts ventures and the creators and implementers of the Utility Scheme. The 'persuaders' in Arts and Crafts terms were eloquence and force of personality rather than the power of government and the legal system. The scale of Arts and Crafts experiments in social control, implementation of design aesthetic and utopian living was much smaller and dependent on free will. The nationally imposed Utility Scheme, with its massive control of design, manufacture and relocation of work-force, was obviously on a much larger scale, but still seems to have been dependent on the socialist ideas, and in Sir Stafford Cripps's case, Christian socialist[92] ideas, of a few.

Notes

My research into St George's Mill began when I was investigating the interaction between Arts and Crafts designers and manufacturers of textiles and wallpaper for an MA thesis (L.S. Coleing, 'The Relationship between Arts and Crafts Designers and Manufacturers of Textiles and Wallpaper in the Late Nineteenth Century', unpublished MA by research, University of Keele, 1991). Despite the lack of published material on the mill, it was clearly of great significance to Ruskin, and study of it suggests that it was successful as a social experiment. An early form of this chapter was delivered as a paper in 1993 to the Textile Society ('"Is the machine a necessary evil?" Attitudes to Hand and Machine Production in Arts and Crafts textiles'). During my research I was surprised to discover that the mill was still in operation in the same premises at Laxey, Isle of Man. Other primary sources used were in the Manx National Library; the Ruskin Galleries, Bembridge (the collection has since moved to Lancaster University); the Archive of the Guild of St George, Sheffield; the John Rylands University Library, Manchester. A number of people assisted with my research, including Ms V. Cottle, a journalist on the Isle of Man; Mrs T. Davidson, a handspinner on the Isle of Man; Mr J.S. Dearden, Director of Ruskin Affairs of the Guild of St George; and Mr R. Wood, manager of St George's Mill.

1 A. Forty, *Objects of Desire*, Cameron Books, 1986, p. 6.

2 See, for example, J. Harvey and J. Press, *William Morris Design and Enterprise in Victorian Britain*, Manchester University Press, 1991.

3 See, for example, *The Works of John Ruskin*, ed. E.T. Cook and A. Wedderburn, George Allen, 1907, Vol. 30: 'The Guild of St George'. (This edition is hereafter cited as Ruskin, *Works*.)

4 A. Callen, *Angel in the Studio*, Astragal, 1979, pp. 2–3.

5 C. Morley, *Ruskin's Late Works, c. 1870–90, the Museum and Guild of St George – an educational experiment*, University of London thesis, published London, Garland, 1984, preface.

6 W. Morris, 'A Factory as it Might Be', in G. Cole, *William Morris*, Nonesuch Press, 1946, pp. 646–54 (originally published in *Justice*).

7 Ruskin, *Works*, Vol. 30, pp. 40–1: The Master's Report, 1881.

8 Ruskin, *Works*, Vol. 27, p. 95: *Fors Clavigera*, Letter 5, May 1871.

9 Ruskin, *Works*, Vol. 28, p. 503: Notes and Correspondence to Letter 61, January 1876.

10 Ruskin, *Works*, Vol. 29, pp. 164–5: Notes and Correspondence to Letter 79, July 1877; Vol. 29, p. 350: Notes and Correspondence to Letter 86, February 1878.

11 Letters 1–87 of *Fors Clavigera* were published in monthly parts from February 1871 to March 1878. Letters 88–96 were published irregularly between 1880 and 1884; Ruskin, *Works*, Cook, Introduction to Vol. 27, p. xvii.

12 Ruskin, *Works*, Vol. 28, p. 23: Letter 37, January 1874.

13 Ruskin, *Works*, Vol. 28, p. 25: Notes and Correspondence to Letter 37, January 1874, Vol. 28, pp. 430–1: Letter 58, October 1875.

14 Ruskin, *Works*, Vol. 28, p. 539: Letter 63.

15 Ruskin, *Works*, Vol. 30, p. 86: The Master's Report, 1884.

16 Ruskin, *Works*, Vol. 30, p. 97: The Master's Report, 1885.

17 Ruskin, *Works*, Vol. 27, pp. 87–90: Letter 5, May 1871; Vol. 28, p. 21: Letter 37, January 1874.

18 Ruskin, *Works*, Vol. 28, p. 132: Letter 44, August 1874, footnote 1, Letter from Ruskin to the manufacturer Mr Joseph Brooke; see also Vol. 29, Appendix 10, pp. 547–52: Correspondence between Ruskin and Brooke on the use of machinery.

19 Ruskin, *Works*, Vol. 28, p. 133: Letter 44, August 1874.

20 G. Naylor, *The Arts and Crafts Movement*, Trefoil, [1971] 1990, p. 6.

21 Ruskin, *Works*, Vol. 28, p. 38: Letter 38, February 1874.

22 Ruskin, *Works*, Vol. 28, p. 30: Letter 38, February 1874.

23 Ruskin, *Works*, Vol. 29, pp. 19–20: Letter 73, January 1877.

24 Ruskin, *Works*, Vol. 28, p. 429: Letter 58, October 1875; see also Vol. 28, p. 768: Notes and Correspondence to Letter 72, December 1876 (a yard of Laxey homespun as a unit of St George's currency).

25 Ruskin, *Works*, Vol. 29, p. 113: Letter 77, May 1877.

26 Ruskin, *Works*, Vol. 28, p. 20: Letter 37, January 1874.

27 Ruskin, *Works*, Vol. 28, p. 21: Letter 37, January 1874.

28 Ruskin, *Works*, Vol. 27, p. 143: Letter 8, August 1871.

29 Ruskin, *Works*, Vol. 28, pp. 448–51: Letter 59, November 1875; see also Vol. 28, p. 468: Notes and Correspondence to Letter 60, December 1875 (the Walkley estate purchased for £600).

30 Ruskin, *Works*, Vol. 29, p. 98: Notes and Correspondence to Letter 76, April 1877.

31 Totley is also known as Mickley or Abbeydale; Ruskin, *Works*, Vol. 30, p. 20: The Master's Report, 1879; Vol. 30, p. 40: The Master's Report, 1881; Vol. 30, p. 49: General Statement, 1882.

32 Ruskin, *Works*, Vol. 29, pp. 144–5: Notes and Correspondence to Letter 78, June 1877, Guy to Ruskin, informing Ruskin of the sacking and eviction of John Guy; Vol. 30, p. 21: The Master's Report, 1879 (Purchase of the cottage and land to be worked by John Guy at Cloughton).

33 Ruskin, *Works*, Vol. 30, p. 23: Guy to Ruskin, 21 February 1878.

34 Ruskin, *Works*, Vol. 28, p. 607: Notes and Correspondence to Letter 65, May 1876.

35 Ruskin, *Works*, Vol. 30, p. 98: The Master's Report, 1885.

36 Ruskin, *Works*, Vol. 30, p. xxvi: Cook, Introduction to Vol. 30.

37 Letter from F. Talbot to Canon Rawnsley, 30 July 1900, John Rylands University Library, Manchester, Ryl. Eng. MS 1164 (19).

38 Ruskin, *Works*, Vol. 30, pp. xxviii–xxx: Cook, Introduction to Vol. 30.

39 Ruskin, *Works*, Vol. 30, p. 95: The Master's Report, 1885.

40 Ruskin, *Works*, Vol. 30, p. 71: The Master's Report, 1884.

41 Ruskin, *Works*, Vol. 30, pp. 71–2: The Master's Report, 1884; pp. 94–7: see also The Master's Report, 1885.

42 Ruskin, *Works*, Vol. 28, p. 451: Letter 59, November 1875.

43 Books were sent to schools in the Shetland Isles and coloured prints were dispatched

via the Art for Schools Association, of which Ruskin was the President; Ruskin, *Works*, Vol. 30, p. 83: The Master's Report, 1884.

44 Examples of young artists employed by St George's Guild included Mr Hackstoun (£120 per year) and Mr Randal (£160 per year); Ruskin, *Works*, Vol. 30, p. 38: The Master's Report, 1881.

'Mr Alessandri gives us the most conscientious and lovely work, at prices which are just sufficient for his maintenance' (Ruskin, *Works*, Vol. 30, p. 72: The Master's Report, 1884).

45 Ruskin, *Works*, Vol. 30, pp. 96–7: The Master's Report, 1885.

46 Ruskin, *Works*, Vol. 30, Appendix 3, pp. 328–30: A. Fleming, 'The Langdale Linen Industry; E. Prickett, *Ruskin Lace and Linen Work*, Batsford, [1985] 1986.

47 Ruskin, *Works*, Vol. 30, p. 329: Fleming, 'The Langdale Linen Industry'.

48 Minutes of meeting of Trustees and Companions of the Guild of St George, Crosthwaite Parish Room, Keswick, 6 September 1902. Sheffield Archives, GSG 22. Reproduced by kind permission of the Guild of St George.

49 Ruskin, *Works*, Vol. 30, Appendix 3, pp. 333–5: W. Clark, 'George Thomson & Co.'.

50 E. Rydings to Ruskin, autobiographical account, 10 March 1876 (unpublished), the Ruskin Foundation, Ruskin Library, University of Lancaster. Reproduced by kind permission of the Guild of St George.

51 Ruskin, *Works*, Vol. 30, p. 330: Cook, 'St George's Cloth', *Pall Mall Gazette*, 8 February 1886.

52 Ruskin, *Works*, Vol. 28, p. 768: Notes and correspondence to Letter 72, December 1876: 'cheque of £25, sent to Mr Rydings for the encouragement of some of the older and feebler workers'.

53 Rydings to Ruskin, autobiographical account.

54 I am grateful to Zoe Munby for drawing my attention to her account of the Ridings family of silk-weavers from Failsworth, Manchester, although she was unable to trace Egbert Rydings specifically in the census returns. See Z. Munby, 'Woven Cottons: Studies in the Role of the Designer in the Production Process', unpublished PhD thesis, Manchester Polytechnic, 1986, p. 137.

55 Rydings to Ruskin, autobiographical account.

56 *Ibid.*

57 Ruskin, *Works*, Vol. 28, p. 611: Notes and correspondence to Letter 65, May 1876.

58 M. West, 'Ruskin Manx Tweed', *The Countryman*, Summer 1969, p. 326.

59 Ruskin, *Works*, Vol. 28, p. 585: Rydings to Ruskin, 4 March 1876.

60 West, 'Ruskin Manx Tweed', p. 326.

61 *Ibid.*

62 Rydings, 'Some Reminiscences of John Ruskin', *The Young Man*, July 1895, pp. 217–21.

63 Ruskin, *Works*, Vol. 30, pp. 331–2: Cook, 'St George's Cloth'.

64 F. Engels, *The Condition of the Working Classes*, Panther [1845], 1984, p. 100.

65 Ruskin, *Letter to Young Girls*, George Allen, n.d., pp. 3–4; Ruskin, *Works*, Vol. 28, p. 666. This letter originally appeared in *Fors Clavigera*, Letter 65, May 1876, and was reprinted with additions because of requests from parents.

66 Ruskin, *Letter to Young Girls*, p. 4.

67 Ruskin, *Works*, Vol. 28, p. xxvi.

68 Ruskin, *Works*, Vol. 28, p. 768: Notes and correspondence to Letter 72, December 1876.

69 Cook, 'St George's Cloth', p. 332.

70 For example, pustular eruptions on the legs from wearing red stockings coloured with an aniline dye containing antimoniac oxide; Anon., 'The poisonous dye scare again', *The Textile Mercury*, 11 April 1891, p. 265.

71 S.M. Newton, *Health, Art and Reason*, John Murray, 1974, pp. 87–114.

72 Ruskin, *Works*, Vol. 30, p. 144: Income and Expenditure Account, The Guild of St George, 1 January to 31 December 1882.

73 Rydings, 'Some Reminiscences of John Ruskin', *The Young Man*, July, 1895, p. 97.

74 Ruskin, *Works*, Vol. 30, p. 332: Rydings, flysheet, 1882.

75 Ruskin, *Works*, Vol. 30, p. 332: Third Annual Report of the Manchester Ruskin Society (Society of the Rose), 13 February 1882.

76 Ruskin, *Works*, Vol. 28, p. 585: Rydings to Ruskin, 4 March 1876.

77 Ruskin, *Works*, Vol. 30, p. 83: The Master's Report, 1884.

78 Interview between the author and Mr Robert Wood, manager of St George's Mill, August 1994.

79 Rydings to Talbot, 10 December 1900, John Rylands University Library, Manchester, Ryl. Eng. Ms. 1164 (10).

80 W.W., 'The Isle of Man and Textiles, Ruskin Guild Outcome', *The Southport Visiter*, 11 June 1938, p. 107.

81 Minutes of a meeting of Trustees and Companions of the Guild of St George, 2 September 1903, Guild of St George Minute Book, 1879–1929, Guild of St George Archive, Sheffield Archives, GSG 22 (unpublished). Reproduced by kind permission of the Guild of St George.

82 Minutes of a meeting of Trustees of the Guild of St George, Whitelands College, Chelsea, 6 and 7 May 1907, Sheffield Archives, GSG 22. Reproduced by kind permission of the Guild of St George.

83 The deaths of Blanche Atkinson and Dora Lees were recorded with a note of sympathy in the minutes of a meeting at Milton Hall, Deansgate, Manchester, 27 June 1912, Sheffield Archive, GSG 22. Reproduced by kind permission of the Guild of St George.

84 Interview with Mr R. Wood, August 1994.

85 F. Bazin (ed.), *The Manx Loaghtan Sheep: the Breed that Refused to Die*, Manx Loaghtan Sheep Breed Society, 1984, p. 11.

86 Interview with Mr R. Wood, August 1994.

87 In 1997 400 LETS schemes were in operation in the UK and Ireland. See the New Economics Foundation, Community Works, *Positive News*, 13, Summer 1997, p. 10.

88 H. Dalton, *The Fateful Years: Memoirs 1931–1945*, F. Muller, 1957, pp. 434–54: 'Location of Industry 1942–1945', especially pp. 434, 435.

89 Anon., 'Utility Clothing', *The Times* (4 March 1942), p. 5.

90 Anon., 'Price Control of Clothing – Utility Apparel Order in Force', *The Times*, 4 February 1942, p. 2.

91 Ruskin, *Works*, Vol. 30, p. 32: Master's Report, 1881: Ruskin suggests that St George's Guild is 'a company designed to extend its operations over the continent of Europe, and number its members, ultimately, by myriads'.

92 Sir R.S. Cripps, *Towards Christian Socialism*, Allen and Unwin, 1945.

2 ✧ 'Pro arte utili': the utility principle in Finnish textile design education

Marjo Wiberg

THE AIM of this chapter is to outline how utility was understood in the Finnish design world during the second quarter of the twentieth century. It is based on a study of the Finnish textile designers' education in which the interrelationship between aesthetic and ethical issues is discussed more extensively.[1] I shall first outline the development of the Finnish concept of 'utility' with reference to three slogans used by Finnish designers and then go on to highlight the interpretation of utility, focusing on articles written by prominent design educators.

The development of the Finnish utility theme can be associated with three slogans. They are, firstly, the motto 'Pro arte utili' (On behalf of useful arts) used by Finnish designers, secondly, the title of the Swedish propaganda publication *Vackrare vardagsvara* (*More Beautiful Everyday Things*), and thirdly, the name of the Finnish exhibition Kauneutta arkeen (Everyday Beauty) held in Helsinki in 1949.[2]

'Pro arte utili', the motto inscribed on a ring, the Finnish designers' emblem, carries possibilities for varied interpretations of the union of art and utility. The emblem was a result of a competition arranged at the design school in 1931–32. The motto can be understood as an expression of a new era which was exemplified with the statement of the Finnish design journal *Domus*, as it observed that the early 1930s saw a move from an era of 'l'art pour l'art' towards an ideal of 'l'art pour la vie'; in other words, a move from the aesthetics of high art toward everyday beauty interpreted in the call of: 'Artists to the factories!'[3]

The name of the exhibition, Everyday Beauty, recalled the principles stated in *Vackrare vardagsvara* by Gregor Paulsson thirty years earlier. The aim of the exhibition was to enlighten the audience on the difference between good and bad design, so good and bad examples were displayed. The exhibition included folk arts, decorative art and industrially produced everyday things. So after the years of war and shortage both traditional Finnish crafts and new interior design and functional planning were exhibited.[4]

It is, however, significant that, as the authoritative design educator and artistic leader, Arttu Brummer, wrote of the exhibition, he presented art and craft objects, not industrially produced everyday things.[5] For example, the majority of the textiles he discussed were hand-woven ryijy-rugs and wall-hangings. Brummer explicitly emphasised the importance of artistic work and artists' personalities.

'Pro arte utili' can, on the one hand, be taken as a review of the previous decades and, on the other hand, as staking out a path towards the future. The motto can be understood as mediating between two eras, with the two exhibitions expressing the design world's goals of beauty and utility.

Utility is usually described as something useful and practical, so utility can be gained either through craft production or industrial production. Although both the union of arts and crafts and the union of art and industry had been discussed in the Finnish design world since design education was introduced in 1871, the arts and crafts tradition[6] retained a dominant position in design education until the 1960s.[7]

In 1875 Veistokoulu, the handicraft school established in 1871, was taken over by the Finnish Society of Crafts and Design. A decade later, as it became the national central school of applied art, it was named Taideteollisuuskeskuskoulu. The annual reports of Taideteollisuuskeskus-koulu throughout the first decades of the twentieth century state that one of the school's most important aims was to meet the challenges of the developing industries.[8] In 1949 the school became an institute for applied arts and was called Taideteollinen Oppilaitos. In 1973 the institute became the University of Industrial Art, which has provided doctoral-level education since 1983. The present name, the University of Art and Design, was adopted in 1993.

However, the textile department was not founded until 1929. This was in spite of the fact that a successful textile industry had developed from the 1820s and the Finnish textile mills were among the largest in the Nordic countries between the two world wars.[9] The reason for the late start of the textile department was said to be economic, but there must have been other factors. For example, two handicraft schools which trained girls in traditional textile crafts had been active for decades, namely Helsingin Käsityökoulu (founded in 1881) and Wetterhoffin Työkoulu (1885) in Hämeenlinna. The fact that the field of textile craft is generally associated with women has obviously had many consequences, not only on education, but more generally on its evaluation.[10]

It is significant that even in 1951 Taideteollinen Oppilaitos trained textile designers or 'artists' following the principles created in the 1920s which emphasised hand-weaving and artistic expression. Recollections by former students describe this eloquently. The quotations that follow draw

attention to the goals which the school's annual reports stated officially, namely efforts toward co-operation with industry, contrasted rather sharply with the textile students' recollections.[11] In the 1930s, 'art textiles were the only acceptable thing' (LU–30). In the 1940s, 'there were extremely few contacts outside the school, with industry or otherwise ... Our projects were along the lines of arts and crafts. They weren't industrial or applicable to industrial production' (PO–40). One designer recalled that 'there wasn't any teaching oriented towards industry, nothing at all ...' (MO–40); 'there was no talk of industrial design, we never even thought of anything like that' (KO–40). In the 1950s:

> It was always thought that industrial textiles are ugly ... Things were happening in glass and furniture design ... but there was no industrial approach at all in textiles [12] ... We didn't know how the machinery worked, and ... there wasn't a single, or I can't remember a single set project with printed fabrics. (PI–50)

The relationship with industry was remote. The two most prominent design educators, Arttu Brummer and Rafael Blomstedt,[13] held important positions at the design school as well as in other design world institutions until the 1950s. Although both Brummer and Blomstedt wrote as early as 1922 of the utility principle with reference to Sweden, their interpretations differed from the Swedish ones.

Brummer wrote that the new term 'utility art' (nyttokonst) was a better expression than the old 'decorative art'. He interpreted the new term in the spirit of the theory of evolution – at first, people made their utility items by means of handicrafts, then as their sense for beauty developed they started to decorate their utensils. Decorative arts thus developed from handicraft and resulted in fine art.

Brummer concluded that, if the decorative arts were unable to free themselves from the utility principle, they could be called utility arts. In other words, both the high arts and the 'real' decorative arts were free of utility principles.[14] It can be added that in 1919 Brummer referred to Darwinism as well as the Ruskinian and Morrisian [15] principles as the basis of his ideas on education.

Blomstedt also deliberated on how the new ideas should be applied in Finland. According to him such new terms as the 'useful arts' or 'practical arts' indicated a move from decorative arts towards real life, from high art towards an art serving the practical needs of life itself. He also predicted that artists would work with the major industries in the future. Blomstedt referred to the Deutscher Werkbund as the initial source from which the new ideas had originated and spread to most civilised countries, for example to Sweden, as seen through the publication *More Beautiful Everyday Things*.

According to Blomstedt the old boundaries between handicrafts, home industries and art industries would vanish as the new concept which combined materials, production methods and beauty into a new form spread. He proposed gradual progress starting with a transition of 'some kind of intermediary form between artistic simplicity and a more decorative orientation towards "rural tastes"'. This would guarantee a firm economic basis for cottage industry. He believed that an advanced taste for a plainer style could be created.[16]

However, he also strongly criticised industrial production and stated that factory production was, directly and indirectly, the cause for the declining appreciation of beauty among the public. He underlined the need for artists to develop new products together with the home industries on the basis of folk tradition. Old textiles – for example, knotted ryijy-rugs and doublecloths – were specifically mentioned as the outstanding examples of Finnish folk art.

In fact, both Brummer and Blomstedt were prejudiced and even hostile towards industry. This was particularly marked in the field of textiles, for example, the much criticised 'new American barbarity'; the machine-made man's suit became more prevalent between the two world wars, though hand-weaving still flourished throughout the sparsely populated agricultural countryside.[17]

In 1927 the architect Carolus Lindberg published a history of the decorative arts, *Koristetaide*, which was much admired. He commented on the dismal artistic results of machine production, considering unique pieces of greater value than 'products by the dozen'. He also argued that machine industry was guilty of plagiarism. This was exemplified by printed fabrics which imitated decorative weaving. Furthermore, he noted that the European weaving industry used cotton as an imitation of other nobler materials, using cotton instead of silk in velvet, for example.[18]

More positive views of factory production were mostly expressed outside the Finnish design world. Magazines like *Kotiliesi* (*Domestic Hearth*) praised the Finnish textile industry as early as 1926. One author who rated home-produced textiles more highly than imported fabrics observed that they were as attractive as foreign fabrics and could be bought at half the price.

National production and national values are, indeed, the key terms that seem to have divided opinion in a country that only gained its national independence in 1917. Those who supported cottage industry and folk arts in the name of national endeavour and patriotism opposed imported products and foreign ideas as dangerous to the nation's identity.

Brummer, for example, wrote that it was pointless to talk of Finnish industry, since a machine imported from Germany would print a German

wallpaper pattern. He advised against the purchase of this type of product, suggesting instead that the public should cherish traditional Finnish handicrafts, offering the standard examples of the Finnish ryijy-rugs and the fine laces from Rauma and Orimattila.[19]

Nils Gustav Hahl, an art critic of the new generation and one of the founders of the firm Artek (which marketed Alvar Aalto furniture) was a spokesman for functionalism with international contacts. By 1933 he already recognised its benefits, citing Marianne Strengell as an artist who had developed a textile collection 'of standardised character' produced by Hemflit-Kotiahkeruus, a company using rural hand-weavers.[20]

Hahl particularly criticised design education that still trained so-called artistic assistants in handicrafts, although the most advanced production methods were available to contemporary designers. He argued that even the ordinary public was acquainted with the ideology of *More Beautiful Everyday Things*. The design school, however, continued to look to the past, with no department offering any kind of industrial training. Hahl noted that in Finland

> the applied arts are understood as some kind of decorative art, i.e. pattern drawing and the adornment of homes and public buildings ... Even ordinary implements or utensils are taken as objects to create decorative values in the first place ... Exclusivity is regarded as the hallmark of an artistic spirit.[21]

In this he voiced particularly sharp criticism of the views expressed by Brummer, who defined 'real' decorative art as attempting to 'free' itself from utility.[22]

Reference to 1960 shows how strong the tradition of decorative arts was still then. Ten years after the death of Arttu Brummer and Rafael Blomstedt the new rector Markus Visanti proposed the reform of an education system he saw as old-fashioned, based on folk tradition and over-refined decorative art instead of having a concern for useful things. According to him the Finnish art industry had to develop co-operation with industry rather than ramble along its own paths in the fairy-tale castles of the late William Morris and Art Nouveau. As a result of his efforts educational reform began and the status of the institute changed as it came under state control in 1965.

Mid-twentieth-century Finnish design education still mirrored the ideologies of the nineteenth-century Arts and Crafts reformers. Alongside this tradition, the issues of 'utility' and the 'everyday' and their association with 'art' or 'beauty' were subject to lively debate throughout the second quarter of the twentieth century.

The Finnish designers's emblem 'Pro arte utili' is the symbol of a long-lasting aspiration towards the promotion of useful arts. It was created

by the two remarkable exhibitions displaying everyday beauty. The 'utility' principle and the 'useful' or 'practical arts' were discussed in Finland especially in connection with the 1919 Swedish pamphlet *More Beautiful Everyday Things*. The name of the 1949 Finnish exhibition Everyday Beauty showed that the theme was still alive after thirty years, though utility was understood in different ways by decorative artists and designers attempting to adapt to factory production. Far into the 1950s the majority of textile artists dreamt of hand-weaving in their own studios rather than designing in weaving-mills, not to mention printed fabrics, which were not even considered as a professional field for textile artists.

Many artists aimed to elevate decorative arts to the realm of fine art, beyond utility. They preferred hand-weaving and cottage industry over factory production, appreciating traditional rural values and folk arts. The avant-garde of the 1930s, on the other hand, was the promoter of international trends aiming to co-operate with factories, and promoting standardisation in a new kind of 'everyday beauty' produced by new machines. It aimed to design products for distribution to everyone. The motto 'Pro arte utili' can be understood as a diplomatic expression mediating between those supporting decorative arts and those aiming at functional design.

It is obvious that the interrelationship between aesthetic and ethical issues has been and is topical in the field of design. The artistic has gained a major role in design education, particularly so in Finnish textiles, where the development of industrial textile design was hampered in favour of hand-weaving and textile art.

Notes

1 Marjo Wiberg, *The Textile Designer and the Art of Design. On the Formation of a Profession in Finland*, The University of Art and Design, Helsinki, 1996. The subject was studied also in my licentiate thesis, 'Kohti teollista tekstiilisuunnittelua, Suomalaisen tekstiilitaiteilijan koulutuksen ja teollisen tekstiilisuunnittelun vaiheista 1871–1951' ('Towards Industrial Textile Design. On Finnish Textile Designer Education 1871–1951 and the beginning of Co-operation between Textile Designer and Industry'), 1992.

2 Wiberg, *The Textile Designer*, pp. 49–78.

3 See *Domus*, Nos. 8–10, 1930, pp. 172–203.

4 Promoters of decorative design and traditional crafts and of functional design were members of the organising committee.

5 Newspapers drew attention to industrial products available in the shops much more than ORNAMO, the designers' organization, and its chairman Brummer. See Wiberg, *The Textile Designer*, pp. 76–7.

6 The strong 'artist-craftsman' tradition was recognised for instance in Britain in the

1930s. For example, Marianne Straub then visited the Finnish textile artist Greta Skogster (Mary Schoeser, *Marianne Straub*, The Design Council, 1984, pp. 28, 48. See also Christine Boydell, 'Women Textile Designers in the 1920s and 1930s: Marion Dorn, a Case Study', in Judy Attfield and Pat Kirkham (eds), *A View from the Interior*, The Women's Press, 1985, pp. 61–2).

7 The major reforms to the curriculum, before the institution of university education, were made in 1902, 1914 and in the 1960s (see Wiberg, *The Textile Designer*, pp. 19–48).

8 See, the annual reports of Taideteollisuuskeskuskoulu, for example, of 1902 and 1915–16; also Werner von Essen, *Suomen taideteollisuusyhdistys ja sen keskuskoulu 1870–1875–1925. Muistokirjoitus. Helsinki, Taideteollisuusyhdistyksen julkaisema 50. vuotuisjuhlansa johdosta, 1925.*

9 In this agricultural country, textile crafts have been carried on in nearly every cottage until the present. The traditional skills that developed because of the need for self-sufficiency were revived and highly valued, for instance bulrush, straw and rag carpets and rugs, and bedlinen woven from shabby rags as well as unpicked threads. Besides the craft skills, the economic growth and progress of the industry was evident in the nineteenth-century Finnish Grand Duchy. Also the textile factories (the first one was founded by the Scot James Finlayson in 1821) prospered because of exports to Russia (Wiberg, *The Textile Designer*, pp. 101–8).

10 It is interesting to note that the Helsinki design school and the famous Bauhaus school in Weimar offer parallel examples: the women's departments were started only after much discussion, and the interrelationship between handicraft and industrial design continued to be problematic. For the Bauhaus see, for example, Gillian Naylor, *The Bauhaus Reassessed. Sources and Design Theory*, Herbert Press, 1985.

11 The interviews with designers which I conducted between 1988 and 1990 were with thirty designers–artists who were educated between 1916 and 1987 at the predecessors of the present University of Art and Design. The interviews are anonymous, but are marked with numbers which refer to the decade of training.

12 Hård af Segerstadt draws attention to the admired Finnish 'design products' of the post-war period – with the remarkable exeption of textiles. He claims that the industrial arts in Finland then became an example of how 'outsiders' promoted, controlled and exploited 'artistic development, as we rather inexactly call it'; Ulf Hård af Segerstadt, 'Two decades around Kaj Franck', in *Kaj Franck. Muotoilija, Formgivare, Designer*, Taideteollisuusmuseo/Konstindustrimuseet/Museum of Applied Arts and WSOY, 1993, pp. 16–30. See also Wiberg, *The Textile Designer*, p. 196.

13 The architect Rafael Blomstedt (1885–1950) was the artistic director from 1912 to 1944, then rector. Arttu Brummer (1891–1951), the interior designer, started his career as teacher of composition drawing in 1919. He succeeded Blomstedt as artistic director in 1944. They both held prominent positions outside the school. Brummer was the dominant artist in most important design world institutions for decades. An entire era was to end with their deaths in 1950 and 1951; Wiberg, *The Textile Designer*.

14 Arttu Brummer-Korvenkontio, 'Koristetaide ja käsiteollisuus', *Käsiteollisuus 1922/1*; Wiberg, *The Textile Designer*, p. 62.

15 Paulsson criticised Morris, for example, for his attempts to change Arts and Crafts items into artworks which thus transform their makers into individual artists (Gregor Paulsson, *Upplevt*. Stockholm, 1974, p. 102). According to Paulsson the new aims

were to move from individual production towards a more social approach and co-operation with industry (Gregor Paulsson, *Vackrare vardagsvara, Svenska Slöjdföre-ningens första propagandapublikation*, Utgiven till Svenska Mässan i Göteborg, Stockholm, 1919, pp. 26–9, also pp. 13, 18, 37.

16 Rafael Blomstedt, 'Kotiteollisuus ja muotoaisti', *Käsiteollisuus 1922/4–5*; see Wiberg, *The Textile Designer* pp. 52–3, 62–4.

17 See Wiberg, *The Textile Designer*, pp. 105–6.

18 Carolus Lindberg, *Koristetaide 1927*, Porvoo. On the opinions he expressed here, see Wiberg, *The Textile Designer* pp. 65–66.

19 Arttu Brummer-Korvenkontio, 'Suuntaviivoja II', *Käsiteollisuus 1923/2*; see also Wiberg, *The Textile Designer*, p. 51. It is interesting that Brummer changed his name into Brummer-Korvenkontio, which stresses national aspects (Korvenkontio might be translated 'a bear from the backwoods'). He also used various pseudonyms, for example, A. Br-r-K-o.

20 N.-G.H., 'Milanoon', *Domus 1933/3* and Nils-Gustav Hahl, 'Vävt och Dräjat', in *Maija Kansanen, Marianne Strengell, Kurt Ekholm. Nationalmusei Utställningskatalog*, No. 50, 1935. See Wiberg, *The Textile Designer*, p. 73.

21 Nils Gustav Hahl (1936), *Om Konst och Konstindustri. Efterlämnade Skrifter med en Epilog av Alvar Aalto*. Samlade och utgivna av Hans Kutter. Arteks förlag. Andra upplagan 1943, p. 183–6. See Wiberg, *The Textile Designer*, p. 74.

22 In the 1930s the 'traditionalist' Arttu Brummer and the 'functionalist' Alvar Aalto faced great tensions. This can be exemplified by the events of 1937. Alvar Aalto was the architect of the Finnish pavilion at the Paris World Fair and Brummer was the chief commissioner. In Aalto's architecturally novel pavilion, the applied arts of Finland were presented under the direction of Brummer and in the spirit of Arts and Crafts. The textiles on show were mainly hand-knotted ryijy-rugs favoured by Brummer and disliked by Aalto. (See Wiberg, *The Textile Designer*, pp. 75–6; Göran Schildt, *Nykyaika. Alvar Aallon Tutustuminen Funktionalismiin*, Helsinki, 1985; Pekka Suhonen, *Artek. Alku, Tausta, Kehitys*. Espoo 1985; Kerstin Smeds, 'The Image of Finland at the World Exhibitions 1900–1992', in P.B. MacKeith and K. Smeds, *The Finland Pavilions. Finland at the Universal Expositions 1900–1992*. Tampere, 1992.) It was in these same years (1937 and 1938) that the first two textile artists were employed in factories. They were real pioneers and mavericks, especially because they started in printing and knitting factories, not in the weaving industry that was considered closest to textile artists.

3 ✧ An episode in post-Utility design management: the Council of Industrial Design and the Co-operative Wholesale Society

Jonathan M. Woodham

T HE IMPORTANCE of aesthetic hegemony as a key precept of both private and state-sponsored design reform organisations in twentieth-century Britain remained unfractured by the disruption of the Second World War. With the establishment of the Board of Trade's Utility Scheme in 1942 the taste-elevating aspirations of the Design and Industries Association (DIA),[1] the British Institute of Industrial Art (BIIA)[2] and the Council for Art and Industry (CAI)[3] received a heady infusion of oxygen. In essence, this gave birth to a system of state-legislated design production which, for a number of years, affected many aspects of design in everyday life in Britain. A number of those ardent proselytisers who had sought so earnestly to 'improve' the taste of British manufacturers and the general public in the inter-war years found themselves in an undreamed-of position of aesthetic dictatorship, intimately involved in the approvals system for the format and production of new Utility designs. The purpose of this chapter is to explore the ways in which such design idealism, subsequently enshrined in the outlook of the early years of the Council of Industrial Design (COID), foundered on the operational realities of the Co-operative movement in post-war Britain. Despite the latter's position as an enormously powerful manufacturing and retailing business, the hoped-for marriage between COID and the Co-operative Wholesale Society (CWS) was never fully consummated; an uneasy relationship between aesthetic propaganda and the management of design in industry ensued, with the aspirations of both organisations undermined by the desires of the everyday consumer.

Utility and beyond: COID efforts to win over a wider public

The relationship between the social utopianism and modernising ambitions of the COID and the opportunities which the Co-operative movement seemingly afforded the COID's intended democratisation of Good Design was led by Gordon Russell.[4] Having served on the the Board of Trade's

Utility Furniture and Furniture Production Committees, he was appointed Chairman of the Board's Design Panel in 1943, becoming a member of the COID from its inception in 1944. Subsequently he was the Council's Director from 1947 to 1959, when the organisation sought to situate itself centre-stage in the politics of design, broadening its influence through film, television, the annual *Daily Mail* Ideal Homes Exhibitions [5] and collaboration with organisations as diverse as the London County Council [6] and the CWS.

With the easing of the Utility regulations warning bells began to ring in the corridors of Petty France, the London headquarters of the COID. Even as the Council's first major public venture, the Britain Can Make It exhibition,[7] was seeking to insinuate its Good Design message into the psyche of large numbers of visitors, a Board of Trade letter of 25 November 1946 expressed the Council's opposition to the termination of controls

Dining Chair

Mercury 6471

Table Radio Model AF21

Stewpan P91 Classic

2 CWS (Co-operative Wholesale Society) products selected for the Council of Industrial Design *Index* in CWS pamphlet of 1959

over furnishing fabrics. Something of the incipient aesthetic dogmatism inherent in the COID perspective can be gleaned from the text, in which it was baldly stated that the

> Design Council are much concerned with this matter, since they hold the view very strongly that it would be disastrous if the design of fabrics for the Utility furniture scheme were allowed to be settled by the trade ... that the trade should not have a free hand in this matter.[8]

The problem confronting the COID was that goods produced under the Utility Scheme had been exempt from purchase tax since August 1942 and, as a consequence, manufacturers and consumers increasingly pressurised the Board of Trade to allow greater latitude in the specifications for their production in the post-war period. This was seen as a means of increasing consumer choice and of giving a psychological boost to consumer morale, so badly undermined by years of austerity and restrictions. Such lobbying bore fruit, and from 1948 onwards broader guidelines were introduced across a wide range of consumer goods, thereby allowing manufacturers considerable leeway in terms of design, materials and modes of construction. The ethos of the 'heroic' period of Utility (1942–48) – with its connotations of restraint, soundness of construction, practicality, aesthetic and moral rectitude – had afforded the design reform lobby a short-lived, but golden, opportunity to influence industrial production and patterns of consumption. However, it was an opportunity brought about by wartime necessity rather than by any direct result of design propagandist campaigning.

Following the post-1948 erosion of the modernising aesthetic guidelines compulsorily inherent in the design and production of Utility goods, the COID became increasingly anxious to find alternative means of promoting its own similarly oriented design creed to the British public. Equally significant as film, television and design exhibitions, as important components in such a strategy, was the Council's wish to involve itself with the Co-operative movement.

The Scottish Co-operative Wholesale Society's modern furniture experiment

Although CWS furniture had been selected for the COID's Britain Can Make It exhibition of 1946 and a number of joint initiatives were entered into between the two organisations in succeeding years, the most tangible early collaborations had taken place in Scotland. The COID's Scottish Committee had been concerned that mass production was not a significant feature of the Scottish furniture industry. Generally it was characterised by

high-quality products in traditional styles, a position articulated clearly in an influential report produced by the Development and Industry Panel of the Scottish Council in 1948. Entitled *The Furniture Industry in Scotland*,[9] it emphasised the potential economic importance for mass-produced contemporary furniture in the post-war years. In turn, the report influenced the Scottish Furniture Manufacturers Association (SFMA) to collaborate with the COID's Scottish Committee in holding a major competition for the design and manufacture of new furniture. Launched in 1948, it attracted entries from forty firms, mainly items for the bedroom and dining-room. Among them were a number of designs framed under the new, more liberal, Utility guidelines by Robert (R.Y.) Godden and Dick (R.D.) Russell [10] for the Scottish Co-operative Wholesale Society (SCWS) at Beith. At the lower end of the (generally fairly expensive) price-range of entries, their products attracted favourable critical attention [11] as well as the esteem of the competition jury, chaired by Brian O'Rorke.[12] A bedroom suite in African mahogany, awarded a first-class diploma, received praise because it avoided 'that chill antiseptic look which afflicts some Continental whitewood furniture' [13] and harmonised their design with a contemporary, yet reassuringly British, context. Godden and Russell's SCWS furniture also received considerable exposure in other exhibition fora: in 1949 it was seen with other award-winning examples from the competition at the New

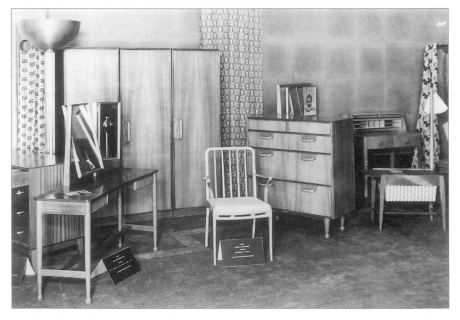

3 Bedroom suite for the Co-operative Wholesale Society designed by R.Y. Godden and R.D. Russell, shown at the RIBA, London in July 1949

Furniture Exhibition stand at the Glasgow To-day and Tomorrow exhibition;[14] its bedroom variant was shown at the Royal Institute of British Architects (RIBA) to coincide with the COID's furniture conference of 1949 (figure 3). The SCWS design initiative also saw its furniture included in the COID's Stock List[15] of well-designed goods at the Festival of Britain in 1951.

Despite such exposure and critical acclaim, the furniture did not sell well and raised awkward questions about the COID's faith in the commercial viability of mass-produced Good Design.[16] In 1952 Gordon Russell, reviewing the SCWS episode at a conference for top managers in the Co-operative movement, sought to shift the blame away from the designers, suggesting that the SCWS experiment should not be seen by his audience as evidence that the public wouldn't buy Good Design, but maintaining that 'Insufficient effort was made to explain the furniture to the retailer – it was indifferently handled in the shops and the retailer was not adequately briefed. Although the experiment was well-meant, the furniture was not really well-made.'[17] The fact that Scottish consumers didn't want it was no doubt partially due to its contemporary styling, but an equally important factor was price. Although technically categorised as Utility under the post-1948 guidelines, it was in fact still comparatively expensive for the everyday purchaser. As will be seen later, a variety of problems were also inherent in Co-operative retailing mechanisms.

The Council and the Co-op: a developing relationship

After many educational initiatives and the institution of training courses for Co-op managers and retailers, in January 1951 Gordon Russell was able to report to the Council that there had been 'evidence of steady growth of interest in design in the Co-operative Movement'.[18] This shift of emphasis away from Scotland to the hub of Council of Industrial Design thinking in the metropolitan climate of South-East England was also revealed in a leading article in *Design* magazine of December of the same year in which the potential of the Co-operative movement as a vehicle for promoting the Council's design values was enthusiastically described: 'From its membership, its turnover, its geographical distribution and its very structure, the Co-operative Movement is ideally placed to exert untold influence on the taste of the public.'[19] However, as the SCWS furniture experiment in Scotland should have suggested to the policy-makers at the Council in London, the difficulties in linking the aesthetic creed of the COID with the realities of manufacturing, retailing and public education in the Co-operative movement were considerable and complex. Efforts to distance the designer from the foibles of the retailing sector and

shortcomings in manufacture kept the design reform ideals of a demo-cratisation of 'good' taste in play. A.N. Silver, a serving COID member and Dry Goods [20] Manager of the London Co-operative Society acknow-ledged the opportunities that the Co-op could offer in spreading the design promotional message of the Council, but argued that 'a Co-operative Society cannot make an immediate switch from Charing Cross Road furniture designs, complete with treacle finish, to contemporary design'. [21]

At the Design and the Co-operative Movement conference comparisons were also made with the more positive developments of the Co-operative movement in Sweden, where links between manufacturers, retailers and consumers/members were more fully integrated. This was clearly outlined by Lennart Uhlin, an architect for the Kooperativa Forbundet (the Swedish Co-operative Union and Wholesale Society) in a paper entitled 'What the Swedish Co-operative Movement Has Been Able to Accomplish in Design'. The Kooperativa Forbundet (KF) exercised a co-ordinated design policy which extended through the spectrum of its activities, from architecture and shop design through to domestic products, furnishings and printed ephe-mera. The KF saw good design as an integral part of economic welfare, a means of fulfilling people's lives, with many of its local societies arranging exhibitions of good design in their retail outlets as a means of demonstrating how well-designed products and environments could make everyday life easier. Although British developments were far removed from such a con-solidated outlook, it is important to contextualise the power and scale of the wholesale network, the manufacturing capacity and the workings of the retail societies of the Co-op in England, Wales and Northern Ireland in order to understand just why Gordon Russell, Paul Reilly and other influen-tial figures at the COID believed that the Co-operative movement presented such a significant opportunity to democratise their design message.

The COID and the CWS: consolidation and strategic developments

During the 1950s the Co-operative movement as a whole (just like the COID) was experiencing a significant period of reorientation in the context of wider economic, political and social shifts. None the less, in the middle of the decade the CWS described itself in a publicity leaflet as 'Britain's Biggest Business', [22] with over 200 productive establishments and almost a quarter of its 31,000 retailing shops devoted to furniture, household goods and clothing. [23]

At the March 1952 Harrogate Co-operative Conference, Arthur Silver had pleaded for comprehensive design advice to be given to the movement. Not only was Silver a member of both the COID and the Co-operative movement, but links between the two organisations had been forged right

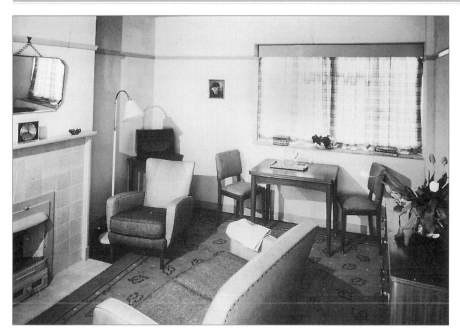

4 Show flat furnished by the London Co-operative Society in collaboration with the Council of Industrial Design at the Lansbury site of the Festival of Britain, 1951. The furniture was designed and made at the CWS factories and the interior decoration and colour schemes were co-ordinated by Grace Lovat Fraser

from the establishment of the Council by the Board of Trade in 1944: among the original appointees was Margaret Allen, a member of the Women's Co-operative Guild, the Central Board of the Co-operative Union and the Management Committee of Watford Co-operative Society; also significant among this first tranche of the constitutional membership was Roger (R.S.) Edwards, Director of the CWS and second chairman of the COID from 1947. Just as CWS furniture had been selected for the Council's propagandist Britain Can Make It exhibition of 1946, so it was shown at the Council's next major public showcase, the Festival of Britain of 1951, where it could be seen in a show flat[24] at Lansbury, Poplar (figure 4), and in the Homes and Gardens Pavilion on London's South Bank site. These were not isolated instances of Co-op/COID collaborations, the latter also providing training courses for members of staff from retailing personnel to management. The Co-operative Union's Education Department also worked closely with the Council in the production of widely circulated booklets such as *Design and Our Homes* (Design for Study)[25] and *Colour and Pattern in Your Home*,[26] as well as other publications and filmstrips. The CWS was also one of the many industrial organisations which contributed to the establishment of

the COID's Design Centre in the Haymarket, London, in 1956, but it was not until the following year that G.R. Buckley, Secretary and Executive Officer of the CWS, initiated a correspondence between the two organisations which the Heads of Division at the Council described as 'one of the most important enquiries ever received'.[27]

The COID's design policy review of the CWS

Thus it was that, five years after Arthur Silver's conference plea at Harrogate, the CWS sought advice from the COID about the establishment of a fully co-ordinated design policy together with recommendations for its implementation. The Council's first practical steps centred on the setting-up of a series of visits by the COID's Industrial Officers to those CWS factories which manufactured products which fell into the Council's Design Review categories. By early May 1957 internal Council discussions had reached a sufficient stage of maturity to enable Gordon Russell to write to G.R. Buckley at the CWS headquarters in Balloon Street, Manchester, with a proposed schedule of visits by the COID Industrial Officers. In order to facilitate the task he also asked that the managers of the CWS factories be informed of the precise nature and purpose of the visits and that facilities be made available as required. To pave the way further, he suggested a series of questions on which discussions would be likely to centre:

> Who decides what shall be made?
>
> Who briefs the designers, and who are the designers, i.e. staff or consultant?
>
> How much latitude is given to the designer?
>
> At what stage are other personnel involved, e.g. salesmen, production staff, publicity staff, etc?
>
> To what extent are retail societies consulted?
>
> To what extent do they rely on market research?
>
> How are their salesmen briefed about a new design?
>
> To what extent is the design policy consistent from product to presentation? [28]

Over the next few months visits were initiated across the spectrum of CWS design-related manufacturing centres including the Cotton Textiles Department at Broughton, Salford, the Coloured Woven Cotton Mill at Radcliffe, the Pottery Factories at Longton (Stoke-on-Trent), the Furniture Factories at Enfield, the Clock Depot in London, the 'Radiophone' Radio Factory at Ilford, the National Works at Dudley, the Aluminium Works at Birmingham and the Birmingham Cycle Factory.

The first phase of reports considered within the Council's London offices were frank and forthright, contrasting with the moderate tone of the final versions eventually submitted to the CWS. A rather depressing picture of design management can be gleaned from analysis of a number of excerpts from the unvarnished internal reports.

A. Gardner-Medwin, Head of the Council's Industrial Division, visited the CWS china and earthenware factories at Longton, conveying a gloomy picture of the Society's pottery design, production and retailing mechanisms. CWS buyers came in for particular criticism, much in line with the blame attached to buyers in general by design reform critics in previous decades. The former were were seen as 'inadequately equipped', without specialised training, buying on grounds of price alone and 'unable to give any advice or lead on design to the factory'. Co-operative retailing outlets also received censure for housing pottery departments which were ineffectual in terms of sales and treated as 'Cinderellas'. However, it was in relation to design and its management that the most telling criticisms were articulated. The two 'decorating' managers of the factories were seen as being quite bitter about their work experiences. Gardner-Medwin summarised the position as follows:

> the situation is a hopeless one and can only be improved by a major change of policy at the top. As to design policy as it stands, clearly there isn't one.
> Nor is there any intelligent guidance on design from any source whatsoever, not even in the form of outside information on what other potters are doing or what the public is buying. Price is an over-riding factor and this challenge cannot be met because of out of date equipment.[29]

Design evaluation undertaken by the Council's other Industrial Officers in CWS manufactories elsewhere were equally pessimistic in tone. On his visit to the CWS Cycle Factory at Tyseley, Birmingham, Peter Whitworth stated that 'The visual approach to design is either by plagiarism of a branded product or by the combined efforts of many ill-informed persons, with no appreciation of design or the ultimate result likely to come from their efforts.'[30] Another of the Council's Industrial Officers, T.W. Gregson, was horrified by his experiences at the CWS ('Invincible') Aluminium Works, also in Birmingham. He reported that

> In no case could I find any evidence of an attempt to design an article properly and systematically, and it was usually abundantly clear that such designing as had been done was the work of an uncritical and uneducated eye.[31]

Yet another of the Council's Industrial Officers, B. McGeoghan, deplored the output of the CWS Furniture Factory at Enfield, declaring that

the standard of design and finish of the pieces seen at Leman Street were deplorably low. I was appalled by one piece, a white cupboard in timber, and asked Mr Martin [the National Production Manager] about his responsibility to the members of the movement. He replied that it was a best seller and he thought he was doing a good job in producing it.[32]

It was the selection process, used to identify designs for production, which was most revealing:

Most designs were cut to the bone by the twice yearly committees, made up of Section Heads (wholesale buyers) from London, Manchester, Newcastle, Cardiff and Bristol. The producer being represented by Mr Martin and the Factory Manager, together with the Designer, Mr Simpson.

Mr Simpson produced his sketch designs (301 this year) to the committee who tore them to shreds. A selection of 50–60 were chosen for further consideration, these were priced, then modified to meet the price of the buyers, before going into production.

I thought the best designs existed amongst the 240 sketches which had been discarded.[33]

Similar evidence can be adduced from many of the other factory visits, whether in relation to the quality of products, their design and distribution, the experience and calibre of the design staff or design management. Occasionally there were slightly more positive evaluations of design standards, as, for example, with cotton textiles. T.W. Gregson's evaluative visit to the CWS Factory at Sheffield was rather ambivalent. Although he drew attention to the Harlequin set of coloured-handled knives (accepted for the Council's Design Review), he felt generally that the cutlery and garden-tool designs were 'of uninspired design but of reasonable quality'.[34]

The considered findings of the COID were submitted to the CWS in Manchester on 3 October 1957, taking the form of a consolidated overview with specific recommendations backed up by a series of heavily edited and shortened reports of the individual visits made to each factory. Of greatest importance was the recommendation that a Design Director should be appointed to promote 'good design throughout the Movement'. Other recommendations stressed the need for more up-to-date tools and machinery, the upgrading of the standard of designers employed (with a consequent increase in their freedom and authority), greater knowledge among managers, buyers and designers of trends at home and abroad, better standards of display from factory through to retail outlets and the implementation of a consistent corporate image.

CWS design policy: fresh initiatives advised by the COID

The precise impact of the 1957 COID report on the manufacturing and design ideology of the CWS has yet to be more fully evaluated. None the less, it is clear that during the summer of 1957, at the very time at which the Council's Industrial Officers were finalising the text, the CWS Board was sufficiently persuaded of the potential significance of design in the market-place to appoint a Design Executive to look both to short-term improvements and long-term planning of CWS design policy, trends and price categories in the furniture sector. As the Merchandise Controller of the Furniture Division, N. Grey, later commented:

> The basic aims and objects were to plan efficient working of the Furniture Division and improve design standards, quality, and competitiveness of its products, to increase sales and generally to secure a larger proportion of trade from our Retail Societies.[35]

As a key part of this sea change in company policy in the later 1950s, the CWS sought to set in place a fresh, modern design outlook, much as had been attempted in the late 1940s when Robert Harrison, manager of the SCWS furniture factory, had commissioned Dick Russell and Robert Godden to design modern unit furniture. However, by the late 1950s, through its various collaborations with the COID – including education, publications, conferences and training – the CWS in England, Wales and Northern Ireland was clearly better informed about the shortcomings of its current design policies than its northern counterpart had been in the previous decade.

Mrs Cycill Tomrley, a long-serving member of the COID full-time staff, was drawn into the CWS scheme as an adviser and a key figure in the recommendation that George Fejer be comissioned as Consulting Designer for a new CWS furniture range to work closely with the Chief Furniture Designer of the CWS, together with the CWS design team, on a range of units for bedrooms, dining-rooms and living-rooms. In sharp contrast to the insular approach generally attributed to CWS design departments by the COID's Industrial Officers in their reports, the design team researched into the contemporary design styling of their competitors at home and surveyed trends in furniture abroad. Analysis was also made of the aesthetic potential of a wide variety of timbers and veneers as well as various plastic, metalwork and polyester finishes. Also significant, particularly in terms of previously identified failures in CWS and Co-operative Retail Societies' design policy, was a concerted attempt to implement a co-ordinated sales and advertising strategy, involving catalogues, pattern-books and special sales stands. Furthermore, some level of market research had been carried

out into changing domestic social mores, even with regard to drinks, entertaining and the serving of TV snacks.

The resulting furniture range was launched under the trade-name Universe, and was promoted at a sales conference for the CWS Furniture Division in 1958 as follows:

> The Universe range is the outcome of long-term planning, and forms part of a co-ordinated overall plan, whereby greater production of a limited range of distinctive designs, both in contemporary and traditional styling, can be achieved, promoting greater prestige, trade and benefit to the Furniture Division [of the CWS].[36]

The public launch took place in December 1958 at a trade press conference and subsequently at a series of exhibitions at the main and sub-depots of the CWS which were timed to coincide with the January 1959 National Furniture Exhibition (figure 5).

However, this COID-advised and CWS-implemented scheme soon came off the rails, much as the ill-fated SCWS furniture designed by Russell and Godden had done in the late 1940s. N. Grey, a key figure at the CWS, steeped in the modernising design ethos of the COID, had been one of the few to emerge with credit from the 1957 factory. He was at a loss to understand why things had gone wrong in the twelve months following the optimism of the launch. In a letter of 1 January 1960 to Paul Reilly,

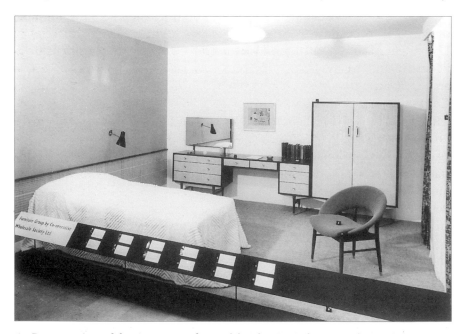

5 Room setting of furniture manufactured by the CWS shown at the Design Centre, London, July 1959

who by that time had succeeded Gordon Russell as Director of the COID, Grey's puzzlement was clear:

> Unquestionably trade and buyers' reactions alike were swift and positive. They liked it. Enthusiasm was such that many thousands worth of sample orders were placed, intended for special links with ITV and other special advertising media planned by the Furniture Division. Regrettably, since its introduction sales of the Universe range have waned. It is understood that many pieces ordered by Societies months ago are still unsold.
>
> [...]
>
> My directors are deeply concerned at the poor sales returns, bearing in mind the prodigious efforts which were made by the Furniture Division to create a distinctive series on behalf of the Co-operative Movement. The cause of poor sales responses is being investigated.[37]

Reilly was asked by Grey for an impartial evaluation by the COID of this worrying state of affairs, inadvertently placing him in a somewhat awkward position with regard to his publicly avowed belief in the Co-operative movement as a major potential disseminator of the cause of Good Design right across the manufacturing, retailing and consuming spectrum.[38] As Director of the Council Reilly was also publicly accountable for the inclusion in the Design Index of many pieces from the Universe range and for its selection for display at the Design Centres in London and Glasgow.

The task of evaluating the reasons for the failure of this furniture scheme fell to Gardner-Medwin who, within a week of Reilly's receipt of Grey's letter at the COID, produced a brief summary of the problems as he saw them.[39] Many of the problems of the lack of sales success of Russell and Godden's 1948/49 SWCS furniture resurfaced once again. Rather as Gordon Russell had diagnosed in respect of the Scottish scheme, problems with retailing outlets, methods of display, resistance to new ideas on the production end at the CWS and the comparative expense of the units were again seen as prominent factors. Although Gardner-Medwin felt that the standard of displays promoting the Universe furniture would have been quite acceptable in the fifty or sixty largest outlets of the Co-operative Retail Societies, he also concluded that a number of the sales problems arose from the fact that 'in the first flush of enthusiasm' nearly all Societies had ordered the range, many of them without the wherewithal to promote and sell them adequately in store.

Gardner-Medwin made some attempt to vindicate the Council's recommendation of designer by alluding to the wider circumstances beyond the latter's control. Hinting strongly that the CWS design policy was not being effectively managed, he suggested that 'Fejer's problem was not only to design the furniture but to help in reorganising the production. This

he did satisfactorily but he was up against considerable opposition.'[40] As the key figure responsible for industrial liaison at the Council, Gardner-Medwin was also keen to point out that in July 1957 the COID had also recommended to the CWS a second designer, David Heywood, drawing attention to the fact that he had designed a dining-room suite and upholstery, both of which had remained in production and were continuing to sell 'quite well'.

Not everyone at the COID was quite so sanguine about the whole affair. In fact, there was a certain amount of internal unease, as on a number of other occasions when ambitious propagandist schemes had fallen short of expectations.[41] In his letter to Reilly, Grey of the CWS had suggested that some of the sales problems of the Universe range derived from the fact that Fejer had not adequately researched into the public's requirements, a point which Jean Stewart of the Council's Retail Section was quick to latch on to. She reported how she had tried to organise a visit with Fejer 'to the sort of homes the Co-op customers live in, but nothing came of it'. Given her involvement in retailing research and her consciousness of the extent to which the COID in the early years of its existence had fought shy of market research and sociological analysis of design, it was her obvious wish that it should be more fully integrated into the Council's activities. Most telling was her accusation that 'if they [the Co-op] had worked out a proper selling campaign they could have done better than they have. We know how bad they are at promoting their own goods with their own retail outlets.'[42]

Earlier, at the Britain Can Make It exhibition of 1946, the COID's rather imprecise and fanciful approach to matching design with social needs and aspirations had been epitomised by the 'invisible' inhabitants of many of the furnished rooms on display – fictional families conjured up in words by the poet John Betjeman. Indeed, many of those associated with the design reform movement in the 1940s implicitly believed in their own capacity to 'read' and influence a wide social spectrum in the market-place.

Such unrealistic intuitive approaches had begun to be replaced by a more hard-nosed approach, informed by surveys (such as those carried out for the COID by Mass Observation)[43] and the harsh realities of the thankless task of attempting to influence manufacturing industry, retailers and the general public. In the late 1950s Jean Stewart, one of the most experienced of the COID's middle-ranking staff, having worked for the Council since the mid-1940s, referring to the CWS furniture project, suggested that 'In future, when a big project of this kind is started I suggest that the Industrial Division should recommend that the manufacturer asks the advice of the Retail Section on promoting it.' In his final report on the Universe furniture

directed at the CWS, Gardner-Medwin absolved the design process of any blame in the sales slump, confidently asserting that

> As I see it this range is in line with other popular modern furniture which is sold by the Co-operative stores and, in my opinion, in design is as good as and, in some cases, better than some of your competitors! [44]

He went further, suggesting to the CWS that perhaps it would have been 'wiser to to have briefed the designer to attempt something more original, which consequently would have less competition, and to have marketed this before the more costly 'Universe' range. Because the furniture could only be sold in Co-operative shops and not in other retail outlets, it could not realistically compete with other well-known brands such as Gomme or Wrighton which were sold alongside it, as well as in a whole range of other far more attractive stores specialising in domestic furniture and furnishings. Gardner-Medwin's resultant and somewhat inevitable conclusion was that the 'disappointing' sales figures were largely due to stiff competition which was of the CWS's own making. Having thus laid some of the blame at the respective doors of the Co-op retail outlets and factories, like many connected with design reform organisations over the previous thirty years or more, he also found fault in the attitude of the buyers and sales staff. His proposed solution was to initiate training courses, an unintentionally ironic suggestion, since this was terrain which the COID and the Co-operative movement had already visited jointly over a number of years.

Conclusion

While it is true, as a number of design historians have argued, that the COID significantly raised its profile over the first fifteen years of its existence, in terms of real influence its achievements are much harder to quantify with any degree of certainty. On a positive note, the Britain Can Make It exhibition of 1946 and the Festival of Britain of 1951 were two major events in which the COID could be seen to have played a significant role in promoting a forward-looking vision of a better-designed and modern British way of life.[45] The opening in 1956 of the London Design Centre as a national (and international) showplace for well-designed British goods was a further fillip to the Council's founding mission to educate manufacturers, retailers, buyers and the general public in design matters.

However, other historians [46] have considered the relative ineffectiveness of the Council over the same period, drawing attention to the fact that it was better at handling government departments in the negotiation of its continuing grant-in-aid than in convincing manufacturers of the apparent

benefits of improving standards of design. The relevant government departments included many people who belonged to the same social and cultural circles as key members of the Council and its administrative staff,[47] while industry was opposed to what it saw as ill-judged attacks on its marketing strategies and business acumen and the mounting of interventionist design policies.

During these years the COID was imbued with a sense of moral purpose, an unrealistic belief in its powers of aesthetic leadership and a commitment to the modern, blaming widespread contemporary preference for the traditional and transiently fashionable on the short-sightedness of manufacturers, retailers and, not least, the general public. The Utility legislation of the 1940s offered a false dawn for the Council's perception of its ability to alter public taste. From 1948 onwards, having lost the opportunity to continue to impose a carefully-defined 'approved' aesthetic on the general public, the COID subsequently looked to influence opinion in the mass market-place by means of linking with the largest manufacturing and retailing conglomerate in Britain.

As has been shown, both with regard to the SCWS furniture experiment of 1948–49 and the launching of the CWS Universe furniture range a decade later, the Council had clearly been unable to influence the adoption of a sound design and marketing policy by the Co-operative movement, despite considerable investment in joint educational ventures, publications, training and detailed advice. It was the failure of such endeavours as these, and the increasingly ephemeral demands of the late 1950s market-place, together with the enduring appeal of traditionally styled products, that led to the COID's attempts to define more carefully what it meant by the term 'good design' alongside a changing emphasis towards capital goods and the place of design in the engineering sector. Both the CWS and the COID had unrealistic expectations of their power to alter consumer taste, particularly in a sector where old habits and associations died hard.

Notes

1 This body was founded in London in May 1915. Inspired by the Deutscher Werkbund, established in Germany in 1907, it sought to promote a better understanding of design matters between designers, manufacturers, retailers and the general public.

2 Originally conceived by the Board of Trade in 1914, the BIIA was incorporated in February 1920 with the twin aims of raising standards of industrial design and levels of public taste in design matters.

3 Appointed by the Board of Trade in 1933, the CAI began work in early 1934 with a brief to educate the consumer in design appreciation, to improve design training

standards in trade and commerce, and to encourage good design practice in manufacturing industry.

4 Russell and others connected with design matters at this time may be seen largely as an intimate and highly influential coterie, as I have argued in J. Woodham, 'Managing British Design Reform I: Fresh Perspectives on the Early Years of the Council of Industrial Design', *Journal of Design History*, Vol. 9, No. 1, 1996, pp. 55 ff.

5 These continued to draw large attendences in the late 1940s and 1950s. For example, in 1955 attendance was 1,135,102.

6 This is discussed in J. Pavitt, 'An Experiment in Design Appreciation: the Formation of the London County Council Circulating Design Scheme' and J. Woodham, 'The Consumers of the Future: the Council of Industrial Design and Educational Strategies for Schools 1944 to the late 1950s', in J. Pavitt (ed.), *The Camberwell Collection: Object Lesson*, Camberwell College of Arts/London Institute, 1996, pp. 4–15 and 16–25.

7 Many aspects of this are fully discussed in P.J. Maguire and J.M. Woodham (eds), *Design and Cultural Politics: the Britain Can Make It Exhibition of 1946*, Leicester University Press, 1997.

8 File BT/64/2177, Public Record Office, Kew.

9 Scottish Council (Development and Industry), *Report of the Panel on the Furniture Industry in Scotland*, 1948.

10 Gordon Russell's younger brother.

11 Unsurprisingly, this included the COID's official mouthpiece, *Design* magazine, which had been launched in 1949. See P.R., 'Scottish Furniture on Show: Contemporary Design Prominent at Glasgow Exhibition', *Design*, Vol. 10, pp. 18–19. I presume from the style and attitude that 'P.R.' was in fact Paul Reilly, the Council's Public Relations Officer, later Head of the Information Division and Director.

12 O'Rorke, a New Zealand architect, first came to public attention with his modern designs for the Orient Line's *Orion* and *Orcades* ocean liners in 1935 and 1937.

13 P.R., 'Scottish Furniture on Show', p. 18.

14 The furniture stand was designed by Basil Spence and the Scottish competition furniture was viewed alongside a small collection of American, Swedish and Danish contemporary designs. There were about 120,000 visitors to the exhibition as a whole.

15 The Stock List, later retitled the Design Review, was a photographic card index of designers approved by panels appointed by the COID. It could be consulted by those wanting to access particular design expertise. After some refinement of the system manufacturers submitted either samples or photographs of their products for consideration by a Selection Panel, chaired by the Director of the COID and including an independent design consultant.

16 John Gloag, *Good Design – Good Business*, COID/HMSO, 1947.

17 G. Russell, 'Design and its Importance', in Co-operative Union Ltd/COID, *Design and the Co-operative Movement*, Co-operative Management Conference, Harrogate, 1952, p. 4.

18 *Director's Report* presented at Council Meeting, 12 January 1951.

19 Paul Reilly, 'Design and the Co-op', *Design*, December 1951, p. 1.

20 These included furniture and other domestic products.

21 A.N. Silver, 'Co-operative Opportunities', in Co-operative Union Ltd/COID, *Design and the Co-operative Movement*, Co-operative Management Conference, Harrogate, 1952, pp. 14–15.

22 *CWS: The World's Largest Training Organisation*, Co-operative Wholesale Society, c. 1956.

23 During the trading year ending 14 January 1956, CWS sales of the major categories of 'dry goods' were as follows: furnishing, hardware and carpets £21,515,777; drapery £12,943,383; menswear £7,697,812; footwear £5,403,178. British Co-operative organisations involved a total combined membership of 11.75 million, representing more than half the homes in Britain.

24 This show flat was furnished by the London Co-operative Society in collaboration with the COID, and all furniture was made in the CWS factories.

25 M. Llewellyn, Education Department, Co-operative Union Ltd and the Council of Industrial Design, 1952.

26 M. Llewellyn, *Colour and Pattern in Your Home: A Book on Design with 'Do It Yourself' Ideas*, Education Department, Co-operative Union Ltd and the Council of Industrial Design, n.d. (early 1950s). This had a print-run of 100,000 and was released alongside a linked filmstrip.

27 Heads of Division Meeting Minutes, 21 February 1957. These and other COID minutes are all located in the Design Council Archive (DCA) in the Design History Research Centre (DHRC) at the University of Brighton.

28 Letter from Gordon Russell, 2 May 1957, in File 819/3.

29 Ibid.

30 Report by Peter Whitworth to A. Gardner-Medwin on his visit to the CWS Cycle Factory at Tyseley, Birmingham, on 4 June 1957.

31 Report by Mr Gregson to A. Gardner-Medwin on his visit to the CWS 'Invincible' Factory (Birmingham Aluminium Works), 25 May 1957.

32 Report by B. McGeoghan to A. Gardner-Medwin on his visit to the CWS Furniture Factory at Enfield, 24 July 1957.

33 *Ibid.*

34 Report by Mr Gregson to A. Gardner-Medwin on CWS Factories at Sheffield, 6 June 1957.

35 Letter from N. Grey, Merchandise Controller, Furniture Division, CWS Ltd, Leman Street, London, to Paul Reilly, Director, COID, 6 January 1960.

36 Notes on Sales Conference 27/28/29 November 1958 for CWS Furniture Division for Universe Range, p. 1.

37 Letter from N. Grey to Paul Reilly, Director, 6 January 1960.

38 See, for example, references in notes 13 and 22 above.

39 re: Letter from N. Grey, A Gardner-Medwin, 12 January 1960.

40 *Ibid.*

41 See, for example, Jonathan M. Woodham, 'Managing British Design Reform II: The Film *Deadly Lampshade* – an Ill-Fated Episode in the Politics of 'Good Taste', *Journal of Design History*, Vol. 9, No. 2, 1996, pp. 101 ff.

42 *Ibid.*

43 As well as the Mass Observation material contained in the University of Sussex, the Design Council Archive at the Design History Research Centre at the University of Brighton has a wide range of surveys conducted by Mass Observation on behalf of the Council of Industrial Design, later the Design Council. These include document 903, *Report by Mass Observation on Britain Can Make It*, Sections A, B and C, December 1946 and published reports such as *Trade Buyers & General Visitors*, February/March 1964, *Design Centre Visitor Profile*, 1976/77 and *Survey of Visitors to the London Design Centre*, July and September 1984.

44 Notes on the CWS Universe range of furniture by A. Gardner-Medwin, Head of Industrial Division, 15 March 1960.

45 Although I would argue that one can also find many retrospective, traditionally oriented and heritage-laden dimensions to both exhibitions.

46 One of the most convincing is my colleague Paddy Maguire in 'Designs on Reconstruction', *Journal of Design History*, Vol. 4, No. 1, 1991, pp. 15 ff.

47 Many aspects of such relationships are discussed in Jonathan M. Woodham, 'Managing British Design Reform I: Fresh Perspectives on the Early Years of the Council of Industrial Design', *Journal of Design History*, Vol. 9, No. 1, 1996, pp. 55 ff.

4 ✧ 'Beauty, everyday and for all': the social vision of design in Stalinist Poland

David Crowley

A centralised furniture designer may not be the most typical representative of the totalitarian system, but as one who unconsciously realises its nihilising intentions, he may have more impact than five government ministers together. Millions of people have no choice but to spend their lives surrounded by his furniture. (Václav Havel) [1]

T HE UTILITY Scheme, initiated in Britain during the Second World War, marked a remarkable phase in the history of consumption because, for the first time, the state undertook a role as regulator of domestic consumption not just through fiscal and regulatory mechanisms but also through design. As the chapters in Part II of this volume note, the furniture, clothing and textile designs produced under the aegis of the scheme were shaped by social ideals as much as the economic pragmatism of wartime rationing, in that 'good design' was presumed to bring beneficial effects to the lives of those who consumed Utility's products. The reform of the scheme in 1948 and its closure in 1953 can be interpreted as an indicator of a return to the free market in the production of domestic goods, and as a sign of Britain's advocacy of 'welfare capitalism', an often uneasy balance between the interests of business and the welfare of the people. Moreover, the return to the market has been interpreted as the assertion of a different taste regime from that on which Utility had been built: 'Though popular with some designers and architects, the stigmas of utility, bureaucracy and puritanism damned the furniture in the eyes of most consumers who, as soon as choice was available in the 1950s, threw it out.' [2]

However, state interest in the reform of design, production and the consumption of domestic goods was plainly not abandoned in the early 1950s, as the history of bodies like the Council of Industrial Design indicates, but was conceived almost exclusively within the framework of competitive business. [3] Likewise in Scandinavia and most of Western Europe the concept of design as an aid to business has prevailed throughout much

of the post-war period. A sharp contrast can, however, be drawn with circumstances in the people's republics of Eastern Europe from the late 1940s. For the next few years until the post-Stalinist 'thaw' of the mid-1950s these countries were organised as 'war economies': domestic consumption was depressed while resources were poured into the 'strategic' sectors of heavy industry and the national infrastructure.

When the countries of Eastern Europe were absorbed into what was euphemistically known as Moscow's 'sphere of interest' at the end of the Second World War, local communist parties, with the support of the Soviet Union, conspired to achieve a monopoly on power. During the early years of reconstruction, coalition governments raised on fragile democracies ensured that private ownership, at least in terms of small businesses, remained a feature of the economy. But as the communists secured the most important government portfolios as *droits de seigneur* by their association with Soviet power, they began removing their political opponents in each country. By the end of the 1940s the so-called Eastern Bloc was made up of one-party states largely modelled on the Soviet system. Stefan Staszewski, a leading Party propagandist in Poland in the early 1950s, described the process of Sovietisation with disturbing candour in an interview in the 1980s:

> the sights were set on the view from the East. Nationalise all economic life, destroy co-operatives and private trade and bring everything under the state monopoly. And if you have the administration, the money, and all the material means under your control, it's not difficult to nationalise society as well, by creating fictitious organisations, fictitious structures, and a fictitious ideology.[4]

In the heightened paranoia of the Cold War, each new people's republic operated what Oscar Lange called '*sui generis* a war economy', which – in brief – was based on massive investment in heavy industry; full nationalisation entailing the closure of many small enterprises to channel resources and labour into larger, 'more efficient' industrial concerns; the imposition of a new financial system controlled by a central bank, thereby keeping all investment in state hands; and, most importantly, the establishment of central planning mechanisms which would manage demand according to a Soviet-style 'Five-Year Plan'.[5] Like the Soviet Union in the 1930s, enormous emphasis was placed on rapid industrial growth in the iron and steel industries as well as in engineering. Official ideology claimed that only intervention in the organisation of the resources of an economy could raise standards of living for all.

While domestic consumption was in reality a very low political priority during the late 1940s and early 1950s, the people's republics established

the means to regulate and shape it according to their ideological pro-
gramme. This took the literal form of control over retailing by eliminating
private shops as well as prohibitions of certain goods. In Poland this was
known as the '*bitwa o handel*' (battle over trade) which was waged from
the Spring of 1947.[6] Although denunciations of 'profiteers, speculators and
dishonest merchants' were largely expressed with the aim of controlling
prices of essential commodities like food for a hungry population, some
particularly *nietowarzystki* (anti-social) commodities such as western music
or motor cars were singled out.[7] However, in places like Poland, provision
of basic commodities was a matter of great social urgency. Levels of
destruction in cities like Warsaw were extreme and, consequently, the need
for basic goods like furniture and utensils was very strong.

 Design – a function which had, it can be argued, developed a relatively
organic role in capitalist industry – now needed to be planned. In a system
which would otherwise tend to ossification, means had to be found to
manage innovation. As a consquence, national design agencies were estab-
lished in Moscow's satellite states in eastern Europe.[8] The earliest of these
bodies – the *Wydział Wytwórczości* (Production Department) of the Min-
isterstwo Kultury i Sztuki (Ministry of Culture and Art) – was set up in
Poland in October 1945, i.e. at the beginning of the communist assault
on power.[9] The *Wydział Wytwórczości* and its successor organisations – the
focus of this study – were important experiments in thinking about the
role of design and product innovation in the command economy.[10] Their
history tells us much about the young communist state's attitude to
domestic consumption, a theme to which I will return after discussing
how design was managed in the early years of the People's Republic of
Poland.

The BNEP

The *Biuro Nadzoru Estetyki Produkcji* (Office for the Supervision of Produc-
tion Aesthetics/BNEP) was established by its director, Wanda Telakowska,
in January 1947 from roots in the Ministry of Culture and Art's *Wydział
Wytwórczści*, a relatively small and uninfluential office. BNEP took shape
during the period of tense political pluralism which Poland experienced
during the post-war years. Its founding statute identified a number of
responsibilities.[11] Firstly, it was to function as an aesthetic and technical
arbiter. Its officers sat alongside architects and members of the art union
on the *Komisje Kwalifikacyjne* (Qualifying Commission) which had been
founded by the Ministry of Culture and Art in March 1946 to evaluate
the merits of designs produced in Poland, recommending prototypes to
the *Komisji Selekcyjne* (Selection Commission), made up of representatives

of industry appointed by the Ministry of Industry and Light Industry. Secondly, BNEP was organised to promote research. It employed artists and technicians working in studios, usually attached to factories and colleges outside Warsaw where living conditions were generally better, to conduct experiments into materials and to design prototypes for Polish industry. These offices included the Experimental Studio of Furniture based in a Warsaw art school; an experimental studio for metalwork in what would become the Industrial Design Department of the Kraków Academy of Fine Art; an experimental printed and painted textiles studio attached to a leading pre-war silk factory in Milanowek; the Experimental Fashion Studio based in Łódź; and the Experimental Glass and Ceramics Studio located in an art school in Wrocław, a city in Poland's so-called 'Recovered Territories'. Later, when BNEP's successor acquired its own premises in the centre of Warsaw, many studios were relocated to the capital. Thirdly, designers were placed in factories and small workshops run as workers' co-operatives. Here BNEP came closest to influencing the production of goods, particularly in the fields of ceramics and textiles. As a result, between 1947 and 1950 BNEP placed a number of artists in Polish ceramic and textile industries. Although BNEP's range of interests was diverse and included weaving, lace-making, clothing, glass, ceramics, basket-making, artistic metalware, jewellery, small sculpture, toy-making and leatherwork, it lay almost exclusively in the domestic sphere, i.e. in things which could furnish the home and clothe the body.

BNEP's founding aims were shaped by a long-established (and, in Telakowska's case, self-consciously Anglophile) view of the relationship of art and industry which envisaged the principal social role of the artist as a creative specialist in industry and the crafts. In fact, Telakowska objected to the distinction between fine and applied art (a view which, when expressed during the height of Stalinism in Poland, often hinted at a covert modernist).[12] This distinction, she believed, perpetuated a form of elitism which elevated art above ordinary life. In this, she was squarely behind the Party's campaign to spread 'Culture' throughout the mass of society. She readily and frequently repeated the slogan 'beauty, every day and for all' (*piękno na co dzień dla wszystkich*) coined by Leon Kruczkowski, a prominent figure in the Ministry of Culture and Art throughout the Stalinist period.[13] The echo of Morris here was no coincidence; before the war Telakowska had been an active figure in Warsaw design reform circles which still claimed the English designer and socialist as an inspirational precursor.

A parallel can be drawn between the intellectual formation of Telakowska and many of her colleagues and that of figures like Gordon Russell in Britain. Holding on to an underlying pragmatism, they disapproved of

the radical Futurism of the Modern Movement in the inter-war years. But during the depressed mid-1930s these reform-minded Polish intellectuals had come to hold the view that they should concentrate their energies on lower-price furniture for serial production and that this necessarily required economical and unadorned designs. However, they also held on to the view, originating in the Arts and Crafts Movement, that design should be closely allied to manufacture. This explains the emphasis placed on locating artists and designers in Polish factories and workshops. Wanda Zawidzka-Manteuffel, a glass-designer, in an unpublished report for BNEP entitled *Piękne i Tanie Szkło* (*Beautiful and Inexpensive Glass*), appears to have regarded her task as that of experimentation with the support of technicians in the industry:

> The first batch of around 40 models, made from designers' drawings is the result of close cooperation between the artist and the workers: the moulder, the glassblower and gaffer. It is the result of adapting the artist's concept to the requirements of material and technology. Glass as an artistic medium is endowed with wonderful properties: it can be shaped according to the fancy of the artist, it can make use of the play of light, various degrees of translucency, and richness of tone ... Our models are the result of experiments with available techniques, and as such do not pretend to be the final product ... The involvement of artists is crucial in the field of glassmaking; they must make every effort to create a new Polish glassware in close cooperation with the technician and the glassblower.[14]

Zawidzka-Manteuffel's 'fieldwork' in the glassworks at Szczytna Śląska in the late 1940s and early 1950s resulted in a series of prototypes of decanters and glasses which, based on the proportions and decorative forms of sixteenth- and seventeenth-century Silesian glass, had a rather traditional character. She also experimented with freer, hand-shaped vessels decorated with gobs and dribbled veins of brightly-coloured glass. However, a recent exhibition catalogue of her works records that not one of her designs from Szczytna Śląska went into mass production, an issue to which I will return below.[15]

Telakowska's enthusiasm for folk culture was not a simple adherence to Morrisian thinking: she was keen to harness the craft skills and design traditions of Polish peasant life. In demographic terms, in 1946 the Poles were still a predominantly rural, peasant people with two-thirds of the population living in the countryside. Schemes connecting artists and designers with peasant organisations which had been initiated in the 1930s were now adopted as official policy under the aegis of BNEP. In a typical though much vaunted project, Eleonora Plutyńska, Professor of Weaving at the Academy of Fine Arts in Warsaw, instituted a revival of woven bedspreads, once traditionally popular in north-eastern Poland (figure 6).[16]

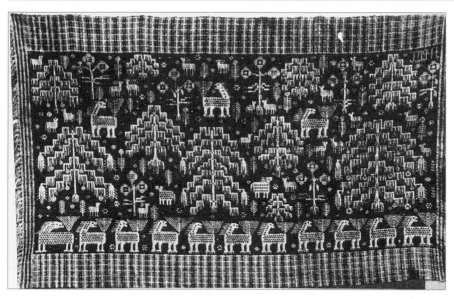

6 'Animals' double-weave bedspread made to a design by Eleonora Plutyńska, c. 1950

The vernacular form of these rugs was a simple two-colour, flat pattern made up of an inner field and a border carrying figurative or abstract motifs. Plutyńska actively encouraged their revival by working with peasant weavers from Sokółka, a village near Białystock. She had, in fact, first started working with weavers from this village in the late 1930s. However, in the post-war period her work was much publicised as an illustration of the changing class basis of the material culture of the new People's Republic. The way in which Plutyńska organised practice was praised far more than the actual bedspreads. Her cadre of peasant artist–weavers from Sokółka were not just the makers of Plutyńska's designs but were encouraged to become the makers of their own bedspreads. In this way the traditional origins of these textiles were left behind (just as Marxist-Leninist determinism predicted that a new culture and a new body of working-class artists would appear in a socialist Poland).

However, BNEP was not exclusively concerned with a revival of workshop production or vernacular traditions. Indeed, it did not advance a single direction in design in terms of aesthetics. Before the hardening of cultural policy in 1949–50, Telakowska commissioned designs from figures associated with the Modern Movement before the war. For instance Władysław Strzemiński, a prominent abstract painter who had been a key figure in pre-war Constructivism as an ally of Kazimir Malevich, was commissioned to design a series of textiles for print and a vase in his characteristic looping,

rhythmic 'Unist' style (figure 7).[17] Strzemiński had himself been a strident critic of currents in Polish design in the inter-war years which had ascribed national character to modernised forms of vernacular ornament, and would hardly seem to be a natural associate of a revivalist like Plutyńska working in Sokółka. In the same spirit of pluralism, one could visit the *Wystawa Przemysł Artystycznego* (Exhibition of Art Industry) held at the National Museum in Warsaw between December 1947 and January 1948 to see a section of furniture made almost exclusively in BNEP's Experimental Furniture Studio. These displays of model rooms as well as one-off pieces of furniture included, for example, remarkably simple designs made from willow by Jan Kurzątkowski,[18] reminiscent of contemporaneous, and now famous, cane and malacca furniture, designed by Franco Albini and Franca Helg in Italy; other, probably unconscious, echoes of contemporary design elsewhere in Europe included rooms furnished to designs by architects from the Arkady co-operative. Jerzy Staniszkis, a member of the group, exhibited a pair of low armchairs in which the seat curved into a chair-back as if made from a single moulded piece of timber, in a room furnished with a 'modular' pine cupboard which, like Le Corbusier's 'casiers standards', could be used to as a room-divider.

A small proportion of BNEP's prototypes went into production after their display in Warsaw. During the period of political cohabitation, the state used the patriotic rallying-call of national reconstruction to draw Poles

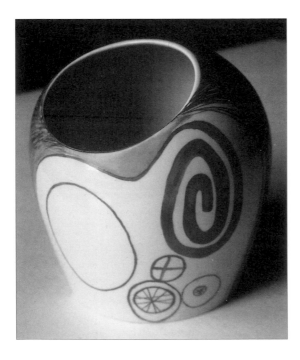

7 'Unist' design for ceramic vessel by Władyłsaw Strzemiński produced for BNEP, 1948

from many backgrounds, and holding diverse political views, into a common culture. While the voluntarism and collectivism of the late 1940s was not necessarily evidence of the wholehearted endorsement of the new system, as Party ideologues often claimed, the collective suffering endured during the war, as well as the collective desire to rebuild Poland, drew enthusiastic practical responses from many different sections of Polish society.[19] A similar mood of unity shaped many aspects of BNEP's activities at that time, which brought together representatives of diverse and even antagonistic currents in Polish intellectual life.

Despite the stylistic dissimilarities between designs and prototypes produced under BNEP's aegis, some common characteristics are discernible. Like Utility in Britain, these Polish designs displayed strong traces of social egalitarianism. Furniture schemes were designed to meet modern living conditions: both in terms of production, by employing humble materials such as pine and wicker; and in terms of consumption, by designing for small, overcrowded flats which had become the norm. A recent survey of the work of Olgierd Szlekys, a designer working with BNEP's Experimental Furniture Studio, shows his primary concerns to be with space-saving furniture: beds that could be folded into walls; ensembles of multi-functional furniture which could be converted for day and night-time use.[20] Szlekys described these inexpensive designs as 'wise furniture'. Not surprisingly, ornate and highly-decorated forms were ruled unacceptable by the sober mood that accompanied the period of reconstruction as well as by the Party's vilification of the 'excesses' and 'luxuries' of bourgeois life. The moral economy (in the sense of a collective and applied sense of social justice) which operated during the period of reconstruction meant that popular opinion disapproved of conspicuous consumption without affirming the Party's attack on the private shopkeeper and other highly visible members of the bourgeoisie.

The one-party state

1949 saw a hardening of political attitudes in all aspects of Polish life. The *Polska Zjednoczona Partia Robotnicza* (Polish United Workers' Party) and its allies, having secured a monopoly on power, set about excising their opponents from public life. This 'class war', like the mythologised revolutionary moment of October 1917, would force opponents of the new state to 'show their hand'.[21] In other words, the communists set the stage for the eradication of potential, imagined and actual opposition within the Party itself. Scapegoats were invented: in industry, in the spectre of the 'speculator' and the 'saboteur'; and in culture in the form of the 'bourgeois' modern artist.[22]

Central control over the economy became total. Enacting policies adumbrated by the Party, the Central Planning Bureau, employing 1,200 members of staff, drew up detailed plans for each manufacturing concern. Copious calculations determined investment levels, the supply of raw materials and other resources, and the range of different products to be made in Poland. This was understood as a politically determined system. Competition, profit and market prices were eliminated. The price paid by consumers, whether for basic foodstuffs or for scarce consumer durables, did not result from an assessment of real relative costs but from a judgement about the 'correct' relationship between the value of things. High demand and low levels of production, as well as an artificial pricing regime, meant that this was a producer's market in which the consumer had relatively little sway over the things which reached the shops. In fact, the volume of production and the quality of goods were not shaped by demand but by the state. Managers in industry were under strong pressure to meet often impractical and inflated targets. As Ivan T. Berend has noted, central planning in its classic Stalinist form was based on fear.[23] Consequently production returns were often falsified and quality thresholds slipped. As plan culture was built on quantitative markers rather than measures of quality, there was little incentive to introduce flexibility or new technology into industrial production. (This was reinforced by Poland's rejection of the Marshall Plan in 1948 and forced entry into the Council for Mutual Economic Aid (COMECON), which resulted in exchanges of materials and technologies with the Soviet Union). Consequently while, for example, millions of shoes or spoons may have been made to order, the plan had little to say about the quality or design of those products.

BNEP was not untouched in this new phase in the post-war history of Poland. The strengthening of Stalinist rule only served to draw it more closely into the command system. In 1950 BNEP was divided into two parts, with Telakowska and the research studios forming the new *Instytut Wzornictwa Przemysłowego* (Institute of Industrial Design/IWP) under the direction of the Ministry of Light Industry. The role of director of the new body was undertaken until 1953 by Jan Rogowski, an economist, with Telakowska as director of artistic matters. Predictably, the new body's statement of aims revealed a more emphatically political role than that which had been articulated by BNEP in 1947. In particular, it was charged – in the jargon-inflected 'Party-speak' of the day – with the role of 'organising new ways of uniting plastic invention in the field of art of different circles [workers, peasants and the young] in collaboration with artists' collectives'.[24] The political rhetoric may have changed, but IWP's *modus operandi* remained essentially the same as BNEP's. The IWP and Telakowska's experiments thrived through the years of high Stalinism in Poland. In particular, the

programme of collaboration between artists and traditional workshops and peasant co-operatives was increasingly championed in the official media.[25] This was largely because it met Stalinist prescriptions about the organisation of culture. One of the most widely repeated axioms of the regime, credited to Stalin himself, was that 'politically correct' culture was to have 'socialist content, expressed in national form'. This notoriously vague dictum proved difficult to apply even in the fields of representational art. What, after all, was *national* form in Polish painting or architecture, when they had been shaped by international currents and influences? In design and the applied arts application of Stalin's axiom was almost impossible.

However, some BNEP/IWP designs and prototypes made in collaboration with peasant collectives seem to have fulfilled Stalinist prescriptions; they were 'national in form' in that Telakowska's schemes had often encouraged a return to traditions of making that were identifiably Polish; and, occasionally, designs carried an appropriate socialist message. The high standing of these works in Poland in the 1950s can be traced to a fetish made of particular and historically specific constructions of 'authentic' working-class culture. Traditional artistic culture – the culture of the gallery and the salon – was tainted by dint of elitist associations, whereas any form of culture which could be linked to working-class or peasant roots was ideologically valuable to the Stalinist regime. Vice-minister of Culture and Art Włodzimierz Sokorski described 'folk art' as richly national, perpetually creative and deeply shaped by class: the antithesis of 'docile cosmopolitanism' and 'fossil-like formalism'.[26] Moreover, in assessing the Institute's schemes, critics claimed that an elitist, artistic imagination was being tempered by the pragmatism of a kind of practical knowledge possessed by the peasantry working in collectives. Aleksander Wojciechowski, a prominent art historian and critic, accommodated ideological orthodoxy by celebrating the 'common-sense' hegemony of the collective of the peasant weavers in Sokółka over the creative individualism of the artist, Plutyńska: 'In Eleonora Plutyńska's woven fabrics', claimed Wojciechowski, 'it is often difficult to detect the difference between her own creativity and the work of the peasant collective as well as the sources of folk inspiration. Anyway the difference is not important or decisive.'[27]

Despite the fanfares of Party propaganda, marriages between ideology and practice were rare. Nevertheless, some zealous activists believed that the advent of a new economic system in Poland would result in different kinds of everyday things. In 1949 Andrzej Kulesza, making the case for socialist planning, wrote:

> Today we boldly and aggressively throw out slogans claiming improvement in production standards, in the quality of materials ... and, above all, in

the aesthetic quality of mass produced products for the great mass of society living in the country and the towns.

For Kulesza, the problem lay in the failure to control production:

> In the system of popular democracy, anarchy in the realm of production has remained in the place that should have been taken by socialist planning. Indeed anarchy in the field of design [*zagadnień estetyki produkcji*] of goods for everyday use, leaving us in circumstances inherited from the period of capitalist economy, continues as before ...[28]

Not only would the overhaul of the economy and production result in a quantitative democratisation of consumption, but, he suggested, a new order would prevail in the design of commonplace things - i.e. things would be qualitatively or *sensibly* different in the People's Republic. But in the impoverished circumstances in which Poland found itself after the Second World War, such declarations of material progress remained largely rhetorical as far as most Poles were concerned.

An assessment

In theory, and according to the inflated rhetoric of the day, BNEP and IWP would seem to have been very well placed to serve an important social role. Built into the chain of ministries which shaped the command economy, they would seem to have been able to realise their aim of good design and ethical production. Design, after all, was now installed in a system of manufacture and provision claimed to be 'superior' to the profligate and mendacious capitalist system. But in terms of practical results their schemes must be viewed as failures. BNEP, for example, claimed that by the end of 1948 it had commissioned the extraordinary figure of 10,000 designs, models and prototypes.[29] Yet very few designs went into production, let alone found their way into the homes of their intended consumers. Estimates vary as to the proportion of prototypes taken up by industry: a recent optimistic suggestion puts that figure at less than 2 per cent.[30] Moreover, a large part of that figure comprised designs in the textile industries, where innovation placed few demands in terms of factory retooling or reorganisation. Recollections of designers and artists working for these agencies in the late 1940s and early 1950s stress the frustrations felt by this failure. Convinced by the message of good design and with firm faith in their social mission, Telakowska and her colleagues could only look back at the late 1940s and 1950s as a period of disappointment.[31]

So why did these bodies fail to make a material difference in the lives of the people whom they served, ordinary Poles? As is usual in these matters, a number of factors can be identified. In the factory, managers

had little encouragement to consider new designs. Stalinist economics, as we have seen, put little stress on matters relating to quality. Factory directors – often political appointees and, invariably, under pressure to exceed production targets – appear to have been dismissive of BNEP/IWP artists sent from Warsaw. Lidia Buczek, an IWP designer, recalled her experience of working in the Polish lace industry in Łódź in an interview with Lou Taylor in 1994.[32] The director allowed her access to the factory on the understanding that her designs would *not* go into production. She was only given the support of two technicians and access to pantograph machines for a few hours. The samples were produced with poor-quality materials which were too weak to support the decorative machine embroidery. Nevertheless, as Taylor acknowledges, 'The samples look perfect in the much reproduced photographs and on exhibition.' Buczek's experience appears to have been typical and, in part, accounts for BNEP/IWP's particular interest in small workshops. They were outside the immediate direction of the Ministry of Light Industry as part of the network of co-operatives managed by the government agency CEPELIA (*Centrala Przemysłu Ludowego i Artystycznego*/Centre of Folk and Artistic Industry).[33] Small workshops offered the promise of flexibility and creativity in an economy which was grinding towards monumental manufacturing units, anathema to Telakowska and her colleagues.

At the level of state policy, other ideological factors must be acknowledged. IWP was established at a time when its patron, the state, pursued policies which attempted to depress consumption. Cold War paranoia resulted in investment in military development and the reconstruction of heavy industry. Moreover, the restraint of consumption was more than just a matter of hard-nosed austerity measures. Party attitudes to domestic consumption were far from encouraging. While in 1952 President Bierut promised to spread the 'ideas of everyday beauty into every home in Poland',[34] Party attacks on domesticity and the notion of private life had the effect of making attention to and interest in one's home seem anti-social traits. 'Private life' was itself a condition viewed with suspicion. The essentially masculine, public and ascetic culture promoted by the most zealous strains of Polish Stalinism viewed the feminine and private values which might be expressed in the consumption of the commonplace things conceived by BNEP/IWP's designers as alien. As Berend has noted, 'Forced collectivism ... embodied peevish intolerance against otherness.'[35] However, one *can* find examples of imaginative, richly decorative designs produced under the auspices of BNEP and IWP. For instance, Andrzej Milwicz, an artist working with traditional folk motifs generated by peasant collaborators, produced extraordinarily colourful and expressive fabric designs for print realised at the Milanowek works. They compare well with

the most imaginative exhibits at the Milan Triennales of the 1950s. But overlooking their colourful exuberance, commentators in Poland in the early 1950s drew attention to such designs' utility and economy.

Ultimately, Telakowska and the designers that she worked with were relatively unmolested by the Stalinist regime and emerged after 'the Thaw' of 1955–56 with many of their ideas about design – both in terms of aesthetics and its social role – intact. However, the impact of their work on the lives of ordinary Poles was marginal. Not one could be accused of being a 'party hack' or an unprincipled opportunist, for it is possible to trace continuity in their approach from the pre-war years. Nevertheless, they served the regime. The frequent reproduction of their designs and the exhibition in Poland and abroad – in Moscow (1948), in Paris (1948 and 1949) and in Brussels (1949) – bolstered the impression that the social base of design and consumption had been significantly widened in the People's Republic. But their designs, far from serving utility, had decorated a bankrupt ideology.

Notes

1 Václav Havel, *Stories and Totalitarianism*, Faber and Faber, 1987, p. 343.

2 Peter Dormer, *Design since 1945*, Thames and Hudson, 1993, p. 126.

3 See Jonathan M. Woodham, 'Managing British Design Reform I: Fresh Perspectives on the Early Years of The Council of Industrial Design', *Journal of Design History*, Vol. 9, No. 1, 1996, pp. 55–66.

4 S. Staszewski interviewed in T. Torańska, *Oni*, Collins Harvill, 1987, p. 138 (translated by Agnieszka Kolakowska).

5 My description of this process is necessarily a brief summary. See Ivan T. Berend, *Central and Eastern Europe 1944–1993*, Cambridge University Press, 1996, pp. 3–94; and Michael C. Kaser, ed., *The Economic History of Eastern Europe 1991–1975*, Vol. III, Oxford University Press, 1987.

6 Padraic Kenney, *Rebuilding Poland, Workers and Communists 1945–1950*, Cornell University Press, 1997, pp. 192–8.

7 R.P. Potocki, 'The Life and Times of Poland's "Bikini Boys"', in *The Polish Review*, No. 3, 1994.

8 For details of Hungarian experiments and debates see Gyula Ernyey, 'The Utility Furniture Program', in his *Made in Hungary*, Rubik Innovation Foundation, 1993, p. 100 and József Vadas, *A Művészi Ipartól az Ipari Művészetig*, Corvina, 1979, pp. 67–9; for Czechoslovak institutions see *50. Léta Užité Umění a Design*, exhibition catalogue, Muzeum Uměleckoprůmyslové, Prague, 1988.

9 See Wanda Telakowska, *Wzornictwo moja miłość*, IWP, 1990, p. 15.

10 The history of these three agencies is, in effect, a single thread. There was continuity in terms of staff, schemes and resources as each new body emerged from its predecessor. The detailed history of this technical and artistic bureacracy is recorded in Alina Dukwicz, 'Biuro Nadzoru Estetyki Produkcji' and Tadeusz Reindl, 'Instytut

Wzornictwa Przemysłowego', in A. Wojciechowski, ed., *Polskie Życie Artystyczne 1945–1960*, Ossolineum, 1992, pp. 347–55.

11 Ministerstwo Kultury i Sztuki, *Sprawozdanie z Działalności za rok 1948*, 1949, pp. 41–2.

12 A number of commentators including Telakowska objected to the distinction that they perceived still operated between fine and applied art in the People's Republic. Claiming that this was a legacy of the hierarchical social structures of the past, these authors wished to open a space in which formal values could be discussed without appearing to encourage the 'error' of formalism. Design and the applied arts could not reasonably be expected to carry the political message that, say, a painting could. Other figures who appear to have shared this view included Aleksander Wojciechowski (see his essay 'Polska wytwórczść artystyczna w latach 1945–51' in *O Sztuce Użytkowej i Użytecznej*, Sztuka, 1955, p. 63) and Janusz Bogucki (see 'Sprawa realizmu w plastyce kształtującej', in *Przegląd Artystyczny*, No. 3, 1952, pp. 42–3).

13 Telakowska, *Wzornictwo moja miłośc*, p. 14.

14 Wanda Zawidzka-Manteuffel, undated MSS cited by Anna Maga in *Wanda Zawidzka-Manteuffel*, exhibition catalogue, Muzeum Narodowe, Warsaw, 1994, pp. 21–3 (translated by Artur Zapałowski).

15 *Ibid.*

16 See A. Wojciechowski, 'Dwuosnowowe Tkaniny Białostockiej', *Polska Sztuka Ludowa*, Vol. 4, Nos. 7–12, July 1950, pp. 107–21.

17 See Muzeum Sztuki, Łódź, *Władysław Strzemiński on the Hundredth Anniversary of his Birth*, exhibition catalogue, 1993. A view prevails today that Telakowska used BNEP's budget from the Ministry of Culture and Art to assist impecunious artists in Poland in a period of great economic hardship. In a 1961 lecture (unpublished) she admitted that BNEP had offered 'government subventions' to artists for designs at a time when they were not needed: 'It permitted artist–designers to leave their non-artistic work which gave them the means of existence during the war.'

18 Wicker had been a traditional material in the Polish furniture industry since the nineteenth century. Workshops in the San valley had been the centre of production in Imperial Austria. See Amelia S. Levetus, 'Modern Austrian Wicker Furniture', *The Studio*, Vol. 30, 1903–4, p. 325.

19 For recollections of this period see J. Marczewski, ed., *Pamiętniki Pokolenia*, Iskry, 1966.

20 Irena Huml, *Olgierd Szlekys i Sztuka Wnętrza*, PAN, 1993.

21 'The fight for Socialism is a class war to build a classless society. It is therefore also a class war to build a united culture. This can only be achieved in an age of the triumph of socialism', pronounced W. Sokorski in 'O Właściwy Stosunek do Sztuki Ludowej', *Polska Sztuka Ludowa*, Vol. 3, No. 5, May 1949.

22 For the attack on modern art see *Sztuka*, No. 2, 1988 – a theme issue on Socialist Realism in Poland.

23 Ivan T. Berend, *Central and Eastern Europe 1944–1993. Detour from the Periphery to the Periphery*, Cambridge University Press, 1996, p. 77.

24 IWP's founding statute, cited by Reindl, 'Instytut Wzornictwa Przemysłowego', p. 350.

25 See, for example, Aleksander Wojciechowski, 'Metody Pracy Zespołowej w Polskim Przemyśle Artystycznym', *Polska Sztuka Ludowa*, Nos. 4–5, 1952, pp. 203–11.

26 Sokorski, 'O Właściwy Stosunek do Sztuki Ludowej'.

27 Wojciechowski, *O Sztuce Użytkowej i Użytecznej*, p. 91.

28 A. Kulesza, 'Przemysł Miejscowy Współpracuje z Biurem Nadzoru Estetyki Produkcji', *Ogólnopolski Informator Państwowego Przemysłu Miejscowego*, Vol. 4, No. 27, 1949, p. 6.

29 Ministerstwo Kultury i Sztuki, *Sprawozdanie z Działalności za rok 1948*, p. 41. The use of any such data from this period is beset with difficulties, not least because managers in industry and bureaucrats were under great pressure to exceed targets. However, BNEP's own records, kept in the Ośrodek Wzornictwo Nowoczesnego of the Muzeum Narodowe in Warsaw, suggest that this figure is quite accurate.

30 This figure takes in the period of Telakowska's directorship until 1968. It is likely that IWP's meagre 'successes' in industry were from the late 1950s and 1960s when the production of consumer goods were given a higher political priority; see Lou Taylor, 'The Search for a Polish National Identity – 1945–68: an Analysis of the Textile Design Work of Prof. Wanda Telakowska, Director of the Institute of Industrial Design, Warsaw', in Suzanne Stern-Gillet, Tadeusz Sławek, Tadeusz Rachwał and Roger Whitehouse, eds, *Culture and Identity. Selected Aspects and Approaches*, Wydawnictwo Uniwersytetu Śląskiego, Katowice, 1996, p. 404.

31 Telakowska records this view in a 1961 lecture, the notes for which are kept with her papers at the Ośrodek Wzornictwo Przemysłowe (part of the Muzeum Narodowe, Warsaw).

32 Taylor, 'The search for a Polish National Identity'.

33 See Irena Bal, 'CEPELIA', in Wojciechowski, *Polskie Życie Artystyczne 1945–1960*. pp. 355–9.

34 Bolesław Bierut, cited by Maria Starzewska in her *Polska ceramika artystyczna pierwszej połowy XX wieku*, Muzeum Śląskie w Wroclawiu, 1952, p. 47.

35 Berend, *Central and Eastern Europe 1994–1993*, p. 84.

5 ✧ 'The beauty of stark utility': rational consumption in America – *Consumer Reports*: 1936–54

Susie McKellar

> I sometimes wonder if we have not lost our buying sense and fallen entirely under the spell of salesmanship. The American of a generation ago was a shrewd buyer. He knew values in the terms of utility and dollars. But nowadays the American people seem to listen and be sold; that is, they do not buy. (Henry Ford, 1926) [1]

IN 1927, Henry Ford, having seen his share of the car market drop from 50 per cent in the early 1920s to 15 per cent in 1927, was forced to cease production of the standardised Model T Ford, retool his River Rouge plant to accommodate a more flexible manufacturing process and in due course he introduced the more 'stylish' Model A. Ford was an engineer and a puritan. As David Riesman noted in his essay 'Autos in America' in 1956, Ford understood production, but concerning consumption he had 'no talent, no appetites and no emulative envy';[2] and yet ironically it had been Ford himself who had been so 'instrumental in creating an economy far too bounteous to be satisfied with the Model T'.[3] One observer referred to Ford's reluctance to accept the triumph of styling over standardised utility as the 'most expensive art lesson in history'[4] and one which dragged him 'into a world he could no longer understand'.[5] Ford was not alone in valuing the utilitarian in an increasingly complex 'culture of consumption'.[6] Like him, there were other engineers and economists whose values and technological achievements had formed the cornerstone of the American economy during the first two decades of the twentieth century, who were also dragged into a world they no longer understood. Yet while Ford, albeit reluctantly, did acknowledge the demise of the value of standardised utility in a 'culture of consumption' by introducing the Model A, others sought to reapply it to objects through consumer guides. In these publications objects were to be valued as Ford had understood them, 'in the terms of utility and dollars'.

Consumer Reports, first published in America in 1936 (figure 8), was the antecedent to *Which?* magazine, and like its younger British counterpart,

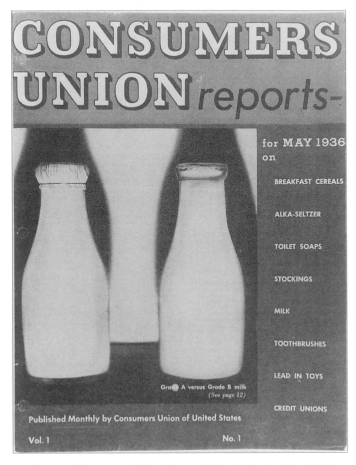

8 Cover of *Consumers Union Reports*, Vol. 1, No. 1, May 1936.
The very first issue of *Consumers Union Reports*, which demon-
strates, through the type of everyday good reviewed, that the
intended target audience was the recently 'consumerized' worker

was set up during a period of rapid expansion in the availability of
consumer goods, to offer consumers impartial advice based on scientific
testing. Both publications value products purely on technological and
economic ratings, and in denying the social role of goods they render
notions of 'conspicuous consumption'[7] effectively redundant. Although
today *Which?* is viewed as a rather anodyne and apolitical publication, the
development of the consumer movement in America differs in that it was
dogged by political turbulence, both internal and external. At the centre
of this lay the notion of American patriotism being closely linked to
consumption and the capitalist economy of abundance: the 'American
Way'. Through documenting the early years of the consumer movement,

this chapter will explore the effect that strict valuing of the utilitarian in objects had, in political and economic terms, between the mid-1930s and mid-1950s in America: a period in design history more usually noted for the birth of the industrial design profession, the development of a cornucopia of consumer goods and increasingly extravagant product styling.[8]

Long before 1957, when Vance Packard published *The Hidden Persuaders*, his alarmist account of the motivational techniques employed by advertisers, Consumers Union (CU),[9] publishers of *Consumer Reports*, sought to expose the 'superlatives, half truths, pseudo-science and irrelevant appeals of the advertisers'.[10] However, during the Depression of the 1930s, stimulating consumption through advertising was considered to be a vital part of the American economy. Consequently, the criticisms raised by the consumer movement were bitterly received. In his 1936 book, *The Poison Pen Of New Jersey* (the home of the consumer movement in the early years), O'Sullivan wrote:

> Consumers' Research strikes at the very heart of our prosperity. How can a nation be prosperous if its citizens do not buy the things it needs? By proclaiming in effect that manufacturers are frauds, crooks and thieves; advertisers, liars and cheats; [Consumers' Research] will bring the consumer to such a state of doubt that he consequently buys nothing and does not know what to know.[11]

In the 1910s and early 1920s, American prosperity was dependent on a manufacturing culture. Precipitated by the work of Frederick Taylor[12] and the efficiency-drives prompted by military production for the First World War, engineers and economists under Herbert Hoover, then Secretary of Commerce, advocated rationalisation, standardisation and uniformity in order to reduce national wastage while increasing national output. Hoover, an engineer himself, was the driving force behind the activities of the American Engineering Standards Committee, later the American Standards Association, and the National Bureau of Standards. 'Standards', by which they meant uniformity and predictability in purchasing, were applied widely in industry, from screw-threads to brick sizes. Grading standards in terms of quality were also introduced by these government agencies, but again their application was primarily to serve the interests of industry and government rather than the individual consumer. Economists of the day were supportive of this manufacturing philosophy, which, they believed, would lead to a balanced and prosperous economy. It was thought that through the sale of products that were either simply preferred or considered technically superior, successful manufacturers would be able to increase scales of production and thus reduce costs to the benefit of the consumer. However, such an economic policy, based on the law of supply and

demand, concerned itself more with the rational engineering principles of production than understanding the 'nature' of consumption. Consumption in this production economy was assumed rather than analysed, but, as Robert Lynd noted at the time, 'the mystical equilibrium of the classical economists' failed to match up with 'an eighteenth-century political economy' applied 'to a twentieth-century industrial system'.[13] Consequently, towards the end of the 1920s, this manufacturing culture began to falter as production began to 'press down like an avalanche on consumption ... resulting in the inability of consumers to perform their official duty of continuing to absorb the output of industry'.[14] Accordingly, manufacturers soon suffered from overproduction, and in order to broaden their markets both horizontally and vertically[15] they increasingly turned to advertisers and designers to 'engineer' consumers into consuming.[16]

In his 1976 Marxist critique of advertising, *Captains of Consciousness*, Stuart Ewen argues that during the 1920s the role of the workers had to change; they had to be 'consumerized'.[17] According to Ewen, modern industry was 'geared towards mass production', and consequently to keep the wheels of industry turning, 'time for mass consumption [became] as much of a necessity'.[18] In this context, Ewen suggested that along with the shorter hours and higher wages initiated by Ford, which made consuming both financially and physically possible, advertising became an 'offensive against thrift' and the Protestant value-system that the modern worker had grown up with.[19] This shift in modern industrial society, although sold to the population through advertising as the 'American Dream', was, according to Ewen, essentially intended to serve the needs of a 'capitalist productive machinery'.[20] By the late 1920s the industrial designer was beginning to be employed by manufacturers to help stimulate sales. In 1926 General Motors employed Harley Earl as Head of Art and Color and gradually began to introduce the concepts of styling, planned obsolescence and the annual model-change, which, along with the dramatic drop in sales of the Model T Ford, prompted Ford to follow suit the following year. 'Fordism', a single-purpose manufacturing process, represented the ultimate standardised mass-production engineering system and was the model for many industries of the decade. Consequently, this shift to the production of cars 'whose appearance if not features changed'[21] with the sole intention of increasing consumer demand cannot be overemphasised in describing the transition from a production economy to a consumption economy.

1927 was also a critical year in the evolution of the American consumer movement. It was in this year that Stuart Chase and Frederick Schlink published their seminal text, *Your Money's Worth*, referred to by Colston Warne, later president of Consumers Union, as 'the Uncle Tom's Cabin of the consumer movement'.[22] Chase and Schlink's text was an explicit assault

on the American economy and its failure to serve the individual consumer, with advertising as one of their main targets. In their introduction they wrote that 'we are all Alices in a Wonderland of conflicting claims, bright promises, fancy packages, soaring words and almost impenetrable ignorance[23] [and they continued] ... when you know the truth about anything, the real inner truth, it is very hard to write the surface stuff that sells it'.[24] However, it was not only advertising that stood accused of deceiving the consumer; styling of industrially manufactured products also came under attack for being 'the surface stuff that sells'. The authors clearly favoured mass production and standardisation, and, like their contemporary, Henry Ford, saw no place for 'irrelevant attempts at ornament'[25] on utilitarian objects. Accordingly, they celebrated a 'functionalist' aesthetic, or rather, the 'beauty of stark utility'.[26] In defence of their aesthetic preference, the authors sought both an artistic authority and an economic rationale:

> Mr Lewis Mumford, distinguished architectural critic, has no quarrel with mass production from an artistic standpoint, provided that it keeps to its own side of the bed. So long as its output takes the simple form of the use to which it is to be put, it is usually welcome and often beautiful – with the beauty of stark utility. But once this form is corrupted with irrelevant attempts at ornament – papyrus leaves on the bases of electric heaters ... Corinthian fluting on wrought iron reading lamps, oriental rug patterns on linoleum ... beauty clutches economy by the hand and they disappear together.[27]

The authors' intervention in debates on consumption, design and advertising in 1927 is very significant. With the shift from an economy based on production to one increasingly dependent on consumption, many of the utilitarian values that they had espoused were becoming increasingly untenable in an age when the higher and 'silent salesman'[28] prevailed over the engineer. It is then, perhaps, not coincidental that during these years the authors turned their attention to applying those same rational engineering values to consumption. As they wrote: 'We shall plead for the extension of the principle of buying goods according to impartial scientific tests, rather than according to the fanfare and trumpets of the higher salesmen.'[29] It was on these basic principles of engineering standards and impartial scientific testing, which would assess strictly the utilitarian properties of goods, that the consumer movement was founded. Ironically, whereas in previous years it was precisely these values which, when applied to production, had been heralded as the keynote to prosperity, that, during the 1930s, when applied to consumption, came to be viewed as subversive and unpatriotic. From the first rumblings among some newspapers and journals, the criticism grew until it eventually reached a national political level and Consumers Union came to be viewed by its enemies

as 'a communist outpost seeking to destroy the American free enterprise economy'.[30]

Consumers Union grew out of Consumers' Research, a consumer group set up by Schlink in 1929. The history of the highly acrimonious split between the two organisations centred around a strike by Consumers' Research employees which occurred when Schlink and J.B. Matthews, a fellow-director, refused to let the employees unionise. The striking employees, who constituted almost the entire staff, were eventually sacked and in 1936 formed the Consumers Union.[31] In a series of lectures Colston Warne wrote that Matthews 'had prided himself on being a champion of militant labor, but the Consumers' Research strike vaulted him into becoming bitterly anti-labor and anti-communist and later landed him in the position of research director for the House Committee on Un-American Activities in Washington'.[32] Warne added that during the strike Matthews had very quickly 'found' a red plot among the strikers in the shape of Dewey Palmer, technical director and fellow board member, and in time went on to claim that Consumers' Research management was 'locked in conflict with a communist outpost'.[33] Consumers Union was undoubtedly left-wing in its agenda during the early days. Although concerned with impartial scientific product testing and informing the consumer about the relative merits of products, just as in the 1920s the 'captains of industry' had identified that the worker had to be 'consumerized', by the 1930s Consumers Union identified the consumer as being the producer and sought to protect him/her in both roles. Accordingly, *Consumer Reports* in its formative years not only reviewed products, it also provided an account of the labour conditions in the industries relevant to the products. The editorial board justified this political stance by claiming that what they were primarily concerned with was improving the standard of living for American citizens. However, what characterised the early publications were strong attacks on both advertising and design rather than straightforward reports based on the results of 'impartial scientific tests'. For example, a review of electric razors in 1936 read:

> Says the Progress Corporation of its Packard, Lifetime Lektro-Shaver: 'it lops off every hair close to the skin and so gently you scarcely realize you're shaving ... There is absolutely no tugging, no rawness and no burning ... Lektro-Shaver brings the evolution of shaving to its end. Human ingenuity cannot possibly devise a more pleasant and more efficient method' ... Compare these statements with technicians' reports of 'poor shave, irritating'. Or compare the Clipshave claim that 'with it, you can shave the heaviest beard smoothly and closely without the slightest irritation' with the technicians' report: 'Results – very poor. After effects terrible ... My face feels as if I had shaved with a dull lawn mower.'[34]

Such aggressively-written reports were not well received in industry. Although it should be noted that Consumers Union was never successfully sued, increasingly the board found it very hard to get newspapers and journals to carry their advertisements. The *New York Times*, for example, by 1938 refused them advertising space on the grounds that they 'couldn't work both sides of the street'.[35] Clearly aggravated by the situation, in January 1939 *Consumer Reports* fought back with an article entitled 'Do Advertisers Dominate the Press?', accusing newspapers of showing 'their prostitution to advertisers every time they refuse a Consumers Union advertisement'.[36] Alongside advertising, the commercial application of product styling, which by the 1930s had become an integral part of the production of many consumer goods with the express intention of 'making things irresistible',[37] was also viewed suspiciously. Planned obsolescence and the annual model stimulated consumerism as Americans were encouraged to replace the new with the newer, helping the economy buy its way out of the Depression. *Consumer Reports* did not share this view of design. For them it served no purpose other than that of beguiling and misleading the consumer. For example, a 1936 review of mechanical refrigerators painted a damning picture of design features and streamlining:

> Conservador – Shelvador – Eject-O-Cube – Adjusto-Shelf – Foodex – Handi-bin – Touch-A-Bar ... With these magic words, mechanical refrigerator makers persuade the American public to buy their product. Yet these words have absolutely nothing to do with the essential qualities of a refrigerator ... The wide variations in design and special features only serve to increase the buyer's difficulty in making a selection on rational grounds ... What are the advantages of a 'Sealed-in-Steel-Thrift-Unit'? ... Streamlining, the art department's contribution to most makes of refrigerators, has no functional value unless, as someone has suggested, one contemplates throwing the box out of the window.[38]

The fear among its critics and detractors seemed to be that Consumers Union was effectively 'deconsumerising' the worker. By appealing to the puritanism of the 'pioneer period', and by applying rationalised engineering standards of production to consumption, *Consumer Reports* were denying the supremacy of the 'higher' and 'silent' salesmen over the engineer in a 'culture of consumption'. From a commercial perspective, these values were believed to have no place in a modern industrial society where the worker's role was as important in the sphere of consumption as in the sphere of production. Consequently, Consumers Union was viewed as unpatriotic during the 1930s, when America was trying to recover from the Depression, and by 1939 it was deemed subversive and blacklisted by the House Committee on Un-American Activities.[39] Because J.B. Matthews, the embittered Consumer Research director, was one of the main protagonists behind

these charges of anti-Americanism, the 'red' allegations were initially laughed off by the Union as a predictable response to their success. However, the consequences were to become more serious in the 1950s, when Joseph McCarthy was most active, and Arthur Kallet, director of Consumers Union, was called to testify before the House Committee on Un-American Activities. During the war years, however, when circumstances changed, the battle between the advertisers and Consumers Union centred on who was the more patriotic.

Following the bombing of Pearl Harbour in 1941, the manufacturing of cars and the majority of domestic consumables was suspended while production was given over to the war effort. Although *Consumer Reports* continued to be published, the 1930s format was largely abandoned simply because there were not the products to review.[40] Instead, the *Reports* strove to keep consumers informed of wartime economics and advised them how to use rationed goods wisely. In much the same way as the British government was encouraging thrift through its 'Make Do and Mend' campaign, Consumers Union launched a 'Make 'Em Last' programme, advising its readers on how to get 'maximum economy along with the best possible service'[41] from household equipment that could not be replaced. In many ways the prudence that had to be exercised by American consumers during the war years was entirely in line with the values of the Consumers Union. The rationing of goods meant that the Union could advocate 'values in terms of utility and dollars', but this time in the interests of reducing national wastage, the very essence of Hoover's drive towards standardised utility initiated during the 1910s and 1920s. Accordingly, rather than the emphasis being on the needs of the individual consumer, the Union prioritised national responsibility. The editorial of May 1942 entitled 'Consumers Union's Pledge to the Nation' stated:

> Far surpassing every other consideration now is this one: that national unity, national sacrifice, and national enterprise must combine in the maximum war effort possible to us. For Americans as consumers – along with Americans as producers – personal interests must be subordinated to the needs of the whole people at war ... Because it was established for the very purpose of aiding families to buy wisely and avoid waste and to maintain health and living standards, and because it is the largest technical organisation providing such guidance, Consumers Union recognises a special responsibility to the nation.[42]

Although Consumers Union was not able to review products, it was able to use the war to help assuage any rumours or accusations of subversive activities. The declared patriotic duty, evident in the editorial above, was consistent throughout the war years. Such statements, along with the use

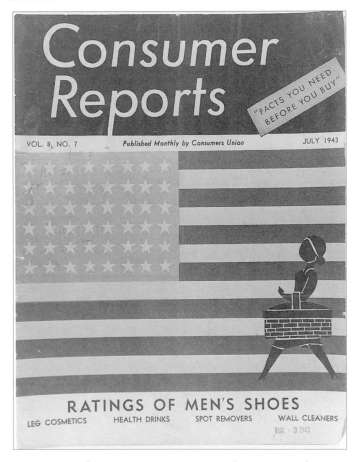

9 Cover of *Consumers Union Reports*, Vol. 8, No. 7, July 1943.
During the war years, Consumers Union declared its patriotic
duty to the nation as is illustrated here. Note that the word
'union' has by this stage been omitted from the title

of the American flag (figure 9) and cover-pages featuring members of the
armed services testing and selecting various products, were no doubt
intended to help vindicate it from accusations of un-Americanism. Never-
theless, the Union did not abandon its political agenda altogether. During
the war its attack on advertising was intensified rather than relinquished.
Although many products had ceased to be produced, the government still
permitted the advertising of them so as to keep brand names in the minds
of consumers. Colston Warne, president of Consumers Union, lobbied
Washington in an attempt to curtail this advertising. For Warne, the
government's sanctification of the advertising industry through tax exemp-
tions constituted nothing short of a national scandal. While the entire

population was being encouraged to 'Make 'Em Last', advertising, apart from using precious resources, was encouraging an acceleration in consumer demand and, ironically, often wrapped its products in a patriotic flag in the process. For Warne, 'advertising had not gone to war'.[43] The response to Warne and his committee was extreme and again accusations of un-Americanism abounded.

Following the war, and continuing into the McCarthy period of the early 1950s, the accusations of subversive activities within the Consumers Union continued until it finally received its 'certificate of purity' in 1954.[44] Like many organisations and individuals that were implicated in the communist witch-hunt, the allegations levelled at the Consumers Union were tenuous and exaggerated. In addition to this they were still associated with the activities of J.B. Matthews, who had made the allegations of communism back in the 1930s. Matthews revised his denunciation of the Consumers Union as a communist front to the House Committee on Un-American Activities twice, once in 1944 and again in 1947, and by the 1950s was employed by McCarthy.[45] Nevertheless, the allegations were taken seriously. *Consumer Reports* were banned in some schools, and many organisations such as the American Home Economics Association sought to disassociate themselves from the Union. As a result, although in the end the accusations against them proved impossible to uphold, Consumers Union's encounter with McCarthyism, and fifteen years of allegations from the House Committee on Un-American Activities, precipitated many changes to the publication in the post-war years.

Eager to emphasise its impartiality rather than engage in any ideological conflict during this period, *Consumer Reports* did not return to its old format of treating the producer as the consumer and, as a consequence, omitted the labour reports. Instead it concentrated its efforts into becoming primarily a technical testing agency. This change of political stance caused many of the more radical members of the editorial board to resign during the 1950s. Some were claimed to have 'abandoned ship ... under intense fire',[46] and Consumers Union responded by appointing in their place members to the board 'who could not possibly be deemed subversive'.[47] The new editorial board tempered the highly aggressive language used to denounce advertising and replaced it with more objective and qualified analysis. A few bitter editorial comments sometimes appeared in a feature called 'Quote Without Comment', articles written by individuals outside the organisation and then simply quoted in the *Reports*, but by 1953 these too had disappeared. In short, the political agenda used to denounce consumerism initiated in the 1930s was, for the most part, conspicuous by its absence.

During the post-war period, attitudes concerning 'values in terms of

utility and dollars' with regard to design also started to change. The stylistic features of a wide range of products, which in the 1930s would have been regarded as having 'no functional value' or 'the surface stuff that sells', began to appear in the *Reports* and were reviewed more objectively. Whereas for Dewey Palmer, the first technical director of Consumers Union, stylistic features were 'de-educating' and 'attention diverting devices' and conspicuous consumption was 'no more sensible than having two tubs in the bathroom',[48] David Riesman noted that by the mid-1950s '*Consumer Reports* ... was beginning to abandon functionalism in its criticism of commodities so that an Oldsmobile or a hydramatic transmission – for all the waste of gas – [could] now enter its pages without being condemned out of hand'.[49] How far the Union really did abandon its aesthetic appreciation of the 'beauty of stark utility' in the post-war period is harder to assess. The gadgets that once would never have been reviewed as anything other than a waste of money do start to be discussed more objectively and conspicuous consumption is acknowledged, albeit as something that could not be evaluated. For example, in May 1952, having listed all the qualities they were able to tests cars for, *Consumer Reports* wrote:

> There is one other consideration which is of some importance to many car buyers – and one which CU does not attempt to rate: the car's prestige value. It probably has to do with the luxury look and feel of the car, but most of all, with its cost and the brand name it carries. How important this is each car buyer will have to judge for himself.[50]

However, a sign of the conflict product-styling posed for the Union is made evident when the comment above is compared to the ambiguous 'Quote Without Comment' which, two months earlier, had euphemistically referred back to the age of the engineer:

> In any automobile he can buy today, he [the driver] can count on being sunk up to his chin in a mass of metal, forced to steer by extrasensory perception ... Remember the cars of ... father's day? ... Cars that sat a man up where he belonged, like a knight upon his charger and let him see where he was going. Cars that really turned when the wheel moved, instead of suggesting, sluggishly, that after a bit they might change direction.[51]

Product-styling presented the Consumers Union with a problem. Clearly it was not within the interest or remit of a technical testing agency, but in the post-war period it would have seemed naive to dismiss it simply as 'the surface stuff that sells'. Furthermore, such an assault on planned obsolescence could have been perceived as being too inflammatory, given the political climate. However, for a short period of time a solution to the problem was found in the guise of Modernism, Eliot Noyes and the respectable authority

of the Museum of Modern Art (MoMA).[52] Between 1947 and 1950 Noyes was commissioned to produce a monthly feature called 'The Shape of Things', in which he selected and discussed 'Good Design'. 'Good Design' for Noyes, as for MoMA, was 'utilitarian' and 'functional', in its aesthetic at least, and consequently Noyes's recommended good buys frequently bore more relation to exhibits at MoMA than the products reviewed in the pages of *Consumer Reports*. As Noyes wrote, his good buys had been 'selected as examples of good utilitarian design, making the most of modern materials and techniques to achieve modern forms for everyday use'.[53]

Throughout his contributions to *Consumer Reports*, Noyes never waivered from his appreciation of Modernism. Just like Mumford, who in his contribution to *Your Money's Worth* dismissed 'irrelevant attempts at ornament', Noyes in 1947 wrote of 'all this silliness where nothing-is-what-it-appears-to-be belong[ing] more to the world of exploding cigars than design'.[54] In commissioning Noyes, and thereby enlisting the design principles of Modernism, Consumers Union had apparently found a solution to their problem. The problem of course was not solved. Consumers Union was under the same illusion as many Modern Movement protagonists; an illusion that Reyner Banham exposed in his 1955 essay 'The Throwaway Aesthetic'. Banham argued that 'the illusion of common "objectivity" residing in the concept of function and in the laws of Platonic aesthetics had been a stumbling block to product criticism.'[55] As Penny Sparke explained in 1986 in her *An Introduction to Design and Culture in the Twentieth Century*:

> [Banham] pointed out that the Modern Movement protagonists had created a confusion between the meaning of objectivity in mechanical engineering laws and its meaning in the laws of aesthetics, and that the concept of standardisation had been misunderstood in its equation with an ideal rather than a momentary norm. The raising of these confusions to the level of creed had resulted, claimed Banham, in the creation of a dominant twentieth-century design aesthetic which was based on fallacy rather than fact.[56]

These 'confusions' were noted by readers of the *Reports*, who not only questioned Noyes's aesthetic preference, which by and large they did not like, but more importantly, the value of it. As one reader wrote:

> I finally must say what is on my chest about 'The Shape of Things'. It certainly does not contribute to a knowledge of the value, worth, wearing qualities or efficiency of an article. It merely reflects the opinion of one Eliot Noyes on design. I never bought CU as an art magazine. Besides he might be a 'classicist' and I might be a 'cubist', so what? I would be very happy if he were omitted.[57]

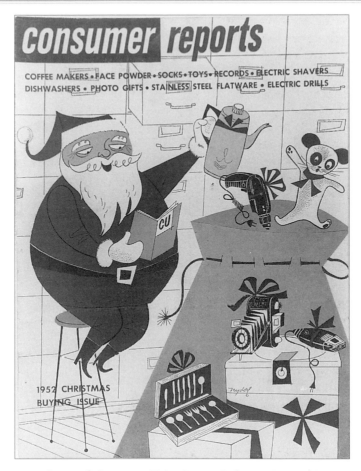

10 Cover of *Consumers Union Reports*, Vol. 17, No. 11, November 1952. This Christmas edition illustrates how, by the 1950s, Consumers Union acknowledged the consumer culture of which it had once been so critical

The alignment with MoMA and Modernism was also an alignment with a cultural elite, the very antithesis of the Union's origins. The encounter with McCarthyism removed all but the last traces of the left-wing idealism that had characterised the Consumers Union's formative years, and by the late 1940s it was primarily a technical testing agency in the hands of engineers. Modernism provided these engineers with an aesthetic that they could understand and one which permitted, seemingly without compromise, an appreciation of 'the beauty of stark utility' in an age of 'borax'[58] and tail-fins. However, in so doing, the last traces of democratic idealism were abandoned. By the 1950s the gulf between the 'functional' values of 'modern' design as upheld and promoted by design organisations internationally, including the

Consumers Union, and the commercial values of popular design and mass taste, was 'wider than ever before'.[59] In his essay 'Autos In America', Riesman noted that

> out of the fifteen hundred [car-makers] that, since 1893, have attempted to produce trade-marked models [the few companies to survive] were those that learned to obey the whim of the consumer rather than the gauges of the engineer ... The engineer had to take second place to the designer, while the auto itself has come more and more to conceal its ancestry in surface transport and to engross the panoply of hitherto unrelated images.[60]

Riesman commented that 'Ford held out as long as he could',[61] and a parallel can be drawn between him and the Consumers Union. After 1927, consumption did not bestow utility as Ford had understood it. Therefore, to continue to advocate such a belief was inevitably going to be problematic politically and economically; hence the turmoil characteristic of the Union's formative years. It was only during the Second World War that Consumers Union's utilitarian values were of economic importance and national relevance. By the 1950s Consumers Union had changed hugely. The left-wing ideologues had resigned and the engineers, like Ford, had been forced to become more flexible in their definition of utility. As for *Consumer Reports* during this period, rather than speaking rhetorically to its ideal audience of the 1930s, the 'consumerized worker', it began to respond to a new audience: the affluent, urban, middle class, keen to shop in the post-war consumer boom (figure 10).[62]

Notes

1 D. Hounshell, *From the American System to Mass Production*, Johns Hopkins University Press, 1984, p. 276.

2 D. Riesman, 'Autos in America', in his *Abundance for What?*, Chatto and Windus, 1964, p. 268.

3 Riesman, 'Autos in America', p. 268.

4 J. Meikle, *Twentieth Century Ltd*, Temple University Press, 1979, p. 14, quoting R. Abercrombie, *The Renaissance of Art in American Business*, American Management Association, 1929, pp. 6–7.

5 Meikle, *Twentieth Century Ltd*, p. 14.

6 T.J. Jackson Lears and R. Wightman Fox, *The Culture of Consumption*, Pantheon Books, 1983.

7 The term 'conspicuous consumption' was introduced by Thorstein Veblen in *The Theory of the Leisure Class*, Macmillan, 1899.

8 Meikle, *Twentieth Century Ltd*.

9 Consumers Union is never referred to as 'the Consumers Union', nor is the word

'Consumers' ever given an apostrophe. To a large extent I have worked in accordance with this, but have included a definite article where I have felt it to be required.

10 C. Warne, *The Consumer Movement* (lectures), ed. R. Morse, Family Economics Trust Press, 1993, p. 91.

11 *Ibid.*, p. 45–6, quoting Frank Sullivan, *The Poison Pen of New Jersey*, O'Sullivan Publishing House, 1936, p. 36.

12 Frederick Winslow Taylor (1856–1915) published his seminal text *Principles of Scientific Management* in 1911. At the heart of his study was the analysis of time and motion in the workplace. The intended outcome was to eliminate time-wasting moving about and thus rationalise production and increase productivity.

13 R. Lynd, 'The Consumer Becomes a Problem', in J.G. Brainerd, ed., *The Ultimate Consumer*, Arno Press, [1934] 1976, pp. 4–5.

14 *Ibid.*, pp. 1–5.

15 This means both class and geographical expansion.

16 'Consumer engineering' was a term first used by Elmo Earnest Calkins in a speech of 1931 and then by R. Sheldon and E. Arens for the title of their book, *Consumer Engineering*, Philadelphia, 1932.

17 S. Ewen, *Captains of Consciousness*, McGraw-Hill, 1976, p. 28.

18 *Ibid.*, p. 29.

19 *Ibid.*

20 *Ibid.*, p. 36.

21 Hounshell, *From the American System to Mass Production*, p. 264.

22 Warne, *The Consumer Movement*, p. 19. *Uncle Tom's Cabin*, published in 1852, was Harriet Beecher Stowe's highly influential anti-slavery text, which raised the awareness of thousands of Americans to the abolitionists' protests.

23 S. Chase and F.J. Schlink, *Your Money's Worth*, Macmillan, 1927, p. 2.

24 Chase and Schlink, *Your Money's Worth*, quoted in N. Silber, *Test and Protest: the Influence of Consumers Union*, Holmes and Meier, 1983, p. 17.

25 Chase and Schlink, *Your Money's Worth*, p. 177.

26 *Ibid.*

27 *Ibid.*

28 P. Sparke, 'From a Lipstick to a Steamship', in T. Bishop, ed, *Fad or Function*, Design Council, 1978, pp. 43–7. Sparke notes that Henry Dreyfuss was quoted as saying that 'design is a silent salesman' by J.D. Radcliff, 'Design for Streamlined Living', *Coronet*, June 1947.

29 Chase and Schlink, *Your Money's Worth*, p. 3.

30 Warne, *The Consumer Movement*, p. 127.

31 Consumers Union rapidly became more successful than Consumers' Research and remained so until Schlink's death in 1994. For a more detailed account of the strike see Warne, *The Consumer Movement*, pp. 49–91.

32 *Ibid.*, p. 53. The House Committee on Un-American Activities (HUAC) was set up in 1938 to identify 'subversive' organisations, although there had been similar committees which predated it. In 1969 the HUAC was renamed the Internal Security Committee, and it was finally abolished six years later in 1975.

33 Warne, *The Consumer Movement*, pp. 53–4.

34 *Consumer Reports*, Vol. 1, No. 6, October 1936, p. 11–12.

35 Warne, *The Consumer Movement*, p. 78.

36 *Consumer Reports*, Vol. 4, No. 1, January 1939, p. 17.

37 Harold Van Doren, *Industrial Design: a Practical Guide*, New York, 1940, quoted in P. Sparke, *Introduction to Design and Culture in the Twentieth Century*, London, Allen and Unwin, 1986, p. 96.

38 *Consumer Reports*, Vol. 1, No. 3, July 1936, p. 3.

39 Warne, *The Consumer Movement*, p. 121.

40 In addition to the reduced-format *Consumer Reports*, CU also produced a weekly publication called *Bread and Butter*, which did not carry product ratings but rather served to advise consumers on how to economise, how to help maintain effective price controls and thus combat war inflation.

41 *Consumer Reports*, Vol. 9, No. 1, January 1944, p. 17.

42 *Consumer Reports*, Vol. 7, No. 5, May 1942, p. 114.

43 Warne, *The Consumer Movement*, p. 107.

44 This certificate was given to Consumers Union after a hearing before the House Committee on Un-American Activities on 6 February. Effectively, this certificate removed CU from the list of subversive organisations once and for all.

45 For a more detailed account see Warne, *The Consumer Movement*.

46 *Ibid.*, p. 148.

47 *Ibid.*, p. 149.

48 D. Palmer, 'Mechanical and Electrical Goods for the Consumer' in Brainerd, *The Ultimate Consumer*, p. 45.

49 Riesman, 'Autos in America', p. 267.

50 *Consumer Reports*, Vol. 17, No. 5, May 1952, p. 213.

51 *Consumer Reports*, Vol. 17, No. 3, March 1952, p. 142, quoting Ken Purdy, 'I'll Shift For Myself', *Atlantic Monthly*, February 1952.

52 Eliot Noyes was Curator of Industrial Design at MoMA from 1940 to 1946. Between 1941 and 1945 he curated a travelling exhibition which toured schools, museums and art colleges entitled 'The Shapes of Things'. Although no longer a curator at MoMA, his contributions to *Consumer Reports* related very closely to the museum's activities.

53 *Consumer Reports*, Vol. 12, No. 11, November 1947, p. 465.

54 *Consumer Reports*, Vol. 12, No. 6, June 1947, p. 210.

55 R. Banham, 'The Throwaway Aesthetic' (1955) in P. Sparke, ed., *Design By Choice*, Academy Editions, 1981, p. 90.

56 Sparke, *Introduction to Design and Culture in the Twentieth Century*, p. 51.

57 *Consumer Reports*, Vol. 13, No. 7, July 1948, p. 333.

58 'Borax' was a derogatory term coined by the American furniture industry which was used to refer to overly elaborate furniture, or, to quote *Consumer Reports*, furniture 'that looks like more than it really is ... made up with much fancy carving and gingerbread' (*Consumer Reports*, Vol. 14, No. 9, September 1949, p. 423). It

was later used to describe much Detroit-inspired product-styling in America during the 1950s.

59 Sparke, *Introduction to Design and Culture in the Twentieth Century*, p. 69.

60 Riesman, 'Autos in America', p. 267.

61 *Ibid.*

62 Subscriptions to CU increased greatly in the post-war period, rising from 50,000 in 1944 to 500,000 in 1951, and there is much to indicate that these members were as I have described. For example, in 1950 91.3 per cent of *Consumer Reports'* readers owned a car against a national average of around 66 per cent (Consumers Union Archive, Survey Research Division 7L, Box 26, Folder 1–2).

II

REASSESSING THE HISTORY
OF UTILITY DESIGN

6 ✧ The design of Utility vehicles in wartime Britain

Jonathan Bell

T HE DESIGN OF private vehicles in Britain during and after the Second World War is an area which has been overlooked in studies of Utility design and production. By examining proposals relating to Utility motoring in this period, the extent of the British motor industry's acknowledgement of a modern design aesthetic and Utility production is compared with production realities. Additionally, the roles of the designer and engineer are examined in relation to the increased emphasis placed by the government on industrial standardisation, and the Utility Scheme's high-profile promotion of design-led production.

The case-study presented in this chapter is that of a speculative proposal made in 1942 for a 'post-war motor vehicle', or National Motor Vehicle (NMV) of essentially utilitarian design, by the engineer Leslie Houns-field.[1] Although the NMV was never manufactured, Hounsfield's proposal for a radical change in the design and consumption of cars reflected the motor industry's growing awareness of the role played by utilitarian design during the war and represented an example of how rapidly advancing military technology was considered for adaptation to civilian use. Wartime design, or 'emergency design', was praised by some modern designers for its parallels to modern principles. In particular, modernist commentators praised the functionalist appearance of objects designed explicitly for the wartime situation, with the emphasis on practical and efficient solutions.[2]

The NMV, 'an ideal utility vehicle suitable for the occasional requirements of the average citizen whose inclinations do not impel him to spend his spare time controlling a motor vehicle', represented the closest link between the motor industry and the official Utility Scheme during the war, despite the latter's lack of application to the domestic motor industry.[3] It is possible to identify a common origin for the ideas and theories in the NMV proposal and the intentions of the government Utility committees. This common origin is examined both as an ideological standpoint arising from social and political concerns and, through contemporary reactions to the NMV, as an indication of the various divisions within the social structure

of British manufacturing industry, particularly in terms of attitudes to the professional roles of engineers and industrial designers. The NMV provides an informative contrast with Rover's 'Land-Rover', a generic 'utility' vehicle informed by a different set of social and political concerns.

At the outbreak of war in 1939, the British motor industry had a clearly defined two-tier structure; smaller manufacturers, such as the Rover Company, produced specialised vehicles for niche markets in relatively low volumes and existed alongside the so-called 'big five' manufacturers (Morris, Austin, Vauxhall, Ford and Standard). These five companies accounted for the majority of British car manufacture, primarily due to their pre-war capital investment in production equipment. Civilian car manufacture was officially halted in October 1940, and the government initiated a series of increasingly stringent rationing measures upon wartime motorists.[4] Many key manufacturing plants were adapted for wartime production under the government 'shadow factory' scheme.[5]

Wartime austerity led many car manufacturers to speculate that the post-war market would continue to suffer economic hardship and frugality, in addition to rationing. In 1944 the government allocated previously rationed materials to fifty-six companies, including the major motor manu-facturers, so that they could commence research into post-war production. Several motor manufacturers developed designs for small, economical cars. The Rover Company produced plans and prototypes for such a vehicle, the 'M' type, which was specifically aimed at the expected post-war austerity market. The 'M' type was intended to be produced profitably at 20,000 units a year, but the government rejected Rover's application for a sufficient allocation of steel to enable the project to remain financially viable.

The 'post-war motor vehicle' discussed here was therefore proposed

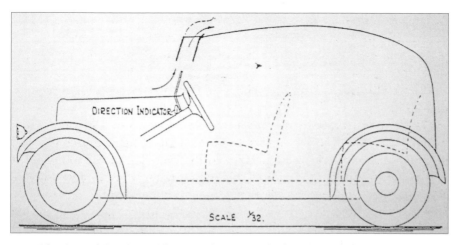

11 Side view of the proposed National Motor Vehicle, 1944

before the government had sanctioned the release of funds and materials for technological development for the post-war market, the needs of which could not be accurately predicted. The NMV was designed from the outset to be a form of personal mass transportation, a method of public transport that was held and maintained in private ownership. The document outlining the proposal is characterised by a detailed explanation of key mechanical aspects of the vehicle, in order that designs of these components could be released from the restraint of patent by their publication. Hounsfield stated that he 'no longer [had] any commercial interest in the industry or in patents relating thereto', and he hoped that the existence of a prototype scheme for the vehicle would encourage further development. Therefore companies which invested in further research would be rewarded with commercially viable patents for the most satisfactory design solution.

Hounsfield proposed that the NMV be built to standardised govern-ment-approved designs, drawing immediate parallels with the official Utility scheme applied to furniture and clothing manufacturers. He stated that 'In

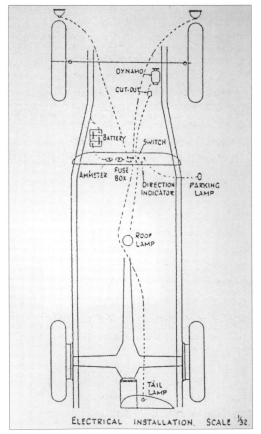

12 Plan of the proposed National Motor Vehicle, demonstrating the simplicity of the equipment, 1944

13 Number plate for the proposed National Motor Vehicle, with mechanical attachments, 1944

order to receive the blessing or approval of the Government, the design would have to comply with a general specification, prepared by, and ultimately approved by, the Ministry of Transport.'[6] Products produced under the auspices of the various Utility committees demonstrated a reductionist approach in terms of quantities and quality of material used, as well as an absence of any applied decoration. This approach was clearly demonstrated in the NMV, regarding which Hounsfield acknowledged that 'the design must be simple, with as few unnecessary accessories as possible, e.g. no road springs, but balloon tyres',[7] if the proposal was to be financially realistic. Hounsfield was also critical of the waste involved in the evolving cycle of manufacturing and scrapping vehicles, an 'extravagance for which succeeding generations may have cause to condemn the present one',[8] indicating the extent to which the wartime situation highlighted problems of material waste that called for responsible design.

The NMV was intended to coexist on the roads with conventional motor vehicles, although it was to be promoted as a vehicle for the 'non-motorist'[9] and 'the enormous number of people who would keep a motor vehicle if the standing charges were not too high for their very limited requirements'. Hounsfield elaborated:

> the man [*sic*] in question is not a motoring enthusiast, takes very little interest in cars and may even dislike driving. Although he may derive little or no pleasure from motoring, he may take very great pleasure in visiting friends or relatives or his little cottage a few miles outside his home town, and a car of any sort would give him this pleasure, which might otherwise be marred by the doubt whether the buses would be too crowded for him to return home. Alternatively he may live in the country and wish to go into town just occasionally to deliver his garden produce or to shop or to take his family to the pictures. Again, he may have a prosperous business which only occasionally requires the collection of heavy goods.[10]

The target consumer described above was termed a 'fairlue', standing for fair value for money, a 'man of moderate means'. Hounsfield explicitly aimed the vehicle at the middle and lower-middle classes, whom he perceived to have demands that were not catered for by public transport. His agenda, although not clearly stated, was superficially a form of idealised socialism; he suggested that subsidised ownership of identically performing cars would reduce the financial cost of motoring and prevent wide distinctions between the classes. In this way Hounsfield intended the NMV to be an 'antidote to communism', stating that

> there are certainly hundreds of thousands [of people] who are denied, not the pleasures of motoring, but the freedom and independence of being able to go a short distance when and where they like with their families and

friends, with luggage or goods, without the limitations concomitant upon the public service vehicles, whether buses or trains.[11]

Hounsfield was convinced that post-war society would be a fairer place, where 'the masses will no longer believe in the old cry that money cannot be found for improvement schemes ... my own opinion is that after this war the whole country will be run very differently'.[12] The NMV broadened the debate regarding utilitarian design to include the motor industry by introducing the concept of the car purely as a means of mass transportation, rather than as a complex piece of machinery that required constant attention and maintenance, either by the 'enthusiast' owner or by the garage. In addition, the proposal contained implicit criticism of previous governments' attitude towards car taxation, by suggesting the implementation of a flat-rate road tax to coincide with the democratic concept of the NMV.[13] In this respect, Hounsfield's NMV can be seen primarily as an attempt by an independent industry at odds with officialdom to propose the preferred type of post-war government legislation that would favour motor-vehicle production.

In terms of aesthetics, it was suggested that the NMV's appearance 'should be as normal as possible', in order that it be removed from the myriad of styling trends that had permeated the market before the war. The body design proposed stylistic features derived from both commercial and private vehicles, built from standardised and recyclable components. The NMV was not innovative in terms of new manufacturing techniques or physical appearance, although a contemporary suggestion was made to use plastics for the body panels. The body design resembled a simplified pre-war vehicle, with a typical 'ladder-frame' chassis upon which the body was mounted in separate sections. Simplification resulted in the removal of 'non-essential' components, such as spring suspension, with a variable interior configuration enabled by removable seats, making the car suitable for either domestic or light commercial use. The NMV's design made no concessions to contemporary fashion, notably streamlining, which covered exposed wheel-arches with extensive bodywork mounted on a welded steel frame, or monocoque, chassis. Streamlining was widely criticised among British engineers, perhaps because of its association with the increased role of the designer and the salesman within the motor industry, and engineers' perception of the diminishing role of their profession. This is typified in the comment by a noted engineer in 1943: 'The average American design has a vulgarity of line that should not be copied.'[14]

The NMV relied on the consumer's willingness to accept new conditions of use for an existing commodity. Hounsfield stressed that 'the essence of [the NMV] is that it should be sponsored by the Government',[15] funded

with a 'pay as you go' system of collecting revenue and insurance. This was achieved with a device called a 'revenue recorder', which recorded and displayed the weekly mileage and charged the driver accordingly with a 'shilling in the slot'. If the motorist desired, it was possible to pay in advance along the same principle as a gas-meter. For the scheme to represent an attractive economy, a potential motorist would not be expected to cover more than 40 miles a week. The other key restriction was the presence of a visible and audible speed-limiter, 'a definite deterrent against exceeding a speed of 35 mph on the level and less downhill'.[16] Although the justification for limitation was the danger of excess speed and in order to improve the economy, safety and durability of the NMV, the authoritarian overtones overshadowed the otherwise democratic intentions of the proposal. Critics observed that limitation and the accompanying legislation would effectively create a two-tier system of car-ownership, highlighting the class divide rather than promoting equality in private transport.

The NMV proposal depended on the government ceasing to perceive the motor car as primarily a source of taxation revenue, notably with the Horsepower Tax.[17] Nevertheless, there was strong criticism from the car industry regarding the extent to which the NMV owner would be controlled by the government through these stringent new regulations. Members of the Institution of Automobile Engineers (IAE) were suspicious of the need to increase official intervention in car production and consumption:

> We have in the past suffered much from Government interference. Taxes have been altered and played about with and all the time increased, and if we have a scheme of this sort we shall find that the Government interference will be absolutely prohibitive.[18]

Hounsfield predicted that consumers would accept the legislation necessary to operate the NMV scheme as part of the need for continued austerity measures in the immediate post-war era. However, there was opposition on the grounds that the various legal and mechanical restrictions would 'prevent [the NMV] from being the National Utility Motor Vehicle',[19] indicating that although the industry recognised the potential of utilitarian vehicle design, it wished to proceed on its own terms, unhindered by the Treasury or the Ministry of Transport. However, at that stage some kind of collaboration with the government Utility scheme was still feasible: 'The scheme submitted by the Author appears to be a logical development of the Government scheme of marketing utility items such as furniture and clothing, applied to motor cars, and as such it is worthy of serious consideration.'[20] The NMV can also be read as an attempt to transfer the government's source of taxation revenue from the industry to the consumer, through closer government co-operation at the design and production stage.

This approach was considered virtually heretical by many automobile engineers and contrary to their understanding of the role of engineering. Surely, it was asked, 'the fundamental design of a "people's car" is more important than scheming a means of taxing and restricting the owner?'[21]

During the 1930s many European car-designers highlighted the potential of a low-maintenance, mass-produced 'people's car', often involving state funding. The Citroën 2CV, for example, was a functional vehicle designed principally for France's large rural farming population. The Italian Fiat 500 was a small family car, developed with financial assistance from Mussolini's government. The NMV represents the start of a debate about the social, political and commercial benefits of such a vehicle in Britain. In the event, the NMV proposal was not representative of the direction taken by the British motor industry immediately after the war, due to limited material availability and restricted markets.[22] The NMV would not have complied with the strict quota systems imposed by the government upon the home market, and the vehicle would have found little favour in export markets, as it was designed for the high-quality, well-maintained British road system.[23] Other so-called 'people's cars', the 2CV, the Fiat 500 and the German Volkswagen, were also initially designed for local conditions.

Although Hounsfield made no mention of the Volkswagen, the 'strength through joy' car of the Nazi state was described by one engineer as a 'very useful and interesting vehicle' in the debate on the NMV. However, the VW's association with the Nazi regime discouraged British engineers from praising the vehicle, and it was stressed by critics that if 'one of these days we shall all be asked to contribute "five marks" a week for a people's motor-car ... [it] would be a rather dangerous thing to encourage'.[24] The VW was a progressive design appropriated and marketed by a fascist regime as a means of indicating 'democratic' intentions and industrial power to the world. Originally intended to provide low-cost family motoring, the VW was also designed to endure high-speed long-distance autobahn journeys. Design was integral to the VW, as Heskett noted in 1991:

> design values were extensively used by the Nazi regime for the furtherance of their policies, and for ideological justification and propaganda ... the subordination of design to political ends makes the need to consider the context in which designs are produced and used nowhere more relevant than in the realm of government intervention.[25]

The weekly five-mark financing of the VW had similar implications to the NMV's 'pay by the mile' revenue recorder. Wartime aversion to the vehicle's role as propaganda and enemy military equipment initially blinded British manufacturers to the VW's potential, as Hopfinger's account describes:

> On the whole British Industry, having tested during the war various captured Volkswagens, did not think at all favourably of the vehicle. Some manufacturers considered the Volkswagen as a vehicle which fell short of the basic technical requirements of a car ... Entirely different conclusions about the Volkswagen were recorded by British Army officers, who considered the military version of the Volkswagen an outstanding vehicle for the purpose for which it was intended, coupled with the fact that any maintenance or repairs necessary for the upkeep of the vehicle could be carried out with a minimum of tools and equipment.[26]

The increasing amount of research conducted into the development of new vehicles for military usage in relatively short time-frames made the automotive engineer aware that integration of the functionalism evident in specialist military equipment with a civilian specification could provide a commercially viable, low-maintenance 'Utility'-type car. However, this integration was not fully realised in the NMV proposal. An example of a utility vehicle designed explicitly for the wartime situation was the American 'Willy's Jeep'.[27] The Jeep's high levels of standardisation, together with its simplified, robust construction, were essential for the efficient manufacture and maintenance of military vehicles in a global conflict.

Despite the NMV's simplicity and pragmatic use of existing technology, the importance of the Jeep was barely acknowledged. The NMV had more in common with the wartime spirit of 'make do and mend' that pervaded among the goods-starved population than with military design. Industrial designers not only welcomed Utility, but also approved of the 'emergency design' of wartime necessity and improvisation, exemplified in specialist military equipment, as examples of the basic tenets of functionalist design. Writing in the *Architectural Review* in 1941, Norbert Dutton stated:

> Emergency design must be rigorously functional and in its meaning self-evident. Moreover, as it is leisureless design, frills are out of the question. Now these specific characteristics of emergency design – fitness for purpose, directness of expression, distrust of applied ornament – happen to coincide with the fundamental characteristics of the best contemporary architecture and design. The war and its sudden imperative needs afford thus an opportunity of the first order to the clear-headed and the determined – not only in strategy and diplomacy, but also in design.[28]

The political and theoretical ideology behind Modernism, exemplified in pre-war modernist architecture and furniture design, perceived as alien and expensive, had failed to capture the popular imagination in Britain.[29] Public acceptance of Modernism was therefore unlikely to be advanced by the mental association of functionalist design with times of national strife and hardship. In many respects, the official Utility Scheme was resented for

precisely these reasons, as well as for the sudden disappearance of choice. Utility goods were perceived as plain and unattractive,[30] although the scheme broadened in range and style after the war.

Rather than debate the validity of a utilitarian or even 'Utility' approach to post-war production, motor manufacturers concentrated on how to expand into new global markets. The primary concern was to lobby for the removal of restrictive taxation in order to encourage development of larger vehicles, better suited to the American and Australian markets. British automotive engineers were wary of the industry emulating the American model, where industrial designers dominated the large companies, placing what was seen as undue emphasis on styling and fashion:

> Is it in the best interests of the British Motor Industry that its individuality of design is retained as a characteristic, or is its overseas market likely to be increased and the home market improved by following American trends in design? [31]

The acknowledgement of 'utilitarian' design in the British motor industry in the 1940s was also informed by the separate definitions of utilitarian design held by the industrial design and engineering professions. Industrial designers, schooled in the ideology and aesthetic of Modernism, rejected the idea that utilitarian design could be produced by engineers, without any form of artistic training.[32] Automotive engineers were accused of belonging to an industry that had been slow in recognising the benefits of American mass-production methods and lacked 'sympathy' towards the aims of the industrial design profession. In addition, industrial design was not yet established as a profession in 1940s Britain, and engineers foresaw their own work threatened by the motor industry's adoption of the American example.

In the case when an engineering solution exhibited a sound 'under-standing' of the principles of so-called 'Good Design', as in the case of the Aga oven, *Design* magazine described it as a fluke: 'The plain truth is, of course, that [the Aga] is the work of that extremely rare and most valuable bird, the engineer who is also a sensitive artist.'[33] Even though by 1946 an engineer was willing to acknowledge that 'the appearance of a car is of primary importance. Good taste adds value without adding cost',[34] the IAE equated design with superficiality and frivolity, warning:

> The stressing of the importance of external appearance beyond almost everything else, the acceptance of that insistence and the mechanical limi-tation it imposed, and the willingness of the buying public to be guided by fashion and by unsound technical appeals jointly tended to lower the status of the designing engineer to the rank of draughtsman.[35]

The perceived domination of appearance over engineering qualities was

interpreted by the overwhelmingly male engineering profession as intended to appeal to the female consumer, perceived as being less concerned with practical qualities and easily swayed by fashion:

> So far had the cult of the non-essential gone that it is credibly stated that certain motor-cars were 'designed' by artists with an eye to feminine demand and fashion and that thereafter the engineer had to install the essential components of the chassis to fit the creation. The engineer is worthy of something better than this.[36]

A 1943 paper on the social responsibility of the automobile engineer demonstrated that the engineering profession considered itself as having a pivotal social role, which transcended the superficially aesthetic and commercial approach of the industrial designer. This was highlighted by the profession's suggestion that the NMV might become, with some modifications, the 'national Utility motor vehicle'. The engineer would:

> develop the road vehicle wisely and not merely as a commodity to be sold; to help in an escape from that vicious system of building the ephemeral; to check wanton wastage of raw material; and to restore the craftsman his self respect.[37]

Industrial designers and engineers were striving to meet common aims, even sharing the same chauvinist prejudices. In the context of the Utility Scheme, a common definition of *utility* in design terms was absent from all debates. For the industrial designer, utilitarian design resulted from the creation of products that consisted of artistic compositions of geometric forms, devoid of 'frivolous' applied ornament, to imply a functional, machined quality. In contrast, the automotive engineer considered that excessive concentration on vehicle 'styling' detracted from the sound application of engineering principles and possibly disguised unsound technical qualities. Functionalism did not have to be implied through aesthetics; it was considered inherent to the engineering process. However, despite assumptions to the contrary, both engineers and industrial designers were reluctant to acknowledge commercial pressures, leaving little common ground upon which to work together.

The NMV proposal fell between the aims of the two professions. It proposed high levels of state intervention and low engineering input, contrary to the engineering profession's stated desire to retain political independence. Yet, paradoxically, it was also 'anti-design' in that it was available in only one basic form and was therefore a self-conscious rejection of consumer choice. Ironically, this 'functionalism', arising from the need to reduce costs in the interests of practicality, confirmed the prejudices of the design profession, which distrusted engineering interference in the

surface appearance of consumer goods. Yet modernist designers in the field of architecture had suggested that the functional nature of objects produced for wartime conditions exemplified the basic aesthetics of modern design. This was highlighted by the optimism with which designers greeted the Utility Scheme and 'emergency designs' produced for furniture, seen principally as a means of establishing 'good taste' and modernist standards through limited consumer choice.[38]

The NMV could be perceived as utilitarian in that it was essentially functional, but it was arguably not a modern 'design', as it was a throwback to pre-war vehicles, using available technology and placing function before aesthetics. The NMV proposal was not concerned with the motor vehicle as a source of pleasure and convenience, nor as an object which could be appreciated for its function or efficiency. The NMV was conceived as a product which rejected the autonomy of the consumer, making the role of the industrial designer redundant.

Post-war legislation altered wartime production plans,[39] and it was not until limited production had resumed, straight-jacketed by legislation and material restrictions, that a utilitarian private vehicle was produced.[40] Post-war conditions enabled manufacturers and designers to explore areas of design which previously had been neglected. In 1948 the Rover Company

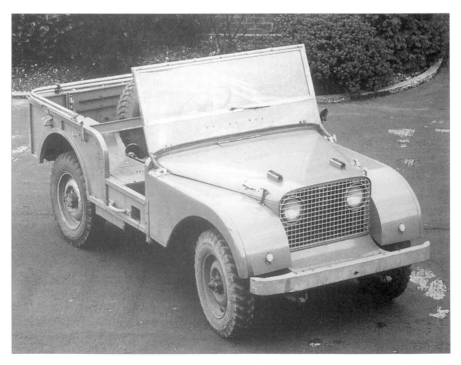

14 Original Land-Rover protoype, 1947

introduced the Land-Rover, a utility vehicle derived from the wartime Jeep and aimed principally at generating agricultural sales in export markets. The government was adamant about the need to increase car production for export in order to reduce the 'dollar gap', and ministers even speculated as to the type of vehicle best suited to this task:

> We must provide a cheap, good-looking car of decent size – not the sort we have hitherto produced for the smooth roads and short journeys of this country – and we must produce them in sufficient quantities to get the benefits of mass production ... We cannot succeed in getting the volume of export we must have if we dispense our efforts over numerous types and makes.[41]

The Land-Rover combined wartime 'emergency design' with pressing commercial concerns to produce a vehicle which exhibited 'fitness for purpose'. Rover realised that there was a potential agricultural and industrial market for a vehicle similar to the Jeep, and accordingly based their prototype on

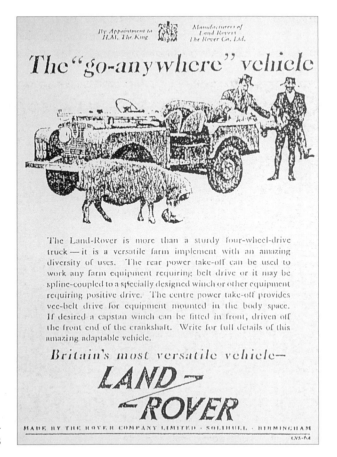

By Appointment to H.M. The King
Manufacturers of Land Rovers
The Rover Co. Ltd.

The "go-anywhere" vehicle

The Land-Rover is more than a sturdy four-wheel-drive truck — it is a versatile farm implement with an amazing diversity of uses. The rear power take-off can be used to work any farm equipment requiring belt drive or it may be spline-coupled to a specially designed winch or other equipment requiring positive drive. The centre power take-off provides vee-belt drive for equipment mounted in the body space. If desired a capstan winch can be fitted in front, driven off the front end of the crankshaft. Write for full details of this amazing adaptable vehicle.

Britain's most versatile vehicle—

LAND-ROVER

MADE BY THE ROVER COMPANY LIMITED · SOLIHULL · BIRMINGHAM
LNS-64

15 Land-Rover advertisement, 1948

a Jeep chassis with many standard Jeep components. The global market for agricultural machinery had grown considerably due to the spread of mechanisation during the war, and Rover intended to exploit this market with the Land-Rover, allowing the company to meet export quotas while their traditional domestic market was affected by the post-war economic situation and material rationing.

The Land-Rover represented a continuation of the pragmatic design tradition practised by Rover before the war. The rise of the 'big five' manufacturers together with mechanised production methods had led Rover to specialise in well-engineered and relatively expensive saloon cars for the middle-class buyer. The company concentrated its efforts on the incremental improvement of rigorously tested designs, rejecting the annual or bi-annual model change, while retaining many hand-based manufacturing processes.[42]

The simplicity of the Land-Rover's construction resulted in high levels of adaptability and practicality, which ensured the vehicle's commercial success in its target markets.[43] The vehicle's shape was derived from the properties of the materials available and the construction methods used, defining the Land-Rover as a modern design, with form following function. By reducing body-panels to a minimum the vehicle had a simple, geometric quality. The chassis was made by hand-welding flat sheet steel together to make long box sections, a method first suggested for Rover's wartime 'M' type proposal, which was cheaper, less wasteful and stronger than a conventional car chassis. By minimising steel usage on the Land-Rover chassis, Rover was able to use more sheet steel for conventional saloon car production, circumventing the material quotas which would otherwise have heavily restricted the company's output.[44]

The decision to retain numerous hand-operated processes is indicative not only of the perilous state of post-war manufacturing industry, but also of the high levels of adaptability and skills available to Rover because of its relatively small output and emphasis on engineering and traditional methods. Paradoxically, the extensive use of manual processes, anathema to the advocates of mass production, resulted in the vehicle's adaptable, simple appearance, and facilitated production during a period of material and labour shortage with minimum disruption.

The aluminium bodywork was less prone to corrosion than steel and was in ready supply because of wartime stockpiling. Aluminium offered the advantage of being easily manipulated to form the bodywork, eliminating the need for expensive investment in machinery, a saving which offset its high cost (three times the price of steel). The slab-sided appearance of the vehicle required minimum panel-beating, and could be largely made up in a hand-operated press.

Because the Land-Rover was classified as a commercial vehicle it was

exempt from high taxation, and enabled Rover to receive a higher material quota from the Ministry of Supply. In contrast with the VW and NMV proposal, the origins of the Land-Rover cannot be entirely attributed to state support and intervention, although it was the restrictive and limiting official controls on material supply and export quotas which played a key part in its development, combined with Rover's engineering ability applied to tested military automotive technology developed during the war. The engineering-based approach of the company defined the 'utilitarian' nature of the vehicle, rather than a consumer-led stylistic approach.

In the absence of an immediate post-war British equivalent to the VW in conventional vehicle design it initially appears that utility and Utility motoring as a politically motivated concept existed only as a discussion in Britain, principally through the NMV proposal. The wartime debate originated not among modernist designers, but among engineers, whose reluctance to increase official involvement in the motor industry was cited as a reason for the NMV scheme's lack of viability, despite an acknowledged relationship to the existing Utility Scheme. Moreover, the NMV was far removed from the political concerns of engineers or industrial designers as an ideological anomaly located in the shadow of the austerity period. The NMV is an indication of the complex nature of attitudes to production and the consumer within the British motor industry during this period, and illustrates the debates surrounding utility and modernism, as well as engineers' professional concerns in the face of emergent industrial and commercial pressures. It was a combination of commercial and political pressures of a different kind that led to the introduction of the Land-Rover, the epitome of a utility-type vehicle and solely the work of the engineering profession, unconcerned with the aesthetics of Modernism:

> If the world has to be strictly economical for years to come, is [the Land-Rover] not the sort of car that most of us need? Washing is reduced to a minimum, and maintenance is easy: there is no carrying about of weight more or less uselessly devoted to fashionable appearance and not really essential luxury.[45]

Notes

1 Leslie H. Hounsfield, 'A Post-War Motor Vehicle' (July 1942), *Proceedings of the Institution of Automobile Engineers* (IAE), Vol. 36, 1941–42, p. 255.

2 'The street lamp in the blackout if it is too light attracts bombers, if too dark causes street accidents. The stretcher if badly designed can be fatal to a fractured spine case. The shelter if illegibly marked remains unused during air raids', N. Dutton, 'Emergency Design', *Architectural Review*, Vol. 90, 1941, p. 169.

3 The existence of Utility vehicles for use in public transport has been well documented

by historians. From 1941 the Ministry of Supply and the Ministry of War Transport began work to 'produce serviceable buses at minimum cost in terms of material or skilled labour ... Standardisation was obviously desirable and operators were under pressure to accept a common specification' (A. Townsin, *The Best of British Buses*, No. 8: *The Utilities*, The Transport Publishing Company, 1983, p. 19). Utility buses were produced from 1941 to 1946 by several companies. Rationing and shortages meant that many of the vehicles were still in service in the 1950s.

4 At the start of the war the government imposed a purchase tax of 33.3 per cent on all goods, including motor cars. Petrol rationing was introduced and continued until 1953. The mileage allowance was gradually reduced until only essential journeys were permitted. In August 1939 there were 2 million vehicles on British roads, a total which had fallen to 700,000 by 1943 (William Plowden, *The Motor Car and Politics*, The Bodley Head, 1971, p. 302).

5 The shadow factory scheme was an official initiative to increase wartime productivity levels. Existing heavy industry was state-financed in order to improve manufacturing facilities and increase arms production as a response to widespread European rearmament in the 1930s.

6 Hounsfield, 'A Post-War Motor Vehicle', p. 260.

7 *Ibid.*, p. 262.

8 *Ibid.*, p. 257.

9 'As this car is being described before an audience of enthusiastic motorists, they will all probably agree that they would not like to be found dead in it' (*Ibid.*, p. 260).

10 *Ibid.*, p. 258.

11 *Ibid.*, p. 273. Hounsfield continued: 'There are three main antidotes to discontent and communism: (a) the possession of one's own home, (b) the security of a congenial occupation, (c) the freedom to come and go when and where one wishes. All these conditions need the most serious consideration of the government.'

12 *Ibid.*, p. 280.

13 The motor industry was considerably disheartened by the government's continued adherence to the Horsepower Tax, whereby the amount of duty levied was linked to engine size. This tax had helped shape the pre-war market by discouraging the development by British manufacturers of cars with larger engines, which were common in America. Manufacturers worried that the retention of this tax after the war would mean a calamitous collapse of the large vehicle market, already weakened by rationing. The Horsepower Tax was replaced with the Road Tax in 1947.

14 Debate: 'The Best Interests of the British Motor Industry', *The Motor Trader*, 14 July 1943, p. 415. Engineering distaste for American styling was widespread: 'The neater the outline of a [car] body the less the need for relief by useless chromium decorations' (George Roesch, Chief Engineer of David Brown Tractors Ltd), 'Post-war Automobile Design', *Proceedings of the IAE*, Vol 36, 1941–42, p. 163. Criticism also came from the British design profession, saying that American motor manufacturers 'pin their sales on bodies as bulbous and billowing as the crinolines Victorian dressmakers hung round women's hips' (P. Morton Shand, 'From the 1951 Stock List', *Design*, No. 7, July 1949, p. 2).

15 Hounsfield, 'A Post-War Motor Vehicle', p. 255.

16 If these speeds were exceeded, the limiter would draw attention to the driver's

misdemeanour by sounding a buzzer and flashing an external light. These would remain activated until a fine was paid. The insurmountable problems of policing such a deterrent were a key objection cited by critics of the NMV (*Ibid.*, pp. 261–2).

17 'A small car may cost anything from £35 to £150, depending on its condition, and with rates of interest on investments varying between 3% and 6%, the cost of a car represents an annual reduction in income between £1 and £9, neither very serious. Tax and insurance, however, will cost around £20 per annum, and depreciation will vary from £10 to £40 on the above prices' (*Ibid.*, p. 256).

18 J.B. Perrett, Debate on 'A Post-War Motor Vehicle', *Proceedings of the IAE*, Vol. 36, 1941–42, p. 377.

19 J.R. Rix, Debate on 'A Post-War Motor Vehicle', p. 388.

20 W.V. Appleby (Austin designer), Debate on 'A Post-War Motor Vehicle', p. 390.

21 A.L. Hobbs (Austin designer), Debate on 'A Post-War Motor Vehicle', p. 390. The debate was conducted in both the south and the north of England. There was considerably more opposition to the proposals in the northern debate, which took place at the Birmingham Centre (Austin Works Group).

22 Speculative proposals were still debated. In 1946 the 'Everyman's' car was proposed, a standardised design that would be sold all over the world and banish the oft-repeated criticism that British cars were too under-powered and small for overseas markets (see John Prioleau, 'An Everyman's Car for Home and Overseas', *Observer*, 23 June 1946, p. 7).

23 'British cars are primarily designed for use in a temperate climate, at low altitudes, and on winding roads of excessively smooth surface [and] such designs … must of necessity be unsuitable for use in many parts of the world' (R.A. Stavert, 'Some Factors Influencing Design for Export', *Proceedings of the IAE*, Vol. 50, April 1946, p. 191).

24 Perrett, Debate on 'A Post-War Motor Vehicle', p. 379. Such a quote can be seen primarily to distance the author from condoning the unsavoury aspects of the VW scheme. Once the war was over the VW factory was placed under British army control and the production lines restored. In September 1949 control of the factory was restored to West Germany, by which time VWs were on the German market. This was followed by a well-documented period of global export and massive expansion for the company.

25 J. Heskett, *Industrial Design*, Thames and Hudson, 1991, p. 193.

26 K.B. Hopfinger, *The Volkswagen Story*, Foulis, 1971, p. 148.

27 The Jeep was the product of US government-funded research by civilian manufacturing organisations (although two military personnel, Captain Howie and Colonel Herrington, acted as consultants). The requirement for a lightweight all-terrain vehicle using standardised parts resulted in a military vehicle which proved invaluable to the allies' war effort (General Eisenhower described the Jeep as one of the four instruments which enabled allied victory). Some 660,000 Jeeps were manufactured during the Second World War by various companies around the world, including several in Britain. Consequently, several Jeep derivatives were produced by British companies after the war, including the 1947 Morris 'Gutty', designed by Alec Issigonis (who would later lead the Morris Minor and Mini projects), the Wolseley 'Mudlark' and the Austin 'Champ'.

28 N. Dutton, 'Emergency Design', *Architectural Review*, Vol. 40, December 1941, p. 157. The magazine also noted that 'it has been encouraging to notice that quite a number

of good standard designs, produced anonymously and without any aesthetic self-consciousness, have grown out of wartime needs' ('Anonymous Design in Wartime', *Architectural Review*, November 1941, p. 149).

29 'As an Englishman I detest the German invasion of architecture and other things, which is now taking place in my native land' (Oliver Bernard, *Building*, December 1936).

30 'Good, solid and sensible … that's just what the public doesn't like' (a source in the furniture trade, quoted in response to the 1942 Board of Trade exhibition of prototype Utility furniture; *CC41: Utility Furniture and Fashion: 1941–1951*, Geffrye Museum and ILEA, 1974).

31 Debate in the *Motor Trader*, 14 July 1943.

32 'Background in engineering training colleges and in the drawing offices of individual firms is, let us admit, usually abominably ugly' (editorial: 'The Engineer–artist and the Industrial Designer', *Design*, No. 27, March 1951); 'Nothing is so painful as an engineer trying to be artistic', professed John Gloag, a leading modernist commentator, in *Industrial Art Explained*, quoted in a letter from R.M. Mackay, an 'appearance design engineer', *Design*, No. 90, June 1956, p. 51. Sympathetic engineers could also be heard to lament that 'the average young engineer receives little or no artistic training' (H.G. Conway, 'An Engineer looks at Industrial Design', *Design*, No. 27, March 1951).

33 Editorial: 'The Engineer–artist and the Industrial Designer', *Design*, No. 27, March 1951.

34 Roesch, 'Post-War Automobile Design', p. 163.

35 D.H. Smith, 'The Social and Economic Responsibility of the Automobile Engineer', *Proceedings of the IAE*, Vol. 36, May 1943, p. 196.

36 *Ibid.*

37 *Ibid.*

38 As Gordon Russell noted, 'Wartime conditions had given a unique opportunity of making an advance [in Modernism]' (F. MacCarthy, *A History of British Design 1830–1970*, p. 69).

39 It was accepted by many that post-war developments would initially be slow: '[After the war] for at least one year, probably two and possibly even three, the cars offered to the public will be of the pre-war type, largely due to the great difficulty there will be in getting going again on motor-car production, and the call we expect from the public [will be] for a car of any type' (J.S. Irving, Debate on 'Post-War Automobile Design', p. 333). Other commentators expressed optimism that 'the end of the conflict will provide the opportunity for using the knowledge in the shape of improved materials, the greatly increased and improved manufacturing facilities available and of so many cars having of necessity to run for long periods without adequate servicing and repair facilities' (Roesch, 'Post-War Automobile Design', p. 157).

40 Towards the end of the war the government suggested that perhaps 30 per cent of renewed vehicle production should be exported, to the consternation of the industry. In 1945 Sir Stafford Cripps had announced that this figure would be 50 per cent, revising the percentage to 60 per cent in 1946. Car manufacturers complained that this high level of export would prevent them from securing the high unit sales in the home market that would allow for low unit costs to aid overseas sales.

41 Sir Stafford Cripps, text of speech in the Cripps papers, Nuffield College, Oxford, quoted in Plowden, *The Motor Car and Politics 1896–1970*, p. 314.

42 Rover had also participated in the Shadow Factory Scheme, under which new factories were built at Acocks Green, Birmingham and Lode Lane in Solihull. The principal Rover factory in Coventry was destroyed by enemy action in 1944, and post-war production was relocated to Solihull, where Hercules radial engines were produced during the war, as well as pioneering research into the Whittle jet engine. Rover's invitation on to the scheme was an indication of official recognition of the company's technical ability, as it was a good deal smaller than the majority of other companies involved.

43 Projected sales of 5,000 units for 1949, the first full year of production, were exceeded by 3,000. By 1950 sales had doubled to 16,000 units, and by 1951 the Land-Rover outsold all other Rover vehicles by two to one.

44 The story of the Land-Rover has been told in several books, notably K. and S. Slavin, *Land-Rover, the Unbeatable 4 x 4*, Hayes, 1989 and James Taylor, *Land-Rover – Series I, II, III and V8*, Windrow and Greene, 1993.

45 *The Autocar*, 30 April 1948.

7 ✧ Utility furniture and the myth of Utility 1943–48

Matthew Denney

T HE HISTORY of Utility furniture and the furniture designs that were supplied under the scheme have been represented in many different ways by various authors since the scheme was introduced by the Board of Trade in 1943. This chapter will consider the factors which led to the introduction of Utility furniture and the designs of the furniture that were included in the scheme between 1943 and 1948. It will be shown that, contrary to some published opinions, the designs for Utility furniture were not the result of any one particular design ideology, but of a complex scheme of rationing, attempting to meet an ever-changing economic and supply problem.

The period between 1943 and 1948 represents a unique moment in English furniture history when the government took complete control of the furniture industry. Only a limited number of authorised firms could obtain timber for furniture production, and of those, each firm was authorised to manufacture a small range of furniture types, the designs for which were clearly laid down by the Board of Trade. For the potential purchaser of furniture, supply was strictly rationed between February 1943 and June 1948. Furniture could only be purchased by those in possession of 'units' issued by the government. Initially units were only available to newly-weds setting up home for the first time, or to those replacing essential furniture damaged by bombing. Towards the end of 1944 rationing was expanded to include expectant mothers and families requiring furniture for growing children.

The experience of severe shortages during the First World War had prompted the Government to prepare for the inevitable supply problems in advance, and it was therefore ready with the legislation to take control of timber prior to the declaration of war. The Ministry of Supply intervened in the furniture industry within days of war being declared by introducing strict controls of all timber supplies.[1] To prevent exploitation of the public, price control was enforced through the Central Price Regulation Committee. Intervention in the furniture industry was introduced with the control of

prices for both new and second-hand furniture from 10 June 1940.[2] Because of the highly diverse nature of the furniture industry, the government found that the control of furniture was difficult to achieve. It was forced to take responsibility for the supply of furniture to those whose need was considered urgent. 'Bombees', as they became known, were the major catalyst for an increase in urgent demand when the London blitz began in September 1940.

From December 1940 only very limited supplies of timber were made available for domestic furniture production.[3] In an attempt to continue to supply those in need, the government introduced Standard Emergency Furniture in February 1941.[4] The furniture for this precursor of the Utility Scheme proper was produced under government contract and was administered by the Ministry of Health, which was responsible for bombees. It was intended that this furniture would be loaned to claimants who could then either return the furniture or purchase it at a reasonable price.

A further attempt to control production was made by the Ministry of Supply in November 1941. The Ministry would only allow the supply of timber to firms who were making furniture which conformed to a Ministry of Supply list of items. This list included twenty-two items of furniture, the only limitation on the manufacturer being the quantity of timber allowed for each item: for example, a 3 foot wardrobe was allowed to include 1.614 cubic feet of wood or material resembling wood and 83.45 square feet of ⅛ inch thick plywood or material resembling plywood.[5]

Prior to the production of Standard Emergency Furniture the Assistance Board had been responsible for allocating compensation to those who had lost furniture because of enemy action. But claims for compensation only fuelled the demand for furniture from a trade that was finding it increasingly difficult to obtain timber. The problem of supplying essential goods at a reasonable price is clearly illustrated by an item that appeared in the *Manchester Daily Despatch* of 15 October 1941, which reported:

> Councillor J.D.L. Nicholson quoted the case of a person who, receiving £45 from the Assistance Board for replacements, found the amount inadequate when she had to pay £18 for a bedstead and things like that, sooner or later some Government steps will have to be taken, because it is amounting to racketeering.[6]

The Board of Trade became involved with consumer needs and supply through necessity. As late as November 1940 the President of the Board of Trade was still hoping that with the co-operation of all those concerned in distribution it would be possible to avoid the rationing of consumer goods.[7] However, the increasingly difficult receding supply situation, causing inflation and a certain amount of exploitation of the public by some

sectors of the furniture trade, forced the Board of Trade to intervene. The initial involvement of so many government departments trying to control the supply of furniture had only confused the situation. A major concern in transferring responsibility to one department was to ensure that domestic furniture should remain available to those in genuine need throughout the war.

By April 1942 the Ministry of Supply warned the Board of Trade that it could no longer guarantee the supply of timber for any domestic furniture production.[8] This was not acceptable to the government, and there were questions in the House of Commons on 5 May 1942, including Watkins's question: 'Are any arrangements afoot by which good substantial furniture at a reasonable price will be provided for the public under Government control?'[9]

In reply Hugh Dalton confirmed that Utility schemes were being considered for a number of different articles, but that furniture was not yet one of these. However, it was not long before plans for a Utility Furniture Scheme were under way, although it took some time for it to take shape and the announcement of its introduction was finally made at a press conference on 3 July 1942.[10] The introduction of the scheme was to be overseen by a Utility Furniture Advisory Committee, which met for the first time on 14 July 1942 under the chairmanship of Charles Tennyson, to 'produce specifications for furniture of good sound construction in simple but agreeable designs for sale at reasonable prices and ensuring the maximum economy of raw materials and labour.'[11] The designs selected by the Advisory Committee for the first range of furniture from drawings submitted by a number of different designers were those of two trade designers from High Wycombe, Edwin Clinch of Goodearl Brothers and Herbert Cutler, who at that time was deputy head of the Wycombe Technical Institute. The chosen designs were for ten standard items comprising two bedroom suites, two dining-room sets and two easy chairs. Although additions were made to the first batch of Utility designs during the various stages of the Utility Furniture Scheme, the originals remained unchanged throughout the duration of the Scheme.

From November 1942 it was decreed that all non-Utility furniture was to be completed by the end of the year and sold by the end of February 1943.[12] All manufacturers had to register with the Board of Trade, abide by its legislation, and all Utility furniture was to be marked as such. With this action the Board of Trade had taken complete control of furniture production and brought all non-Utility production to an end.

The first range of Utility furniture, introduced at the beginning of 1943,[13] consisted of 22 items available in a number of different finishes, bringing the total available choice to 66 items, including five different

designs of oak dining-chairs, costing between £1 3s and £1 10s, each requiring a single furniture unit.

The regulations governing the Utility Furniture Scheme underwent constant changes. When materials became available the schedules of furniture would be increased, and as demand and supply varied, the number of units made available to qualifying purchasers by the Board of Trade were adjusted accordingly. The first changes to the furniture schedules were made as early as March 1943, when a new 'cot (with mesh) model No. 1A' was added.[14] This small alteration was the first of very many changes made to the schedules of furniture between 1943 and 1948. The most important change to the schedules took place after the end of the war in September 1946, when a further 112 items of furniture were added, bringing the total number of different items available to 266.[15]

As the supply and demand situation began to stabilise after the war, the government was eager to relax the Utility Scheme as soon as possible. The rationing of furniture was brought to an end in June 1948, and in November of the same year the 'Freedom of Design' legislation was introduced.[16] The Utility Scheme was finally abolished in 1952, by which time the scheme had become more one of tax control than of design enforcement.

The history of the Utility designs that were first produced in 1943 needs to be reassessed in the light of the myth which has built up around the Utility Scheme through the ways in which it has been represented. As Judy Attfield has written, 'most accounts of the history of design which deal with the Utility scheme (1942–1952) present it in a heroic light from the Good Design establishment's point of view.'[17] The majority of general furniture histories tend to deal very briefly with the Second World War and the Reconstruction period. This is perhaps not surprising, as there was so little decorative design produced then. Many of the texts are more concerned with issues of style rather than design history, and therefore ignore the Utility scheme, like the trade designers who didn't consider the Utility designs to be 'design'. When it is mentioned in books on the history of the decorative arts, it is usually fitted in between the 'Art Deco' of the inter-war period and the 'contemporary' of the Festival of Britain and dealt with summarily in a few paragraphs or relegated to a footnote.

Much of the literature which considers Utility furniture in more detail characterises it in an over-simplified manner, concentrating on the period from 1943 to 1946 before the Freedom of Design and overemphasising the role of Gordon Russell.[18] Gordon Russell was a member of Charles Tennyson's wartime Utility Furniture Advisory and Furniture Production Committees and Chairman of the Board of Trade's Design Panel from 1943 until 1947, when he became Director of the Council of Industrial Design. However, although he was a prime mover in promoting design

reform through the Utility Scheme, to give the impression, as some of the literature does, that he was wholly responsible for the form the Utility furniture designs took, is inaccurate. Yet although some historians mention the involvement of the two trade designers who actually carried out the designs, Edwin Clinch and Herbert Cutler,[19] the consensual view would appear to suggest that it was Russell's views, representing the 'conservative faction of the reform lobby,'[20] referring to those who supported an Arts and Crafts view, that prevailed. Although it could be construed that this turned out to be the case to some extent, it must be borne in mind that at mid-century, though Russell was clearly embedded in the Cotswold tradition of hand-workmanship, he nevertheless saw himself at that time as supporting industrialisation and 'mass production' and was an influential member of the reform lobby that was trying to promote Modernism.

Jonathan Woodham has traced the traditional view of 'good design' and its Arts and Crafts roots from the Design and Industries Association (DIA) onwards as a 'continuity in aesthetic hegemony from the pre- to the post-Second World War period via the Utility Design Scheme', recognising the limitations of the small circle of cultural elite from which the principal players were drawn.[21]

Two key works on Utility furniture design that have contributed to the personality-cult of the designer as 'hero' are Gordon Russell's own memoirs, *Designer's Trade*, published in 1968 and the Geffrye Museum's 1974 exhibition Utility Furniture and Fashion 1941–1951.[22] In *Designer's Trade* the chapter on 'National production: Utility furniture' presents Russell's strongly held opinion that the Utility Scheme was a means of raising the standard of design and making 'good design' available to the masses, reflecting the outlook of the DIA and the Council of Industrial Design. Russell's account did not include a critical review of the Utility Scheme, nor of the mechanisms that put it in place. The overall tone is one of success – describing the Scheme as an achievement and a job well done. He emphasised the part of the directive given by the Board of Trade which specified that Utility furniture 'should be soundly made of the best available materials ... and of a pleasant design,'[23] rather than the maximum economy requirement that mainly dictated its form. His assertion that 'the basic rightness of contemporary design won the day'[24] was reiterated in the often-quoted claim: 'I felt that to raise the whole standard of furniture for the mass of the people was not a bad war job',[25] explained as 'attempting to interpret to the trade and to the public what was in effect a nation-wide drive for better design',[26] and suggesting much more control than was actually the case. Russell's belief that the Utility Scheme would have a far-reaching beneficial effect on the British public's taste was never more than an aspiration, described by Sparke as a 'rash prediction'.[27]

The Geffrye Museum catalogue for the exhibition Utility Furniture and Fashion 1941–1951, mounted in 1974, still represents an important document providing a chronological outline of the development of the Utility Scheme. Nevertheless, it concentrates largely on the first-stage Utility designs, giving proportionally much less space to the longer post-war second stage, and then only highlighting Russell's favoured post-war Cotswold range and its conversion to the Diversified range after 'Freedom of Design' was conceded. The featuring of the Russell-inspired Cotswold and Diversified ranges reflected the interests of the design reformers and the heroic role they conferred on Utility design to lead the way in design reform, with little reference to the perspective on the Scheme of either the trade or the general public at the time. The imbalance of information gives the impression that Utility furniture is typified by the first range, which actually only represents the period between 1943 and 1946.[28]

An interesting and telling omission from the Geffrye catalogue chronology indicates the over-simplification that historical accounts have wrought in the presentation of the history of the Utility Design Scheme. Under the heading '1943 January 1st', the specification of the units required to allow the purchase of Utility furniture under the rationing regulations states: 'A special fifteen unit bed-settee permit was issued only to those who lived in bedsitters. People with houses or flats were not allowed to buy the bed settee.'[29] The bed-settee is not mentioned again, suggesting that this remained the case until rationing was abandoned in 1948. In fact, the first amendment to the schedule that came into effect at the beginning of September of the same year specified that the requirement be lowered to ten units. Although this is a small detail, it is indicative of the many and confusing changes which took place under the regulations during the life of the Utility Scheme.

The interpretation of the Utility furniture designs by the Geffrye Museum catalogue, upholding the myth of Utility as producing 'new' design, is not uncharacteristic of the period when 'Good Design' was synonymous with Modernism. Its insistence on treating the Utility Scheme as innovative is apparent even while overriding the designers' own claims, for example in asserting that 'Although to Clinch and Cutler it was an exercise in "plain common sense", their application to the problem without any preconceived ideas resulted in some of the best furniture designed in this country, well conceived and well made.'[30] This quotation clearly contradicts what those responsible for the designing of the first range of Utility furniture said about their own approach. The normal design practice within the furniture trade of coming up with a set of working drawings adapted from existing generic types, which was how the Utility designs were produced, was all in a day's work. For Edwin Clinch and Herbert

Cutler, two experienced trade designers, to approach the designing without 'any preconceived ideas' is not only highly unlikely but apparently not true, according to the interviews reported in *Design* magazine of September 1974.[31] Such a statement suggests that the range was new and entirely different from any produced before the war, when the designs were clearly on very similar lines to types which not only already formed part of the furniture industry's repertoire, but also were almost identical to recommended pre-war models of 'Good Design'. In 'Good Design By Law: Adapting Utility Furniture to Peace-time Production – Domestic Furniture in the Reconstruction Period 1946–1956' Judy Attfield writes:

> [The] No. 3 Utility ladder-back dining chair, apart from slimmer members, is exactly the same as an unidentified model illustrated among the recommended items in *The Council for Art and Industry Report – The Working Class Home* published in 1937. While the No. 3a Utility dining chair appears to be a slimmed down version of a model illustrated in Anthony Bertram's *Design in Everyday Things* produced to accompany a series of lectures broadcast by the BBC in the same year.[32]

Another usual misrepresentation of the Utility Scheme portrays the furniture designs as completely standardised. In *Designer's Trade* Russell's description of the range – 'Nothing less than standard design and rigid specification would meet this exceptional case'[33] – never became a reality. It is true that in 1943, when Utility was first introduced, the scheme only included 66 items, but by 1946 the number had grown to 266 pieces, including 99 different types of beds.[34] The principle of standardisation that depended on arriving at a single best type for each set of requirements was incompatible with the concept of consumer choice that depended on variety allowed by the 'Freedom of Design' legislation introduction in November 1948, which remained in force until 1952.

A full study of the public reaction to Utility furniture has not yet been made, but there is sufficient material to suggest that it was not widely popular with the consumer, nor with the furniture trade.[35] Government files indicate that once the choice of Utility furniture was extended, the Cotswold range proved unpopular.[36]

The confusion that exists regarding the origin of Utility furniture designs is illustrated in the following two contradictory quotations – the first from John Heskett's *Industrial Design* and the second from Anne Massey's *Interior Design of the Twentieth Century*:

> The Arts and Crafts tradition, strong in both Britain and Germany, was pressed into service by the Board of Trade for a wartime programme of Utility furniture.[37]

> The British Government officially adopted Modernism during the war with the Utility schemes.[38]

Trying to associate Utility with either Arts and Crafts or modernist roots has only confused the issue, because neither theory is sufficient in itself to explain the various forms that the Utility furniture designs actually took in the various phases of its history.

The link between Utility furniture and the Arts and Crafts Movement was explained in an article that appeared in the *Architectural Review* in 1943, attributing the limitations of the design of the first range to '[hardboard], a comparatively new and not yet fully tried-out material' that 'limited the design to the Arts and Crafts technique of frame and panel construction and to small panels at that'.[39] The reason for the limitation to small panels was the fear that hardboard would warp if not firmly held in place. It was also difficult to cut hardboard without leaving a ragged edge, thus eliminating the possibility of flush panelling. Had it been available, plywood would have been used, but all supplies were required for more urgent war needs. In the wider context of furniture history, the technique of frame and panel construction can be traced much further back than the nineteenth-century Arts and Crafts Movement, since it was part of a traditional constructional practice in furniture-making that was already in general use by the seventeenth century.

Alongside frame and panel construction there were certain other stylistic features present in the first range of Utility furniture which may have led some authors to describe it as being 'Arts and Crafts'-inspired. The predominant use of an oak finish, the linear nature of the designs, the lack of ornamentation and decorative carving and the choice of handles used for the first range of Utility furniture are all important features. Because no other material was available, the first range had either small turned wooden knob handles or straight wooden handles, while pre-war pieces of carcass furniture had ornamental pierced metal handles or 'Georgian'-style brass handles. The small turned knob or straight wooden handles had been favoured by many Arts and Crafts-inspired manufacturers, including Ambrose Heal and the Cotswold group of designer/makers. But the designers of Utility furniture must have been motivated primarily by the functional constraints of supply and ease of manufacture rather than by a conscious decision to emphasise hand-production and craft skills. This last point may seem a detail, but it does provide an important clue, since the first range of Utility furniture, shown in ideal settings, as in the Board of Trade's 1942 promotional exhibition display-rooms, is seen in the illustrations most frequently used to represent Utility furniture.

The association between Utility furniture and the Arts and Crafts

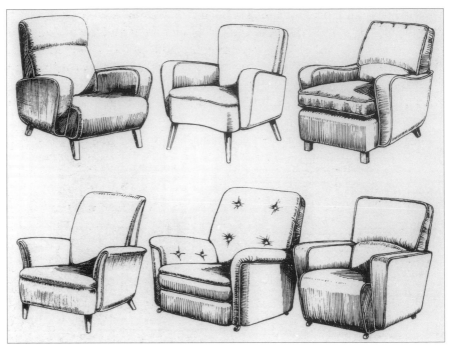

16 Drawings for six upholstered easy chairs published in *Design Suitable for Utility Furniture* by the Board of Trade in 1949

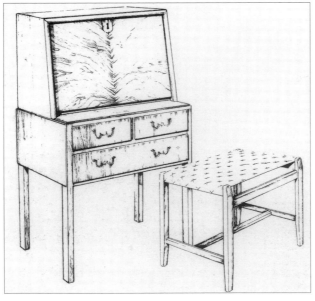

17 Drawing of a bureau and dressing-stool published in *Design Suitable for Utility Furniture* by the Board of Trade in 1949

Movement has also been encouraged by the similarities between the theories of William Morris and other Arts and Crafts supporters and the information provided by the Board of Trade regarding the principles of Utility furniture. The Advisory Committee's brief for 'furniture of good sound construction in simple but agreeable designs' finds a parallel in William Morris's often-quoted maxim that furniture should be 'solid and well made in

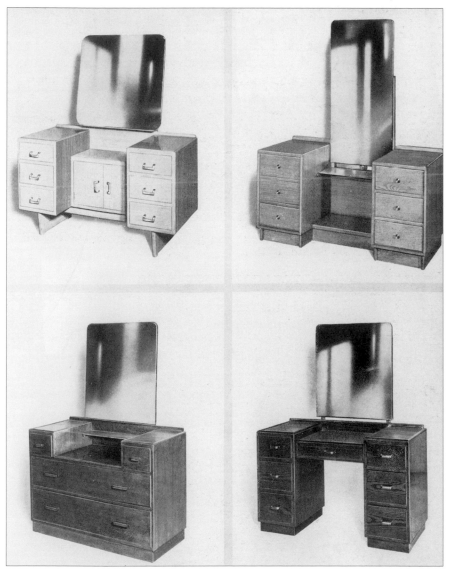

18 Four dressing-tables from the second *Utility furniture Catalogue* published in June 1947: (top left) Cotswold Range; (top right) Cotswold Range; (bottom left) Chiltern Range; (bottom left) Chiltern Range.

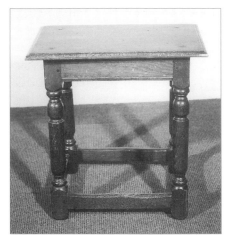

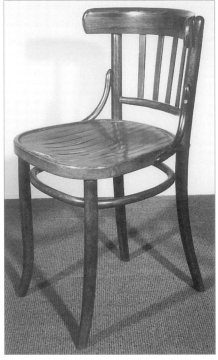

19 Oak 'joint stool' manufactured by William Bartlett and Sons of the Sheraton Works, High Wycombe, produced during the 'Freedom of Design' period from 1948

20 An Austrian bentwood chair imported into the Utility Furniture Scheme from 1946

workmanship, and in design should have nothing about it that is not easily defensible, no monstrosities or extravagances'.[40]

From a visual inspection of certain items of Utility furniture it would be just as possible to draw links between Utility furniture and Modernism as it is between Utility and the Arts and Crafts Movement. The diversity of designs produced under the Utility Scheme, when the Freedom of Design period is recognised as part of it, is sufficiently large that a design could be found to characterise the gamut of styles from reproduction Jacobean to contemporary (figures 16–20).

The alternative view that there are links between Utility furniture and Modernism can be argued by suggesting that the reforming and improving ideas contained within the 1937 *Working Class Home* report[41] were put into practice through the Utility furniture scheme. There is a general perception that many of the wartime controls were part of a wider socialist economic policy. This has been argued on the grounds that the agenda of the Utility Scheme was to democratise 'Good Design' and make it available to all levels of society. Indeed, one of the main roles of the Utility Scheme established by the government was that it should be seen to be fair to the whole population in its allocation of scarce consumer goods. While the Utility schemes were being devised there had been suggestions that

furniture units could be sold at high prices to those who could afford them, in an attempt to raise revenue.[42] But this idea was rejected on the ground that it would leave the government open to the criticism that it would be creating a system that favoured the wealthier classes. Further evidence of the government's intention to use Utility as an equitable means of distributing essential goods was seen in its using it to replace the Assistance Board's compensation scheme, which made allowances pro-portional to the wealth of the household in compensation payments for bomb damage to furniture. But above all the scheme adopted was con-sidered the most workable solution to an urgent and deteriorating supply problem. Had the Utility Furniture Scheme continued to dictate design after 1948, when the supply situation began to improve, then it could have been accused of upholding a socialist ideology. However, the 1948 relaxation of control, when Utility was limited only by 'Freedom of Design' legislation suggests that any such latent plans for the Utility Scheme were dropped by the government as soon as the supply and demand restrictions allowed.

Perhaps the main problem with the use of terms like 'Modernism' and 'Arts and Crafts' lies in the use of such terms as stylistic historical pigeon-holes, suggesting that a particular style such as 'Modernism' was confined to a particular political ideological denomination. Furniture pro-duced under the aegis of Utility is far too diverse to be categorised so narrowly. In relation to the history of the Utility Furniture Scheme, neither description is particularly helpful. Such attempts to theorise the designs of Utility furniture produced between 1943 and 1948 ignore the overriding factors which brought about the scheme in the first place.

The factors which led to the introduction of Utility furniture and the designs supplied by the Board of Trade between 1943 and 1948 are many, but they can be briefly summarised under six headings – (1) the shortage of furniture due to lack of timber supply to the furniture trade; (2) the demand for new furniture created by damage from bombing, new house-holds and a degree of disposable income; (3) general shortages resulting in rapid inflation and the threat of racketeering if there were no supervision; (4) the introduction of rationing; (5) the established trade practices and traditional forms built into the Utility designs by its two trade designers, Edwin Clinch and Herbert Cutler, ensuring that the rump of the furniture industry not recruited to essential war production could cope with the production of civilian furniture; (6) the paramount importance of the need for economy, simplicity of manufacturing techniques and the limitations of available materials, for example, substituting hardboard for plywood.

So it is more accurate to conclude that the designs for Utility furniture were not the result of any one particular design ideology, but the result

of a complex scheme of rationing which was attempting to meet the constantly changing economic and supply problems under wartime conditions.

Notes

1 The Ministry of Supply issued the control of timber (No. 1) Order on 5 September 1939, two days after war was declared. This Order established the Ministry of Control of Timber. The Utility Furniture Scheme was controlled by many different laws issued by the government. These laws provide the historian with a precise historical chronology of the scheme. However, due to the continual changes in the supplies of raw materials, many of the laws enacted were revoked or re-enacted with amendments within weeks of being issued. The large number of different laws which were issued to control the production, marking, supply and price of furniture make the scheme's history a complex one.

2 Public Record Office Assistance Board documents (AST) 11/214. Although price control was extended to furniture at this date, the control was difficult to enforce, and full control of the industry was not brought about until the Utility furniture scheme was introduced.

3 The almost total withdrawal of timber to the furniture trade from July 1940 (Public Record Office Board of Trade documents (BT) 64/1835), linked with the increase in disposable income among certain sections of the public, was to lead to racketeering by certain sectors of the furniture trade.

4 Standard Emergency furniture was featured in *The Cabinet Maker and Complete House Furnisher* in February 1941.

5 BT 64/1730. The list of furniture was introduced by the Ministry of Supply in November 1941, but it was not until 1942 that the list was adopted by the Board of Trade which, by the publication of an Interim Order, prohibited the production of furniture which did not comply with the list from 1 August.

6 Press cutting filed with AST 11/196.

7 BT 131/41. The Board of Trade took an interest in consumer goods from the summer of 1940, although traditionally it had been a non-interventionist department concerned with the promotion of trade abroad, rather than the affairs of individual home industries.

8 This warning was given in a letter from the Ministry of Supply to the Board of Trade (BT 64/1835).

9 BT 64/1835 contains notes for and reports of parliamentary questions from 5 May 1942.

10 BT 64/1835.

11 BT 64/1897.

12 These regulations were introduced in the Domestic Furniture (Control of Manufacture and supply) (No. 2) Order 1942.

13 The first Utility catalogue was published on 1 January 1943, but it was a number of weeks later before the furniture was available for sale.

14 The cot was introduced in the Domestic Furniture (Control of Manufacture and Supply) (No. 4) Order issued on 22 March 1943.

15 The additional items were added to the schedules through the Furniture (Control of Manufacture and Supply) (Amendment) (No. 5) Order. The new designs were published in a second catalogue published in June 1947.

16 See Chapter 13, 'Freedom of Design', in this volume.

17 J. Attfield, '"Then we were making furniture, and not money": a Case Study of J. Clarke, Wycombe Furniture Makers', *Oral History*, Vol. 18, No. 2, Autumn 1990, p. 54.

18 For example, in his *Fifties Source Book* (Virgin, 1990, p. 14) C. Pearce states 'The functional well made Utility furniture was produced by designer Gordon Russell', while C. and P. Fiell's *Modern Furniture Classics Since 1945* (Thames and Hudson, 1991) attributes to Russell 'the chairmanship of the Board of Trade' (an office he never held), when he is supposed to have 'designed a range of Utility furniture' (p. 14).

19 I.e. P. Sparke, *Furniture*, Bell and Hyman, 1986, p. 74; H. Dover, *Home Front Furniture: British Utility Design 1941–1951*, Scolar Press, 1981, p. 7.

20 Dover, *Home Front Furniture*, p. 19.

21 J.M. Woodham, 'Managing British Design Reform I: Fresh Perspectives on the Early Years of the Council of Industrial Design', *Journal of Design History*, Vol. 9, No. 1, 1996, p. 55.

22 G. Russell, *Designer's Trade*, Allen and Unwin, 1968; Geffrye Museum, *Utility Furniture and Fashion 1941–1951*, ILEA, 1974.

23 Russell, *Designer's Trade*, p. 197.

24 *Ibid.*, p. 199.

25 *Ibid.*, p. 200.

26 *Ibid.*, p. 205.

27 Sparke, *Furniture*, p. 75.

28 BT 64/2177. This file contains a letter from Russell in which he outlined his objections to the 'Freedom of Design' legislation. In allowing the trade to produce its own designs, he believed that the advances in design made by the Utility Scheme would be lost, and as a result that 'many firms [would] fall below even pre-war standards'.

29 Geffrye Museum, *Utility Furniture and Fashion, 1941–1951*, p. 15.

30 *Ibid.*, p. 13.

31 M. Brutton, 'Utility: Strengths and Weaknesses of Government Controlled Crisis Design', *Design*, No. 309, September 1974, pp. 66–9.

32 J. Attfield, 'Good Design By Law: Adapting Utility Furniture to Peace-time Production – Domestic Furniture in the Reconstruction Period 1946–1956', in J.M. Woodham and P. Maguire (eds), *Design and Cultural Politics in Post-war Britain*, Leicester University Press, 1997.

33 Russell, *Designer's Trade*, p. 198.

34 The list of 266 different pieces can be found in the Schedule of Furniture No. 1530 (Control of Manufacture and Supply) (Amendment) (No. 5) Order, 1946, dated 16 September 1946.

35 See, for example, *The Cabinet Maker and Complete House Furnisher* and similar publications of the period.

36 BT 64/2091. An internal Board of Trade report dating from the end of 1947 documents that since the increase in choice, certain items of Utility furniture were becoming difficult to sell.

37 J. Heskett, *Industrial Design*, Thames and Hudson, 1980, p. 156.

38 A. Massey, *Interior Design of the Twentieth Century*, Thames and Hudson, 1990, p. 158.

39 'Utility and Austerity', *Architectural Review*, Vol. 93, January 1943, p. 3.

40 W. Morris, 'The Lesser Arts of Life', *The Collected Works of William Morris*, ed. M. Morris, Longmans, Green and Co., 1914, p. 261.

41 The Council for Art and Industry, *The Working Class Home: Its Furnishing and Equipment*, HMSO, 1937.

42 BT 131/41. There were a number of recommendations made by economists as to how the Utility Scheme might be used to create extra revenue; but it was decided that the possible creation of a wealth gap-would be unacceptable, and the production of basic goods would suffer if a strict scheme of rationing was not adopted.

8 ✧ The Utility garment: its design and effect on the mass market 1942–45

Helen Reynolds

THIS CHAPTER examines wartime fashions produced under the directives of the Utility Clothing Scheme, using government records as its principal resource. To date, much of what has been written about dress during this period focuses on 'fashion and austerity' as perceived through surviving garments, censored newspapers, magazines, the cinema, radio broadcasts and later interviews. This provides us with information on the public perception of wartime clothing, including Utility clothing, which is also examined by Pat Kirkham (Chapter 9). However, the reasons for the implementation of the Scheme by the Board of Trade, and its subsequent planning, have been obscured in this wealth of censored material. I shall attempt to reassess the Scheme's main functions, its legacies and the importance of the contemporary and historically acclaimed women's garments designed for the scheme by the Incorporated Society of London Fashion.[1]

In a letter to Sir Thomas Barlow, the Director-General of Civilian Clothing at the Board of Trade from 1941 to 1945, the clothes designer Peter Russell wrote that the Board's control of clothing through rationing, the Austerity Regulations and the Utility Scheme 'had created a vast improvement in the general dressing of the public by teaching them a discipline in dress and the appreciation of simplicity'.[2]

The Board of Trade's Utility Clothing Scheme, first introduced in 1941, approximately two years after the outbreak of the Second World War, was the last in a series of far-reaching measures to control the production, distribution and cost of clothing on sale to the general public. The prime objective of the Scheme was to produce the nation's essential new clothing using as little power, labour and material as possible.[3] In effect, it was direct government intervention in Britain's clothing markets to control quality, limit prices and channel production into garments which were in the shortest supply.

The Utility Clothing Scheme formed part of the Board of Trade's programme of control over the cloth and clothing industry that makes this

period unique in British history. Never before had a British government chosen to exercise such powers. Along the manufacturer's name, by statutory order, the Board's distinctive CC41 label was printed or attached to all cloth and ready-made clothing that was produced under the Scheme's directives. In 1945 it accounted for about 90 per cent of all civilian clothing produced commercially for the British market. The Scheme therefore became central to the Board of Trade's control over clothing, following the failure of a number of less intrusive methods which were devised to ensure a fair distribution of the nation's clothing.[4]

When war with Germany was declared in 1939 Britain was under the control of a Conservative government. Neville Chamberlain was Prime Minister. The Board of Trade,[5] a vast government department that oversaw all aspects of British industry except food and munitions, implemented a government policy to help the war effort. Less civilian clothing was progressively produced, as firms lost both labour and raw materials, which were redirected to the war effort and turned to the production of uniforms. At first this had little effect on the supplies available for purchase, as conscription and increased taxation suppressed overall demand for clothing. This enabled manufacturers and retailers to keep the general public supplied with clothing, using the reduced new supplies supplemented with stocks of pre-war cloth and clothing. Two years into the war the Board's regional officials reported that the situation was changing and certain types of basic clothing were becoming increasingly difficult to obtain, as manufacturers concentrated on more lucrative lines. It was at this point that a number of measures were taken by the Board to restrict the supply of civilian clothing.

On 21 October 1940 Purchase Tax was introduced on clothing. Five months later on 21 March 1941 the first 'Making of Civilian Clothing [Restriction] Orders' came into force. Commonly known as the Austerity Regulations, they limited the amount of material and trimmings manufacturers, tailors and commercial dressmakers were allowed to use.[6] Just over two months later on 1 June clothing rationing was implemented.[7] Although these measures eased the overall supplies of new civilian clothing, spiralling inflation, taxation and profiteering meant that supplies were rapidly becoming unavailable to the poorer sections of the population and contributing to the already rising cost inflation in clothing. By 1941 the clothing retail price index had risen 66 per cent above its 1938 level.[8] This led the Chancellor of the Exchequer, Kingsley Wood, to announce in parliament in April 1941 that action was needed to stabilise clothing prices.[9]

In May 1940 a coalition government had been formed under Winston Churchill, and government policy began to change. A number of new ministers were appointed and gradually there was a shift away from the

Conservative ideology of the Chamberlain government. The new Chancellor appointed Maynard Keynes as Treasury adviser. The latter's *General Theory of Employment, Interest and Money*, published in December 1936, was highly critical of the government policies of the previous decade. He introduced a new budgetary policy designed to align the prices of personal goods to people's incomes.

It was in this climate that the first Utility measures were introduced. Aware of the clothing shortages that had existed in the First World War, the Utility Clothing Scheme was devised to enable the civilian population in the lower income brackets to purchase adequate supplies of clothing, which the rationing and purchase-tax measures had failed to do. The Scheme fitted neatly into the government 'Keynesian' planning by providing clothing aligned to the majority of people's income at a time of shortages. The Utility Clothing Scheme rapidly became the focal point of all the Board's civilian clothing controls, and, although publicly stage-managed to look well prepared, in reality it was a series of measures responding pragmatically to the prevailing circumstances.

In the first year of the war only a small department within the Board was concerned with the supply of clothing. As more complicated regulations and restrictions were devised, the department quickly expanded, and a large number of temporary civil servants was brought in to work alongside existing staff. The first committee to oversee clothing was led by Melford Watkins, a director of the department store, John Lewis. The Civilian Clothing Directorate, as this department was called, was run side by side with the Price Regulation Committee, introduced in 1939 to curb the widespread profiteering that had flourished in the First World War.

By late 1941 Sir Thomas Barlow had replaced Melford Watkins as Director-General. This appointment came just before the one-time pupil of Maynard Keynes and prominent socialist, Hugh Dalton, was appointed as President of the Board of Trade.[10] From this point the Utility Scheme became central to the Board's control of civilian clothing, which resulted in the systematic reorganisation of the clothing industry to produce Utility uniforms and clothing for export. By 1943, by means of statutory rules and orders the Board of Trade controlled all aspects of the supply of the nation's new civilian clothing, except what was obtained by illegal methods on the black market.

Barlow, whose previous wartime appointment had been in the Board's Factory Control department, was a prominent banker and industrialist. He was responsible for the setting up of Helios within Barlow and Jones, his family textile conglomerate. Helios produced furnishing fabrics at the cheaper end of the market, using innovative designs at a time where many of its direct competitors were using traditional designs. Barlow had also

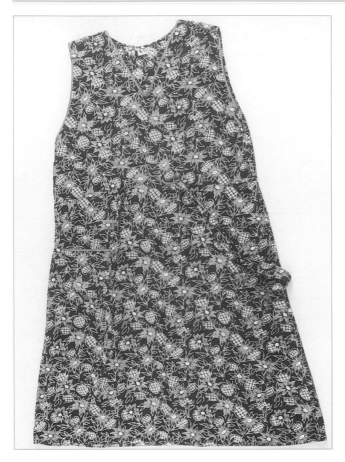

21, 22 Utility overall in printed cotton and inside showing Utility label. Rationing and shortages made impulse buying impossible during the Utility period, mainly confining the clothes-buying habits of the British public to essential items only. To avoid wastage, the Board of Trade commissioned market research studies to instruct manufacturers on the quantity and types of garments to produce under the Utility directives. Printed cotton overalls and pinafores, routinely worn by most women at home to protect their clothes while cooking and cleaning, were considered essential and therefore produced in great numbers

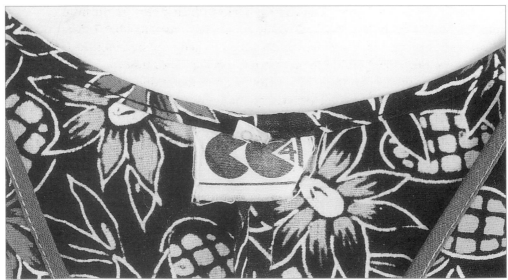

served as a member of the Council for Art and Industry, the forerunner of the Council of Industrial Design. As Director-General Barlow oversaw the Utility Clothing Scheme from its launch stages through to the end of the war, and was responsible for the removal of purchase tax from all Utility garments except fur coats.

The Utility Scheme was based on a number of Acts and Government Orders which the Civilian Clothing Directorate used to run the Utility Clothing Scheme. The Utility Clothing Acts and Orders were complex and regularly amended to suit the conditions of the time. By the end of the war hundreds of amendments had been passed. However, the basis of the Scheme comprised a number of core Acts and Orders; the main ones were:

1. *The Limitations of Supply [Cloth and Apparel Orders]* of 1941 and 1942, which controlled the production and output of all Utility cloth and clothing. It also laid down strict quality specifications, which had been worked out by the British Standards Institution to ensure longevity in both material and production;

2. *The Goods and Services [Price Control] Act* of December 1941, which gave further powers to the Board's Central Price Regulation Committee, enabling it to enforce the Scheme's rigid price structure and prosecute manufacturers and traders who did not sell the cloth and clothing at or below the set price;

3. *The Utility Cloth [Maximum Price] Order* and the *Utility Apparel [Maximum Prices and Charges] Order*, which contained details of how much profit could be made on Utility cloth and clothing. The Board rigidly enforced a policy under which manufacturer's, wholesaler's and retailer's profit margins were cut to the minimum; and

4. *The Price Controlled Goods [Invoice] Order*, which followed on from the Prices of Goods Act and laid down strict rules ensuring that Utility cloth and clothing was numbered and invoiced when it passed from one trader to another. The Utility mark and the specification numbers had to be attached or printed on the cloth or clothing and the selling price clearly written on the accompanying paperwork. This ensured that the Board's Price Regulation Committee had the means to check that the maximum price had not been exceeded by any firm involved in the production or selling of Utility clothing.[11]

Subsequently many of the core orders relating to the Scheme were adjusted under The Emergency Powers Act of 1939 to improve the Scheme, adjust prices and allow for change in consumer needs. Garment and cloth specifications were also regularly changed to allow for fluctuations in the supply of raw materials. With the core orders in place, the Civilian Clothing Directorate was able to start organising the clothing industry along more efficient lines to produce the nation's clothing requirements.

During the crucial first months of the Scheme from late 1941 until mid-1942, when the core legalisation was introduced, no measures were taken to regulate design. Before the war the government-backed Committee for Art and Industry had commissioned a report on *Design and the Designer in the Dress Trade,* which was one of a number of extensions of the Committee's first report, *Design and the Designer in Industrial Design. Design and the Designer in the Dress Trade* was at report stage immediately prior to the war, and 400 advance copies were printed, but only 200 were distributed for comment.[12] Although both reports highlighted the importance of the design of mass-produced products, this factor played no part in the planning of the Utility Scheme.

The next step taken by the Board was the 'designation' and 'concentration' of the clothing industry. It was a task ideally suited to Barlow, with his contacts in the mass-produced textile industry. Manufacturers were designated under an Essential Works Order if they produced Utility garments to the type and number required by the Board. Concentration was the voluntary merger of one factory with another to create extra space for the manufacture and storage of munitions, a by-product of which was to create larger clothing factory units. In return for becoming designated manufacturers were given the bulk of the available cloth allocated for civilian clothing in order to produce the garments the Board required. They were also guaranteed labour, as at the time of military call-up designated labour was regarded as essential war work.[13]

The clothing industry before the war, as now, was susceptible to the whims of fashion, but during the period under discussion fashion styles changed very little, so manufacturers and retailers were not left with last season's style. The Board assessed consumer demand in order to be able to honour the clothing coupons issued through rationing, and controlled the type and number of garments produced by clothing manufacturers, designating factories to produce the exact amount of clothing required.[14] 100 per cent sales were virtually guaranteed, previously unheard of in the fashion industry.

Designation, being a licence to produce clothing, was therefore highly prized, as it guaranteed supplies of cloth and labour and a guaranteed market. The Board was only keen to designate firms that used the most efficient production methods. At the time this was thought to be mass-produced clothing made by the 'conveyor-belt method'. This entailed a division of labour, with each process in the garment construction being assigned to one worker before it was passed on to another, who completed the next stage. In Britain in 1941 this method of production was only practised by a few large firms in this country producing civilian clothing such as Burton's, although mass production or the 'Fordist' method were

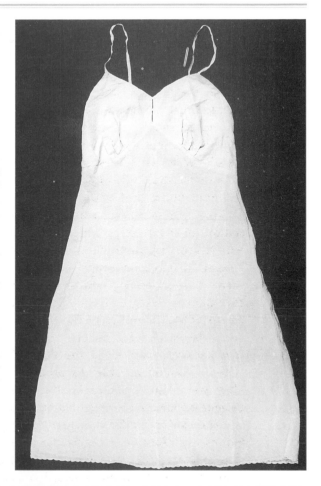

23, 24 Utility petticoat in salmon pink rayon and inside showing Utility and maker's labels. The Utility Scheme assigned rayon cloth for civilian clothing because it was not required for uniforms or export. The petticoat in 23 shows the narrow hem required by the austerity regulations. Under wartime emergency powers the Board of Trade insisted that the CC42 logo was stamped, stitched or incorporated with the manufacturer's label on every garment made under its directives. In addition all Utility fabric was given a specification number which related to its type, quality and the type of garment it was to be used for. This number stayed with the garment throughout manufacturing and retailing and enabled the Board to ensure adherence to its pricing policy

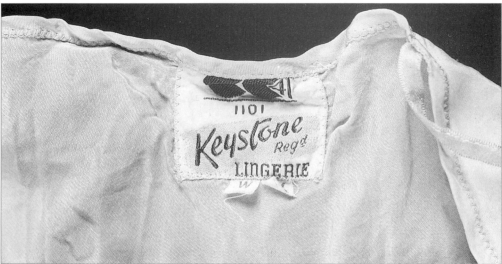

widely used in the United States. This system contrasted sharply with the 'individual making-through method' in which one worker was assigned the whole garment, as was usual in small tailoring shops, dressmakers and couturiers, as well as in many small firms involved in the making of women's outerwear.

Although designation was under the direct control of Barlow, it was managed by George Carruthers, a career civil servant and Under-Secretary. Firms were first invited to apply for designation in January 1942. Applications closed in March of that year, and the first list of designated factories was published on 1 June 1942. Other factories were designated to produce military clothing and clothing for export. The list numbered 1,996, of which 1,006 were producing Utility or part Utility.[15]

By early 1942 the Ministry of Labour had classified the United Kingdom into areas according to density of war production, named Scarlet, Red, Amber and Green. Firms in the Scarlet and Red areas, such as Liverpool, had an acute shortage of labour and a large percentage of munitions factories. Even if a firm in a Red or Scarlet area fulfilled the criteria for clothing manufacture designation, it was not designated if a factory in an Amber or Green area could produce the same type of clothing in sufficient quantities. The Board therefore designated a number of small firms not using conveyor-belt methods in Amber and Green areas because their labour and factory space was not required by industries supplying the direct war effort. Couturiers, the makers of exclusive made-to-measure and expensive women's clothing, had an international clientele which the Board was to keen to preserve and expand as a valuable export, particularly as Paris couture was unavailable outside France and Germany. Although not meeting the criteria for designation status, the Department of Overseas Trade requested that a number of firms had guaranteed supplies of cloth and labour. The firms thus protected included Fortnum and Mason, Norman Hartnell, Lachasse, Molyneux, Digby Morton, Paquin, Peter Russell, Victor Stiebel, Strassner and Worth.[16]

The designation list for the manufacture of British civilian clothes included a variety of firms making good-quality mass-produced clothing, such as Austin Reed Ltd, Rembrandt Dresses Ltd, D. Ritters' (Derata) and Simpsons. However, most of the list consisted of firms making ordinary items of clothing at the cheaper end of the market, including the Co-operative Wholesale Society (CWS). Marks and Spencer under their brand 'St Michael' were particularly successful producers of middle-market Utility clothing.

Once designation had taken place under the essential works order Barlow attempted to rationalise the clothing industry under the concentration scheme in order to achieve the government's demand for extra

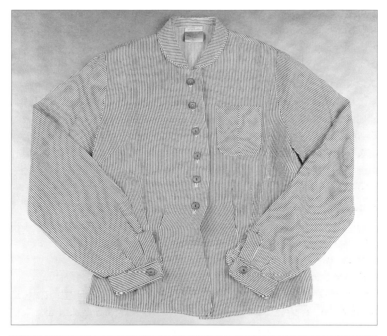

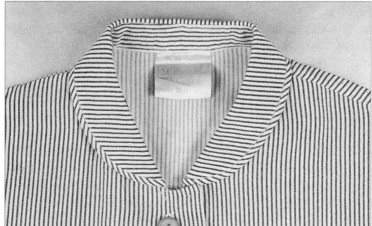

25, 26 Marks and Spencer Utility blouse and detail showing the Utility label sewn under the St Michael brand name. Marks and Spencer were highly successful producers of Utility clothing because they manufactured in long runs well before the introduction of the Utility directives and were used to working on small profit margins, and were thus able to produce and sell their clothing at the prices set by the Board of Trade, even managing to sell garments below the ceiling price. This blouse shows the wartime need for economy of material put to good advantage with narrow bias edgings and clever use of the small offcuts on the pocket. The blouse also illustrates the restricted amount of cloth allowed by the Austerity regulations, leaving little spare length to tuck in at the waistline

space for the manufacture and storage of munitions. The first area to be 'concentrated' was Leeds, followed by Manchester, Coventry and London. Concentration was not enforced and regarded as only a limited success,[17] although in the clothing industry, because Barlow's personal contacts with fellow textile industrialists and his persuasive arguments, Dalton considered that concentration had worked well.[18]

When the Board introduced the Austerity Regulations, which applied to all clothes, including non-Utility, destined for the home market, it forced manufacturers to rethink their designs. The policy of mainly designating factories that used mass-production methods encouraged firms to change to this method to gain designation status. Many manufacturers who before the war had made cheap clothing turned to the production of Utility clothing. Their pre-war clothes concentrated on a large range of designs, rather than using efficient production methods. This was partly the result of retailers insisting on exclusive designs which forced manufacturers to produce small runs of garments, using the individual making-through method, with fussy details to differentiate the styles.[19] This way of making garments appear different from previous runs was condemned by the Utility principle.

The Board also insisted on minimum profits for manufacturers using standardisation as the only viable method of production. Before the war, manufacturers of ready-to-wear were averaging 100 garments per run, but under the Utility Scheme they were forced to make runs of 1,000 or more garments per style.[20] This also meant that more attention could be made to the design of the simpler garments demanded through the Austerity Regulations.

The guaranteed market the Utility Clothing Scheme offered also encouraged manufacturers to produce long runs, as they were not at the mercy of the retailers. Understandably it was the large manufacturers who favoured the Utility Scheme more than tailors, dressmakers and retailers. Although working on reduced profits, there was no wastage. T.M. (Tom) Heron, Managing Director of Cresta Silks, who was employed by the Board during the war and credited with having initiated the Couturier Scheme, wrote at the time: 'It is safe to say that in many factories to-day better dresses are being produced than was the case before the war, although the proportion of skilled labour available is very much less than it was.'[21]

Apart from simplifying production, the Utility Scheme had not concerned itself with design until now. On Sunday, 1 March 1941, in an interview on BBC Radio News, Dalton referred to Utility clothing as 'standard' clothing. *The Times*'s leading article of 4 March 1942 criticised Utility clothing for making civilians look like Anatole France's 'deplorable penguins'.[22] The public did not relish standard clothing, and Dalton was

criticised for overemphasising standardisation instead of value, quality and price.[23]

In an interview with a Mass Observation observer on 5 April 1942, Anne Seymour, editor of *Woman and Home*, complained that the media were not conveying the scope for individualism in the Utility Scheme.[24] At the same time, *Picture Post* published one of the first articles on Utility clothes, entitled 'Deborah Kerr Shows Off the New Utility Clothes for Women'. Before this date articles in the national press only referred to the price-control aspect of Utility clothes. The new articles pointed out that although clothes had to fulfil government criteria and were sold at maximum fixed prices, there was no restriction on the design of Utility clothes, provided they conformed to the General Austerity Regulations. Anne Scott James stated: 'Mrs Brown need not look like Mrs Robinson's twin sister if she doesn't care to, for there is as yet no question of standard clothing.'[25]

Throughout this period, senior members of the Civilian Clothing Directorate had regular interviews with journalists to promote the scheme. Barlow wrote a number of letters to *The Times* pointing out the benefits of Utility. *The Times* quotes him as saying that the garments which came under the Utility Scheme were not all of the same design, and he 'deprecate[d] the use of the term "standard clothes", as [he did] not wish to standardise them'.[26] However, the idea of standard clothing persisted, and it was partly to dispel this notion that the couturiers were brought in to design a Utility range.

In May 1942, seven months after the Utility clothes had been conceived, the Board announced that it was inviting well-known fashion designers to prepare a range of patterns that would be available, at a nominal charge, to firms making Utility garments. *The Times* named the invited couturiers as Hardy Amies, Edward Molyneux, Digby Morton, Bianca Mosa, Peter Russell and Worth of London.[27] The couturiers who designed the Utility prototypes were all members of the newly-formed Incorporated Society of London Fashion Designers, which pooled the designs and removed their names. The patterns they designed were for women's wear only, and came to be known within the Board as the Couturier Scheme. The Couturier Scheme was introduced as part of the already running Utility Scheme to encourage manufacturers to produce the best designs possible with the limited labour and materials at their disposal.

The prototypes were simple, yet stylish garments, and as required by the General Austerity Regulations, they all used the minimum of material. They were, however, couture garments both in their design and in their construction. Heron's notes in Board files reveal that the designs needed amendment to make it possible to mass-produce them. A wholesale manufacturer was given instructions by the Board to adapt the models for

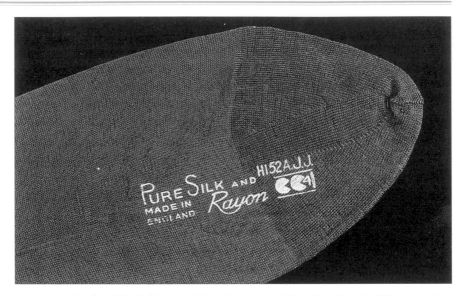

27 Example of a fully-fashioned silk and rayon stocking. The Board of Trade used any material not required for uniforms and export for the Utility programme, ranging, as we see here, from the very cheap to the luxurious. All were made to high specifications, hence earning Utility clothing the reputation for quality and endurance

mass production.[28] The amended models were then shown to the couturiers for agreement before they were produced in a range of standard sizes specified by the British Standards Institution. Templates were produced by the Board for the dress trade at 10s 6d for overcoats, suits and dresses, and 7s 6d for blouses. Attached to each template sold was a cutting of the materials from which the original garment was made. Manufacturers were advised to experiment with the fabric they were using before embarking on a long run.[29]

Much fashion literature on Utility describes the designs by the Incorporated Society of London Fashion Designers as a central part of the Utility Scheme because of the high profile the Couturier Scheme was given in the press at the time, with a fashion show held to launch the clothes. The prototype designs were given to the Victoria and Albert Museum by Barlow in 1943. There was intense competition among museums to have the prototypes in their collections, including a request from the Brooklyn Museum. The Museum of London was given a sizeable number of coupons to purchase unused Utility garments, because it was not given the prototypes.[30]

In October 1942, approximately ten months after Utility clothes had been in production, *Vogue* published the Incorporated Society of London Fashion Designers' Utility designs. Under the heading 'Fashionable

Intelligence', with photographs of the designs by Cecil Beaton, Audrey Withers, the editor of *Vogue* wrote:

> When the visionary and philanthropic band, the Board of Trade, conceived Utility clothes, it was generally agreed that however doubtful their name might be, the goods were indeed the goods. They were simple, practical, agreeable-looking and inexpensive. They were made in reasonably good materials and bore close relation to fashion as such. What more, the Board of Trade might ask, could the consumer demand? But now the same visionary and helpful band have gone many steps forward to ensure the finest clothes in the best, most suitable styles at reasonable rates, and in the soundest materials available.

Vogue then, and later writers of fashion history considered these designs an important landmark in the Utility Scheme. In many respects they were, as they gave a boost to the Scheme and encouraged couture designers to design for the mass market. After the first prototype Utility designs, Norman Hartnell, the Queen's dressmaker, who did not co-operate in the original Couturier Scheme, started designing dresses for Berketex; his name even appeared in their promotional advertisements.[31] Records indicate that after the initial Couturier Scheme was introduced, Digby Morton and Peter Russell also continued designing for mass production.[32]

In spite of the high-profile publicity given to the Couturier Scheme, the response of the manufacturers who were offered the templates for sale was disappointing. Only 1,200 templates covering the whole range of the 34 prototype models were sold.[33] This equates roughly to one template sold per designated firm producing Utility garments in 1942–43. Heron suggested the simplicity of styles as the explanation for the poor response from manufacturers. Despite the General Austerity Regulations, he felt they were expecting sensational styles from top couturier designers.

Following the disappointing take-up of the Couturier Scheme designs, the Board examined how manufacturers at the lower end of the market could improve their design and be encouraged to employ trained designers. On 3 February 1944 Lord Woolton (Frederick Marquis), Minister for Reconstruction and former Chairman of Lewis's Department Store, wrote to Dalton on the subject:

> Before the war I served for many years on the Board of the Trade Committee for Art and Industry ... The section of work that concerned the development of designing women's clothes reached the report stage. I imagine you have a copy of that report on your files.
>
> Paris formerly attracted designers and acquired a considerable reputation in the dress trade, not only of the couturier, but as a medium class ... If after the fighting is over, Europe is slow in settling down, I believe there will be a great opportunity for making London into such a centre.[34]

Following the experiment of the Couturier Scheme, Woolton was anxious that the pre-war report *Design and the Designer in the Dress Trade* would be implemented. The above letter was passed to Barlow, who then invited members of the manufacturing industry, retailers and the Incorporated Society of London Fashion Designers to meet at the Board to discuss the development of the Couturier Scheme.

While the Couturier Scheme was not as successful as the Board had hoped, Barlow, whose family firm Helios had employed textile designers at the forefront of modern innovative design before the war, hoped that the mass clothing market would adopt the same concept of employing designers, rather than the common practice of adapting current trends. The Board were helped in their aims, as British manufacturers had no access to French designs. Although some turned to America and the British couture firms for inspiration, the General Austerity Regulations made it more difficult for copy designs, relying on extra design details to make them 'original'.

Although designers like Norman Harnell often had difficulties in designing clothes under the General Austerity Regulations,[35] a requirement of the home market, Heron regarded the couturiers' designs under the Regulations as a complete success, although not for the reasons usually cited. In a Board memorandum of 6 July 1944 he wrote:

> The trade ... resented the implication that it was necessary to go outside the trade for design talent. We were, however, on fairly safe ground because in imposing our austerity style regulations, many makers-up told us that we were going to prevent good styles being made. Couturiers showed that it was possible to achieve good style in the framework of the prohibitions we imposed and the leading firms in the industry immediately set out to prove that they could do better than the couturiers.

Between 1942 and 1945 The Utility Clothing Scheme was devised by the Board to supply reasonably priced clothing to the civilian population. It was run by a vast department and imposed a prohibitive number of regulations and restrictions on the industry. However, it was deemed necessary by the government of the time in order to supply the nation's clothing. The Board always held regular meetings with journalists to promote the Scheme to the general public and dispel the concept of standard clothing. The Couturier Scheme, which was introduced into an already mature Utility Clothing Scheme and was initially devised to raise the profile of the Scheme, played no part in the basic framework of the Utility Clothing Scheme, which was devised to ensure that everyone had access to basic clothing.

Although relatively few manufacturers subscribed to the Couturier

Scheme, Woolton, Barlow and former members of the Council for Art and Industry saw the Utility Scheme as a means of promoting original design in an industry which was renowned for fussy details and adaptations, particularly in the middle and lower price ranges.

It was not intended that the Utility Scheme should standardise the clothing industry; rather it was an initiative to provide cheap adequate clothing for the civilian population. However, in attempting to achieve this goal the Board actively encouraged mass production in the clothing industry. Large firms like Burtons and Price Tailors had the capacity to mass produce and were able to expand in the immediate post-war period, a time of extreme difficulty for many firms, because they were able to obtain the highly lucrative demob clothing contracts and were allowed extra labour, over and above the wartime allocation.

Before the war a significant amount of commercially-produced clothing was made by small tailors and dressmakers. During the war small firms were only given a small percentage of available materials. Many survived using the small amounts of material not designated by the Board that could be obtained on the black market and by doing alterations, remodelling and using customers' own cloth, often left over from the pre-war period. It was not surprising therefore that there was fierce criticism of the Scheme from this area of industry. Although many of the small firms survived, their numbers were much reduced. Similarly small middle-market clothing retailers relied on a large mark-up from manufacturers' prices because of their small turnover. Many were unable to sustain the Board's strict and vastly reduced profit margins, whereas large retailers, such as C & A, the Co-operative Societies and Marks and Spencer fared better because they had a higher turnover.

The 1997 exhibition Forties Fashion at the Imperial War Museum and the accompanying publication by Colin McDowell attest to the myriad ways the public managed to obtain their clothes. Although Utility was central to the Board's clothing programme, it actively discouraged encouraged people from buying more than they actually needed. When women's groups suggested a national 'Make-Do and Mend scheme' in line with other wartime salvage operations, it was immediately embraced by the Board, together with the promotion of sewing classes to encourage women not only to make new clothes for their families but to preserve and remodel old ones.

Although mass manufacture continued in the clothing industry, the lessons in simplicity taught by the General Austerity Regulations were only fully embraced in women's wear by firms at the higher end of the ready-to-wear market, such as Berketex, Jacqmar and Jaeger, which generally continued to use simpler designs. However, many manufacturers at the

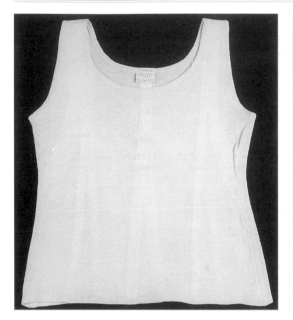
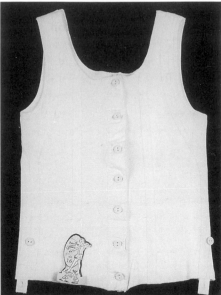

28, 29 Utility liberty bodices. Cotton and wool liberty bodices were standard items of clothing for girls, widely produced under the Utility label

cheap end of the market reverted to the fussy designs of the pre-war period in a similar way that many women unwilling to embrace similar designs customised their plain Utility clothes by adding home-made decorations.[36] Although the legacy of wartime mass-produced clothing manufacture persisted in the clothing industry, the lessons learnt by the Couturiers Scheme, which only ever promoted the design of women's garments, were not universally adopted. It was left to the Council of Industrial Design, of which Barlow was the first Chairman, to promote the use of innovative design in mass-produced products.

During the First World War many families on low incomes had been unable to clothe themselves adequately because of the high price of new clothing. Therefore, anxious to ensure total support for the war effort, the new ministers in Churchill's government quickly adopted a policy of 'fair shares for all'. The success of the Utility Scheme lay in providing the civilian population with adequate clothing of reasonable quality at controlled prices.

By mid-1942, Dalton and Barlow were using the Utility Clothing Scheme as an 'administrative instrument' to produce and distribute clothing and to make the best use of scarce raw materials by using the most efficient production methods. They planned Utility to be sold at the cheapest possible price, ensuring that civilian clothing was available to all, thereby

fulfilling the coalition government's 'fair shares' promise. In attempting to clothe the civilian population as efficiently and economically as possible, the Civilian Clothing Directorate totally reorganised the manufacturing industry during this period, bringing about far-reaching effects in the clothing industry. It gave large firms a good base on which to expand in the post-war period, and therefore the undoubted greater legacy of the Utility Scheme was the expansion of mass-manufactured clothing rather than the experiment of the Couturier Scheme.

Notes

1 Subsequently called the Couturier Scheme.

2 Public Record Office Board of Trade documents (BT) 64/3579, letter of 3 May 1944.

3 Wholesale Garment Association, *Manufacturers' Wholesale and Retailers' Maximum Selling Price for Utility Apparel*, 1942, p. 7.

4 A good overview of the Utility Clothing Scheme appears in *the Midland Bank Review* for August 1951.

5 Subsequently called 'the Board'.

6 *Annual Statutory Rules, Orders and Instruments 1942–1945*, HMSO, 1945.

7 *Statutory Instruments to 31 December 1948, Vol. XVIII*, HMSO, 1948.

8 *One Hundred Years of Economic Statistics*, Economist Publications, 1989, Table UK 8.

9 *Parliamentary Debates*, Vol. 370: 18 March–10 April 1942, HMSO, pp. 1320–2.

10 B. Pimlott, *Hugh Dalton*, Jonathan Cape, 1985.

11 This information was obtained from the BT 64 series, which collectively contain the surviving files of the Civilian Clothing Directorate.

12 BT 64/3579.

13 BT 64/98, BT 64/853, BT 64/867, BT 64/893, BT 64/979 and BT 94/14 contain details of designation policies.

14 BT 64/177, taken from the draft of an article written by Francis Meynell ('Look Before you Leap'). Meynell was a poet, publisher, member of the Bloomsbury Group and Head of Consumer Needs at the Board during the second half of the war. By 1942 Meynell's department, set up at the end of 1941 within the Board of Trade, had started to assess demand for clothing.

15 See the documents referred to in note 13 above.

16 BT 64/853.

17 *The History of the Second World War, Vol. 4: Manpower*, by H.M.D. Parker, HMSO, 1957.

18 Handwritten memorandum by Hugh Dalton, BT 64/867.

19 M. Wray, in the first chapter of her book *The Women's Outerwear Industry* (Duckworth, 1957), details the position of ready-to-wear factories before the war.

20 BT 64/3579.

21 From notes on *The Present State of the Clothing Industry* by T.H. Heron, BT 64/3579.

22 A. France, *Penguin Island*, John Lane, The Bodley Head, [1909] 1925. This story states that St Mael mistakenly blessed penguins instead of people. As they had been blessed, the Council of Saints decided to dress them in identical clothes. The author of *The Times* leading article likens these clothes to Utility clothes.

23 Independent surveys and reports produced throughout the war on a variety of subjects including the public's attitude to Utility are now housed in the Mass Observation Archive, at the University of Sussex.

24 Mass Observation Archive, the University of Sussex.

25 A. Scott James, 'Deborah Kerr Shows Off the New Utility Clothes for Women', *Picture Post*, 28 March 1942, pp. 18–19.

26 *The Times*, 4 March 1942.

27 *The Times*, 12 May 1942, p. 2: 'War Time Clothes for Women. Expert fashion designers to prepare models.' (The Victoria and Albert Museum attributes some of the designs to Victor Stiebel. See N. Rothstein, ed., *Four Hundred Years of Fashion* Collins, 1984, p. 89).

28 From T.H. Heron's notes; BT 64/3579.

29 *Ibid.*

30 PRO BT 64/953. Some of the original clothes brought from the coupons are still in the Museum of London collection, others have been dispersed among provincial museums. In a letter to the author, Liz Salmon, Assistant Keeper of Decorative Arts at Stoke-on-Trent Museum states that much of the Stoke collection came from the Museum of London.

31 In 1943–44 *Vogue* (English edition) carried a number of adverts for Berketex Utility; all mention Hartnell's name. The first advert appears in January 1943. According to his autobiography (*Gold and Silver*, Evans Brothers, 1955, p. 102), when first asked to design for Berketex Hartwell refused, saying it would harm his status. The Board intervened, suggesting that his name as a designer would help promote the clothes. Hartnell apparently asked the Queen for advice; she replied: 'One has made so many charming things for me that if one can do likewise for my countrywomen I think it an excellent thing to do.'

32 BT 64/3579 (T.H. Heron writing on the response to the Couturier Scheme in 1944).

33 BT 64/3579.

34 BT 64/3579, letter to Dalton from Lord Woolton, 3 February 1944.

35 N. Harnell, *Gold and Silver*.

36 From T.H. Heron's notes; RT 64/3579.

9 ✧ Fashion, femininity and 'frivolous' consumption in World-War-Two Britain

Pat Kirkham

My lipstick and my engagement ring were two protections against Hitler. I'd never go without those.[1]

It is axiomatic that the good spirits of the fighting men depend on the civilian and more particularly the female of the species. And what do hers depend on? Well largely on her clothes ... this business of looking beautiful is largely a duty. (*Vogue*, 1941)

Fashion has never died in this War. (*Vogue*, 1944)

We have been making Utility clothes for years. (Molyneux and Hardy Amies) [2]

THIS CHAPTER addresses issues related to fashion and femininity during the period of 'Utility' dress, considers responses to fashion, cosmetics and looking attractive during a state of unprecedented national emergency and raises questions about 'necessary' and 'unnecessary' production and consumption during the war. Drawing on a range of sources including oral history, contemporary photographs and commentaries, extant dress and accessories, biographies and women's magazines, it challenges claims that there was no such thing as fashion during the years 1939–45.

As a small girl I never tired of hearing my mother and her friends talk about how they managed to look fashionable and glamorous during the war.[3] Forty years later, however, when I came to research the topic of women's dress during the Second World War, I was surprised to find secondary sources suggest that women's wartime attire and appearance was utilitarian, drab, uniform and somehow unrelated to fashion.[4] Primary sources show this to be far from the case. Being 'fashionable' and taking a pride and interest in what you wore was an important part of 'women's culture' which did not suddenly cease because Britain was at war.[5]

This is not to say that there were not those, women included, who thought fashion and related areas of women's culture trivial and frivolous

before the war, let alone during a period of immense hardship and self-sacrifice. One of the problems about writing about 'women', even during a period in which government agencies endeavoured to forge a common national identity across class and other barriers, is that 'women' did and do not constitute a single homogeneous group. During the war women were not all of one opinion, nor did they all behave in similar ways. Some differences related to age and class, but even within tightly-knit communities there were differences in attitudes towards dress and appearance between women of similar age.[6] Although younger and single women generally gave greater priority to questions of fashion and appearance, this was not exclusively the case, and one of the most poignant of all wartime diaries, that kept by Nella Last, a 50-year-old working-class Mass Observationist who was married with two sons in the armed forces, shows just how central those concerns were to older women.[7]

The period 1939–45 is a complex one in terms of desires and consumption, and if consideration of fashion and appearance in those years teaches us anything about the wider issues addressed by this book, it is the importance of considering questions of 'necessary' and 'unnecessary' production and consumption, not as absolutes or polar opposites, but as variable points within a broad spectrum between two extremes. 'Necessary'/'non-frivolous' and 'unnecessary'/'frivolous' are shifting concepts, dependent on specific historical and often individual circumstances. What was deemed important and trivial changed significantly in relation to certain items with the onset of war. New 'necessities' such as bombs and bullets were quickly accepted and prioritised. Staple items such as bread and adequate bedding continued to be considered necessary – as did sugar, a commodity which today would probably not make it on to a priority food list during a major national crisis. At the other end of the spectrum there was a general consensus that overly conspicuous and ostentatious consumption was not only unnecessary but also unacceptable. 'Useless' items, such as grape-scissors, diamond tiaras and extravagant *haute couture* ball-gowns were frowned upon as inappropriate objects of a lifestyle which had no place in the new world of war, where class divisions were played down in an attempt to unite the population more effectively behind the war effort. But not everything was so clear-cut. There were many objects related to the dress and appearance of women which were culturally contested, particularly in the early years of the war, when many people felt uncertain about what was and was not 'appropriate behaviour' in a rapidly changing world.

It cannot be said that the Civilian Clothing Scheme of 1941 described by Helen Reynolds in Chapter 8 of this volume met with general approval, or that there was a consensus about the need for 'fair shares for all' in

relation to clothing. No one argued about the functional nature of clothes, but 'frivolous' attire and items such as silk stockings, lingerie, lipstick and nail-varnish were another matter. In a situation of 'total war' and insufficient supplies of materials and weapons, there were inevitable tensions between the continued production of 'useless' items such as make-up and the expenditure of precious time and energy on personal appearance – no matter how 'rational', 'modern', 'democratic' or patriotic the mode.

Such was the power of certain social conventions that they ensured the continued production and consumption of 'non-essentials'. For example, production continued of non-medical corsets and civilian hats which from today's viewpoint seem unnecessary in a period of national crisis. However, so embedded in women's culture were they and other items of dress, underwear and make-up, that government restrictions on scarce materials and the use of labour were, at times, set aside. Difficult to describe as 'necessary' in any strict functionalist sense, these items were perceived by women as socially 'necessary' and by the government as 'necessary' for the morale of millions of women, many of whom were dealing with situations of considerable stress. Make-up, corsets and attractive clothes, hairstyles and accessories meant different things to different women; they also had multiple meanings for individual women. Among other things, they brought the comfort of familiarity and continuities, memories of times past, signified femininity and played a part in constructing confident 'fronts' which helped boost individual and collective morale.

The corset strengthened resolve as well as the back, and symbolised the feminine even when worn under military uniform or baggy overalls. So great was the War Office's concern to meet the demands of women and maintain the status quo in terms of gender relations during the first-ever period of women's conscription into the armed forces in Britain that the Board of Trade allocated vital and scarce materials, including rubber and steel, for the manufacture of corsets.[8] The Ministry of Defence commissioned the well-known foundation garment company, Berlei, to design a corset issued to every female in the armed forces; 'a garment designed to safe-guard women's femininity for the duration'.[9] Bold lipstick played complex roles in definitions of women's identities and sexualities. Sometimes worn in defiance of commanding officers and parents, this 'red badge of courage' was also worn in defiance of Hitler.[10] Nella Last's diary brings home the heroism and heartaches of everyday life during the war and the symbolic significance of 'putting on a brave face' – in her case, literally, with make-up. She wrote with remarkable self-awareness of her transition from a 'retiring' woman to one who 'uses too bright lipstick and on dim days makes the corners turn up when lips will not keep smiling'.[11] Aided by her cosmetics and her gayest of frocks, she, and millions

of other women, faced situations previously thought unendurable, including bombing raids and seeing sons off to war.

It is ironic that an aspect of women's culture previously considered to be trivial, if not narcissistic, should be endorsed by the state arguing that 'beauty' concerns should remain central to the lives of women. The British government considered 'beauty' vital to achieving the final victory by the nation. The focus on femininity also helped relieve fears (real and imaginary) about the 'masculinisation' of women entering the male world at an unprecedented rate and in unprecedented ways, and worked towards a successful re-establishment of pre-war gender relations after the cessation of hostilities. So great was the fear of collapsing morale in the face of possible military defeat, short supplies, men drafted into the military and many women working at 'men's' or different jobs or joining the armed forces, that in 1940 the government instituted a 'beauty as duty' campaign.[12] Women could not be relied upon to continue their pre-war preoccupations with fashion and appearance. The fear was that women might actually believe that such pursuits truly were not worthy of serious attention and set them aside – at least for the duration of the war, as German women were exhorted to do.[13] Older moral strictures about make-up had been breaking down in the inter-war years, but there were some British women who felt that the mood of national austerity should be reflected in individual appearance. In Australia this viewpoint led to an official 'austerity campaign' in 1942. This was backed by women's magazines which argued that it was both patriotic and smart to go without major signifiers of femininity such as pretty clothes, make-up and stockings.[14] The British government, by contrast, took the view that the morale not only of the Home Front but also of the fighting front (particularly men home on leave) was dependent on women looking and feeling attractive. American policy followed that of Britain, and women were encouraged to keep up their looks and their 'femininity'. The author of a *Ladies Home Journal* article of 1943 entitled 'War, Women and Lipstick' commented that it was a reflection of 'the free democratic way of life that you have succeeded in keeping your femininity – even though you are doing man's work! If a symbol were needed of this fine independent spirit – of this courage and strength – I would choose lipstick.'[15]

In Britain what had been deemed inconsequential and a matter of individual choice before 1939 became a matter of patriotism central to the war effort. In 1940 a committee was established comprising government officials, editors of women's magazines and others considered to represent the interests of women. Beauty as duty became a recurrent theme in publications which addressed women, from *Woman*, *Woman's Own* and *Vogue* to *Picture Post* (which appointed a 'woman's editor' in February 1940).

[handwritten margin note: These ideas contradict the term frivolous]

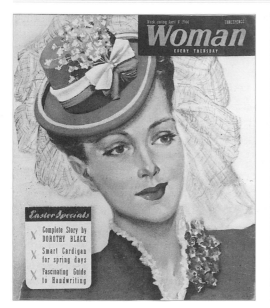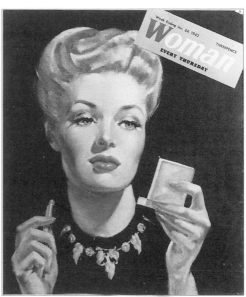

30, 31 Covers of *Woman* magazine, 8 April 1944 and 24 January 1942

Consumption which might otherwise have been considered frivolous, in-cluding sexy see-through nightdresses and hats adorned with artificial flowers, ribbons and veiling (figures 30, 31), was validated in these widely-read publications which backed to the hilt the government's 'beauty as duty' campaign. One woman who wrote to a national women's magazine in 1942 accusing her sister-in-law of the unpatriotic act of 'dolling herself up' found little sympathy from the editor, who supported the sister-in-law, defending her right to do so because it cheered people up to see well-dressed women.[16] Manufacturers who desperately wanted women to continue their traditional areas of consumption addressed uncertainties about the ethics of personal adornment and consumption in a period of national emergency. A Yardley advertisement of 1942, for example, assured women, 'never must we consider careful grooming a quisling gesture' – the use of the collective 'we' suggesting an address by one woman to others.[17]

The beauty business propagandised about beauty and duty even before the government; the December 1939 advertisement for Evan Williams Shampoo, for example, was captioned 'Hair Beauty is a duty, too!'. It urged women to beautify their hair for the forthcoming Christmas reunions; 'the men of the services on leave will expect and deserve it'.[18] A range of Icilma beauty aids advertisements in 1940 were captioned 'Beauty Is Your Duty' and Vinolia soaps stressed it was a woman's 'duty to stay beautiful',[19] while Tangee lipsticks and Conlowe rayon both promised 'beauty on duty'.[20] Slogans for the struggle against the enemy and beauty care became

interchangeable: in 1942 Yardley ran advertisements headed 'No Surrender', which proclaimed the ideal woman as one who honoured 'the subtle bonds between good looks and good morale'.[21]

The government exhorted all women to look as good as possible while, on the other hand, it restricted their means of so doing – and this was increasingly the case as the war stretched on. It was because the government understood that women's dread of being without 'a bit of face-powder and lipstick' or their corsets[22] was a very real one that production continued of items that were in no way related to the war effort except in relation to morale. However, although morale was of paramount importance, it was not simply a case of sanctioning everything women desired. There was a constant tension between the needs of the military war effort and the need to maintain morale. In 1942 the Board of Trade weighed the pros and cons of prohibiting cosmetics, which by then carried a high purchase tax. In strict economic terms it could not afford to allocate materials, plant and labour to such production when they could have been used to produce armaments, but the 'con' was that cosmetics were 'essential to female morale'.[23] Production continued – albeit restricted – with the exception of women munition workers, who were granted special allowances of high-grade make-up in an attempt to keep these key workers happy.[24] In the same year it was made easier for hairdressers to be exempted from conscription into factory work, 'since a neat head is held to be an invaluable booster of feminine morale'.[25] In late 1943, when the very suggestion that lipstick and nail-varnish might be taken off the market was sufficient to trigger 'acute feminine consternation' in all walks of life, the Board of Trade was forced to placate 'the female half of the population somewhat by announcing that there would be a small *increase* in the amount of cosmetics released for consumption' (emphasis added).[26]

Demand for cosmetics remained high throughout the war, despite high prices. Categorised as a luxury, they were subject to a heavy purchase tax, which suggests that the government did not regard them as 'essential' as did many women. Cost seems to have been less of a problem than supply. The middle-class Mass Observationist Celia Fremlin noted just how important appearance was to young working-class women in the Wiltshire factory to which she was conscripted. Fremlin's censorious tones underlie her descriptions, particularly of Peggy, who always wore 'nice dresses and stockings to work, regardless of the fact that among the dirt and oil of the machine-shop they were going to be ruined very quickly'.[27] Peggy stated that she was not going to work in 'slops' for anyone; she had always worn nice clothes for work and was not going to stop. There is no doubt that she and her fellow-workers took very seriously the question of appearance, though it seems to have been for their own concerns rather than out of

public 'duty'. Fremlin noted that some of the women spent approximately half their weekly wages on beautification. One spent 12s 11d on dance-shoes, 2s 6d on an ornamental flower for a dance-dress, 4s 6d on a shampoo and set and 1s 9d on nail-polish remover; another 7s 11d on wool and needles to knit a jumper, 3s 6d on a pair of stockings, 2s 6d on a jar of cold cream, 1s 6d on vanishing-cream and 5d on ribbon.[28]

When women's desires in relation to particular items such as stockings and cosmetics were not met by the government, many simply purchased them on the black market, on the basis that there was nothing wrong with obtaining such items by illegal means, even though these very same women regarded the illegal purchase of other items as immoral. Time and time again women recall how they thought that it was 'not really wrong' to use the black market for stockings and make-up because 'everyone did it', 'we really needed them' and 'we thought of them as a necessity'.[29] The general sanctioning of what were illegal purchases because they were central to women's femininity indicates that these items were reclassified in people's minds as necessities or at least as necessary luxuries. Women, to a degree, redefined what was accepted as 'necessary'; if that fitted government regulations, then that was fine. If not, they were prepared to break the rules. Even in the armed forces some women regularly disregarded regulations about the appropriate amount of make-up to be worn (despite, or rather more probably because of conscription, make-up was not banned in the women's branches of the armed forces). Rules about length of hair and length of skirt were also broken, often by working-class women whose views of 'appropriate' appearance and what was or was not in 'good taste' differed from those of their officers.[30]

It is well known that Churchill was against the introduction of the rationing of clothes on the grounds of morale, and his statement about government interference with something so personal as 'a man and his wardrobe'[31] suggests that there was some understanding in the government of the complex issues related to clothing, consumption, identity, morale and other matters. It was vital that the Civilian Clothing Scheme did not undermine other morale-building propaganda aimed at women. It therefore attempted to provide necessary clothing while satisfying its 'customers', particularly women, in terms of the fashionability of what was on offer. What has not been sufficiently stressed in the past is just how closely Utility clothes for women followed the fashions of Paris, London and New York at the outbreak of war and just how close they were to the fashion 'looks' portrayed in American and British women's magazines during the period from 1939 to 1945, even though America was not at first at war and when it was, did not institute a government-controlled clothing scheme. Items such as tailored suits with longer jackets (25 inches) and shorter

skirts (16 inches off the ground), trousers, turbans, rope-soled sandals and snoods could not have been the direct result of wartime economies as some have argued, because they appear in both the 'quality' and popular fashion magazines of early 1939. Fashion dictated the *appearance* of Utility dress more than wartime economies. Had economy or rationality been the sole guiding criteria, then why retain skirts that were often flared and pleated (certainly not pencil-slim), and which went all the way down to the knee? Why jackets with large shoulders, which not only took up precious fabric but also required padding? Clearly other factors, including fashion, were important.

Proof of the intention that the Utility (CC41) clothes should be fashionable as well as durable lies in the fact that the government brought in the very top designers, such as Hardy Amies, Edward Molyneux, Digby Morton, Victor Stiebel and Worth to produce prototypes.[32] Proof of fashionability lies in the facts that *Vogue* welcomed the scheme and that the up-market non-Utility manufactured clothes which made up the other 15 per cent of the market ('Utility' accounted for 85 per cent), as well as the home-dressmaking sector, followed the styles and trends set by the 'Utility' Scheme. This all suggests that the goods on offer and the variety available were, to a large degree, deemed acceptable to the wardrobe of fashion-conscious women. This is further supported by the fact that clothes which could be described as 'Utility' regularly appeared in the pages of fashion magazines in the USA throughout the war.[33]

According to British *Vogue*, fashion was 'slow but sure' during the war.[34] New trends developed, such as that for small witty prints which enlivened frocks, blouses and other items, and, although the traditional fashion 'seasons' officially ceased, there were definite and changing fashions in colours, patterns, hemlines, accessories, hairstyles and hats – not only from year to year but also from season to season. In 1942, for example, pastel shades were 'in' for spring and summer, while the following spring saw a greater mixing and matching of colours, patterns and garments, and 1944 favoured bold vivid contrasts.[35] The government-sponsored 'Make Do and Mend' campaigns (figure 32) offered women many aids and tips to be fashionable during the war, and the items featured were far less dour than the name implied – as was, of course, the case with the term 'Utility' itself, which was hated by clothing manufacturers because they felt it insulted their products. If fashion had remained static, there would have been little demand for the many clothes remodelling agencies which flourished during the war, there would have been far less home dressmaking, and certainly less of the wonderfully creative improvisation involved in producing fashionable outfits which copied 'Utility' styles out of whatever was to hand – from old dance-dresses to a new suit worn with a revamped

32 'Make Do and Mend' in *Woman* magazine, 28 February 1942

blouse, to frocks made out of curtains, skirts out of cut-down military uniforms or dressing gowns and lingerie from parachute-silk (though this was not so widespread as is sometimes thought).

Choice was not as great as in the pre-war years, but the Utility Scheme allowed for thousands of permutations of line, detail, finish, fabric and trimmings, thus offering a considerable degree of choice. Designers and home dressmakers alike made clever use of fabrics, combinations of fabrics and details such as collars, neck-ruffles, pin-tucking, buttoning, belts of all sizes and shapes, quilting, piping, peplums, bows, overstitching and open-work, to ring changes.[36]

Female civilian hats – not exactly a functional necessity – were neither banned nor rationed during the war, and contemporary photographs show that they were regularly worn by women from all walks of life, particularly by those over 30 years old. Such was the strength of the convention of wearing hats that demand continued and production continued, albeit on a restricted scale. Prices soared, but many middle-class women such as Ernestine Carter could afford to buy new hats to cheer themselves up 'when the news was extra bad',[37] and sometimes working-class women were lucky and found affordable new ones in shops or on the black

market.[38] Many hats were remade; a piece of veiling, a few flowers and a lot of patience meant that one had a new and fashionable item to wear for relatively little cost. Hats were especially important for weddings and church-going. Although the Archbishop of Canterbury reassured women that they would not forgo their chance of a place in heaven if they failed to wear a hat to church on Sundays, the practice continued.[39] An acceptable alternative for many other occasions was the less expensive yet stylish headscarf, a pre-war fashion item which became one of the most popular products of the war years and was worn in a variety of ways.

Hair remained a major marker of femininity, and instant glamour could be achieved by unrolling long tresses. In the early years of the war some women adopted the 'patriotic' 'Liberty Cut' or styles such as the 'Regimental Curl'. Nella Last describes an almost pathological impulse to have her hair cut short at the beginning of the war – as if that in some way would satisfy her that she was doing everything she could for the war effort. The disapproval of the men in her household led her to grow her hair again, but for a while she knotted it at the back of her neck; she was still not sure that her former style was appropriate for the new circumstances of war. For Christmas 1940, however, she decided to have a 'permanent wave', which she had favoured as suitably feminine and fashionable before the war.[40] This example is a reminder of the immense symbolic power of 'things', including hair-design.

'Feminine' underwear became scarce during the war, but it should be remembered that a great deal was made at home and that extant 'Utility' examples suggest that manufacturers were more liberal with lace and trimmings than the government regulations allowed.[41] Less easily available on the black market than, say, stockings, what underwear women did have was 'treasured'; washed and stored carefully, with the 'best' worn only on high days and holidays. Service-issue knickers were known as 'passion killers' because of their lack of erotic appeal, but the name also suggested a lack of the particular soft, suggestive and alluring type of femininity associated with traditional lingerie. Advertisements regularly suggested that wearing 'feminine' underwear under military uniform or quasi-military uniform was a means of preserving one's femininity in a 'man's world'.[42] Dainty lingerie was a staple trousseau item in the late 1930s and remained so in the dreams of many women. Brides-to-be and their friends collected coupons so it could be bought or sewed long into the night to ensure that some of the 'frivolous' markers of femininity continued to contribute to special significant events during wartime. In the 1943 film *Millions Like Us*, one of the female characters argues that coupons spent on lingerie for a honeymoon rather than on more practical items would prove a good 'investment'.

The number of women who managed to marry in traditional white wedding-dresses and veils during the period of clothes rationing is remarkable.[43] Such occasions symbolised a past of peace and normality which they hoped for in the future. Fancy hats, bouquets and flower-sprays helped transform the tailored suit and matching accessories into the 'wedding outfit' for those brides who did not choose or could not afford the conventional 'white wedding'. Both were fashionable, even though the 'form' of one was more 'modern' than the other.

Weddings, honeymoons, big dances and men home on leave were the main occasions for 'glamour', and many wedding-dresses were altered and dyed to find a new life as dance-dresses. The garment which perhaps above all others signified luxury and added instant glamour to an outfit was the fur coat, yet this pre-war 'luxury' item was not so classified by the Board of Trade, because it believed that significant savings of fabrics suitable for military uniforms would be made if women would wear coats of fur.[44] They were even planned for the 'Utility' range and were available on coupons towards the end of the war. If these 'Utility' furs did not play a large part in maintaining the morale of women during the entirety of the war, they played a role in the very last part of it and in the years immediately afterwards. They were certainly seen as luxuries by, and helped maintain the morale of, those de-mobilised servicewomen who spent some or all of their 'demob' pay on them.[45]

This discussion of women and wartime appearances and consumption is by no means exhaustive, but I hope that it is sufficient to indicate that histories which see the war as a period of utilitarian and uniform dress and appearance miss some of the more intriguing aspects of production and consumption in that period. 'Utility' clothes were not simply utilitarian. Nor were they dull, uniform or unfashionable. 'Frivolity' within women's dress culture had its place and was, on many occasions, validated officially in a way that would have been incomprehensible before the war and needs to be considered within the context of Home Front morale.

Notes

1 Maggie Wood, *'We wore what we'd got': Women's Clothes in World War II*, Warwickshire County Council, 1989.

2 Hardy Amies's introduction to Colin McDowell, *Forties Fashion and the New Look*, Bloomsbury Publishing, 1997, p. 11.

3 I was born in 1945 in Northumberland, the daughter of a housewife (my mother had to give up her job in the local Co-op store when pregnant with me) and a coal-miner, whose 'reserved' occupation brought full employment during the war. Being fashionable was an important part of my mother's culture before, during and after the war. This chapter is dedicated to her and to her friends for introducing

me to the complex meanings and pleasures of 'things', including dress; to Nella Last, whose wartime diary moved me enormously; and to the 'millions like them', whose courage and convictions still go largely unheeded by historians.

4 See Jane Ashelford, 'Utility Fashion', in *CC41 Utility Furniture and Fashion 1941–1951*, catalogue, Geffrye Museum, London, ILEA, 1974, p. 33 and, to a degree, McDowell's interesting *Forties Fashion And The New Look*, although somewhat contradictory evidence is offered in relation to fashion in this book. An oral history compilation, Wood's *'We wore what we'd got': Women's Clothes in World War II* and Joan Heath's ' "Fashion by Government Order": Fact or Fiction?', unpublished undergraduate thesis, North Staffordshire Polytechnic (now Staffordshire University), History of Art and Design, 1988, redress the balance and challenge what has become an orthodoxy in dress history.

5 To discuss fashion and what some might consider some of the more 'frivolous' aspects of production and consumption and time spent on making oneself look attractive during the war is not to deny the many and significant hardships suffered by women during those years. The heroism of Nella Last in dealing with the contingencies of 'everyday' wartime life leaps out from her writing; but her enjoyment of attractive clothes and underwear (the one thing she protected during bombing raids) was as much a part of her wartime experience as was her voluntary work, her fears for her sons or impatience with her husband. See Richard Broad and Suzie Fleming, eds, *Nella Last's War: a Mother's Diary 1939–45*, Sphere Books, 1981.

6 These differences are well exemplified by my mother and her only sister (2 years older) whose views on dress were more conservative and conventional – not only than those of my mother, but also than their mother, my grandmother.

7 Broad and Fleming, *Nella Last's War*.

8 Angus Calder, *The People's War: Britain 1939–45*, Panther, 1971, p. 438.

9 *Picture Post*, 2 March 1940, p. 26.

10 Wood, 'We wore what we'd got', p. 62. I took the phrase 'the red badge of courage' from a movie title, but Margaret Maynard of the University of Queensland very kindly pointed out its use by Man Ray.

11 Broad and Fleming, *Nella Last's War*, p. 266.

12 See Pat Kirkham, 'Beauty and Duty: Keeping Up the (Home) Front', in Pat Kirkham and David Thoms, eds, *War Culture: Social Change and Changing Experience in World War Two*, Lawrence and Wishart, 1995 and Pat Kirkham, 'Fashioning the Feminine: Dress, Appearance and Femininity in Wartime Britain', in Christine Gledhill and Gillian Swanson, eds, *Nationalising Femininity: Culture, Sexuality and British Cinema in the Second World War*, Manchester University Press, 1996.

13 Lou Taylor and Elizabeth Wilson, *Through the Looking Glass*, BBC Books, 1989, pp. 107–8 and Kirkham, 'Beauty and Duty', note 6.

14 Sandi Clarke, introduction to catalogue, *Dressed to Kill, 1935–1950*, Brisbane, 1985, p. 3.

15 Cynthia Henshorn, 'Commercial Fallout: the Image of Progress, the Culture of War, and the Feminine Consumer, 1939–1959', unpublished PhD thesis, City University of New York, 1997, p. 135.

16 *Home Chat*, March 1942, letters page.

17 McDowell, *Forties Fashion and the New Look*, p. 54.

18 *Picture Post*, 16 December 1939, p. 66.

19 Caroline Lang, *Keep Smiling Through: Women in the Second World War*, Cambridge University Press, 1989, p. 100 and Jane Waller and Michael Vaughan-Rees, *Women in Wartime: The Role of Women's Magazines 1939–1945*, Macdonald, 1987, pp. 99–100.

20 *Woman*, 9 August 1941.

21 Yardley advertisement, July 1942, cited in Waller and Vaughan-Rees, *Women in Wartime*, p. 102.

22 The quotation is taken from conversations with my mother, Gladys Dodd, in February 1976. The other women I have interviewed and spoken to less formally have nearly all mentioned make-up or foundation garments, as did those interviewed in the 'Leicester women at war' project organised by The Living History Unit, Leicester City Council.

23 Calder, *The People's War*, p. 321.

24 Ashelford, 'Utility Fashion', p. 33.

25 Mollie Panter-Downes, ed. William Shawn, *London War Notes 1939–45*, Longman, 1972, p. 257.

26 *Ibid.*, p. 310.

27 Celia Fremlin, *War Factory. Mass-Observation*, The Cresset Library, 1987, p. 34.

28 *Ibid.*, pp. 93–4.

29 See Wood, 'We wore what we'd got' and the Leicester women at war project. Nearly all of the women to whom I have ever spoken or have ever heard speak about this have made comments such as these.

30 Wood, 'We wore what we'd got', *passim*. See also Kirkham, 'Fashioning the Feminine', pp. 159–60.

31 See Chapter 8 in this volume.

32 For dress and the Utility scheme see the works cited in notes 4, 12 and 13 as well as Elizabeth Ewing, *History of Twentieth-Century Fashion*, Batsford, 1986, chapter 6 and Peter McNeil, ' "Put Your Best Face Forward": the Impact of the Second World War on British Dress', *Journal of Design History*, Vol. 6, No. 4, 1994, pp. 283–99.

33 (American) *Vogue* and *Harper's Bazaar*.

34 *Vogue*, December 1943 quoted in Heath, ' "Fashion by Government Order" ', p. 28.

35 *Vogue*, 1942–44. The spring 1943 fashion, first featured in *Vogue* in 1943 as the 'New Look' and later in the year taken up by the more popular magazines, was one of the wartime fashions influenced by the 'Make Do And Mend' propaganda and 'street' fashions which violated the 'high fashion' code of only wearing a suit jacket with the skirt with which it was bought. See also Angela Partington, 'Popular Fashion and Working-Class Affluence', in Juliet Ash and Elizabeth Wilson, eds, *Chic Thrills: a Fashion Reader*, Pandora Press, 1992.

36 Kirkham, 'Fashioning the Feminine', p. 158.

37 Heath, ' "Fashion by Government Order" ', p. 29.

38 Broad and Fleming, *Nella Last's War*, p. 200.

39 Kirkham, 'Fashioning the Feminine', pp. 162–3.

40 Broad and Fleming, *Nella Last's War*, p. 89.

41 Heath, ' "Fashion by Government Order" ', p. 21.

42 Waller and Vaughan-Rees, *Women in Wartime*, p. 102 cites a Wolsey advertisement
 which reads:

 Keep beneath your Dungaree
 dainty femininity! Wearing
 while you do your bit,
 Wolsey undies fairy-knit!
 [...]
 Emerging from your chrysalis
 a Wolsey jersey frock is bliss!

43 See Kirkham, 'Fashioning the Feminine', pp. 166–70. Some women managed to
 look like film-stars – literally so in the case of those who took advantage of the
 wedding-dress (and evening gown) hire service from the Gainsborough Film Studios.
 Gowns were available without coupons at a 'moderate hire cost' (advertisement in
 programme for the Comedy Theatre, London, n.d., possibly from the immediate
 post-war period; the play was *The Man From The Ministry*). I am grateful to Mimi
 Martell for recently giving me this programme – and for much else besides.

44 Elizabeth Ewing, *Fur in Dress*, Batsford, 1981, p. 131.

45 Wood, 'We wore what we'd got', p. 70.

10 ✧ Utility forgot: shaping the future of the British pottery industry 1941–45

Graham McLaren

It is the glorious month of June
And quotas will be coming soon.
We have no plates, we have no mugs,
We have no cups, we have no jugs.
So when you have the same in stock,
Please send some Willow Pattern crock. (1942)

W HEN IN 1945 The *Architectural Review* launched a 'Design Review' section with an advisory panel composed of many of the leading modernist thinkers of the period, including Misha Black, Nikolaus Pevsner and Herbert Read, it was generally highly positive about the purifying role of Utility as a design aesthetic,[1] but reserved particular praise for ceramics:

> the Utility designs for tableware have probably reached the highest standard of any Utility products; and these have been produced naturally within the industries themselves without any of the 'sweat and toil' which unavailingly has been expended in many other fields.[2]

This enthusiasm begs the question of why since then Utility ceramics have largely been ignored by design historians.[3] Part of the answer must surely lie in the early concentration of research on the experience of the furniture industry within the Scheme, a focus partly caused by the popular misconception that saw Gordon Russell as the 'creator' of the Utility aesthetic.[4] A further explanation which tells us much about the way in which the decorative arts are discussed and indeed valued according to surface interest, is that the application of the scheme to ceramics resulted, at its height from about 1943 onwards, in the reduction of form to a bare, ascetic minimum with the total elimination of any colouration, even to produce a backstamp (figure 33). This of course is one of the elements of Utility which excited advocates of modern design who looked to continental interpretations of Modernism as an answer to future design

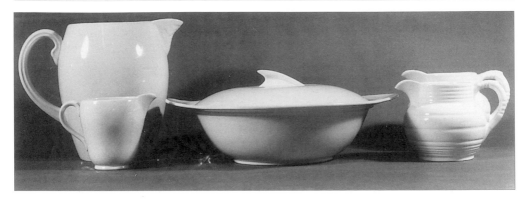

33 A range of Utility earthenware of the 1940s and early 1950s by Stoke-on-Trent manufacturers

needs. Clean lines seemed to epitomise the aesthetic qualities of German modernism in particular (although this could never be stated overtly during the war). Its widespread use in the British home through Utility ware seemed to hold out the hope of improving public taste in ceramics. Utility ceramics, however, appear to offer current observers very few aesthetic or critical footholds by comparison with Utility furniture, which can to some extent still be discussed in terms of form, decoration, quality of materials and workmanship, while ceramics appear merely to have been reduced to a dull, bare minimum, and so were truly 'utilitarian' in comparison.

If these factors help us to understand why we know so little today about the position of ceramic production within the Utility Scheme as a whole, it is also very important to acknowledge that the process of 'forgetting' Utility ceramics actually began during the early 1940s, and after the war performed a key role in the redevelopment of the British pottery industry. From the late 1940s onwards this process took the form of a reaction away from the austerity of Utility towards ware covered with intricate patterns and bright colours. This reaction was as much about the hopes and beliefs of a few influential individuals as it was about institutions and government. Their early support for, and subsequent loss of faith in the Scheme, frequently played out in the pages of the trade press, will be the focus of this chapter, as will the tensions which existed between government and industry, and the battle between them, quite literally, over the future shape of British ceramics.

The 'very real hostility'[5] towards the largely London-based 'design establishment' felt by the pottery industry (and particularly its insular Staffordshire core,[6]) had its roots in the pre-war period, and was provoked by the campaigning work of organisations such as the Design and Industries Association (DIA). These arbiters of design were frequently and loudly

critical of the reliance of the pottery industry on largely nineteenth-century decorative traditions. Such overt criticism concealed dangers for the modernisers. As early as 1937 Nikolaus Pevsner had recognised this by warning modernists against ridiculing nostalgia and decoration, because this 'can only deter people from studying the modern style, and from trying to appreciate it'[7] Nevertheless, the eventual embracing of the movement by British industry was seen as inevitable by Pevsner, 'For it is a simple and rational style.'[8] He took the lead in ceramics from the products of the Bauhaus, because they expressed 'the spirit of the twentieth century'.[9] However, he only provided two named examples of British ceramics which conformed to the modernist aesthetic – Royal Doulton's acid jars and the 'Cornish Cookware' range manufactured by T.G. Green.

The 'concentration' of the industry (a process of government-planned factory amalgamations and closures) had by the early 1940s imposed a functionalism far more austere than Pevsner could have hoped for, and led many manufacturers to associate the stylistic elements of Modernism with state control during the war and also (their greatest fear), after it. As the controlling grip of the government on all stages of the production and distribution process grew ever tighter, the hostility of industry would have probably been total, had it not been for the mediation of certain individuals who acted as bridges between industry and government.

Of these, Gordon Forsyth and Harry Trethowan stand out as key to an understanding of the industry's perception of Utility ceramics. Forsyth, Superintendent of Art Instruction in Stoke-on-Trent from 1919 to 1945, was a highly respected figure in the industry and well known nationally as someone who wished to raise the standard of ceramic design. Harry Trethowan, managing director of Heal's Wholesale and Export Limited and a former President of the China and Glass Retailers' Association, was also a very real influence on the industry from the retail side of the trade. As a buyer of ceramics of long standing, he was regarded as a man well able to gauge the taste of the buying public, and was therefore held in high regard by the industry. Both were known nationally as well as in the Potteries, frequently writing articles for the trade press and appearing on various design-related committees (Forsyth, for instance, was Art Adviser to the British Manufacturers' Federation, while Harry Trethowan had been a member of the Gorrel Commission on Art and Industry). They also shared some (but by no means all) of the tenets of Modernism. In particular, their view that the basic shape of the piece, rather than its decoration, was the overwhelming issue facing ceramic designers, formed a valuable bridge between their beliefs and the wider concerns of the modernist critics like Pevsner.

The positive attitude represented by Forsyth and Trethowan was par-

ticularly significant because the government had to overcome the industry's opposition to Utility ceramics which began as soon as the Scheme, with all of its implications in terms of concentration, was first mooted. The manufacturers, hoping to preserve as much of their industry as possible, had proposed an approach which would have kept planned factory amalgamations and closures to a minimum. But this proposal was rejected out of hand by the Board of Trade in favour of a much more drastic reduction of the industry. In this context the logical, balanced argument,[10] generally in favour of the scheme put forward by individuals like Forsyth and Trethowan, had a role in tempering the anger of industry towards the government.

In order to achieve agreement they had to explain the logic behind Utility in a form acceptable to industry. This was important because the Scheme quickly opened divisions between 'concentrated' manufacturers and the 'nucleus' firms which had been allowed to continue production. The nucleus firms were predominantly the fine china firms with established records of export achievement – because exporting to win hard currency (particularly American dollars) was a central plank of government economic policy during the early years of the war. Some in the industry believed they saw duplicity between government and the nucleus firms; and although the argument in favour of export earnings eventually proved unassailable, supplying export markets did pose an early and severe ideological problem for those advocating modern design. The output of nucleus firms was overwhelmingly traditional in both form and decoration, with the emphasis heavily on the craft skills which had historically found a ready market in North America.

By comparison the competitive earthenware and stoneware sectors of the industry, specialising in low- to mid-priced ware for home consumption, bore the brunt of concentration. This was also the sector of the industry which had proved most adaptable to the ideas of continental Modernism immediately before the war, and so the closure of forward-thinking companies like that owned by Susie Cooper was undeniably a blow to those seeking an improvement in the quality of future British ceramic design. The early years of Utility clearly posed as much of a threat for those who hoped to see new, modern shapes thriving, as for the traditionalists who feared the demise of skills in ceramic decoration.

Supporters of Utility like Forsyth and Trethowan had to justify it in the context of wartime need, with the added value of 'wiping the slate' for ceramic design in the post-war period. Articles in the early 1940s by both men use terms like 'chastity', 'virginity', 'cleanliness', 'morality' and 'new growth' to describe the potential of the Scheme. Nor were they alone in setting this tone. The American trade press, for example (in this case

the journal *China and Glass*), chose to present the hardships that Utility imposed on the home market as epitomising the brave struggle of the industry:

> But in our awareness of their problems, let us not forget that the British potter, too, has lost the major portion of his skilled workers and has had to find substitutes for some of his materials; that for long periods of time his work was done under the constant threats of air raids, and that often enough the threats materialised into actual bombings ... The home market has been under stringent restrictive measures. Only utility articles are manu-factured for home consumption. A simplification program has had drastic effects on china and earthenware in English homes. Colours are entirely eliminated ... England is sacrificing in comfort and commodity.[11]

The key element in all this discussion was the belief that Utility fundamen-tally embodied a moral approach to the necessities of war, and that this enforced morality could have benefits extending beyond the end of the war. Both Forsyth and Trethowan clearly hoped that the Scheme would impose new aesthetic standards on the industry. For instance, Forsyth, writing in 1942, suggested that 'They [the Board of Trade] can be as ruthless as they please in the elimination of inane "fancies", and any waste of skilled labour on alleged "Art" pottery'.[12] This moral tone can be seen at its most extreme a year later in an article in the *Studio* by Harry Trethowan, which emphasised the testing nature of war (and by implication the Utility Scheme) for the British pottery industry:

> This day of austerity, in every phase of its rationed life, proves to us that hitherto we were wasteful and improvident – wasteful in every section of our life – and the things of which we have been deprived create no real hardship, and life is not really inwardly or outwardly defrauded or con-strained. We have in all spheres time to estimate life's true values ... how are we going to assess the values, and are we going to be *the better* for having passed through a fire that refines? [13]

The date of this article (1943), is highly significant, in that it marks something of a turning-point in attitudes towards Utility. The accompanying editorial hints at the reason: 'by giving space to the Utility wares here illustrated, the *Studio* looks beyond the present, and sees in the present the future prospect ... what will he [the potter] make of this great chance?' [14] By 1943 the concept of eventual victory in the war was moving from being a hope to a probability; a change in feeling which was marked at governmental level by increased investment in reports discussing the reconstruction of the post-war economy, and at the level of industry by a mood to reassert its independence from government control.

In the face of these changing attitudes to the war, the role of com-

mentators on Utility necessarily had to change. The mid-1940s were a period of reflection on the possible long-term future influence of the Utility aesthetic. Interestingly, one of those who were employed by the government to carry out studies towards post-war reconstruction was Forsyth's daughter Moira, who suggested in her report 'Design in the Pottery Industry' for the Nuffield College Social Reconstruction Survey (1943) that while Utility ware 'bears out the contentions of functional dogma',[15] 'Functionalism, or "Fitness for Purpose" as an aesthetic creed, made no appeal to the pottery industry'.[16] The original moral underpinning of Utility as it affected ceramic production, that it was an unfortunate necessity of war intended to make the best use of vital labour resources and conserve valuable raw materials, was also re-evaluated by Moira Forsyth in her report. She interpreted these altruistic reasons instead as government dogma, citing plain coloured bodies, for instance, as being 'forbidden as being too attractive to the purchaser'.[17] The language Moira Forsyth used to discuss Utility suggests that she thought the austere appearance of the ware was due more to the influence of a pro-modernist tendency at the Board of Trade than to the necessities of war.

Although there is no substantive evidence to suggest that this was the case, Moira Forsyth's report does reflect a loss of faith on the part of many who had formerly been in favour of the Scheme, and a concern that control in the future would no longer be in the hands of the industry. The strongly-held belief that the design and manufacture of ceramics was something which could only be achieved as a result of long training and experience within the industry was already perceived as under attack by the government and the London-based design establishment, as can be seen in the war of words which raged in the correspondence columns of *The Times* during September 1942. The debate was started by J.P. Blake, Chairman of the London County Council, who believed that Utility was 'an unparalleled opportunity to put good designs into nearly every home in England. Fortunately, good designs in pottery or glass cost no more to make up than bad ones; so let us, if you please, have the good ones.'[18] In this context the industrialists' ire was caused not so much by the Utility Scheme itself as by the 'unbearable insolence'[19] of such outside interference in pottery design. Lord Sempill's letter favouring the Board of Trade taking over design decisions in the pottery industry[20] and, worst of all, Dorothy Allhusen's suggestion that designs should be produced by the 'many refugees now in Great Britain who are versed in the art of making beautiful pottery and glass'[21] confirmed all of the manufacturers' worst fears:

> The assumption underlying the recent stir is that no one now in the industry is capable of good shapes; but that all over the rest of Britain (and, as we

have seen, from the Continent – an idea that in its possibilities of bad feeling might have come from Goebbels) are lots of artists able and eager to do good ware, who are not allowed to do it, and who must therefore do it for some committee that will dictate its use to the manufacturers.[22]

Behind this debate (and particularly that part of it which dealt with 'foreigners') lay a concern on the part of manufacturers that the national characteristics of pottery design, which had differentiated the industries of different countries, ran the risk of being diffused in the post-war world. As early as February 1942 John Desmond (the editor of the *Pottery Gazette*) was noting that the concentration of the German pottery industry had been so structured that no factory had been allowed to go out of business, operating instead on a 'skeleton staff' and keeping the prospect of a healthy differentiation of production for the post-war period by comparison with the homogenising process of the Utility Scheme in Britain. Alarmingly for long-term trading prospects, even though German imports of ceramics had already been banned in America, it was noted that 'Under the name of "Castleton China" many of the much-admired [German] Rosenthal designs and shapes are being made in the States.'[23]

The British manufacturers' concerns regarding ceramic design centred on how to keep control of the design process away from central government and retain a characteristically British aesthetic in the post-war period. This was regarded as essential in order to stave off competition from foreign (including German) competition. A final spur to these concerns was provided by Gordon Russell's increasingly high profile. His self-identification as an 'interior architect',[24] and therefore equipped to judge the design of ceramics as ably as he could furniture, certainly reinforced to the pottery industry the notion of Utility as a centrally-conceived design style based on government defining what manufacturers should produce. More tellingly it also focused their attention on the experience of the furniture industry under Utility, where design decisions were taken out of the hands of manufacturers by government. Although those who were most concerned with design within the industry quickly discounted a government take-over of ceramic design as a serious threat,[25] the notion that Russell sought to treat ceramics in the same way as furniture became part of a popular mythology of an anti-manufacturer, centralising government machine within the pottery industry which continued well into the post-war period.[26]

Amid these tensions it is not surprising that the unified approach of commentators from within the industry like Trethowan and Forsyth should itself come under pressure. Although they both believed that an answer to the problem of post-war reconstruction of the industry, and in particular to its future identity through design, lay in focusing on the role of shape, their attitudes towards the value of the Utility Scheme in this process

began to diverge. As late as 1944 Harry Trethowan was still extolling the value of Utility to the trade while diplomatically shifting the blame for pre-war excesses in design from industry to the retailer and consumer:

> Your palette is clean. You have a glorious opportunity to lead public taste, instead of being misled by buyer and public. What has undermined the greatness of your industry is that for many years you have been called upon to supply articles to increase turnover.[27]

By contrast, for Gordon Forsyth the Utility Scheme presented a direct threat to the retention of national identity through ceramic form. He campaigned vigorously to retain the pre-war, traditional 'British' shapes, but shorn of decoration as an approach to the production of Utility. In an important 1944 article on 'Planning Prosperity' in the *Pottery Gazette* (with the heading: '"Utility" will die as quickly as it was imposed'), he argued for just such an approach, comparing in illustration the 'excellent' traditional shape of a piece of Pountney hotelware with the modern, cylindrical 'Mass Utility' which was 'produced by the million to Government specification, and likely to damage [the] reputation of British Potters' (figure 34).[28]

With hindsight, however, we can see in the basic cylinder shape of mug illustrated by Forsyth as an example of the government-inspired 'elephantine cups, with clogs on for handles'[29] a shape which was to prosper in the post-war period. The new technology of the tunnel-kiln, demanding constant 'feeding', pushed manufacturers towards more limited ranges of standardised, easily stackable shapes. The mug which Forsyth described as being 'produced by the million' proved remarkably useful as a vehicle for the new generation of photo-lithographic and silk-screen

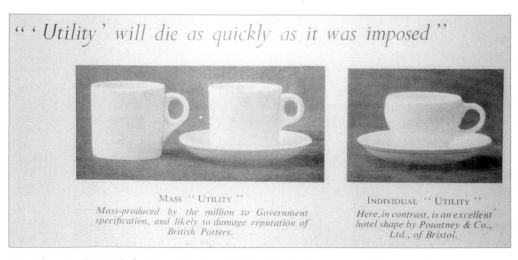

34 'Planning Prosperity', *Pottery Gazette and Glass Trade Review*, May 1943

printed decoration, and it is a shape which continues to be produced (in a suitably refined form) to this day.

How do we explain this wartime emphasis on shape as an answer to the post-war needs of the pottery industry? The debate had its beginnings in the early 1940s,[30] but by the end of the war it seems to have offered those who wished to see an improvement in ceramic design after the war a 'middle way' between the emphasis on *laissez-faire* capitalism promoted by the industrialists and the spectre of post-war centralisation and government control of design raised by the example of the Utility furniture. This 'middle way' was a unifying approach to Reconstruction towards meeting the hope of most manufacturers for a return to pre-war eclecticism in design and above all a future controlled by them, based on pre-war design traditions. For the modernisers it could also retain something of the essence of the pre-war design reform debate in its emphasis on getting to the very root of the problem – shape and form.

Above all, however, the concern over the impact on ceramic design of the Utility Scheme was part of the posturing and positioning between various groups with an interest in the future of the pottery industry. The broad consensus which had existed between manufacturers and the unions throughout the war broke down in April 1945, when the National Society

35 Illustrations, 'Good Shapes Already Exist', *Pottery Gazette and Glass Trade Review*, November 1942

of Pottery Workers split away from the National Pottery Council and at the same time issued a widely circulated report on reconstruction in the industry which clearly favoured nationalisation. On the manufacturers' side, the rejection by the Board of Trade of the industry's Post-War Reconstruction Scheme in February of the same year, together with the clear signal from government that austerity measures would continue for the foreseeable future, reawakened hostilities which were never far from the surface.

One group for whom the emphasis on shape could never be a complete answer, however, were the designers. The struggle for the recognition of the designer's role as an important element of reconstruction was an arduous one. Designers in general (and particularly those who worked 'in house') had never been accorded high status within the pottery industry. Those promoting their cause faced the very real problem that pottery design as an activity had come to a virtual standstill because of the necessities of concentration and conscription of the best young designers. During the early years of the war, pottery designers, and particularly their representative body, the Society of Industrial Artists (SIA), had shared the despondency of manufacturers regarding the future of the industry.[31] At this time the heritage of the industry was seen to be not so much in the objects themselves as in the men and women who designed and made them, and much was made of the irretrievable loss of skills within the industry because of conscription.

The designers' initial despondency, however, quickly turned to optimism over the improving influence of Utility upon ceramic design. The SIA seems to have allied itself most closely to the early opinions of Gordon Forsyth, who 'knows what he is saying and has had plenty of opportunity to find out the facts'.[32] A November 1942 statement presenting their position to the industry stated:

> the S.I.A. sees the position as regards ceramic shape design as generally satisfactory. The need to produce only plain ware will direct attention from both designers and manufacturers to those plain shapes which the industry already makes in great variety ... The restricted production of it will have the greatest influence for good, because the number of functions to be performed by each item will cause close attention to be given to detail design.[33]

The emphasis on shape and form was always going to be something of a double-edged sword, and most designers seem to have shared Forsyth's later loss of faith in Utility as a basis on which to build post-war reconstruction. The vast majority of the younger generation of designers agreed with the outlook of the modernisers towards the stultifying influence of tradition on the industry, and hoped for the 'cleansing' effect of Utility.

Merely retaining pre-war shapes, shorn of decoration, into the post-war period, held out little prospect for an advancement of the designer's position within the industry. Furthermore, the implied abandonment of pattern to the whims of the manufacturers signalled a return to pre-war eclecticism and sheer bad taste in the minds of many. Most designers earned their living from pattern design, rather than from the much more costly and time-consuming process of shape design, and therefore their interest lay more in that direction.

Opinion among the designers as to alternative strategies was divided during the early 1940s between radicals like T.A. ('Taff') Fennemore, a designer well known to the pre-war pottery industry,[34] who advocated a scientific approach to design and believed that 'control will be the keynote of the post-war epoch'[35] and the far more pragmatic James Hogan, who by 1942 had already recognised the dilemma Utility presented to the designer – at its most extreme it heralded a degree of standardisation that implied a designer*less* future.[36]

By the last years of the war, therefore, Utility had effectively excluded itself as a model for the future in the minds of those most interested in pottery design. The debate had shifted towards a search for an alternative which could somehow embody the aspirations of all the interested parties, but without offending any of them. It is ironic that this loss of faith was articulated best by John Adams, acting as both Chief Executive and Art Director at Carter, Stabler and Adams Limited (Poole Pottery), in a similar manner to Trethowan and Forsyth in being able to act as a bridge between government and industry, and highly esteemed by both. By 1944 he was noting that 'The few outstanding Utility shapes have certainly not prepared the way for a New Jerusalem in the post-war ceramic world',[37] and he went on to comment:

> Many idealists welcomed Utility ware as a chance to start afresh on clean, pure lines. 'Now', they said, 'the potter will have to get down to the bare bones, and from these puritanical and austere beginnings will emerge the masterpieces of the future.' We had only to get down to essential form – the bones and the beak – and the fur and the feathers could be put on later where they ought to be. The miracle didn't happen because the potter was rarely able to model new services under war conditions. The obvious thing to do was to select the simplest shapes already in the factory.[38]

The debate after the end of the war turned instead towards export markets once again. Utility had always been an insular, inward-looking scheme, and in the austerity of the late 1940s export earnings were vital. Although the Utility Scheme continued to have an influence on ceramic design through into the early 1950s, the argument for it as a viable aesthetic for

the post-war world was effectively lost by 1945. Instead designers, manu-
facturers and government-funded organisations like the Council of
Industrial Design (COID) struggled to develop an aesthetic which could
embody essentially 'British' characteristics (seen even then as a key sell-
ing-point in export markets) alongside a 'modern' feel. The spur for the
modern was coming no longer from modernist critics but from the young
consumers of North America. The sterility of Utility held no interest for
them, and the most innovative and exciting designs coming out of the
British pottery industry during the early 1950s looked more to the bright
colours and soft, organic shapes of Italy and Scandinavia. These new designs
were released on to the home market when austerity measures were relaxed
in August 1952, and it seems as though British consumers were as quick
to forget Utility in favour of the 'New Look' in ceramic design as were
government and industry.

Notes

1 Its stated intention was to produce 'a discussion of new designs, new materials
 and new processes, and as a reminder of the specific qualities of our age which
 war necessities are bringing out in their purest form, and which a more carefree
 and fanciful post-war world should not forget' ('Tableware in Wartime', *Architectural
 Review*, Vol. 97, January 1945, pp. 27–8).

2 *Ibid.*

3 The best sources are F. Hannah, *Ceramics*, Bell and Hyman, 1986, pp. 71–84;
 C. Watkins, W. Harvey and R. Senft, *Shelley Potteries: the History and Production of a
 Staffordshire Family of Potters*, Barrie and Jenkins, 1980 and, for a detailed examination
 of the chronology and mechanics of the Utility Scheme as it affected the pottery
 industry, K. Niblett, 'Ten Plain Years: the British Pottery Industry 1942–1952', *Journal
 of the Northern Ceramic Society*, Vol. 12, 1995, pp. 175–213

4 This misconception was partly caused by Russell's autobiography, *Designer's Trade*,
 Allen and Unwin, 1968, in which he presents himself as the unifying force in the
 Utility scheme, and the one who imbued it with an emphasis on the improvement
 of post-war design: 'I felt that to raise the whole standard of furniture for the mass
 of the people was not a bad war job' (*Designer's Trade*, p. 200).

5 'Design Week in the Potteries', *Pottery Gazette and Glass Trade Review*, Vol. 74, No.
 862, April 1949, pp. 375–6.

6 The Stoke-on-Trent area of Staffordshire (known as 'The Potteries') had been the
 centre of the British pottery industry for more than two centuries, with over 80
 per cent of production coming from the region during the inter-war period.

7 N. Pevsner, *An Enquiry into Industrial Art in England*, Cambridge University Press,
 1937, p. 10.

8 *Ibid.*, p. 204.

9 *Ibid.*, p. 83.

10 See, for instance, G.M. Forsyth, 'Utility Ware', *Pottery Gazette and Glass Trade Review*,

Vol. 67, No. 785, November 1942, pp. 621–3 and H. Trethowan, 'Utility Pottery' *The Studio*, Vol. 125, February 1943, pp. 48–9.

11 'The Export Angle', *Pottery Gazette and Glass Trade Review*, Vol. 68, No. 795, September 1943, p. 502.

12 Forsyth, 'Utility Ware', p. 623.

13 Trethowan, 'Utility Pottery', p. 48.

14 *Ibid.*

15 M. Forsyth, 'Design in the Pottery Industry', Nuffield College Social Reconstruction Survey, 1943, pp. 2–3.

16 *Ibid.*

17 M. Forsyth, 'Design in the Pottery Industry', *Pottery Gazette and Glass Trade Review*, Vol. 69, No. 801, March 1944, p. 135.

18 *The Times*, 11 September 1942, p. 5.

19 'Design in Pottery and Glassware: Will Utility Ware Help?', *Pottery Gazette and Glass Trade Review*, Vol. 67, No. 784, October 1942, p. 571.

20 *The Times*, 14 September 1942, p. 5.

21 *The Times*, 15 September 1942, p. 5.

22 'Design in Pottery and Glassware: Will Utility Ware Help?'

23 J. Desmond, 'Plain China – a Limitation or a Challenge?' *Pottery Gazette and Glass Trade Review*, Vol. 77, No. 776, February 1942, p. 111.

24 G. Russell, letter to the *Pottery Gazette and Glass Trade Review*, Vol. 74, No. 863, May 1949, p. 506:

> you infer that my ideas might have been alright on Utility furniture, but I could hardly be expected to have any knowledge of other trades. I am proud to have been connected with Utility furniture, which was simple in design for very good reasons, but before the war I designed much furniture of a more elaborate kind, and I can claim to be what is called in Scandinavia 'an interior architect' who has also designed metalwork, glass, and other things.

25 See, for instance, J.F. Price, 'How the Designers See It', *Pottery Gazette and Glass Trade Review*, Vol. 67, No. 785, November 1942, p. 625:

> when it is suggested that the Board of Trade might act in such a way that design of that kind would be practically forced on the industry, the reply is that, no matter what has happened to furniture, 'we don't believe it'.

26 'Utility furniture was all right in its way. It has fulfilled its immediate, temporary aim, but its translation into the sphere of pottery has at all costs to be avoided ... Let us not become Utility-furniture-minded about pottery' ('Design Week in the Potteries: an Account and Some Impressions', *Pottery Gazette and Glass Trade Review*, Vol. 74, No. 862, April 1949, p. 376).

27 'Design – by a Retailer: Mr Harry Trethowan Gives his Views', *Pottery Gazette and Glass Trade Review*, Vol. 69, No. 801, March 1944, p. 145.

28 G. Forsyth, 'Planning Prosperity', *Pottery Gazette and Glass Trade Review*, Vol. 69, No. 803, May 1944, p. 262.

29 *Ibid.*

30 See, for example, 'Design: Good Shapes Already Exist', *Pottery Gazette and Glass Trade Review*, Vol. 67, No. 785, November 1942, p. 621.

31 See, for example, 'Keep the Designers' (editorial), *Pottery Gazette and Glass Trade Review*, Vol. 66, No. 769, July 1941, p. 543.

32 Price, 'How the Designers See it', p. 623.

33 *Ibid.*, p. 625.

34 Fennemore had considerable influence as Director of the Central Institute of Art and Design. Before the war and while working for E. Brain and Sons, he achieved considerable notoriety by devising the famous Harrods exhibition of ceramics decorated by notable artists of the time such as Duncan Grant, Laura Knight and Graham Sutherland. A financial disaster, although it received considerable publicity, it tended to confirm manufacturers' prejudices regarding the design reformers' lack of commercial acumen.

35 T.A. Fennemore, 'The Future of Industrial Design', *Art and Industry*, Vol. 33, July 1942, p. 5.

36 J. Hogan, 'Pottery, Glass and Plastics', *Journal of the Royal Society of Arts*, Vol. 90, 17 April 1942, pp. 336–47.

37 J. Adams, 'The Potter's Art, *Pottery Gazette and Glass Trade Review*, Vol. 69, No. 804, June 1944, p. 322.

38 *Ibid.*

11 ✧ Enid Marx: designing textiles for the Utility Furniture Design Advisory Panel

Cynthia R. Weaver

Although best known for her hand-block printing on paper and fabric, two of Enid Marx's most acclaimed professional collaborations did, in fact, involve her in designing for mass-produced woven fabrics: those for underground train seating for the London Passenger Transport Board (the LPTB) in the 1930s and around thirty upholstery fabrics for the British government's Utility Furniture Scheme in the 1940s.[1] These two occasions represented Marx's first forays into designing weaves intended for machine production, and the respective success of these ventures she attributes to the relative degree of co-operation she received from the manufacturers involved. Despite an apparently unlimited budget when working for London Transport during the inter-war period, Marx identifies her wartime Utility fabrics as having been the more successful, reflecting well on the happy collaboration achieved here between technical adviser and designer. This chapter focuses on Marx's experiences when designing for the Utility Scheme, concentrating on her own and others' 1980s first-hand recollections of the Design Advisory Panel and the role played by Gordon Russell as the Panel's Chairman throughout the period of Marx's involvement with the Scheme.

Enid Crystal Dorothy Marx, a second cousin of Karl Marx, was born in London on 20 October 1902 and died there on 18 May 1998. Her father, Robert J. Marx, a consultant paper-making engineer, and a pioneer in his own right, died leaving fifty patents in his name. Marx acknowledges him as seminal to one of the major crusades of her own career; that of making 'art' and 'aesthetics' available to a wider public, by accepting and harnessing the machine age. This tenet – combining high standards of design with mass production – harmonised with Marx's work as a member of the Utility Furniture Design Advisory Panel (the UFDP) between 1943 and 1948. By that point, Marx's belief – derived from that of Paul Nash, a part-time teacher in the Design School of the Royal College of Art during her student days there – that all artists and designers could, and should, design in all media and for all purposes, was already established.

At 'the College'

In 1921, Marx's application to study at London's Royal College of Art (RCA), was rejected. Instead, she spent a fruitful intermediate year – 1921–22 – at the Central School of Arts and Crafts, London. Her training there, and her earlier experiences as a student at Roedean School in Sussex (from September 1916 to July 1921), encouraged Marx to develop sensibilities working in both two and three dimensions. At her second attempt, in 1922, she entered the flourishing RCA Painting School, where she and her fellow-student Barnett Freedman were failed in their Final Diploma Assessments by the illustrator Charles Ricketts in 1925. James Holland, who followed Marx to the Painting School in 1924, recalled William Rothenstein, Principal at the RCA in 1925, commenting at the time that it was 'always the more independent students ... the most outstanding students, who were likely to fail',[2] a prophetic remark in the light of Marx being made an Honorary Fellow of the Royal College nearly sixty years later, in 1982.

'Marx was, by College standards, "avant-garde".'[3] Marx's 'failure' at the RCA centred around a painting based on a fairground scene; a subject deemed too vulgar for the so-called 'fine' arts of the day but one that revealed Marx's early interest in the traditional popular arts and her inclination to eschew establishment doctrines, and the stimulation to which she responded when working with like minds – in this case, her notable student colleagues and, of course, Nash. This last facet of Marx's professional personality goes some way towards explaining the immense enjoyment that she experienced as a member of the UFDP. Apprenticed for a year (1925–26) to the hand-block fabric printers, Barron and Larcher, Marx next established four consecutive independent studio–workshops where she usually worked alone, cutting wooden blocks for hand-printing, until the outbreak of war in 1939.

The beginnings of 'Utility' and government-controlled design

Gordon Russell recalled in his autobiography[4] receiving a letter in 1942 from Hugh Dalton (then President of the Board of Trade), asking him to sit on a Committee 'to advise on the introduction of Utility furniture'. The aims of the Committee with regard to furniture production were to ensure maximum economy of raw materials and labour and to produce simple, agreeable designs, sound in construction and capable of being sold at reasonable prices. These same aims were later also to be applied to the production of Marx's upholstery fabrics within the Utility Scheme.

This was a time of crisis and things happened with remarkable speed: the need for expediency and the dearth of available materials appropriate

to furniture construction (including upholstery fibres of all kinds) required standard designs of fixed specification.[5] The Committee's initial government remit was completed when, in 1943, the first 'Utility' (Board of Trade-controlled) furniture was made available to the public; but the Committee was retained because of the need to respond to the ever-fluctuating supply of materials, and because Russell believed that Utility specifications also had peacetime potential as a means of continuing to ensure quality of design and production. Russell saw an opportunity to further the 'Good Design' pioneered by him and others before the war, and an opportunity to further design research. It was with this in mind, and at Russell's instigation, that the subsidiary Utility Furniture Design Advisory Panel was formed, under Russell's chairmanship, to aid the Committee in this ongoing developmental work.

Utility textiles expert

For the production of upholstered furniture, the need for a textiles expert on Russell's Advisory Panel soon became clear. Initially, the Panel had used existing furnishing fabric stocks, many of which were aesthetically inappropriate to the uncluttered simplicity of those furniture designs favoured by Russell. When fabric stocks dwindled, the need for renewed supplies encouraged Russell to focus on this as a new design problem. The question was, what patterns and fabrics should be produced next? The old ones from the trade were capable of going into urgent production, but could not adjust to restricted and erratic yarn supplies, while new commissioned designs could respond to the limitations imposed by war-time scarcity and match Utility furniture in terms of quality of design and manufacture. Russell had an abhorrence of what he termed those 'dreadful pre-war moquettes'[6] and argued that, if freedom of consumer choice was to be restricted during wartime, then it was incumbent upon his Panel to ensure that the few products offered by the Scheme should be essentially good. To Russell, the limited consumer choice brought about by Utility regulations was no more restricting than the pre-war condition when only poor-quality and poorly-designed goods were available.

Late in 1943 Russell began his enquiries into renewed woven upholstery fabric supplies by visiting Thomas Barlow, the Scheme's Yarn Controller. At this point, Russell was still forced to select from existing patterns for upholstery; this was an anathema to Russell, and in his concern for raising design standards he next set about consulting some of the foremost weavers of the day to explore the viability of alternative solutions, starting with Anthony Hunt, Edinburgh Weavers' pre-war manager. Edinburgh Weavers' reputation as manufacturers of design-led, factory-woven fabrics

was already well established. Broadening his approach, Russell next visited the innovative hand-weaver, Ethel Mairet,[7] at her 'Gospels' studio home[8] where the weaver Marianne Straub was staying at the time. During that visit Russell offered the position of Textile Consultant to the UFDP to Straub.

At that point, the role of Textile Consultant to the Panel was still envisaged as being one of seeking out existing fabric patterns appropriate for modified production within the Scheme. Straub – renowned for raising standards in industrial textile design – appeared, in every respect, suited to Russell's task because of her experience designing for woven furnishing fabrics, her proven working knowledge of weave production and all major woven cloth constructions, and, potentially, the fact that her current employer at Helios – Thomas Barlow – was already involved with the Utility Scheme. But Straub perceived Barlow's connections with the Scheme as a disincentive for her to become involved in it, as Barlow had made it quite clear that, as Yarn Controller, he could not be seen to favour his own firm, and Straub felt that Helios' basic yarn allocation had suffered from Barlow's over-caution in this regard. Additionally, she was wary that Russell's Textile Consultant would not have guaranteed control over production, a situation which Straub would not have tolerated; and on the basis of those reservations she refused Russell's offer.[9]

When Straub declined the position, Russell picked up on Ethel Mairet's suggestion of Enid Marx for the job – and Marx accepted. Looking back, Marx has said that 'it soon became clear' that existing fabric patterns 'simply would not do': 'there was nothing for it but to do some designs myself'[10] which could take account of Utility restrictions from the outset.[11] Had the role of the Utility Textile Consultant been recognised initially as that of a designer of woven fabrics suitable for upholstery – as opposed to that of a selector of patterns – it is possible that Marx's name may never have cropped up, as her only experience of designing weaves for mass production – for London Transport – had been confined to the very specialist area of moquette fabrics.

Panel members, including Marx, acted as a specialist design advisory sub-committee, and in theory had the luxury of a guarantee that whatever they designed would be made at least to prototype stage; at which point, the designs would then be considered by the full Committee. Marx did not attend Panel meetings; and Utility textile design appears to have been a matter for designer and manufacturer alone – under the watchful eye of Russell. But Marx does recall 'sneaking herself in' on some 'hilarious' Committee meetings.[12] There she once witnessed prototype furniture – a chair – embarrassingly falling apart on Committee scrutiny, and amusing debates as to whether – to use the press phrase – 'cardboard' (Utility)

beds would be sturdy enough to stand up to the passions of young soldiers home on leave!

Designing furnishing fabrics for the Utility Scheme

As the Second World War dragged on, the word 'utility' took on unfortunate connotations of austerity and restricted choice, and by 1948 – the final year of Marx's appointment to the Panel – the influential textile export magazine, the *Ambassador*, reported that 'for years' 'utility' had been 'the arch-enemy of the word fashion'.[13] This prejudice against rational design was one of several challenges that Marx had to address when designing Utility upholstery woven tapestries.

The constraints imposed when designing Utility furnishing fabrics were: a restricted number and range of available looms; the need for small, economic, pattern repeats; and a limited colour-range. Furthermore, there were only two specified yarns made available, both in short supply: an Egyptian cotton for the vertical warp and an (irregular) slub cotton for the horizontal weft.[14] Within those limitations, Marx was given a very clear brief and alerted at an early stage to the problems inherent in using such insubstantial cottons – lacking in terms of both durability and the handling qualities of the cloth – for upholstery. Additionally, the process of tapestry-weaving produces a flat-surfaced cloth, lacking the depth of pile that, by this time, the public had come to expect from fabrics such as moquette.

Thanks to the technical advisers at Morton Sundour (the weavers of Marx's Utility prototype fabrics), she was able to identify and use the intrinsic properties of these two cotton yarns, impressively achieving 'a pretty wide range of textures within the necessary restrictions'.[15] Her comprehension of the woven structures was developed as a result of a range of fabric 'feelers' (sample cloths) woven by Morton Sundour to show the textures possible by using the only two yarns available.[16] Marx viewed the need to work 'within [the] very tight restrictions' of Utility as 'stimulating',[17] and she enjoyed her education at the hands of Morton Sundour, in which she experienced the joining of artist and maker. In this and other regards, Russell had, in Marx, come fortuitously upon someone whose existing design philosophies and practice were in harmony both with his own and with the Scheme's requirements. Previously, in her studio, Marx had cut wood blocks to produce geometric designs (rarely larger than 6 in., often smaller), and some abstract florals. For Utility upholstery, her small-scale, all-over, geometric pattern, *Box* (figure 36), redolent of several of her earlier block-printed fabric designs, was among the first in production, in 1944. In that year Marx was honoured as a Royal Designer for Industry (for pattern design), a landmark in the design establishment's

36 *Box*, Utility woven cotton tapestry, 1944. One of Enid Marx's first Utility designs to go into production

recognition of the contribution made by textiles to the raising of standards in design for mass production.

Design themes which have recurred throughout Marx's career – nature, simplicity and geometry – are all represented within this Utility range. The *Box* fabric met well the Utility demands of restricted manufacture being capable of production on a wide range of loom types, and with little wastage when cutting into the cloth or when pattern-matching. In contrast, Marx's *Pyramus* design, a significantly larger (12 in.) repeat pattern – and of only single direction – was not put into production within the Scheme because of its uneconomic pattern. The other factor that helped dictate the nature of Marx's designs and her small-scale patterns of subdued and limited colour was the need to respond visually to compact wartime living-spaces.

Before the war, Marx often chose to design using restricted colour, and in an undated draft article, 'Hand-block Printing for Amateurs', she wrote advocating simplicity in design and restraint in the use of colour:

> One of the most effective of designs is the spot. The important thing is the spacing ... they must be regularly and evenly spaced, exactly the right distance apart ... Stripes are very effective ... you can get a check by printing your stripe sideways as well ... Do not try to be elaborate ... the most effective ... results, will be the simplest ... Use one, or at the most, two, colours.[18]

Of her meeting with the Japanese potter Hamada and his friend Yanagi in the late 1920s, when herself staying with the potter Michael Cardew, Marx wrote: 'I had for a long time enjoyed the Japanese colour range of indigo, blues, browns and buff, interspersed with blacks; spicy colours.'[19] It was not, therefore, the limited number of colours within the Utility range *per se* that caused Marx's dissatisfaction here, but the lack of 'spice' within that range; quality in density and consistency of colour being difficult for dyers to achieve with thinly-spread dyestuffs of limited availability.

The colours accepted by the Committee for use in Utility upholstery fabrics have been described by Marx as 'buff, mid-green, a blue and a rust red'. The last she felt to be 'a particularly unfortunate choice', and tried to introduce a 'cherry red' and a 'deep yellow' into the range, recognising that her fabrics for Utility needed to have a wider appeal than her own pre-war fabrics, designed for a more customised market. To promote her own proposed extended colour-range, Marx painted some of her Utility designs in these colours, and some fabric samples were produced in cherry red and in yellow, again by Morton Sundour. But, to Marx's chagrin, the new colours were rejected by the Committee, 'despite the public's enthusiastic support' of the yellow at an opinion poll held at the Victoria and Albert Museum's promotional Britain Can Make It exhibition in 1946.[20] Production fabrics such as *Star* (figure 37) look dull in comparison to Marx's original 'cherry red' artwork for this design.

Before 1946 Marx had already attempted to ascertain the public response to her patterns for Utility upholstery by seeking the opinion of her charlady. She was a 'bombee' – the government term for those whose homes had been 'bombed out' and one of the official priority entitlement categories eligible for coupons to allow the purchase of new, replacement, furniture – and she disapproved of the non-representational designs within the Marx range: 'What women wanted', the charlady asserted, were floral patterns 'that would bring cheer' into devastated homes. Marx's *Lily* Utility fabric of 1945 shows one of her design responses to this advice (figure 38).[21]

The production of Marx-designed fabrics (yardage, as opposed to samples) was distributed between several mills, as with the distinction made between the manufacturers of furniture prototypes and those sanctioned to put specified furniture designs into production within the Scheme. Licensing mills only to produce specific fabrics saved valuable working-hours by making it possible to leave certain looms permanently set up. In addition to their role as consultants and sample weavers, Morton Sundour were also licensed by the government to mass-produce some of the Marx fabrics. Other textile firms, including Lister's of Bradford and Wood's of Bromley, were also licensed by the Board of Trade. Some firms were also allowed to continue to weave certain of their own upholstery

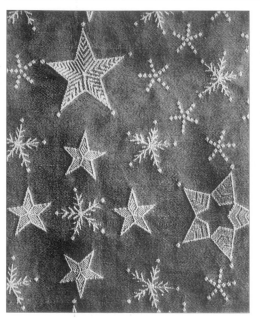 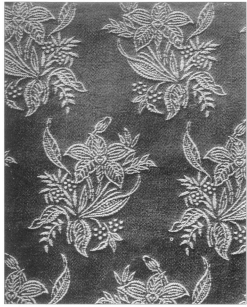

37, 38 Utility woven cotton tapestries designed by Enid Marx: [*left*] *Star*, 1947; [*right*] *Lily*, 1945, designed in response to the popular taste for floral patterns

designs to Utility specifications. Lister's, for example, proudly manufactured their own 'cinnamon best seller moquette' under regulations.[22] At least three of the Marx-designed fabrics were woven by Associated Weavers, under the control of Harry Straker. A skilled designer and technician with training in art and draughtsmanship, Straker criticised Utility upholstery designs, in retrospect, for being too austere. He believed that, even within restrictions, his intimate knowledge of machinery and processes – coupled with his own drawing skills – would have enabled him to design fabrics of greater variety. Straker later recorded that, throughout the years of specifications, he had yearned to add more detail to many a Utility upholstery fabric design; one of his first acts on the relaxation of restrictions was to add another 'frond' to Marx's *Moss* design.[23]

 Despite the suggestion that the restricted circumstances of Utility were used to educate public taste in the matter of design – including textile design – there were anomalies within this aspect of the Scheme. One pertaining to the employment of Marx as Textile Consultant was that she also worked some designs for upholstery fabrics to be woven in wool. These were sampled within Utility and exhibited alongside her cotton tapestries at the Board of Trade headquarters in 1946. But Marx's designs for woollen cloths were never put into wartime production, and the Scheme

continued to use pre-war patterns for woollen upholstery fabrics. The pre-war fashion for 'Jacobean' furniture was a predilection that Russell and others had already set out to redress prior to the 1940s. However, some of the old-stock fabrics used to upholster furniture for the first (1943) Utility Furniture Catalogue do still reflect that prevailing, lingering taste.

Within the Scheme, Marx also worked on designs for other – at the time innovatory – materials for use as furniture cladding.

The development of synthetic alternatives for Utility furniture cladding

In 1945, with supplies of raw materials further depleted, Stafford Cripps – Dalton's successor as President of the Board of Trade – championed a shift in furniture design emphasis to the exploration of alternative materials, such as metals and plastics, to replace the more traditional wood and natural fibres. By this point the Panel, still under Russell's guidance, comprised Frank Austin, Robert Goodden, Enid Marx, Eden Mills, Cyril Rostgart, Dick Russell (Gordon Russell's brother) and Neville Ward. Austin, Marx and Ward were among those who helped develop synthetic substitute materials for use in furniture design: Marx's remit was to produce patterns suitable for application to laminate veneers and PVC (polyvinyl chloride) cloths, as alternatives to traditional furniture cladding. Together, this trio designed a suite of nursery furniture utilising these materials, which won for the manufacturer involved (H. and A.G. Alexander and Co. of Rutherglen) a first-class diploma in the furniture competition organised by the Scottish Committee of the Council of Industrial Design in January 1949.[24] Marx's contribution was a pale-coloured patterned vinyl suitable for chair cushioning and a patterned laminate to front the nursery cupboard. The notion of white, washable seating for nursery use Marx thought an interesting one.

The enjoyment and perceived success – or otherwise – of work undertaken by Panel members does appear to correlate with the level of co-operation that designers received at the hands of those of the trade with whom they were each most involved, as in the case of Marx's happy association with Morton Sundour. However, when designing patterning for laminates and vinyls for the Utility Scheme, Marx was confronted by two very differing responses from the two fabricants concerned. Laminates and vinyls were both at that time materials in their infancy in Britain, and their successful development, therefore, relied especially on the co-operation of manufacturers. Marx asked to visit the respective makers of these new plastic materials so that she could take account of production methods at the design stage. ICI refused her permission to visit their

factory, denying her the opportunity to witness the processes of vinyl manufacture and decorative embossing; but Marx did observe laminates in production, and for this reason she believes her pattern designs for laminated materials to have been the more successful of these two design ranges.

For the laminates Marx again designed small-scale striped or repeat patterns or all-over spot motifs, all similar to her own pre-war hand-printed fabrics. During the production of laminates, manufacturers could, effectively, reproduce the designer's own original pattern marks and, as Marx noted, in theory using this method one could produce an 'original laminate Picasso'.[25] For vinyls, however, the design problem was an unusually difficult one because pattern was introduced not by the application of drawn or printed marks on to the flat vinyl ground, but by a process of indenting decoration directly into the surface of the material. The problem Marx faced was how to depict levels of embossment at the design stage (it was clearly not possible on paper). This was overcome by her development of a system of impressing pattern into Plasticine sheets, which were then submitted to the manufacturer, as her designs relied aesthetically on the effect of varying levels of embossment. Marx's solution here may have derived from her knowledge of engraving and block-cutting techniques. In her studio-based experiments she sometimes printed immediately on to fabrics using everyday objects: pastry-cutters, rubber mats, hair-grips. For her designs for Utility vinyls Marx worked with similar humble objects, at times using her pencil not to draw, but as an instrument with which to impress the pattern directly.

That Cripps's initiative to encourage experimentation with the new synthetics in furniture design was initially a personal one is suggested by the fact that until 1946 the Board of Trade files show no official recognition of this venture. Then in April of that year the Board, somewhat hesitantly, wrote to the Treasury: 'In the not too distant future, it is likely that we shall wish to make use of various substitute materials ... steel and plastics.'[26] But several manufacturers were to prove themselves lacking in their support of such new developments.

Dealings with the trade

According to Marx certain manufacturers required especially dextrous handling; they were 'anxious to keep out new ideas, for fear these might jeopardise trade when ... restrictions ceased'.[27] Marx sees the 'managing of the Trade' as having been 'far from plain sailing', with Russell, as 'Captain', in that impossible position 'between the frying pan and the fire'. But although Marx has said that Russell did succeed in persuading manu-

facturers 'that Good Industrial Design was not expensive, but paid',[28] Russell did not, in fact, always get his way: Austin, for example, has cited the 'case of the Scotsman, Henderson', who developed a method of making 'carcass furniture' – particularly wardrobes – from timber laminates wrapped around and curved on a rotating steel former; and whom Russell 'wished to encourage ... but in whose favour [he] was never able to persuade the industry'.[29]

Robert Goodden's unfortunate experiences as a Panel member – for but a few months – suffered in part from the timing of his contribution to Utility coinciding with 'a sort of breathing space when useful thinking and planning ahead were going on, but nothing tangible was coming out of the pipeline'. Goodden's recollections help shed light on some of the less publicised aspects of working within the Scheme: 'To be honest,' wrote Goodden in 1986, 'I did not particularly enjoy my small part of the Utility venture ...'. Goodden was seconded, for about three weeks, to Littlewoods in Liverpool, who, for the duration of the war, had been required to convert their football pools accommodation into a metal furniture factory, producing 'kitchen cabinets and suchlike'. Russell's idea had been that Goodden should collaborate with the firm's chief production engineer in 'trying out possible systems of metal furniture construction, prototypes of which could be manufactured on the spot, as fast as they came off the drawing board ...'. A representative of the firm visited Russell's London office in advance and 'declared himself warmly in favour of the scheme'; but what Goodden encountered at the works was 'an atmosphere of the densest suspicion, out of which nothing fruitful could ever come'. For although whatever new designs Goodden needed to 'try out' were indeed sampled in the factory, the experienced personnel involved offered him 'no advice whatsoever' on the technical possibilities of working with sheet metal for this purpose. To Goodden it seemed that he was regarded by the firm as 'a civil servant sent down to spy, and their chief concern was to let me see as little as possible and not to collaborate in any real sense; but to honour the bargain minimally ...'.[30]

Neville Ward's Utility experiences with the trade contrast markedly with those of Henderson and Goodden. Ward 'enjoyed enormously'[31] a successful collaboration working directly – on behalf of the Panel – with manufacturers of schoolroom furniture. Again the aim was to explore the possibilities offered to this area of furniture production by using metals and plastics. The nature of the furniture under consideration here may help explain these firms' positive responses to Russell's plan; as Austin has pointed out, such furniture was already 'somewhat advanced, since the special requirements for strength and durability [in schoolroom furniture] had already resulted here in the introduction of metals and plastics'.[32] In

effect, this particular aspect of the trade had no reason to fear competition from such developmental work.

Ward's appointment to the Panel not only reflected Russell's search for new design talent throughout Britain – Ward was a northerner – but also a continuation of the 1930s notion of architecture as the saviour of 'good' (rational) design.[33] As a young architect Ward felt himself to be a very junior member of the Panel, but within it he experienced 'no hint of rank or status', except that Russell was 'a quite splendid leader'.[34]

Austin and Marx have also commented on the crucial part played by Russell, the design ethos he engendered and his interpersonal skills in achieving those successes credited to the Panel. Austin said of him: 'He was a delightful man to work with, patient and considerate and with the gift of recognising the peculiar talents of individual designers.'[35] Russell's role as the Panel's chair was a political one, and Marx regards his 'supreme tact' as having 'proved invaluable' in dealings both with the Committee and with 'the Trade'.[36] Austin has also commented that Russell's abilities as diplomat and mediator were used by him to aid the Panel in its furtherance of good design:

> Gordon ... understood the importance of keeping in everybody's mind the value of good design ... He would sometimes give way to criticism of a particular design but always on some technical or economic ground. He would go only as far as a consensus of opinion would permit – though he was a master of quiet lobbying and persuasion, of delaying a decision or formulating an inoffensive minute. He never pressed an advantage too far or lay himself open to a defeat on a matter of principle.
>
> It was this political skill, combined with a unique gift for recognising and encouraging designers in many fields, which enabled him so magnificently to advance the appreciation of the importance of design in industry.[37]

Responses to Marx's designs for Utility upholstery fabrics

Marx responded well to the challenges set when designing within Utility restrictions, but the reaction during wartime to those fabrics produced to her designs can roughly be divided into two: a *cognoscenti*, in favour; and a public at large, unsure. That many members of the public were – even in a period of austerity – interested in the appearance of furniture, as well as in its quality, its ability to function and its price, is made clear in the May 1947 Report of the 'Consumer Needs Flying Squad', a team set up by, and 'confidentially' to report to, the Board of Trade. The 'Squad's' findings were that several customers whose need for furniture had been deemed 'urgent' by the government – and who had been allocated furniture coupons – had, in fact, been prepared to wait for up to six months to

take delivery of specified furniture designs of their own choosing, rather than take immediate delivery of whatever happened to be available in the shops at the time.[38] The Report also suggested that issues of economy had ceased to have such an impact on consumer choice even before the war, since the introduction of hire-purchase options for buying the more expensive household items such as furniture.

Not surprisingly perhaps, the Report's survey of public opinion on the subject of Utility furniture, carried out by Government employees, did present an overall favourable response: 'It is ... unquestionably *un*true that Utility would not be chosen in a free market; almost everyone ... admires and covets Utility.' Upholstered furniture was concluded to have 'un-doubtedly' sold because of its covering material, and 'Rexine' aside (a plastic-coated material; its washable properties made it the 'great favourite' in mining communities), the luxury of uncut moquette (with its looped pile) was deemed the most 'sought after', while cotton tapestries (the form in which the Marx Utility designs went into wartime production), duck (a coarse cloth, more usually used for small sails or sacking) and dowlas (a coarse linen) were all reported as being 'scorned' by the public. The phrasing of the Report does suggest that it was the intrinsic nature of these cloths – and not the designs – to which consumers were responding. But this is not made clear, and the extent to which the Marx cotton tapestries may have been rejected because of the poor quality of the yarns made available for Utility fabrics – or simply because of their associations with restricted wartime choice – can only remain an object of conjecture.

While the public may have 'scorned' cotton tapestry upholstery at the time, the *cognoscenti*, after the war, did not. Usually produced in only two colours; 'buff' being constant to most, the Marx tapestries revelled in the restraint of limitations and found favour with a design avant-garde. Re-flecting approval by the design establishment, in 1947 Marx's *Flora* Utility fabric was selected for illustration in the Society of Industrial Artists and Designers' first volume of *Designers in Britain*. In the second (1949), four Marx Utility fabrics were shown. In spring 1947 the *Vogue House and Garden Book* illustrated Marx's *Star* (figure 37) and *Astrantia* Utility tapestries alongside four non-Utility trade designs. The text praised British weavers, busy 'evolving some of the finest furnishing fabrics in the world'; albeit, as was pointed out, all-too-often labelled 'For Export Only'. The designs shown, *Vogue* assured its readers, were 'not there to tantalise', but to remind them that 'skilful designing and first class workmanship' were, once again, absorbing the attention of producers until 'recently making parachutes, cartridge bags, or other still less peaceful textiles'.[39]

The Marx fabrics shown in *Vogue* elicited a favourable written response direct to Marx herself from Parker Knoll,[40] a firm ranked by Marx as being

39 *Primrose*, Utility cotton tapestry, designed by Enid Marx and produced by Morton Sundour

among the best British makers of mass-produced furniture of the day. Parker Knoll's interest in her fabric designs was seen by Marx as 'a nice little tribute to the standard of our Utility designs'.[41] Seizing this opportunity to defend those of her fabric designs produced within the Scheme, Marx wrote of Parker Knoll's expressed interest both to Charles Tennyson – in his capacity as Chairman of the Furniture Committee – and directly to the Board of Trade: 'This is an answer to the fears expressed by Committee, that designs might not be approved by the trade.' In this letter Marx also suggested that 'the merits of Utility Furniture' had 'not been sufficiently appreciated by the public, because they have received so little publicity'. To stress her point that the problem did not lie with the furniture and fabrics themselves, Marx also noted that she had 'received word' from Morton Sundour that their production fabrics, Marx's *Primrose* and *Squib* designs (figures 39, 40) had, by 1947, become best-sellers, ahead of all trade designs: 'I think this is very encouraging, don't you?', Marx wrote.

The conviction that Utility fabrics would pave the way for the raising of standards in both design and manufacture within the textile industry had, by 1947, already been made clear by Marx in her article on 'Furnishing Fabrics' in *Design '46*: 'We are standing on the threshold of a great renaissance in English textile design – once the present shortages have been relieved.'[42]

40 *Squib*, Utility woven cotton tapestry designed by Enid Marx, noted together with *Primrose* (39) as 'best sellers' in February 1947

Debating the success of Utility furniture coverings

In 1948 the Manchester Cotton Cloth and Clothing Scheme reported – somewhat enigmatically – that, in relation to textiles in general, Utility had 'helped sweep away a good deal of mediocre stuff ... together with a few pearls'. More specifically, the Report favourably concluded that where textiles were concerned, the Utility Scheme had performed its main task of price control 'tolerably well', and had provided the public and manufacturers with the salutary lesson of 'serviceability'. According to this Manchester report of the late 1940s, overall, it can be said that for the textile trade, Utility specifications had succeeded in improving both on pre-war manufacturing methods and on technical fabric processes such as dye-fastness and crease- and shrink-resistant finishes, and that government-regulated standardisation had left a legacy of increased consistency in these areas.[43] But by 1953–54, with the end of the Utility Scheme, the *News of The World Better Homes Book* in discussing 'Furnishing Fabrics' was less enthusiastic with regard to quality within the fabric industry: 'Unfortunately pre-war standards of fade-less, non-shrink fabrics have not completely returned ... readers should test material before making a ... purchase.'[44]

Though Russell's proselytising campaign to raise the profile and standard of design in everyday household objects had elicited a varied response both

from within the trade and from the public, those designers consulted in the mid-1980s (Austin, Goodden, Marx and Ward) were unanimous in their appreciation of Russell's efforts as Chairman of the Utility Furniture Design Advisory Panel. In terms of Enid Marx's involvement with Russell's Panel, the Scheme did, undeniably, have its successes; most notably here perhaps in the creation of an experimental design climate which allowed the exploration of new materials, including those for furniture cladding. Marx had come to the task of designing upholstery fabrics for mass-production within Utility potentially disadvantaged by her lack of direct experience in this area, but this problem had been overcome by Morton Sundour, under Russell's guidance – and by the 'energy and enthusiasm'[45] that the designer herself brought to this work. Having been led by public opinion into designing floral patterns within the Scheme, it would appear with hindsight that the designer's own inclination towards small-scale geometric patterns – subtle spots, stripes and checks – had, after all, been the way ahead for fashionable upholstery design in the decade that followed.

Notes

This chapter is dedicated to the memory of Enid Marx who died, after its completion, aged 95, on 18 May 1998. Her dedication to re-establishing the importance of our folk heritage and her contribution to the repositioning of craft-based skills within the so-called industrial arts remain as two of her lasting legacies. From my own point of view, it was Marco's reverence for the past, combined with her tireless zest for exploring the new, that helped lead me towards my career as a design historian.

1 Marx's reflective comments were expressed during several conversations with and communications to Cynthia Weaver, mostly between 1984 and 1987. See also *Enid Marx: a Retrospective Exhibition* (exhibition catalogue), Camden Arts Centre, London, 1979; Alan Powers, *Modern Block Printed Textiles*, London, 1992; Cynthia R. Weaver, 'Marx, Enid (Crystal Dorothy). British Painter and Designer', *Dictionary of Women Artists*, Vol. II, pp. 932–4, London, 1997; Cynthia R. Weaver, 'Enid Marx: Textile Designer for Industry', MA thesis, University of Central England, Birmingham, 1987; Cynthia R. Weaver, 'Enid Marx: Designing Fabrics for the London Passenger Transport Board in the 1930s', *Journal of Design History*, Vol. 2, No 1, 1989, pp. 35–46.

2 J. Holland, letter to the author, 30 July 1986.

3 *Ibid.*

4 G. Russell, *Designer's Trade: an Autobiography of Gordon Russell*, Allen and Unwin, 1968; see also K. and K. Baines, *Gordon Russell*, Design Council, 1981.

5 M. Bruton, 'Utility – Strengths and Weaknesses of Government-controlled Crisis Design', *Design*, No. 309, September 1974, pp. 62–71.

6 Russell, *Designer's Trade*, p. 204; 'moquette' is a traditional soft-furnishing fabric with a loose pile of cut and/or uncut threads.

7 For Mairet see M. Coatts, *A Weaver's Life: Ethel Mairet 1872–1952*, Crafts Council, 1983, and E. Mairet, *Handweaving Today*, Faber and Faber, 1939..

8 M. Straub, letter to the author, 6 August 1986. For Straub see M. Schoeser, *Marianne Straub*, Design Council, 1984, and M. Straub, *Handweaving and Cloth Design*, Pelham Press, 1977.

9 M. Straub, letter to the author, 6 August 1986.

10 E. Marx, *The War Years: 'Hitler Didn't Cater for Us'*, unpublished manuscript, 1984, p. 3 (in the author's possession). Samples of twenty-four Marx-designed Utility furnishing fabrics from 1944 to 1947 – including *Box, Lily* and *Primrose*, illustrated in this volume (figures 36, 38, 39) – are held by the Victoria and Albert Museum, London (Circ. 202TOA–221TOK, 1949 and Circ. 13–20, acquired 1950). See also the listings in *CC41: Utility Furniture and Fashion 1941–51*, exhibition catalogue, Geffrye Museum, London, 1974.

11 Russell, *Designer's Trade*, p. 204.

12 E. Marx, letter to the author, 1 June 1985.

13 'M.L.S.', 'The Art and Power of Fashion', the *Ambassador*, No. 10, 1948, pp. 90 ff. The word 'utility' was not new in the textile world, having earlier meant 'durable', or 'appropriate to use'.

14 E. Marx, letter to the author, 1 June 1985.

15 Marx, *The War Years*, p. 4.

16 E. Marx, letter to the author, 1 June 1985.

17 E. Marx, unpublished, untitled manuscript written for Mr Coutts, Victoria and Albert Museum Print Department, London, April 1984, p. 11.

18 E. Marx, 'Hand-block Printing for Amateurs', unpublished draft, n.d. (in the author's possession).

19 E. Marx, the unpublished manuscript cited in note 17 above, p. 4.

20 Marx, *The War Years*, p. 3.

21 Interview with Enid Marx, 15 September 1993 (notes in the author's possession).

22 Interview with Arthur Bennett, a retired employee of Lister & Co., Bradford, 9 September 1986 (notes in the author's possession).

23 Interview with Harry Straker, a former employee of Associated Weavers, 19 August 1986 (notes in the author's possession).

24 See also F. Austin and N. Ward, 'Design Review: UK Furniture 1954–55', *Architectural Review*, Vol. 117, No. 699, March 1955, pp. 205–9.

25 Interview with Enid Marx, 15 September 1993.

26 Letter from Clibbens, Board of Trade, to P.L. Smith, Treasury, 17 April 1946 (PRO BT 64/775.73135, Utility Scheme IMID46, reg. 1947.)

27 E. Marx, the unpublished manuscript cited in note 17 above, p. 11.

28 Marx, *The War Years*, p. 4.

29 F. Austin, letter to the author, 12 July 1986.

30 R. Goodden, letter to the author, 6 July 1986.

31 N. Ward, letter to the author, 2 July 1986.

32 F. Austin, letter to the author, 12 July 1986.

33 See F. MacCarthy, *A History of British Design 1830–1970*, London, 1979, chapter 4, 'The Architects 1928–1940'.

34 N. Ward, letter to the author, 2 July 1986.

35 F. Austin, letter to the author, 12 July 1986.

36 E. Marx, the unpublished manuscript cited in note 17, p. 11.

37 F. Austin, letter to the author, 12 July 1986.

38 Report of the Consumer Needs Flying Squad, May 1947 (BT 64/775. 73135).

39 *Vogue House and Garden Book*, Spring 1947, p. 44.

40 Letter from G.H. Alpe, Assistant General Manager, Parker Knoll to E. Marx, 21 February 1947 (E. Marx's estate).

41 E. Marx, letter to Charles Tennyson and Ms. Gower, 28 February 1947 (E. Marx's estate).

42 E. Marx, 'Furnishing Fabrics', in Council of Industrial Design, *Design '46: a Survey of British Industrial Design as Displayed at the Britain Can Make It Exhibition*, HMSO, 1946, pp. 87–8.

43 H.E. Wadsworth, *The Utility Cotton Cloth and Clothing Scheme*, paper in the collection of the Manchester Statistical Society, 1948, p. 21.

44 R. Smithells, ed., *News of the World Better Homes Book*, London, n.d. (*c.* 1953 or 1954), p. 51.

45 M. Straub, letter to the author, 6 August 1986.

III

THEORISING THE ETHICS OF UTILITY DESIGN

12 ✧ Utility, design principles and the ethical tradition

Nigel Whiteley

F ROM the perspective of an age in which the word 'utility' is something we associate with controversial sales and consumerist profits – the privatisation of the public utilities of gas, electricity and water – the idea that Utility was once related to public principles and the common good may come to some as a surprise. Yet Utility, whatever the pressing causes of its origins in war-torn Britain, was part of an approach to design which express a belief in a higher role for design than just the profit motive: design was a way of improving the life of citizens and the ethos of society. In committing itself to this belief, Utility can be located in a tradition of design thinking which upholds the idea that there is an ethical dimension which stands both above and in judgement on any particular design manifestation. It is a tradition that stretches back to the mid-nineteenth century and forward to the present. However, just what it is that constitutes the ethical dimension has changed significantly over 150 years, and the focus has shifted from such concerns as the virtue of the maker, through the integrity and aesthetics of the object, to the role of the designer – and consumer – in a just society. This chapter maps the changing nature of the ethical dimension in design and locates Utility within that continuing tradition.

The 'characters of men' and timeless principles

In a series of lectures entitled *The Queen of the Air*, John Ruskin, Britain's most widely-read cultural critic of the nineteenth century, pronounced that

> Great art is the expression of the mind of a great man, and mean art, that of the want of mind of a weak man. A foolish person builds foolishly, and a wise one, sensibly; a virtuous one, beautifully; and a vicious one, basely. If stone work is well put together, it means that a thoughtful man planned it, and a careful man cut it, and an honest man cemented it. If it has too much ornament, it means that its carver was too greedy of pleasure; if too little, that he was rude, or insensitive, or stupid, and the like.[1]

In this case, design was a representation of the moral state of the creator/builder. Indeed, Ruskin believed that 'you may read the characters of men, and of nations, in their art, as in a mirror ...'.[2] Ethical principles were applied to cultural artefacts as a means of judging the worth of humans, whether as individuals or as citizens of a nation.

An ethical dimension in design is one of the two major bases of the tradition which gave rise to Utility. The other – the aesthetic dimension – is evident in the systematic writings and designs of Owen Jones, whose *Grammar of Ornament*, published in 1856, contains thirty-seven 'propositions' under the heading of 'general principles in the arrangement of form and colour, in architecture and the decorative arts, which are advocated throughout this work'.[3] The principles that Jones was advocating were essentially aesthetic principles which, according to him, would secure 'the future progress of Ornamental Art'. He also acknowledged the importance of the past and traditional practices when he wrote:

> To attempt to build up theories of art, or to form a style, independently of the past, would be an act of supreme folly. It would be at once to reject the experiences and accumulated knowledge of thousands of years. On the contrary, we should regard as our inheritance all the successful labours of the past, not blindly following them, but employing them simply as guides to find the true path.[4]

The 'true path', for Jones as for other rationalist reformers, has been to build upon timeless and transhistorical principles. The manifestations and aesthetics of design might be numerous, but 'the leading ideas on which they are based are very few'.[5] For example, Jones stated in proposition 13 that nature must never be naturalistically copied, but should always be simplified and stylised in a way which is 'sufficiently suggestive to convey the intended image to the mind'. This principle, Jones concluded, was 'universally obeyed in the best periods of Art, equally violated when Art declines'.[6] It was, in other words, the health of art (including design) that was at stake, rather than the 'characters of men, and of nations'.

There are parallels with the prioritising of structure over decoration, which became an aesthetic principle attributed to Utility furniture in Jones's proposition 5, that ruled: 'construction should be decorated. Decoration should never be purposely constructed.'

The Enlightenment-derived belief in rational principles, the deductive method and the analytical presentation adopted by Jones, anticipate Modernism and indicate a departure from Ruskin's labyrinthine exegeses. Even more significantly in the context of this chapter, Jones does not mention the moral character of designers or artisans; the focus rests squarely on the designed object or surface as a manifestation of transhistorical aesthetic principles.

But, taken together, the moral approach of Ruskin and the aesthetic principles of Jones coalesce into what might be termed 'aesthetico–moral' principles, in which a concern for the moral improvement of humans is seen as integrally related to the aesthetic reform of design along the lines of supposedly timeless principles. Typical of the synthesis of the two approaches are principles such as 'truth to materials' and 'integrity of surface', both of which combine ethical conditions and aesthetic concerns. Indeed, Ruskin himself sometimes implored designers to adhere to this synthesis. In *The Stones Of Venice* he wrote that

> All art, working with given materials, must propose to itself the objects which, with those materials, are most perfectly attainable; and becomes illegitimate and debased if it propose to itself any other objects better attainable with other materials ... The workman has not done his duty, and is not working on safe principles, unless he even so far *honours* the materials with which he is working as to set himself to bring out their beauty, and to recommend and exalt, as far as he can, their peculiar qualities.[7]

For Ruskin, the object would never be a complete end in itself – the word 'exalt' refers to the joyful labour of humans as ultimately celebratory of God's existence – but the workman's duty, and not his moral character, was being judged.

At other times in the nineteenth century when a commitment to design principles was declared, their virtue was not attributed so much to an advance in society along ethical lines, but to an improvement in the taste of the public, or even to efforts to foster commercial gain. For example, the educator, designer and painter Richard Redgrave wrote to the Prime Minister in the 1840s imploring him to found an art school system that would facilitate the 'inculcation of *principles* in design'.[8] But the principles were not invoked in the cause of an ethically superior society, but to 'improve [the] taste' of the public, partly, it was hoped, to produce more discerning *consumers*. The educator and entrepreneur Henry Cole also fought for design principles, believing that 'a total forgetfulness of principles will end in disappointment, and although the resulting novelty may, for a short time, be attractive, yet the sense of truth will ultimately reject wrong treatments'. Furthermore, he believed, the public had to be 'taught to appreciate the best designs'.[9] The 'sense of truth' that supposedly ensured that 'rational' aesthetic principles would be seen as superior and even timeless, was upheld by Cole and Redgrave who, like Owen Jones but more paternalistically, linked it with aesthetic appreciation and taste, rather than with a social or ethical mission.

During the 1880s proponents of the Arts and Crafts Movement returned to the Ruskinian theme of art and design, expressing the moral condition

both of the maker and of the society in which it was produced. William Morris, one of the Arts and Crafts Movement's foremost proponents, argued that the capitalist system had created a visually ugly environment and debased design. Writing in 1885, he argued that 'surely it is but just that outward ugliness and disgrace should be the result of the slavery and misery of the people; and that slavery and misery once changed, it is but reasonable to expect that external ugliness will give place to beauty, the sign of free and happy work'.[10] And when it came to actual designing, beauty, Morris believed, resulted from the appreciation and application of design principles, suggesting that 'the more obvious the geometrical structure of a pattern is, the less its parts should tend toward naturalism'.[11] On another occasion he employed aesthetico–moral principles: the 'first conditions' or fundamental principles underlying glass-painting should be based on truth to the material and its characteristic properties.[12]

The mission for the rational object

By the end of the nineteenth century, aesthetico–moral principles were established in progressive design circles. But the change from the hand-crafted to machine-made method of production which characterises the shift from the Arts and Craft Movement to the Modern Movement, also represents another significant shift in terms of ethical design principles. The Ruskinian ideal prioritised the morality of the maker; the Morrisian ideal also focused on the maker, but on the social conditions in which art and design were produced. The modernist commitment to the machine signified a move away from a concern with the maker or producer to the *object* produced within the context of a progressive, democratic, 'good' society. The new emphasis can be detected in the writings of Adolf Loos, the Austrian architect, designer and controversial polemicist. In his notorious essay 'Ornament and Crime', published in 1908, Loos stated without apparent fear of contradiction that 'the evolution of culture is synonymous with the removal of ornament from utilitarian objects'.[13] Here cultural progress is linked with the aesthetics of the object, rather than the morality of the maker or the social conditions in which the maker produced design.

The modernists' sense of an ethical mission was widespread. Le Corbusier, the most widely-read and influential architect of the Modern Movement, pronounced that the new architecture and design was nothing less than a 'question of morality; lack of truth is intolerable, we perish in untruth'.[14] At the Bauhaus, that seminal art and design institution in Germany, the designer Marcel Breuer was typical of those modernists who saw their work as part of a grand mission: 'Against the changing habits of human utterance there stand the powerful movements of human physical

and psychic development.' Such a sense of purpose meant that one must 'regard [artistic] sincerity as a sort of moral duty'. Sincerity was, Breuer believed, inevitably manifested in 'clear and logical forms, based on rational principles'.[15]

Thus the Bauhaus was committed, in the words of Walter Gropius, its founding director, in 1926, to 'the creation of standard types for all practical commodities of everyday use [which] is a social necessity'.[16] This social necessity was to be achieved by the 'resolute consideration of modern production methods, constructions, and materials', and design would result which was limited to 'characteristic, primary forms and colours, readily accessible to everyone'.[17]

The two major points of continuity between the nineteenth-century reformist and the twentieth-century modernist approaches to design are the beliefs that one can read the state of civilisation through its arts and design and that there are transhistorical design principles which are aesthetico–moral and rational. The major point of discontinuity is the change from an emphasis on the morality of the makers and their work conditions to the object itself and the commitment to social and cultural progress through design. The point of discontinuity represents a shift from individualism to the modernist ideal of collectivism, with its corollary of impersonality.

In Britain, the critic J.M. Richards helped to spread modernist aesthetico–moral principles in articles such as 'Towards a Rational Aesthetic', published in 1935. In this Richards described three major characteristics of modern design: standardisation, simplicity and impersonality. Standardisation implied not just regularity and conformity, but a guarantee of quality as a standard that products could attain. It was, therefore, not just the process to which standardisation referred, but also the object. Simplicity may have been put forward by Richards as the logical outcome of machine production, but it was also an aesthetico–moral characteristic ('honesty', 'integrity') embodied in the object. Richards underlined the shift from the ethical condition of the producer to the object as a symbol of cultural progress, when he wrote that the commitment to simplicity 'has liberated the craftsman from the routine of production, and transferred his special qualities from the process to the object'.[18] Impersonality, Richards's third characteristic of modern design, was symptomatic of the quest for 'generic types rather than ad hoc products'[19] and, again, threw the spotlight on to the formal characteristics of the (standard type) object which may have shed decoration and ornament but, in doing so, gained meaning and aesthetico–moral value.

Herbert Read, in his *Art and Industry*, published around the same time as Richards's article, also placed the emphasis on the formal qualities of the object, arguing that principles should be manifested in an 'economy

of material and [the] utmost clarity'.[20] However, the clarity and order of the object was not to be such that it became too 'cold, precise, imageless, repetitive, bloodless, nerveless [and] dead'.[21] The use of natural materials and limited ornament, so long as it was secondary to the construction, would ensure that the ethical mission was unaffected and aesthetico–moral principles upheld, but a link with nature and the aesthetic of the Arts and Crafts could become an ingredient that asserted a form of national and cultural identity amid the cosmopolitanism and internationalism of the Modern Movement. However, the fact that the Arts and Crafts-influenced aesthetic was not seen as integrally related to handicraft production meant that the emphasis was focused squarely on the object rather than on the producer.

Necessity and Utility

The Arts and Crafts aesthetic funnelled through Modernism is the aesthetic underlying Utility. The Utility idea certainly fits into the notion, outlined above, of design as a moral improver. The Utility designer Gordon Russell considered the irony that the depravations and shortages of 'wartime conditions had given us a unique opportunity of making an advance'[22] by raising the standard of design. The advancement was in social and cultural terms: Utility would give people 'something better than they might be expected to demand'.[23] Michael Farr's comment on Utility as a 'step forward in the education of the manufacturer and the consumer', both in terms of improving taste and making a better society,[24] was typical of those who supported design reform.

The ethical mission was manifested in the visual characteristics of the products. In Utility furniture, simplicity, quality of finish, good proportions, the qualities of the material and a lack of decoration are evident, representing the British version of the standardisation and impersonality that describe modernist values. It embodied the principles of 'truth to materials' and 'integrity of the surface' with an 'economy of material' and the 'utmost clarity' that resulted from sound construction.

After the war, the design mission was carried on by the newly-founded Council of Industrial Design. Gordon Russell, in the very first issue of *Design*, the Council's monthly magazine, wrote of design in terms of quality. It is significant that he included the principle that 'good design always takes into account the technique of production, the material to be used and the purpose for which the object is wanted,'[25] because this principle married functional performance with aesthetico–moral principles. Farr described design as a 'social question, it is an integral part of *the* social question of our time. To fight against the shoddy design of those goods

by which most of our fellow-men are surrounded has become a duty.'[26] The emphasis in design principles remained largely on the object until the arrival of the 1960s and consumerism, when the situation rapidly changed. It was less a case of a change in design principles than an overwhelming rejection of the very notion of principles.

The responsible designer

In the 1960s, talk of design principles and ethical imperatives was drowned out by the predominant discourses of 'design and business' and 'design and lifestyle'.[27] Liberated from any connection with the public good, design was increasingly seen in terms of corporate identity or individual expression. Most design students were too busy paying homage to Swiss graphics or Pop icons to trouble themselves with ethical principles, yet, in the wake of 1968 political radicalism, a reborn interest in design and morality emerged.

The spirit of dissatisfaction with consumerist values in design around 1970 was given its most forceful and articulate voice with the publication of Victor Papanek's *Design for the Real World*. Papanek's motivation for writing the book grew from his realisation of the mismatch between the power and influence of design and the lack of moral responsibility felt by the design profession: 'design has become the most powerful tool with which man shapes his tools and environment [and, by extension, society and himself]. This demands high social and moral responsibility from the designer.'[28] Papanek argued that the designer should prioritise 'six possible directions in which the design profession can and must go if it is to do a worthwhile job'. These included design for the Third World, training and teaching devices for those with special needs, for medicine, for experimental research, survival systems for difficult environments and design for break-through concepts.

Design for the Real World is a very 'moral' book in tone and content, and the author's fundamental tenet that 'it is wrong to make money from the needs of others' chimed well with the radical climate in the early 1970s. Ethical principles and the role of the designer were once again being debated, but the combination of ethics and aesthetics was effectively being prised apart. As far as Papanek was concerned, the designer was responsible for ethical thinking, manifested in the type of work which he or she undertook. There was no interest in the type of aesthetico–moral principles previously associated with ethical design and design reformers: Papanek had no interest in aesthetic principles of any kind – relevance of the design in terms of the ethical agenda was all.

For the radical, post-1968 ethical designer, then, the importance was

still placed on the object, but on the object as a means to the end of improving society. Aesthetico–moral principles were exposed as conflating, if not confusing, matters of design and taste. Design – in terms of its use and benefit to a prioritised user – was one thing; taste – how the product looks – was another. Papanek was not the first to distinguish clearly between, on the one hand, effective or appropriate design and, on the other, 'good' or elegant taste, but the context in which he did distinguish between them has been the most telling.

Papanek's establishment of a design agenda had the effect of focusing some attention back on the designer as an ethical agent. However, unlike the Ruskinian model, which assumed a causal relationship between the *personal* morality of the producer and the *appearance* of his or her design, Papanek's model drew a connection between the *political* morality of the producer – his or her commitment to social change through improvement in the lives of the underprivileged – and the *function* and *effect* of the designer's work. Designers themselves could, presumably, in the postmodern age of diversity, tolerance and individualism, live private lives with values that were, within reason, unrelated to their public values. In that respect, Papanek's emphasis on the public realm of morality converges with the version of the Ruskinian model which links the ethical state of a nation with its art and design, although it is not as concerned with form.

The Green product and 'externality'

One of the legacies of Papanek's *Design for the Real World* has been an influence on the 'Green', 'eco-' or 'sustainable' design movement. Green design, as I have discussed elsewhere,[29] ranges from anti-consumerist 'deep' Green through to 'pale' Green as a consumerist lifestyle category. For the former, consuming as little as possible is the aim; for the latter, consuming products which are more or less 'environment-friendly' is the preferred option. The problem with pale Green design is that it might not actually reduce the amount of consumption at all. None the less, an interest in Green issues among the public has had the effect of raising a more general awareness of design's ethical dimension.

Green design reintroduces an emphasis on the product in terms of whether the materials used in its construction are sustainable, used economically and frugally, whether the processes of production are polluting and whether the product can be reused or recycled when its useful life comes to an end. This return to the object is in line with Papanek's separation of design and taste, because it is the impact of materials and processes which comes under scrutiny, not the appearance of the product. The Green concern with the object connects it to wider – indeed global

– matters such as deforestation and chloro-fluorocarbon (CFC) pollution. An analysis of the product immediately moves *externally* into society, whereas with Modernism and Utility the design focus on the product maintained a largely *internal* discourse. The philosophical, aesthetico–moral concern with beauty and truth is replaced by a more practical concern with the effects and consequences of the product in use.

How Green was Utility?

When one compares the principles surrounding Utility design – the ethical mission for a better society, and aesthetico–moral principles – with those relating to Green design, one is struck by both similarities and differences. The most obvious positive link between Utility and Green design is the economical use of materials – economy of means applies to both movements. In November 1941 the Ministry of Supply stipulated the maximum amount of timber that could be used in the twenty specified articles of essential furniture. Green designers will, as a matter of course, use as little material as possible. The aim is similar for both – the conservation of resources – but the motivating force is obviously different.

The different historical circumstances giving rise to Utility and Green design reveal a significant difference in attitudes to the use of materials. At the beginning of 1941, plywood, because of its weight-to-strength ratio and general economy in use, accounted for 80 per cent of Utility furniture. In Green terms, plywood can be a sustainable material: there are now sustainable birch and conifer plantations in northern Europe, but those from tropical forests are seldom conserved. With Utility, sustainability was not considered an issue compared to functionality and availability. The reason for the withdrawal of plywood from Utility at the beginning of 1942 was because it was needed for aircraft production.[30]

In 1942 it was specified that only hardwoods – oak or mahogany – were to be used in Utility designs. By the beginning of the next decade, the global trade in hardwoods began to expand at an alarming rate to the extent that, by 1980, it had increased sixteenfold. Mahogany is one of the main tropical timbers traded in the UK, and the public is now much more aware that the exploitation of mahogany is a major environmental problem.

Utility and Green design may share a commitment to an economical use of materials, but where the ethical and aesthetic conjoin – the aesthetico–moral – there are significant differences. The Green designer's economical use of materials may result in simplicity and a lack of ornamentation, but in Utility, as in the Modern Movement more generally, the economical use of materials is related closely to aesthetic ideals of simplicity and purity which are essentially Platonic and formalist.

Although a certain 'natural' look has become associated with Green design, the aesthetico–moral link is not an issue for the Green designer: appearance, theoretically and visually, can be varied and 'impure'. Modernists and nineteenth-century design reformers, including Ruskin and Pugin, despised the use of veneers, 'false fronts' or 'shams'. Veneers were considered to be unethical because they implied that the material you saw was the material of which the item was constructed. A veneer was deemed, therefore, to cheat the viewer because the part was not consistent with the whole. Rationalist values of logic, order and consistency governed this principle. Veneers are liberally used by the Green designer and, according to the Timber Trades Federation, their use has been growing in recent years, fuelled by technological advances which have facilitated the coupling of thin, decorative hardwood surfaces to modern timber compositions such as medium-density fibreboard. That the surface does not indicate the whole is not an issue for the Green designer because rationalist order is of little consequence compared to the principled and responsible conservation of resources. Thus the similarity between Utility and Green exists at the level of economy of means and awareness of resources, albeit for different historical reasons. But the particular assumption upheld by Utility designers about economy's relationship to a supposedly superior aesthetic has been rejected in Green design thinking.

The conflation of design principles and matters of taste which was characteristic of both Modernism and Utility was, we now realise, a form of cultural elitism. The Pop sensibility liberated taste from moral superiority but, with its appetite for fantasy, fun and visual impact, disregarded the implications of design in terms of the exploitation of resources and polluting processes of production. The post-Pop re-engagement with the ethical dimension of design was established and developed by separating design and taste. Therefore an interest in aesthetico–moral principles was viewed as suspect – simulation and visual inconsistency were perfectly acceptable so long as materials and processes were responsibly employed. This represented a rejection of a narrow rationalism which had become equated with uniformity, earnestness and sobriety. Inasmuch as the denial of aesthetico–moral principles does not contravene genuine Green ethical principles, appearance is a matter of style which is more concerned with reflecting social pluralism and cultural diversity.

Ethical designers and consumers

The ethics of Green design shifted attention to the product, but in relation to 'external', environmental factors. In recent years a further shift has seen Green product criteria such as environmental impact and energy

consumption being subsumed under ethical criteria in an expanded field which includes whether the company that produces the product operates in a country with an oppressive regime, the quality of its labour-force relations, the wages and conditions of the workforce, its environmental responsibility, its involvement, directly or indirectly, in nuclear power, infringement of land rights, role in armaments, animal testing and whether it employs irresponsible marketing.

These wider ethical criteria are applied not to particular products, or even whole brands, but to the parent company. The redesign of a particular product so that it can be labelled 'ozone-friendly' or 'made from sustainable materials' can be beneficial, but other products produced by the same company may continue to be polluting and harmful. The obvious short-coming, therefore, in an object-centred approach, however externally orientated, is that some environmentally-friendly or ethically sound products may be produced by companies with a less than environment-friendly corporate record. The growth of ethical consuming (as well as ethical investment) testifies to the existence of a vital, continuing ethical dimension in design. At the time of the Gulf War, the editorial of *The Ethical Consumer* magazine underlined how 'Ethical consumerism is essentially a pacifist philosophy. It argues that the marketplace is a vast untapped resource that people can use to express their ethical and political beliefs in a non-violent manner.'[31] But it is an ethical dimension which sees design not as a relatively self-contained, let alone aesthetico–moral discourse, but as inexcusably implicated by, and fully integrated into a social and political system.

Conclusion

The company-orientated basis of ethical consuming makes Utility seem a very distant relation within the ethical tradition of design. Even the product emphasis in Green design, because of its strongly external orientation towards environmental questions, can be sharply distinguished from Utility. But a part of the tradition of the ethical dimension of design it certainly is, upholding a commitment to an ethical role for the designer, and applying aesthetico–moral principles in the creation of the product, however inward that orientation becomes, and however confused and paternalistic it is in its conflation of design and taste.

Yet even at its most paternalistic, the ethical tradition is one which upholds the notion of 'the common good', and in an era in which we have witnessed governments' commitment to 'Design for Profit', wholesale privatisation and even a denial that 'society' exists, it is a tradition which we ought to revisit, reassess, value and promulgate, because it upholds the virtues of social idealism, social conscience and social justice.

Notes

1 John Ruskin, from *The Queen of the Air* (1865–66), quoted in Kenneth Clark, ed., *Ruskin Today*, Pelican, 1967, p. 168.

2 *Ibid.*

3 Owen Jones, *The Grammar of Ornament*, Studio Editions, [1856] 1986, p. 5.

4 *Ibid.*, p. 2.

5 *Ibid.*

6 *Ibid.*, p. 6.

7 John Ruskin, *The Stones of Venice*, Vol. II (1853), quoted in *Selections from the Writings of John Ruskin*, Allen and Unwin, 1898, p. 373.

8 Richard Redgrave, 'Suggestions About the School of Design' (1846) in Bernard Denvir, ed., *The Early Nineteenth Century: Art, Design and Society 1789–1852*, Longman, 1984, p. 235.

9 Henry Cole, 'Standards and Fashions in Textiles' (1844) in Denvir, *The Early Nineteenth Century*, p. 266.

10 William Morris, 'The Worker's Share of Art' (1885) in Bernard Denvir, *The Late Victorians*, Longman, 1986, p. 72.

11 William Morris, quoted in Paul Thompson, *The Work of William Morris*, London, 1955, p. 89.

12 William Morris, quoted in Ray Watkinson, *William Morris as Designer*, Trefoil, 1990, p. 39.

13 Adolf Loos, 'Ornament and Crime' (1908) in Ulrich Conrads, ed., *Programs and Manifestoes on Twentieth-century Architecture*, MIT Press, 1970, p. 20.

14 Le Corbusier, *Towards a New Architecture*, Architectural Press, [1927] 1970, p. 17.

15 Marcel Breuer, 'Metal Furniture' (1927), in Tim and Charlotte Benton with Dennis Sharp, eds, *Form and Function*, Open University/Butterworths, 1975, p. 226.

16 Walter Gropius, 'Principles of Bauhaus Production' (1926), in Conrads, *Programs and Manifestoes*, p. 96.

17 *Ibid.*, p. 95.

18 J.M. Richards, 'Towards a Rational Aesthetic', *Architectural Review*, December 1935, p. 137.

19 *Ibid.*

20 Herbert Read, *Art and Industry*, Faber and Faber, 1934, p. 34.

21 *Ibid.*, p. 14.

22 Gordon Russell quoted in Fiona MacCarthy, *A History of British Design 1830–1970*, Allan and Unwin, 1979, p. 69.

23 Gordon Russell, 'National Furniture Production', *Architectural Review*, December 1946, p. 184.

24 Michael Farr, *Design in British Industry*, Cambridge University Press, 1955, p. 5.

25 Gordon Russell, 'What is Good Design?', *Design*, Vol. 1, No. 1, January 1949, p. 2.

26 Farr, *Design in British Industry*, p. xxxvi.

27 See Nigel Whiteley, *Pop Design: Modernism to Mod*, Design Council, 1987.

28 Victor Papanek, *Design for the Real World*, Thames and Hudson, 1974, p. 9. A revised edition was published, also by Thames and Hudson, in 1984.

29 See Nigel Whiteley, *Design For Society* Reaktion, 1993, chapter 2.

30 See Chapters 7 ('Utility furniture') and 13 ('Freedom of Design') in this volume for an account of the use of plywood in Utility furniture.

31 Editorial, *The Ethical Consumer*, No. 12, February/March 1991, p. 1.

13 ✦ Freedom of Design

Judy Attfield

IT WAS only in the British furniture industry that the Utility Scheme managed to gain total design control by actually imposing a specific range of statutory designs.[1] Although the stricture on form only lasted for five years, between 1943 and 1948, it nevertheless contributed irrevocably to some of the most swingeing structural changes the furniture industry was forced to undergo during the war and the austerity years that followed the declaration of peace in 1945.[2] But the impact of the Utility Scheme on furniture design cannot be fully evaluated without taking into account its post-war phase during the 'freedom of design' period between 1948 and 1952, when a new range of prescribed designs were introduced while a degree of regulation was still in force. The aim of this chapter is to expose the clash between a post-war furniture industry eager to enter the new 'freedom of design' era with its own ideas on modernisation and the small but powerful group of advisers on the Design Panel of the Furniture Working Party,[3] eager to retain some measure of enforcement in the campaign to reform design standards once peacetime conditions no longer justified total design control.

Design history accounts tend to concentrate on the Utility Scheme as a throw-back to the ideals of the nineteenth-century Arts and Crafts Movement in the guise of twentieth-century Modernism.[4] But glossing over it as part of a heroic, doomed campaign to reform the design of everyday things through the imposition of a minimal range of pared-down designs approved by a specialist committee of experts only gives a partial representation. Little reference has been made to the way in which the industry fought back to regain its traditional hierarchical structure from what it perceived as the heavy hand of government intervention.

Because the furniture industry was the only industry to be subjected to design by statute, it offers a unique opportunity to study how the Utility Scheme at its most extreme was used in a bid to transmit the 'good design' message; a lesson that neither the industry nor the public were particularly eager to learn. It should be noted that for all the heroism attributed to

the Utility Scheme as an influential force in the campaign for modern design reform, the first Utility range, composed of the barest of essentials, was far from being a model of 'good design', either visually or in the method of its manufacture. The stark designs were determined more by the wartime spirit that managed to make do with the minimum of limited resources, and had more in common with the nineteenth-century workshop method of production than the modernists' dream of elegant forms resulting from rationalisation and new industrialised production processes. While the large well-equipped factories were reserved for war work, the few makers licensed to produce furniture for civilian use were left to manage with antiquated methods of production, resurrected machinery and an inadequate work force. Tradesmen in their seventies who had served their apprenticeships in the late 1800s were drawn back into the industry to work alongside boys too young to be drafted and with no training or experience.[5]

When the Utility designs first came into force in 1942, they added yet another restriction to the more general statutory limitations already being applied to most goods produced for civilian consumption as part of the war effort. Added to the measures to limit labour through the allocation of licences that restricted the number of manufacturers permitted to produce for the home market and to ration the resources essential to furniture production such as timber and textiles, the Utility designs divested the industry of any vestige of independence it might otherwise have retained. Further controls were effected through price regulation, strict zoning of distribution areas and tight rationing of furniture consumption.

Following the years of austerity immediately after the end of the war and in response to the furniture industry's demands, 'freedom of design' was conceded in 1948, the same year that rationing was lifted; but not before the Design Panel of the Furniture Working Party had a try at bringing in a range of standard furniture for universal application while they still held the reins of power. Shortage of supplies continued and it was not until goods were more generally available in the mid-1950s that the industry found it necessary to switch its attention away from production to concentrating on the selling of its goods in an increasingly competitive market. Yet because of shortage between 1948 and 1952 there was no need to recruit styling in order to sell. Many makers chose to continue producing the Utility designs rather than bother to submit their own designs for approval, while others stopped producing the Utility designs before it was commercially necessary.

In many ways the most telling period for Utility furniture was that of the Freedom of Design years, rarely referred to in accounts of the history of design, because it was when the ideals of 'Good Design'[6] suffered an

all-time low. In the post-war Utility years (1945–1952) the range of
furniture designs was augmented and diversification introduced to banish
the unfortunate reputation for uniformity that Utility goods had acquired.
It may well be that because so much of the literature of design history
has until recently insisted on only tracking the progress of Good Design
that it has ignored as an embarrassment those years when Utility designs
were no longer obligatory and every rule of good design was broken. In
order to avoid the prohibitive tax imposed on non-Utility goods, carved
ornament became an add-on black-market commodity, and countless
travesties of 'repro-contemporary'[7] were produced by furniture-makers eager
to assert their independence from government intervention and readily
bought by a public starved of consumer goods.

There was an awareness among the critics of popular taste that once
the instruments of enforcement could not be relied upon any longer, they
would have to muster their best powers of persuasion to convert the public
to choose plain, honest design and desist from the seductive attractions
of the decorative. The interim period, between the end of the war and
before the Utility Scheme was finally revoked in 1952, saw how the design
reformers sought to put their ideas into action and commence the process
of persuasion while they still held some power through regulation. The
main task they set themselves was to produce a range of visually pleasing
designs. Their approach assumed a natural correlation between process and
form, revealing the modernist principles which lay behind their strategy.
Although there was an acknowledgement of the need for propaganda to
persuade the public to accept Utility principles, they hoped to do this
through an attractive popular version of the modern aesthetic, failing to
take account of the powerfully negative image of uniformity that Utility
held for most people who had lived through the war, and for whom it
represented deprivation. As late as 1947, one year before the dissolution
of the Design Panel and the granting of 'freedom of design', there still
seemed to be a mistaken assumption on the part of the advisers that the
industry would welcome standardisation and that it only remained to
convert the consumer.

The object of this chapter is not to present a critique of the democratic
ideals behind Utility with its initiative to make a good standard quality
of furniture available at a reasonable price and by the most economic
means to those in most need. There is little doubt that the intention of
those involved in trying to apply the principles of Utility to furniture was
to marshal design to mediate the cause of social reform and modernisation.
But it was only a small band of individuals who were concerned with the
details of what form should be used to embody those principles. Modernism
was the only aesthetic they considered appropriate to express the ethics of

the design practice they were advocating. In exposing the multiplicity of styles and forms that actually appeared under the post-war Utility Scheme, however, it is possible to see how the various interpretations produced managed to objectify a diversity of perspectives and design discourses from within the furniture trade as well as emanating from the various factions of the Good Design movement.[8] Nevertheless, the diversity was subtly hidden behind a perceived modern aesthetic representing for the reformers a wish rather than a fulfilment, and for the industry a patriotic duty it was only prepared to tolerate during wartime.

Freedom of Design and Diversification

The second phase of Utility furniture designs were produced under the guidance of Gordon Russell and the Design Panel of the Furniture Working Party, formed immediately after the war. What made it markedly different

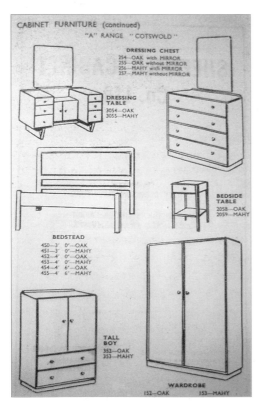

41, 42 Post-war Utility bedroom furniture from the 'Cotswold' 'A' range illustrated in the Northern Furniture Trades Federation Utility Furniture manual, 1947 and [*right*] a 'Cotswold' 'A' range dressing table illustrated in the 1947 Council of Industrial Design pamphlet *How to Buy Furniture* by Gordon Russell

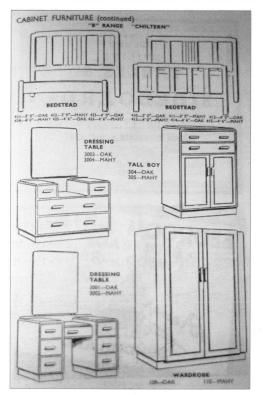

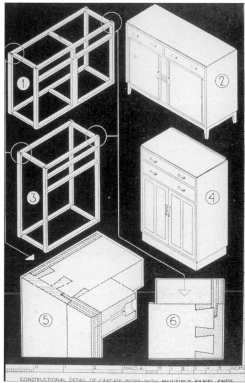

43, 44 Post-war Utility bedroom furniture from the 'B' range illustrated in the Northern Furniture Trades Federation Utility Furniture manual, 1947 and [*right*] working drawings showing construction recommended for post-war Utility furniture using multi-ply, once it became available for civilian use after the war. The panelled tallboy doors were a characteristic feature of the Chiltern range adopted from the original wartime Utility range

from the first series, produced in 1942, which had consisted of a single universal range, was the addition of a number of alternative models and types. These were grouped into three ranges distinguished by the names Cotswold 'A', Chiltern 'B' and Cockaigne 'C', in an attempt to provide a semblance of consumer choice, but also to respond to the reconstruction of the furniture industry after the war by replicating the pre-war hierarchical three-tiered system of manufacturers of first class (A) (figures 41, 42), second class (B) (figures 43, 44), and third class (C) (figures 45, 46), in three different qualities and price bands of goods. The Cotswold represented the modernist version derived from the traditional Arts and Crafts, more exclusive end of the market, based around firms in the Cotswolds like Russell's own. The Chiltern, preferred by the majority of the furniture manufacturers and retailers, was the original Utility range designed by trade designers from High Wycombe and based on their own pre-war tried and

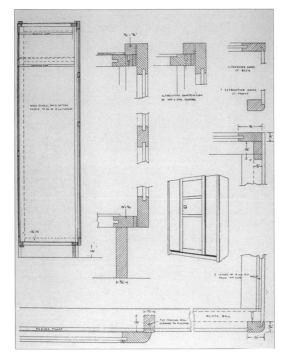 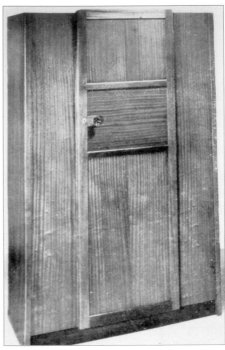

45, 46 Working drawings for a wardrobe in the 'C' range of bedroom furniture planned for post-war Utility furniture production. Although some prototypes were produced and exhibited, this cheaper range of Utility furniture never went into production. [*Right*] Prototype wardrobe designed for post-war production

tested designs and practices. It was the Cockaigne range that was intended for the new type of mass production encouraged by the government along American Fordist principles. But it was never adopted commercially and not even illustrated in the second Utility catalogue, published in 1947. Factory mass-produced furniture was unknown in the British furniture trade except from one firm – Lebus of Tottenham, who had set out in 1920 to manufacture a new type of factory-produced 'C' class goods aimed at the working-class market, previously only made by sweated labour in the small workshops of the East End of London.[9]

Lebus brought American factory production methods to Britain, and was one of the first firms to move its premises from the East End to the Lea Valley, where it set up a huge purpose-built modern factory which was fully operational by 1901.[10] A minute of a board meeting under the heading 'Manufacturing Policy', recorded in 1920, shows how early Lebus saw the possibilities of adopting Fordist manufacturing methods to furniture production:

The Firm has decided to attempt the manufacture of, not the lowest class

of furniture, but of the fourth class; it is not its intention to make anything that is not likely to wear well, and puts forward as an analogy between the present and the proposed kinds of furniture – the motor cars of Rolls Royce and Ford.[11]

The directors recognised that there was a risk attached to changing from the 'second class' grade of furniture they had been manufacturing before the First World War to the 'fourth class', which until that time had been confined to what they called 'Garret class'[12] production, which no other factory 'had succeeded in competing with'.[13]

Herman Lebus sat on the Furniture Advisory Committee to the Board of Trade responsible for the Utility designs between 1942 and 1949. His firm had the means to manufacture the type of mass-produced democratic product the reformers were aiming at, but by the rest of the industry Lebus was merely regarded as the lower, 'C' end of the market. And no sooner was freedom of design conceded, even though one of the most radical of the modernist reformers – Jack Pritchard – had been recruited as Director of Design and Development, than Lebus returned to retailer-led design that demanded sideboards with 'waterfall fronts' and novelty handles (figures 47, 48).[14] It is significant that in the obituary Gordon Russell wrote for *Design* magazine on the death of Sir Herman Lebus in 1957[15] he felt it necessary to point out that he did not agree with Lebus's approach to furniture-making, picking out the most uncharacteristic of Lebus's production, the 'Link' range newly launched in 1956 and expressly designed for the more expensive middle-market sector,[16] as the only range worthy of mention because it set 'a higher standard of design'.

In spite of the Council of Industrial Design's efforts to promote the new post-war Utility designs through exhibitions and numerous publications, the Cotswold 'A' and the Cockaigne 'C' ranges never got past the prototype stages, and in spite of the latter's several redesigns and renamings, proved commercially unviable. It was only the Chiltern 'B', based on the original first-phase designs by the two trade designers, Edwin Clinch and Herbert Cutler of High Wycombe, and therefore appropriate to traditional batch production practices, that proved popular and remained in wide circulation with minor variations for many years.

The third phase of Utility designs after 1948 were non-statutory. Brought out concurrently with the introduction of 'freedom of design' and in expectation of predictions made by critics like John Gloag who feared that 'rubbish' would once more be 'foisted upon the undiscriminating'[17] if manufacturers were not given guidance, the significantly named 'Diversified' range (figures 49, 50) was developed as a more popular variation of the by then discontinued Cotswold. It tried to cater for the demands of the trade and the public for a new, less austere look than that of

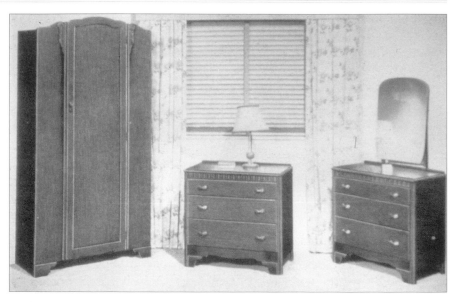

47 Bedroom furniture illustrated in the Lebus catalogue of 1954

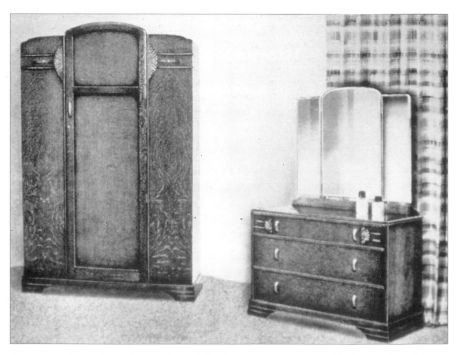

48 Example used to educate the public about good design, with the caption: 'The shapes have gone to seed a bit and the pressed decoration bears little relation to them. Decoration is not necessarily wrong, but what is the point of the bits applied to these pieces?'

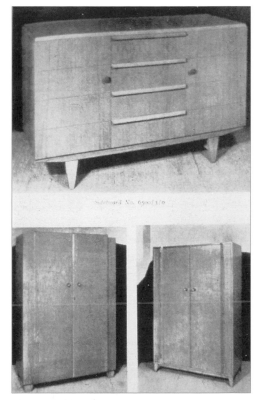

49, 50 Examples of prototypes adapted for the 'Diversified' range designed for the last phase of Utility once 'freedom of design' was allowed within the tax-free Utility Scheme and [*right*] A page of advertisements in *The Cabinet Maker Utility Furniture Guide* published in 1948, the year when 'freedom of design' was conceded to the furniture industry

wartime Utility. As its name implied, it was formulated to offer manufacturers a greater range of approved designs with the expectation that its stylish appearance would be attractive enough to prevent them from resorting to the popular 'repro' and 'modernistic' styles from which reformers had worked so hard to steer them.

Variations and adaptations of Utility designs survived long after the controls were lifted. In the instance of J. Clarke, chairmakers of High Wycombe, a Utility-derived design was among their best sellers in the 1950s and continued to be produced until 1979.[18] Vestiges of it are still discernible in some furniture produced today. But standardisation, initially one of the central principles behind the Utility Scheme, did not survive the post-war period. Even before the inception of 'freedom of design' the number of Utility designs increased and diversified to such an extent that it would be impossible to compile and document a complete catalogue

of all the variations sold under its name. The analysis of just a few examples of the designs detailed by John Hooper,[19] head of the Ministry of Building and Works and one of the instigators of the original Utility Scheme for furniture, confirms the point that neither uniformity of form nor stand- ardisation of production characterised the post-war Utility designs. Hooper was responsible for the production of the working drawings for the post-war Utility designs, quite a feat of rationalisation in view of the confusion of different ideas that emerged from the Design Panel discussions.[20]

However, the superficial appearance and style of the post-war Utility designs does not necessarily reveal the changes to the structure of the furniture industry that took place during and after the war. A close look at the construction details of some of the models worked on by John Hooper in the development of the Diversified range shows up much more clearly some of the problems faced by the industry in returning to peacetime production. Trained draughtsmen like John Hooper considered the con- struction more their province and responsibility than the external appearance of the piece. But manufacturers who were not in the habit of following drawings and saw no reason why they should be forced to deviate from their traditional practices, in which they already considered themselves to be expert, did not take kindly to being told how to design furniture by government officials.[21]

The sixth edition of John Hooper's textbook on furniture construction, published in 1952 but actually written in 1949, gives an insight into the development of the peacetime Utility design in the context of contemporary design education. It acknowledged that 'major changes in the furniture industry'[22] were reflected in contemporary design and 'post-war practice in handcraft and machine production' through the 'different technique arising from new materials, improved machinery, the introduction of the vacuum bag veneering process, and the development of shaping and forming presses'. But it stated quite categorically that it did not deal with 'the highly specialised machine and assembly processes of mass production' which required 'engineering and jig practice'. This was apparently still seen as the type of production process to be used for the 'C' category of cheaper furniture production. Hooper's outlook illustrates the mainstream tradi- tional approach to furniture design at that time, which did not consider engineering solutions and could not envisage furniture as a suitable case for applying 'industrial design'. Indeed, in his preface Hooper asserted that he did not intend his book to 'be a treatise on furniture *design*' (emphasis added); an interesting disclaimer in view of the content, most of which comprised highly detailed descriptions of construction processes and tech- nical drawings, machinery and materials – all with a direct bearing on the design of furniture. But 'design' in Hooper's vocabulary referred to aes-

thetics, an area he did not consider his responsibility. His expertise was confined to 'technical practice', to translating the specifications supplied by a professional designer (at that time usually an architect) into working drawings to instruct the manufacturers.

A distinction between different types of designers within the furniture industries at this time needs to be recognised. Trade designers like Maurice Clarke and George Plested, who had worked in the High Wycombe furniture industry all their lives, objected to designs produced by the 'Ministry' because they weren't 'in line with the standard trade procedure'. Clarke and Plested were sceptical, because although 'they' (meaning the Ministry of Buildings and Works designers like John Hooper) '*said* they were furniture designers, they weren't factory people' (emphasis added), and consequently used a different set of practices, for example, so that the 'finished' size specifications in Ministry drawings did not accord with standard plank sizes, so causing waste of timber if the drawings were to be followed exactly.[23]

That division of labour that separated head from hand is typical of the dilemma facing mid-twentieth-century design reformers. It encapsulated the problem identified by modern functionalist theory which insisted that form was the logical result of process. It also shows that modern functionalist theory, synonymous with industrial design practice, was not present within the furniture trade designer's education. The strict class division between 'useful' and 'artistic' knowledge that existed in the nineteenth-century schools of design [24] was still alive and kicking in design education a century later. Nor, for that matter, was the logic of functionalist theory upheld by the design consultants to the Utility Scheme, who, like Gordon Russell, appear to have continued to support Arts and Crafts practices, although much lip-service was paid to design for mass production.

The 'Good Design' faction which believed that furniture should be designed and manufactured as an industrial product was headed by Jack Pritchard,[25] mentioned above with reference to his connection with Lebus. Before the war, associated with the Venesta Plywood Company and the modernist architect Wells Coates, he represented the view in favour of mass production and standardisation on the Furniture Working Party responsible for the post-war Utility designs. His type of uncompromising view required a complete break from craft traditions and regarded furniture as a candidate for industrial design and mass production along Fordist principles. But although Pritchard's would appear to have been a rather lone voice, he did achieve a position of some influence as Secretary to the Furniture Development Council.

The Geffrye Museum's catalogue of its Utility Furniture and Fashion exhibition (1974), described the Furniture Development Council as 'the

natural successor of the Utility Furniture Design Panel',[26] but did not question the fact that the furniture industry did not 'concentrate' or switch over to mass-production techniques. Hooper's textbook, even in its 1952 revised edition, gave precedence to handcraft, more in keeping with the hierarchical and fragmented structure of the traditional furniture industry with its large number of workshops and small factories in the pre-war period, than with a reconstituted industry equipped and ready for mass production.

The ply-frame construction flush finish

'Ply-frame' construction is a recurrent motif that embodies the progress of the principles upheld by the advocates of Good Design who hoped that the Utility Scheme would initiate a post-war period of design reform. Because the ply-frame technique is not a visible feature, it serves to illustrate in material form how a diversity of perspectives and design discourses was built into the furniture itself. Hiding behind a bland surface style of standard Utility designs, we have seen how the pre-war hierarchical structure devised for a deregulated industry managed to reconstruct itself in the Cotswold 'A', Chiltern 'B' and Cockaigne 'C' ranges in the post-war period.

It was not until after the war that the Utility design group could get back to the niceties of considering design from first principles, much less hope to obtain the necessary resources to achieve it. In theory the big advantage of the release of plywood and manufacturing technology from vital war work was the possibility it offered to design low-cost furniture by mass production as an engineered product rather than as a machine-assisted craft process, as used by the smaller factory manufacturers during the war.

When John Hooper, as head of the Ministry of Building and Works, first made the recommendation to the Central Price Regulation Committee which led to the original Utility designs in 1942, he submitted designs based on a ply-frame construction – the conventional mortise-and-tenon-jointed frame originally used when plywood was introduced into furniture manufacture during the 1920s.[27] In other words, it combined a modern material – plywood – enabling the use of wood in an economic and stable thin-skin form, to be used with a traditional jointed frame. When ply was superseded in the inter-war period by the multi-ply and lamin boards that did not require a frame, the ply-frame technique fell into disuse. Hooper resurrected it in the early developmental stages of the Utility designs because it adapted well to factories with limited plant while the more highly equipped were engaged in essential war work. But ply could not be spared from war work, and was replaced by hardboard, which could only be used

in a construction that produced a panelled rather than the preferred streamlined effect.

Hooper's textbook, published in the same year as the dissolution of the Utility Scheme in 1952, appears to have assumed that the furniture industry would continue to use the techniques and designs introduced by the Scheme's Good Design initiative. The feature he singled out for particular mention in Utility furniture design was the ply-frame technique and the possibility it offered, once plywood became available for furniture production once more, of 'overlaying or sheathing the framing to obtain a streamlined look' (figure 49).[28] This was the opportunity for the wartime Utility designs to be revised in keeping with a more contemporary interpretation of the machine aesthetic, by then represented by 'flush finish' detailing to replace the outdated 'streamlined look'.

An analysis of the different constructions of the Cotswold, Chiltern and Cockaigne ranges illustrates the conflict between the ideals of mass production and the realities of the post-war furniture industry as it re-formed for peacetime production. Although the stated intention of the Design Panel was to produce a range of economic and lightweight modern designs, the construction reveals the importance accorded to the contemporary flush-finish aesthetic. Although the Chiltern proved the most popular of the post-war adaptations of the original Utility designs using a basic system of framed-up standard panels and joints, it did not conform with the contemporary 'look' because of the use of panelled construction criticised by Christopher Heal for giving it a 'period look' (figures 43, 44).[29]

The more sophisticated but commercially unviable Cotswold range displayed a number of complex styling features attesting to the Design Panel's efforts to achieve an appropriate contemporary style, based on multi-ply carcass ends on horizontal framing with vertical rails. One of the Cotswold wardrobes shows a pair of veneered blockboard doors with a bevelled moulding glued on the face. Raised off the floor by four legs on a stand, rather than by the more old-fashioned plinth, it included a number of complicated details such as chamfered edging on the pilasters on either side of the doors, resulting in a more contemporary style than that of the panelled Chiltern. The Cotswold range comprised a larger number of variations and even included two bow-fronted sideboards.[30] Hooper stated that the Cotswold was 'primarily designed for mass production', but at the same time, obviously aware of the limitations of the structure of the furniture industry, had made sure that 'it was also suited to handcraft processes'.[31] The Cotswold was stylistically 'light' looking, but unnecessarily heavy in weight with its multi-ply sides and blockboard doors, and when costed proved unrealistically expensive.

The Cockaigne range was designed specifically 'for mass production

and made much greater use of machinery than either the Cotswold or the Chiltern'.[32] It was exhibited at the *Daily Herald* Modern Homes Exhibition as one of the three prototype Utility ranges in 1946, but never went into production. In her book *Contemporary Cabinet Design and Construction*, Denise Bonnett refers to a 'C' range, a later variation of the Cockaigne – possibly the so-called 'Cheviot' – and described it as designed by 'some of the best British furniture designers employed at the end of the war ... [representing] a considerable advance both in design and construction on the original 'A' [Cotswold] and 'B' [Chiltern] ranges'.[33] The only difference between the Cockaigne and the Cheviot wardrobe, as far as can be established, is the latter's three-panel rather than two-panel door and the handle and lock details. An early prototype of the same wardrobe was illustrated in a 1947 Council of Industrial Design pamphlet *How to Buy Furniture* by Gordon Russell, in which he pointed out 'how much care had been taken to bring handle and key-plate into a harmonious relationship' (figure 46).[34] However, he omitted the more significant fact that the later commercial version of the 'C' range wardrobe was designed with a con- siderably reduced framework and minimal ply thickness, making for a much more economical product.

To summarise – the Cotswold range was designed to be made from prefabricated timber materials and a system of assembly dependent on glued and screwed carcass parts, rather than the more conventional furniture construction reliant for strength on a standard jointed frame of the type used for the Chiltern range and suited to the majority of the furniture manufacturing industry's practices and resources. But the 'C' category of mass-produced furniture at the lower end of the market never succeeded in getting off the ground, because as soon as freedom of design was conceded, manufacturers like Lebus returned to their traditional role of 'serving the retailer' with a large variety of ornate novelty goods of the type deplored by the Good Design reformers.

The Diversified range was much more style-conscious than the earlier Utility ranges. It was characterised by the chamfer, an angled detail employed in a number of different guises, which was to become a typical fashion feature associated with the 1950s. The chamfer was used on the fillet edging of drawers and chest-tops and in the shape of the splayed and tapered feet or legs of sideboards and dressing-tables, often set back from the edge so that the cabinet appeared to float over the stand, giving a much lighter appearance than that of the more usual skirting-board type of plinth. The chamfer also appeared in details such as the pilasters on either side of a sideboard front, splayed for no apparent reason other than to provide an angle on the front reinforcing pilasters, giving the effect of setting the doors back from the frame (figure 49).

A characteristic feature of the Diversified range was the incorporation of what Hooper described as 'new developments' in constructional technique using horizontal framing with vertical rails to receive overlaid plywood and small finishing fillets to obtain a 'perfect flush finish'.[35] 'Flush finish' replaced the 'streamlined' look associated with the inter-war elitist version of the minimal Modernism the design reformers were trying hard to throw off in a bid to gain popular support for Good Design. Once ply became available for civilian use after the war, it was associated with a contemporary form that made it distinctive from Utility carcass furniture with hardboard panels. The Diversified range was the culmination of the efforts of the Design Panel of the Furniture Working Party to produce a range of Good Design furniture using the latest materials and production processes. But the abolition of the Utility Scheme that lifted the last of the design restrictions and the introduction of the new fairer D scheme for tax on furniture also rendered the Diversified designs obsolete.

Conclusion

Lebus, the largest furniture manufacturing company in Britain, and one of the few who were all set to engage in mass production, went on to use the frame and ply panel construction in their post-war bedroom and dining furniture, but ignored the stylistic strictures which the Utility Design Panel advised.[36] The Utility designs did not manage to persuade manufacturers to adopt modern styling nor to change their production processes. On the contrary, it is evident that it was the manufacturers' production practices as much as the limitations imposed by the shortages of resources which shaped the Utility designs. Nor can it be said that Utility design managed to mediate between the different factions within the small circle of Good Design reformers. There was some recognition of changes in cabinet-work construction brought about by the use of materials such as plywood, the technology necessary to be able to supply it in good-quality work and the development of 'component' techniques that entailed the use of stock or bought-in prefabricated parts. But none of these techniques were particularly innovatory, since they were originally introduced into the furniture industry in the 1920s.[37] Nor did they require much technology to apply them, and they could be used for batch as well as for mass production.

The Utility designs have been represented as producing a universal set of designs that guaranteed high quality at minimal cost. The mythical 'heroic age' did not last for long, and it is evident from the history of the variety of different constructions, that in spite of great efforts to achieve standardisation, this only happened for a very short period, between 1943 and 1945. And even the first designs were neither conceived for nor made

by mass-production means. The later peacetime variations, limited to specific sizes to avoid purchase tax, were fairly standard in appearance because of restrictions regulating dimensions and proportions, thereby also prohibiting certain types that fell outside the size specifications. But the Cotswold 'A', Chiltern 'B' and Cockaigne 'C' ranges clearly reproduced the hierarchy within the industry in terms of class, quality of goods and status of producer, cutting across the Good Design ideal of a single set of models universally applicable to all.

In the first of the Penguin 'Things We See' series, *Indoors and Out* (1947), Alan Jarvis expressed the hopes of a generation of design reformers who believed in the benefits of industrial design:

> Machine technology, properly ordered to serve man's deepest and most real needs, can mean the creation of a congenial, gay and efficient environment for the great mass of people. It could bring about a cultural as well as an economic democracy; but it will not do so until we, the consumers, understand the real potential of machine production and give clearer and less prejudiced guidance to the designers who set the machines to work.[38]

The attempts to achieve a levelling effect through Utility designs were not fulfilled (figure 50). The evidence of post-war Utility designs suggests that they were more determined by the production capabilities of the various categories of manufactures than by Good Design ideology. The external appearance, which did manage to retain a certain semblance of standardisation while the scheme was in operation, was interpreted negatively by makers and consumers alike, as uniformity.

After a strict period of regulation which attempted unsuccessfully to homogenise an industry fragmented by a conservative hierarchical structure, and with the dissolution of the last vestiges of the Utility Scheme in 1952, the heterogeneity of the furniture trade resurfaced once more. It did not reincarnate itself in its exact pre-war form. With many of the small firms gone and some lessons learnt about the benefits of modernisation forced by the stringent requirements during the Utility period, it constructed a version based on the traditional hierarchical culture of the furniture trades, but modified to face the challenges of the standardisation that was perceived to be the only possible future for the industry.

Notes

I dedicate this chapter to the memory of Maurice Clarke, who died in October of this year (1997), a High Wycombe chairmaker, a true craftsman and a dedicated contributor to the pursuance of high-quality furniture-making through his productions, teaching and, in his latter years, through the legacy of his generously shared memories and firm's records, both housed in the Archive of Art and Design (Blythe Road) of the Victoria and Albert Museum (see note 5).

1 For a full account of the first phase of the Utility furniture designs see Chapter 7 of this volume.

2 See J. Attfield, 'Good Design By Law: Adapting Utility Furniture to Peace-time Production – Domestic Furniture in the Reconstruction Period 1946–1956', in P.J. Maguire and J.M. Woodham, eds, *Design and Cultural Politics in Post-war Britain*, Leicester University Press, 1997.

3 A peacetime subsidiary of the Board of Trade's Advisory Committee on Utility.

4 H. Dover, *Home Front Furniture: British Utility Design 1941–1951*, Scolar Press, 1991; *Utility Furniture and Fashion 1941–1951* (catalogue), Geffrye Museum, 1974.

5 Interviews with M. Clarke of J. Clarke, furniture-makers of High Wycombe, in March 1987 and C.B. Pratt, furniture retailers of Bradford, in November 1989; J. Attfield, 'The Role of Design in the Relationship between Furniture Manufacture and its Retailing 1939–1965 with Initial Reference to the Furniture Firm of J. Clarke', PhD dissertation, University of Brighton, 1992, Chapter 5; J. Attfield, '"Then we were making furniture and not money": a Case Study of J. Clarke, Wycombe Furniture Makers', *Oral History*, Vol. 18, No. 2, Autumn 1990, pp. 54–7.

6 'Good Design' is used as a shorthand term to refer to the design reform initiatives based on Modernism advocated in the post-war period. For a fuller definition see the Introduction to this volume.

7 'Repro-contemporary' was a term of disparagement used by critics to describe the popular hybrid styles produced by furniture manufacturers adapting pre-war 'moderne' and reproduction styling to their versions of contemporary design.

8 For an account of the Arts and Crafts versus the industrial mass-production factions see Attfield, 'Good Design By Law'.

9 L.S. Lebus, 'History of the Firm of Harris Lebus' (unpublished), 1965, p. 38 (manuscript lent to the author by Oliver Lebus).

10 J. Attfield, 'The Role of Design in the Relationship between Furniture Manufacture and its Retailing', chapter 9.

11 Lebus, 'History of the Firm of Harris Lebus', p. 38.

12 Garret-masters were the most exploited 'sweated labour' sector of the furniture trade, craftsmen who worked from small workshops rather than factories and sold through intermediary wholesalers (see P. Kirkham, R. Mace and J. Porter, *Furnishing the World: the East London Furniture Trade 1830–1980*, Journeyman, 1987). This tier of the trade was abolished through the Utility system that helped to bring the price of furniture down.

13 Lebus, 'History of the Firm of Harris Lebus', p. 38.

14 J. Pritchard, *View From a Long Chair*, Routledge & Kegan Paul, 1984, chapters 16 and 17.

15 Gordon Russell, 'News' obituary for Herman Lebus), *Design*, No. 111, March 1958, p. 67.

16 'Link' was Lebus's answer to E. Gomme's very successful contemporary-styled 'G-Plan' branded ranges, launched to enter the more expensive middle-market sector and styled along approved 'Good Design' lines.

17 J. Gloag, *English Furniture*, Adam and Charles Black, 1944, p. 168.

18 J. Attfield '"Give 'em something dark and heavy": The Role of Design in the Material Culture of British Popular Furniture, 1939–1965', *Journal of Design History*, Vol. 19, No. 3, 1966, p. 198.

19 John Hooper, *Modern Cabinet Work Furniture and Fitments*, 6th edn, Batsford, 1952, chapter 17, pp. 273–94.

20 In an interview with Mark Brutton, Edwin Clinch recalled: 'The Panel developed the Cotswold range, and I've never sat in such a hoo-hah in all my life ... design by committee ... it went on for days and days ... when the designs were approved ... John Hooper got the whole thing going on a proper basis' (*Design*, No. 309, September 1974, p. 68).

21 Attfield, '"Give 'em something dark and heavy"', p. 190.

22 Hooper, *Modern Cabinet Work Furniture and Fitments*, p. 1.

23 Attfield, 'The Role of Design', chapter 13.

24 Adrian Rifkin, 'Success Disavowed: the School of Design in Mid-nineteenth Century Britain', *Journal of Design History*, Vol. 1, No. 2, 1988, pp. 89–102; Stefan Muthesius, '"We do not understand what is meant by a company designing": Design versus Commerce in late Nineteenth Century English Furniture', *Journal of Design History*, Vol. 5, No. 2, 1992, pp. 113–19.

25 Pritchard, *View From a Long Chair*.

26 *Utility Furniture and Fashion*, p. 20.

27 Hooper, *Modern Cabinet Work Furniture and Fitments*, pp. 12–14.

28 *Ibid.*, p. 275.

29 Interview with Brutton, *Design*, No. 309, September 1974, p. 71.

30 *Northern Furniture Trades Federation Utility Furniture* (catalogue), 1947.

31 Hooper, *Modern Cabinet Work Furniture and Fitments*, p. 286.

32 *Utility Furniture and Fashion*, p. 18.

33 Denise Bonnett, *Contemporary Cabinet Design and Construction*, Batsford, 1956, p. 36.

34 Gordon Russell, *How To Buy Furniture*, Council of Industrial Design, 1947, p. 18.

35 Hooper, *Modern Cabinet Work Furniture and Fitments*, p. 284.

36 Russell, 'News', p. 67.

37 J.L. Oliver, *The Development and Structure of the Furniture Industry*, Pergamon, 1966.

38 Alan Jarvis, *Indoors and Out* (Things We See), Penguin, 1947, p. 62.

14 ✧ Utility and the politics of consumption

Patrick J. Maguire

I N MARCH 1950 Herbert Morrison, reflecting on Labour's recent electoral performance, concluded that 'we should feature a more convincing case about the *rights and interests of consumers* ... the needs of the consumer and the needs of the housewife must be recognised as a real factor in politics ...'. Two months later, at a special conference summoned by the Party's National Executive Committee (NEC) to analyse policy as well as performance, it was suggested that

> in future the Party should prepare its policy from the consumer's point of view. We should treat electors more as consumers and less as producers. There was a need for a Consumers' Charter which would embody the setting up of Consumers' Advice Centres and the use of permanent price control. It would be easy, from the consumer's point of view, to stage an attack on inefficiency and high cost in the private sector.[1]

Much of the political rationale for embracing the cause of the consumer so rapidly is to be found in the last sentence. Not only did Labour no longer appear to enjoy the overwhelming electoral advantage and popular endorsement which had swept it to power in 1945, but one of the key perceived weaknesses was already emerging as the position, performance and status of the newly nationalised industries. From his position as Lord President of the Council, Morrison, perhaps the most instinctively populist of Labour's senior political figures, had long been embroiled in arguments about the impact of the socialisation of industry, albeit most commonly in terms of industrial democracy (or its absence).

Another politician with an emerging flair for publicity, the then President of the Board of Trade, Harold Wilson, who in Party terms was on opposite sides to Morrison, and who had rapidly established his popular political persona through the much-vaunted 'bonfire of controls', was equally sure that the rights of consumers offered substantial political rewards for Party involvement. To Wilson, in a paper circulated to Party colleagues in May 1950 entitled 'The State and Private Industry', it seemed evident that

in 'the relation between Government and private industry we have what is almost a vacuum in Socialist thought' and that the fear of nationalisation of industries, including retailing, was an electoral weakness. To participants in the discussion like Gaitskell, the then Minister of State for Economic Affairs, Douglas Jay, then Financial Secretary at the Treasury, and Christopher Mayhew, one-time Parliamentary Private Secretary to Morrison and Minister of State at the Foreign Office until losing his South Norfolk seat, it seemed evident that Labour should embrace competition and 'stand as the representative of the consumer ... [as] the last election showed that the electorate was tending to vote more as consumers'.[2]

By July 1950, the NEC had agreed a draft policy statement on a Consumer Charter including, *inter alia*, the continuation of Utility, assured by public purchasing, and the establishment of a Consumer Advice Centre 'to protect the housewife against shoddy and unsuitable goods and to expose unscrupulous advertising'.[3] In the same month, in what looked suspiciously like a government-inspired question from Elaine Burton, the member for Coventry South, who had a long record of championing consumer causes, the Parliamentary Secretary to the Board of Trade assured the House that the government was committed to finding 'appropriate means of protection' for consumers in the rapidly changing domestic market.[4] By October, Wilson was envisaging the establishment of a consumer advisory service embodying central direction for 'consumer education' which would concentrate on 'bad buys' and 'disadvertising' while being characterised by close liaison with consumer groups, under which heading Wilson included trade unions.[5] The inclusion of a commitment to consumer protection, in whatever guise and for whatever reason, in both the 1949 Party policy document 'Labour Believes in Britain' and in the President of the Board of Trade's official deliberations, would ensure a Whitehall response. That response would itself be revealing and will be returned to later, but for the moment it is important to situate the initiative in the broader politics of consumption which coloured perspectives in the late 1940s and early 1950s. Although aspects of consumer protection, most notably in terms of the purity of foodstuffs and the quality of manufactures, had a long-standing position in Labour movement politics, particularly the politics of the Co-operative movement, Party deliberations, particularly since the reconstitution of the Party in 1918, had rarely significantly embraced such concerns.

To a considerable extent the debate was predicated upon the restoration of 'normal' market conditions. For ten years British domestic consumption had been dominated, and constricted, by the various structures of rationing and controls with which the government sought to regulate and prioritise economic activity. While that structure remained largely intact, particularly

where, as with the various Utility schemes, it was allied to state control of minimum standards, consumer rights or consumer protection, of the kind being pursued and formulated in the United States, were both a political and an economic irrelevance. In that sense the state acted as guarantor of consumer entitlements and, through the myriad committees established during the war, as arbiter of consumer requirements and, in the grandiose title enjoyed by one functionary, Frances Meynell, as adviser on consumer needs. Nor should the extent of state immersion in the regulation of production and consumption be underestimated. By 1949 the Board of Trade alone employed 12,699 staff.[6] While the state regulated consumption, and post-war economic crises ensured the continuation and, briefly, intensification of rationing, this necessarily politicised consumption. Compelled to hold down domestic consumption both to diminish import demands and to 'free' production for export, the Party was rapidly associated with shortages and rationing. Faced with an overwhelmingly hostile press and with the agitation of such groups as the Housewives' League, as well as with the more ascetic inclinations of some of its leading members like Cripps, Labour's political profile was inescapably linked with austerity, particularly when the fuel and convertibility crises instigated the extension of rationing, even to the extent of rationing some foodstuffs which had been unrationed during the war.

Where Labour was associated with consumption, it was specifically with public consumption, with programmes such as the housing drive, prioritised over private building, and rail nationalisation, prioritised over private vehicles. The archetypal figure of post-war popular culture, the spiv, was very much the product of this prioritisation and, try as it might, Labour could not escape the political repercussions of its domestic agenda. To some extent, it has been argued, Labour's policy priorities reflected the gendered construction of the party in general and the political decision-making apparatus in particular, with women allegedly increasingly disenchanted by Labour's relative ignoring of consumer issues and concentration on the masculine public sphere.[7] Certainly Morrison felt that significant changes were under way, warning his colleagues that 'married women are increasingly thinking for themselves politically'.[8] At the same time, fearful of inflation in a situation of full employment, government sought to hold down wage levels, further restraining domestic consumption, particularly as production expanded rapidly after 1948. Such was the shortage of goods that ambitions to direct more unrationed goods into mining areas, in an attempt to stimulate output of the *key* item for industrial recovery, had to be abandoned, and more direct powers of compulsion, including unpaid extra weekend stints (shifts) were resorted to, with considerable detrimental impact on industrial relations and industrial

perceptions.[9] Indeed, some forms of consumption, particularly greyhound-racing (horse-racing enjoying a different social cachet and clientele) and football, particularly the pools and midweek matches, were clearly considered suspect and ripe for banning.[10]

While such restrictions might seem feasible, however politically damaging, in moments of national crisis and while wartime controls were initially considered *politically* as well as economically and strategically desirable, they could hardly be deemed to constitute a desirable state of political normalcy. The erosion of state control, for whatever reasons, raised the question of what role the state should be expected to play in regulating and policing consumption once 'normal conditions' had been restored. Despite the push towards liberalisation, some structure of controls lay at the heart of Labour's approach to economic management and, as Martin Francis has recently pointed out, this was an area of consensus within the Attlee Cabinet, a consensus which transcended internal Party divisions.[11] To Hugh Gaitskell, later opponent of Clause Four, the Party's most celebrated commitment to extending public ownership, and Labour's Chancellor from October 1950, it seemed evident that controls were 'the distinguishing feature of British socialist planning'.[12]

As late as 1949, in response to the devaluation crisis, Morrison was urging the reinstatement of a battery of previously abandoned controls.[13] Given the commitment to maintaining high levels of output, and hence employment, and the perceived mechanisms for so doing through the various controls associated with demand management, that question acquired a politically sensitive edge which had largely been absent before 1939. While the state might assume responsibility for controlling the overall level of demand within the economy, a very different political calculus applied when it sought to regulate the type of demand. This was even more so when it appeared to venture into the relationship between buyer and seller which, whatever the impact of Keynes, lay at the heart of the kind of neo-classical economics which officials, often unconsciously, subscribed to, and which held a particular place in the English legal system. To an official like Edwin Plowden, one of the key figures in Treasury deliberations in the immediate post-war period, it seemed self-evident that

> It was our job to plan so that we might return the economy to a more
> normal state of affairs where consumer sovereignty would be re-established.
> Planning was a means whereby we could overcome the enormous effects of
> the war on our nation, just as it had been a method whereby we could
> achieve the maximum mobilisation of resources in the war.[14]

That assumption of consumer sovereignty would be central to arguments about the role of the state in ensuring the quality, as well as the quantity,

of supplies. Not only was it a question of returning to the pre-war system where supply and demand would operate in loose equilibrium and the alleged disciplines of the market would ensure appropriate quality (however clearly and often that had failed to be the case), but it could also be viewed as a question of fundamental liberties. As an official paper warned in 1943, when discussing the role of the state in controlling the quality of consumer goods, as the various Utility schemes sought to,

> the state [i.e. some official] would impose a standard on the consumer which was either arbitrary or based on personal taste or preference. This seems to us to involve, in the long run, an interference with consumers' liberty which is unjustifiable.[15]

Other arguments could be advanced against state involvement in product standards (as opposed to the more specific sense of standardisation, in terms of specifications of size, and so on, although that had also often been the subject of considerable debate and disagreement in the inter-war period), including the alleged disincentive to innovation, but it was consumer sovereignty which was most often deployed in opposition to proposals relating to quality controls.

Equally, such proposals rubbed against the voluntarist system which had long characterised relations between business and government. With Labour particularly sensitive to employers' opposition to most of its nationalisation and much of its welfare programmes, opening another front on consumer rights might prove politically damaging. Indeed, when the Utility schemes were finally formally abolished, it would be on such self-policing, through various forms of British Standards Institute marks, agreed by the manufacturers concerned, that government would place the responsibility for 'satisfying the public demand for some guarantee of quality'. Even the then President of the Board of Trade, Peter Thorneycroft, who had campaigned for the ending of Utility, had to admit that progress in this direction was 'rather slow'.[16]

The closer the government moved towards relaxing controls, the more politically important became the issue of the state's role in consumer affairs. Even by mid-1948, that is, before Wilson's much publicised bonfire, rationed goods accounted for only 12 per cent of consumer expenditure, although controlled goods, as with all Utility items, accounted for a more substantial proportion. The relaxation of controls also meant that quality control was relaxed, and by 1949, other than in the crucial area of price control, it could be argued that the reconstituted Utility schemes had lost their rationale. As a Board of Trade paper in July saw it, 'it is doubtful whether ... any of the Utility schemes do more to guarantee "value for money" than would be the case anyhow as a result of competition'.[17] If

that was true of Utility goods, what could be said of non-Utility goods? It was already clear that senior officials in the Board of Trade were anxious to avoid any responsibility for policing standards, with officials warning that it was 'inadvisable' to encourage any certification of minimum quality and passing the paper secretly to a representative of the British Standards Institute.[18] In particular, officials were concerned at the implications of any government commitment to enforce minimum standards. As early as August 1948 one official was warning that

> The idea of a consumer council might well emerge at a later stage in a standardisation campaign, but it is not a suggestion which I should like the Government to sponsor. Such a body, independent of producers, would probably need to operate under a revised law of libel.[19]

The legislative complexities of establishing any consumer protection agency would frequently be resorted to by officials, especially when the administration's tenuous Parliamentary majority imperilled any controversial legislation.

Officials were anxious to avoid being implicated in the politically perilous sphere of consumer affairs, where they risked the wrath of manufacturers and retailers on the one hand and of consumers on the other. Avoidance of what one of the leading civil servants involved in the administration of the Utility schemes once memorably described as 'the odium of failure' was extraordinarily difficult. They were equally anxious to relinquish their existing exposure to contentious issues through government intervention in the market-place.[20] Indeed, the more controls were relaxed, the weaker became the argument for their continuance. Manufacturers complained that direction of specifications not only hindered the process of product innovation and product development, but specifically damaged export potential, as a controlled home market prevented their either using it for trial runs, as innovative designs or products would not comply with existing specifications, or for disposing of unwanted or surplus export production. In the face of resurgent foreign competition, and with the export drive still crucial to economic survival, the Board of Trade warned of the dangers of pursuing policies of enforced standardisation, as 'there are attendant dangers, principally those of the sterilisation of design ... and the need, particularly in the export market, to be able to quote variety to suit the taste of the market'.[21] Retailers were particularly vociferous in their opposition, some large manufacturers appearing to support minimum standards as a defence against the kind of cut-throat competition which had characterised some sectors, like cloth production, in the inter-war period. Indeed, the Cotton and Rayon Manufacturers' Association warned that 'only ignorance of the pre-war market can excuse

the assumption that a utility scheme is of no benefit whatever except in war time'.[22] By 1950 the Retail Distributors' Association was arguing that Utility had outlived its usefulness and was more likely to hinder, rather than further, consumer interests as 'in the absence of sellers' market conditions, the availability to consumers of goods of satisfactory quality at reasonable prices can best be secured through the medium of competitive trading'.[23] Opposition was mounted not only on the grounds of market efficiency. Board of Trade officials convinced Wilson that the tax privileges enjoyed by Utility goods could be construed as discriminatory by foreign producers and that, therefore, the only alternative was what would become the 'D' scheme, while retailers and manufacturers opposed it as irretrievably skewing the market and leaving a quality/price gap in the crucial mid-range of goods.[24] Moreover, it could be argued that as the burden of purchase tax was borne by the the high-quality end of industry, it retarded the move up-market which was considered essential in areas like cotton textiles, subject to growing price competition from low-cost producers whose goods enjoyed tax-free status.[25] The Federation of British Industries added its weight to the opposition with a public declaration from its sub-committee on purchase tax and Utility that the existing structure of taxation and direction hindered 'the testing of new merchandise on the British public' and adversely affected the export trade.[26] Indeed, when Thorneycroft moved to abolish the Utility schemes it would be specifically on the grounds that they were 'harmful to trade' and that the 'D' scheme was in reality a new Utility scheme, with industry being encouraged to adopt standards as recommended in the Douglas Report. Officials duly presented Wilson with three options in terms of public presentation, favouring the option of utilising the Report's general recommendations, as well as those specifically detailed in paragraph 127.[27]

Quite why the issue should be deemed so sensitive revealed a great deal about the politics of consumer affairs. Two concerns dominated thinking. The first was a purely party-political concern because, as Thorneycroft informed his colleagues, Conservative candidates in the 1951 general election had been instructed to say that the Conservative Party 'had no intention of abolishing the schemes', but also because 'the schemes were still generally, and incorrectly, believed to provide a guarantee of the quality and value of the goods they covered'.[28] That belief in the necessity of state endorsement of quality was fundamental to the politics of consumer affairs. Officials, politicians and retailers might believe in the efficacy of the market, but consumers, particularly working-class consumers, did not. That was partly a result of the experience of untrammelled trading, an experience which had fuelled the growth of the Co-operative movement, which had been so bitterly resisted by private traders since the 1880s and

by elements of the Conservative Party in the inter-war period. It was also partly as a result of the structure of the Utility schemes, in which the coupon system of rationing inadvertently encouraged consumers to purchase the best quality available at the specified token level (money, in a situation of full, or over-full, employment being in more abundant supply than coupons).[29] The growing purchasing power of working-class consumers, however constrained by rationing and controls, was also effecting a significant change in attitudes, with some retailers apparently aghast at the influx of the lower orders into previously self-styled exclusive outlets.[30] The politics of consumer affairs, therefore, appeared to incline government in the direction of direct intervention. It was this which prompted schemes of self-regulation. As one Board of Trade official observed in June 1950,

> it is desirable to inculcate the adoption of voluntary standards as opposed to statutory controls imposed upon industry by the State. Enforcement of statutory controls would not only involve the maintenance by Government of large numbers of technical staff but a degree of interference with, and inspection of, industry which would probably be extremely unwelcome; statutory controls would also, I suggest, tend towards a rigidity which would, by and large, not be in the best interests of technical development.[31]

Part of the reason for mounting official concerns at the prospect of statutory consumer protection arose from the secret review of Utility commissioned by the Board of Trade in June 1950; secret, because it was believed that any imputation that the schemes might be terminated would detonate considerable political opposition, an opposition which would enjoy even greater significance in a year in which a general election had to be held.[32]

Whitehall opposition to any statutory consumer protection increasingly focused on the practicality of operating the kind of system beginning to emerge in the United States. Given Labour's partial commitment to consumer advice centres, outlined in 'Labour Believes in Britain', it concentrated on the difficulties which allegedly would accompany the establishment of any testing agency. As well as the supposed legislative implications, particularly an alleged necessity to rewrite British libel laws, opposition focused on the economics of any such operation. It was claimed that the 'setting up of a publicly financed consumer organisation *purely and simply as a testing and reporting agency* would not be justified on a "value for money" calculation'.[33] Even more damningly, to the Whitehall mind, there was a danger that such schemes might prove successful and popular and would, therefore, incur untold further cost. By October 1950, after the general election, Wilson had become convinced of the dangers of success, arguing that any publication which sought to disseminate the results of product

testing, or any other form of consumer advice, 'would be too expensive to attract much of a circulation and, conversely, that if it was meant to reach the masses, it would need subsidising on a large scale'.[34]

As in many other areas, therefore, the answer to the immediate political problem, the removal of a statutory scheme which was believed to enshrine minimum standards without its replacement by any other statutory controls, was seen to lie in the traditional resort of Whitehall. The institutionalisation of inaction would depend upon a combination of a carefully selected committee's recommendations (hence the establishment and careful adoption of the Douglas Committee), and a commitment to 'education'. The propagation of controls was to be replaced by the propaganda of voluntary standards and consumer education. As it was recognised that 'Any suggestion for dropping the Utility scheme would be strongly opposed in many quarters in the belief that it ensured some quality standards and value for money', some political initiative was required to ease the transition.[35] To Harold Wilson it seemed obvious that 'consumer education' should be a key function of his proposed advice centres.[36] To officials, 'education' could offer the answer to their political dilemma. At the same time as rejecting any state-sponsored consumer organisation, therefore, it was suggested that the initiative could shift to education, as 'What seems to be wanted is a professional body responsible full-time for the systematic education – in the broadest sense – of consumers.'[37] The problem there would be in identifying a 'professional body'. When the Lord President's Office suggested, in September 1950, that this might be a suitable task for the Council of Industrial Design (COID), the suggestion was rapidly rebuffed by the same civil servant who had instituted the secret social survey of Utility. The initial proposition had been that 'the general education of consumers should include advice on how to use goods and take care of them as well as on how to choose them when purchasing', but this would meet 'overriding objections', with any potential role for the COID being restricted 'to the very limited question of design'.[38] Already buffeted by manufacturers and retailers, it was scarcely surprising that the Council was not considered appropriate for such a sensitive role. Its credentials for dealing with working-class organisations left a lot to be desired, as it seems often to have invited representatives of such organisations as the Standing Joint Committee of Working Women's Organisations to its exhibitions after they had closed, causing some considerable confusion and not a little annoyance to the individuals and organisations concerned, and this despite its efforts to utilise the power of the Co-operative movement (which it clearly never understood to be, at best, a federal, rather than a unitary organisation).[39]

Labour's electoral defeat in 1951 removed much of the political imperative to pursue the question of consumer protection. The incoming

administration had, after all, campaigned on the slogan 'set the people free', and Wilson's immediate successor would be that committed opponent of intervention and proponent of economic liberalisation, Peer Thorney-croft. While political considerations still dictated that the Utility schemes be handled with a degree of sensitivity, it could not be doubted that their rapid termination was envisaged from the outset by the incoming admin-istration. In opposition, particularly as the post-war boom gathered momentum and abundance, rather than shortage, appeared to be the order of the day, Labour lost its emerging commitment to consumer affairs, which would only be resurrected, for very different political reasons, in the 1970s. In attempting to come to terms with repeated electoral defeat, it retreated from its interventionist approach, a retreat which had begun before 1951 but accelerated thereafter, particularly given the concerns of the apparently triumphant Gaitskellite wing of the Party. By 1956, after the substantial electoral defeat of 1955, speaking at a conference in Bonn on behalf of the Home Policy Committee of the NEC, Wilson had convinced himself that

> Consumer rationing and labour controls ... affect everybody [and] arouse the maximum of annoyance and resistance. They also interfere with human liberties, and are consequently only acceptable when greater liberties are at stake, such as in wartime, or periods of world-wide scarcity, when they may be needed to assure everybody the basis of existence.[40]

At the same time the agitation for enhanced consumer protection rights continued but, like many single-issue campaigns, it was largely conducted outside the political party framework. The development of British consumer organisations and publications in the 1950s was, therefore, often viewed as 'unpolitical', sometimes as a 'woman's issue' (it was the National Council of Women which invited the National Labour Women's Advisory Com-mittee to a conference on consumer protection in the same year as Wilson's public pronouncement) and, as such, marginal to 'real' politics. For Labour, it remained, after the brief flirtation of the late 1940s and early 1950s, something of a non-issue, as it did for the Conservative Party. Butskellite economics, in that sense, excluded consumption from the polical agenda other than in terms of demand management. For Labour, too, the success of the mixed economy in satisfying, or appearing to satisfy, consumer needs became an essential ingredient of Party policy. The precise nature of the 'mix' might be subject to political debate, but the efficacy of the model could not. Morrison's strictures about being too closely identified as a Party of producers, in hock ideologically as well as financially to the trade union movement, thereby went by the board, and the debates about the nature of the Party would wait until many of those producers had

been removed from the political equation by the structural, ideological and political onslaughts of the 1980s and early 1990s.

Notes

Abbreviations

BT Board of Trade Papers
CAB Cabinet Minutes and Cabinet Papers
CP Circulated Paper (Cabinet Briefing Paper)
EA Economic Affairs Committee
EPC Economic Policy Committee
GEN Cabinet Sub-Committee
LP Ministry of Labour Briefing Paper

1 Labour Party, Minutes of the National Executive Committee, March and May 1950, National Museum of Labour History, Manchester.

2 CAB 124/1200, Minutes of meeting, 17 May 1950.

3 NEC, Minutes, 12 July 1950.

4 *Hansard*, 28 July 1950.

5 CAB 134/133, DM (50) 29, 30 October 1950.

6 B. Pimlott, *Harold Wilson*, HarperCollins, 1992, p. 111.

7 See, for example, A. Partington, 'The Days of the New Look: Working-Class Affluence and the Consumer Culture', in J. Fyrth, ed., *Labour's Promised Land?*, Lawrence and Wishart, 1995 and A. Black and S. Brooke, 'The Labour Party, Women and the Problem of Gender, 1951–1966', *Journal Of British Studies*, No. 36, 1997.

8 NEC, Minutes, March 1950.

9 CAB 124/693; LP (46) 201, Paper on Incentives for Miners, 2 May 1946; CAB 124/1060; LP (46) 218, Paper on Absenteeism, 1 August 1946 and CAB 134/215; EPC (47) 16, Paper By the Minister of Labour, 15 November 1947.

10 CAB 129/16; CP (47) 8, 3 January 1947, CAB 129/17; CP (47) 86, 12 March 1947 and CAB 128/741, 11 August 1947.

11 M. Francis, *Ideas and Politics under Labour*, Manchester University Press, 1997.

12 CAB 134/225; EPC (50) 9, 7 January 1950.

13 CAB 134/300, Paper on Future Legislation, 24 April 1949.

14 E. Plowden, *An Industrialist at the Treasury*, Deutsch, 1989, p. 46.

15 BT 64/1970, Reconstruction Reports, DR 25, October 1943.

16 BT 190/8, National Production Advisory Committee on Industry, Minutes, (52) 482.

17 BT 64/735, Paper on Utility, July 1949.

18 BT 64/2399, Minute, 3 August 1948.

19 BT 64/2399, Memorandum, 14 August 1948.

20 Alix Kilroy on an internal survey of the administration of the Utility schemes, June 1945.

21 BT 644/2399, Memorandum on Standardisation, 4 November 1950.

22 Cotton and Rayon Manufacturers' Association, *Members Bulletin*, Vol. 6, No. 1, July 1950.

23 BT 64/735, Paper from the Retail Distributors' Association, 1950.

24 CAB 130/66; GEN 358/1, Memorandum by Wilson and Gaitskell, 14 March 1951 and minutes of meeting of 16 March 1951.

25 CAB 129/73 C (55) 42, 14 February 1955.

26 *The Times*, 12 April 1951.

27 CAB 134/843; EA (52) 17, Briefing Paper, 26 January 1952.

28 CAB 301/34; EA (52) 5, Minutes of the Meeting of the Economic Affairs Sub-Committee of the Cabinet, 30 January 1952.

29 See, for example, the *Economist* of 24 July 1943, for the observations of Sir Alan Sykes of the Bleachers' Association concerning the tendency of consumers to concentrate on more expensive lines. It was partly for this reason that differential coupon values were introduced.

30 See, for example, the attitude of staff at Brown's department store in Chester, revealed in a Mass Observation survey (Mass Observation Archive, Sussex University, *Brown's of Chester: Portrait of a Shop*). I am indebted to Dr Bill Lancaster for this reference.

31 BT 258/394, 13 June 1950.

32 BT 64/735, 9 June 1950.

33 BT 653, Paper on Consumer Advice Centres, 1950.

34 CAB 134/133; DM (50) 29, 3 October 1950.

35 BT 213/75, Briefing Paper on ending Utility, 1952.

36 CAB 134/133; DM (50) 29, 30 October 1950.

37 BT 353, 1950.

38 BT 258/354, Memorandum from G. Parker, 7 September 1950.

39 See, for example, the minutes of the General Purposes Committee of the Standing Joint Committee of Working Women's Organisations, 11 May 1950, National Museum Of Labour History, Manchester. Equally, representatives were concerned that the COID should supply a representative to explain the function of exhibitions to representatives (Minutes, 6 July 1950). Relationships seem to have ceased shortly afterwards.

40 NEC, Minutes, 17 January 1956.

15 ✧ Fascinating Fitness: the dangers of Good Design

Judy Attfield

THE UTILITY Scheme and its direct impact on furniture design focuses on a seminal moment in the history of design which has been mythologised as one of the spurs to the post-war phase of the Good Design movement that aimed to promote Modernism. What reassessment discloses is the narrowness of interpreting Utility in purely functional terms without consideration of the social meanings embodied in the designs, or how the romantic view of history that attempts to find the realisation of the exemplar is doomed by its very nature to failure. As we have seen in Chapter 13, 'Freedom of Design', a more grounded examination of designed objects in context as manifestations of material culture, rather than as pristine examples on a scale of value measured against Good Design principles, can show how manufacturers, retailers and consumers used goods like furniture to make sense of a very changing world – from war to peace and from austerity towards the more consumer-orientated society that followed.

Utility's pre-war antecedents included visions of the future as modern. Propaganda from the Design and Industries Association (DIA) and other bodies promoting good design was disseminated via exhibitions and lantern-slide lectures, by BBC broadcasts and numerous publications, from school textbooks to popular pamphlets. During the war the DIA was actively involved in preparing for the Reconstruction [1] which would follow the end of the war, presenting its aims as 'above all to obtain "fitness for purpose" in the productions of industry ... from tea-pots to trolley buses, and from toys to those towns to be rebuilt in days to come'.[2]

The fascination with the concept of 'fitness' that characterised the principles of Good Design during the Reconstruction period was understood at the time as a logical correlation between use and beauty – the correct response to needs would automatically produce an aesthetic solution.[3] It is only possible in retrospect to see how the politics of Functionalism associated with the principles of Fitness, where they did manage some measure of realisation, although not necessarily producing the desired

benefits, could be explained away by a self-referential logic that linked the correct solution with the apparent inevitability of its own acceptable aesthetic. Even during the height of the war, when it would seem unnecessary to mystify pragmatic rational practice arising from the need for common-sense solutions, there is evidence of attempts to justify Fitness in aesthetic terms. To contemporary sensibilities, the example that follows would appear the most bizarre and inappropriate of applications. Such was the blind faith in the concept that Fitness automatically produced a correct solution in economic and aesthetic terms, that in a DIA lecture series mounted in 1943 to propagandise design reform through standardisation and mass production, Henry Strauss MP could say

> If an article is completely honest and wholly fitted for its purpose, it will almost certainly be satisfying, and beautiful. For beauty is not some physical extra thing which is added to an object already complete; it is an intrinsic grace or perfection that is found in an object which fulfils its purpose with precision and economy ... This machine-made beauty will have style, the style that is characteristic of the best of our age. It comes from extreme economy, from accomplishing the task in hand in the simplest way, with the cleanest lines and the fewest interruptions. It was recently stated that, as a result of re-design, the price of a Bren gun part had been reduced from £238 15s per hundred to £11 10s per hundred. I do not know what the part was, but I should be surprised if the re-designed part was not more beautiful than that which it replaced.[4]

That blindness which could separate the intended use of the object from its economy and perceive it in terms of an abstract aesthetic could by the same logic have attributed beauty to the Nazi concentration camps designed to sort, separate and dispatch their victims with such efficiency. It may seem unfair to pick on this particular instance to suggest that the concept of 'fitness for purpose' was in any way referring to the intended use of a weapon. But the fact that it was not is significantly telling. Not to consider the use of the object suggests that the logic of Functionalism was not fully understood, if the analysis served as a means of formal appraisal stopping short at the appearance of the gun-part as if it were an art object. It can be claimed, therefore, that the example is symptomatic of a period fixated on the problems of production, when an economic solution justified itself within its own terms. The illogicality of the 'fitness for purpose' theory that accepted the 'purpose' as given, as if questioning the ethical value-system was superfluous, suggests how that gap in the logic could so easily fall prey to unethical intent.

It is more possible to understand how modernity was experienced through design by the way products like cars, ceramics, clothes and furniture were conceived, manufactured, distributed and consumed during a time

of intense change in the Reconstruction period, than to focus too closely on the internal views as stated in the aims of design reform propaganda. The material culture of modernity in the Reconstruction period was in distinct contrast to the theory of Good Design – the style of Modernism through which design reformers hoped to promulgate the ideology of mass production and standardisation. However, looking at the symbolic significance of Utility furniture within the context of the domestic interior makes it possible to investigate how it was appropriated and converted into different representational forms as an aspect of the material culture of the Reconstruction period. The distinction between Modernism as the style of an ideology and design as a material practice of modernity, as discussed elsewhere,[5] shows up different material interpretations of the future; the latter turning out to be untidy, disordered and undisciplined in its forms, expressive of the complex problems of adapting to modernity. Specifically, a consideration of the fascination with Fitness – the irrational dimension of the Good Design phenomenon – may help to explain its survival through the strength of its symbolism, rather than attempting the fruitless task of finding the non-existent representative paradigmatic exemplar.

The campaign for design reform taken up in the post-war Reconstruction period by the Council of Industrial Design, set up in 1944, used similar tactics to those of the DIA to drive the Good Design message home. A series of educational Penguin booklets, 'The Things We See', illustrated the hopes of a generation of design reformers who believed in the benefits of industrial design and mass production, and is typical of the didactic publications produced at that time. To represent Good Design a series of paired images were shown alongside each other to make a contrast between the 'good' and the 'bad', or the 'As it is' and the 'As it might be'. In the first volume of the series, *Indoors and Out*,[6] the illustrations of two bedrooms are juxtaposed, each matched with an illustration of food, taking advantage of the literal reference to taste. The didactic caption to the 'bad' example – a bedroom with showy 'vulgar' shiny rayon (erstaz silk) fabrics – was matched to the obviously deemed unhealthy image of a dish of 'fancies', the popular term for small iced cakes (figure 51). The 'good' example, on the other hand, linked the correctly furnished bedroom in honest, unvarnished, plain Utility furniture to the wholesome image of a loaf of nutritious brown bread (figure 52). The choice and layout of the furniture in each setting was devised to make specific points. The positioning of a dressing-table with a large mirror in front of the window, a popular bedroom layout criticised by design reformers because it blocked out light and air, would have been construed as an analogy for the rejection of Modernism in favour of the unhealthy retention of tradition. It is likely

51, 52 These two pages from *Indoors and Out*, in a 1947 Penguin series entitled 'The Things We See', was accompanied by text clearly intended to teach 'good taste' in design matters: 'We know the childish impulse to gorge on sweets and we recognise at once a visual example of the same thing: a mature taste in either food or furnishings would be made sick by too much sweetness. The mark of a mature taste is the capacity to discriminate among simple things, to enjoy the subtler differences of flavour in, for example, bread and honey as well as the cruder differences between cakes and scones'

that many of the subtle points made in the illustrations would have been lost on those not initiated in the rules of Good Design, which condemned over-furnishing, reproduction style and any implication of showy 'vulgarity', that is, furnishing for display. The missionary zeal of much of that type of Good Design propaganda relied on an optimistic faith in the enlightening influence of rational design.

'Fitness is not enough'

In the field of furniture design, consultants on the Advisory Panel of the Board of Trade enthusiastically embraced the rhetoric offered by the rationalisation imposed by the Utility Scheme to justify the uncompromising prohibition of the traditional trade practices required in the making of reproduction antiques. But after the war the legacy of slogans from an earlier period, such as 'fitness for purpose' or 'truth to materials', used by propagandists, depending on their stance, to inculcate or inspire, were cast aside. By then even the Good Design reformers no longer believed they could convince the public to appreciate the poverty of the lean results achieved from back-to-the-wall paring down to basics. During the war it

might have suggested patriotic sacrifice, but by 1946 the Utility image of stark bareness held other, more sinister connotations when John Gloag, champion of the Good Design cause, wrote

> [everybody] is heartily sick of [the] plainness and austerity imposed by the state. The beliefs of the modern designer before 1939 had an alluring simplicity; he, or she, had a faith which supplied all the answers; only, of course, it wasn't called *faith*. It was called something high-sounding and intimidating like 'the logical adjustment of economic facts and mechanical means to functional ends', and it masqueraded as reason, pure-burning and undimmed by any concessions to ordinary human likes and dislikes

and he went on:

> We have a duty to doubt the convenient and tidy creeds that, like some patent medicines, are said to cure … every ill. Good design is not a matter of faith. Fitness is not enough. Functionalism is not enough. Unlit by imagination, functionalism and fitness may end in the grimness of *inhumanism*. The modern movement in design could easily degenerate into that dark opposite of liberty and variety in life.[7]

To add a semblance of increased variety and appease the generally-held fear that Gloag was voicing, and in spite of Britain's dire economic straits at the end of the war, a number of new items previously prohibited as inessential luxuries were added to the basic Utility range. The new items included dressing-tables and upholstered upright and easy chairs. Small items like occasional tables (categorised by the furniture trade as 'fancy goods') were derestricted, providing they did not exceed a maximum quantity of timber. The need for a more popular, democratic type of design, was perceived in the form of a lighter mainstream style that was meant to be seen as allowing for more individual choice from a wider range of goods. As detailed in Chapters 7 and 13, the original Utility furniture designs had been far from ideal, having been cobbled hurriedly together to suit the antiquated production processes of furniture producers not streamlined enough to be allocated war work.

The post-war period, while Utility regulations were still in force, was to offer the chance for design reformers to redeem the ideals of Good Design. But the introduction of the additional 'approved' designs did little to satisfy the furniture industry, clamouring to be released from its confinement to a small set of universal designs. By 1946 the Utility Scheme had replicated the pre-war hierarchical furniture trade structure in its three ranges (Costwold 'A', Chiltern 'B' and Cockaigne 'C') in line with the three-tiered system of first-, second- and third-class goods in matching qualities and price bands. The Freedom of Design period and its immediate aftermath found two very different visions of the future existing side by

side – the ethical aesthetic envisaged by the utopian Good Design move-
ment prevalent among designers with a reforming mission, and the much
more widely disseminated popular versions, objectified in hybrid adapta-
tions of the 'contemporary' style, frivolously flaunting functionless style
and decoration.

The concession made to the trade in the latter stages of the Utility
Scheme released manufacturers from statutory adherence to the official
designs. Under Gordon Russell's chairmanship the peacetime Design Panel
of the Furniture Working Party initiated the developments which were to
culminate in the Diversified range of furniture, making the designs freely
available to the trade as an incentive to manufacture approved designs on
a voluntary basis. In order to qualify for the tax-free status enjoyed by
Utility goods, however, furniture was still subject to strict controls through
price, dimensions, specification and the official approval required for new
designs. Freedom of Design was symptomatic of the first signs of dispen-
sation from the stark unremitting bareness of the Utility designs forced on
the civilian population as part of the sacrifice demanded in support of the
war effort.

The Council of Industrial Design was aware that there was a need for
new tactics if the general prejudice against modernity was to be combated
successfully. That awareness, however, did not extend to questioning its
own authority to lead the campaign.[8] There are many accounts of the
offence caused by the pronouncements of design reformers[9] dismissing the
expertise of trade designers, like the case of Maurice Clarke, who considered
himself a competent furniture designer. Having served his apprenticeship
in his father's furniture-making firm, Clarke attended evening classes on
furniture design at his local Technical Institute in High Wycombe, and
worked in the industry all his life. He bitterly recalled the lecture he went
to as a hopeful young designer, only to hear an expert assert that architects
belonged to the only profession capable of producing good design. Al-
though Clarke was listed on the National Register of Industrial Art Designers
from its inception in 1939, he found that he was often passed over for
commissions in favour of architects.[10] To add insult to injury, the Board
of Trade Working Party report on *Furniture*, produced in 1946, recom-
mended the use of 'industrial designers and architects' as the ideal type
of designers for furniture, giving secondary importance to trade designers
by patronisingly acknowledging the 'comprehensive experience of their own
production methods'.[11] Increasing sensitivity to the need not to cause
offence to manufacturers and retailers by implying that they were making
and peddling bad design, even though that was indeed what the reformers
actually believed, led the Good Design initiatives during the Reconstruction
period to put the onus on the consumer.

The Festival of Britain in 1951 was seen as a chance to develop new design ideas which was taken up eagerly by a new generation of young architects and designers. The main aim of the festival was to educate and inform in a palatable, entertaining way. It used forms borrowed from popular entertainment, such as the circus, the fun-fair and the pleasure-gardens in a new light-hearted contemporary style, picturing the future as leisured, fun, frivolous, decorative and indulgently flooded with light, pattern and colour. The only official view of non-elitist popular arts exhibited at the Festival of Britain was represented by the Black Eyes and Lemonade exhibition at the Whitechapel Gallery, based on a picturesque rural tradition and a quirky, rather condescending middle-class appreciation of the so-called 'unsophisticated arts'.[12]

Most design history accounts only discuss the public reception of officially sanctioned design even when discussing exhibitions like the Register Your Choice room-settings mounted by the DIA in 1953[13] to test public reaction to the new 'contemporary' approved style of furnishing. Apart from contemporary publications and documentary sources such as the Mass Observation archive, there are some clues in oral history accounts of the way in which modernity was assimilated in popular form.[14] This already made itself felt before the Utility Scheme was dissolved in 1952, showing that even while the public could still buy tax-free furnishings under the Scheme, many were choosing to buy the much more expensive Non-Utility and non-approved ranges of design.[15] The more traditional sectors of the trade were quick to return to traditional reproduction styling,[16] announcing with pride the production of 'non-Utility' furniture as a distinguishing sign of prestige. Many modernists blamed the retailers for the vulgarisation of furniture design. Jack Pritchard, a Good Design pro-moter of mass production, retrospectively observed the way in which 'Guided purely by the salesmen, the industry celebrated the end of the Utility scheme by piling glamour upon glamour – gorgeous cocktail cabinets and amazing dressing tables.'[17]

From 1953, when a more proportional system of taxation was intro-duced which broadened the band between the basic and luxury categories, furniture design adapted to modernity with an unrestrained exuberance that even the most severe critics had to acknowledge was not unexpected. Paul Reilly disparaged the new 'repro-contemporary' style in mock melo-dramatic Victorian indignation as 'monstrous ostentation' pandering to fashionability.[18] His many articles in the *Daily Mail Ideal Home Book* warned against the poor imitations of the 'real thing' using the same didactic format that previous generations of reformers had used of contrasting 'good' with 'bad' illustrations.

But it was the familiarity of the returning repro-style ornament that

was often the attraction (figure 49). Even during the inter-war period, firms which introduced modern designs into their furniture ranges found that the most successful sale strategy was to disguise innovation by incorporating traditional styling using dark stain and repro-Jacobean carved ornament. By the mid-1950s, however, the 'contemporary' style became very popular with a younger, more style- and glamour-conscious consumer, whose image was increasingly used in advertising to indicate modernity.

Although the Utility Scheme never managed to produce a standard single range of universal 'good' designs to the satisfaction of the idealists, it did bring a form of modernity to the public's attention and persuaded the more antiquated sectors of the industry to review their production processes. Hybrid repro/contemporary designs, seen as travesties by the design idealists, resulted from the strategies used to circumvent the strictures of the Utility Scheme that still remained during the so-called 'freedom of design' phase of the Scheme.

The semblance of decorative features and the exaggerated emphasis given to the new 'contemporary' style signalled the longed-for excess missed during the period of deprivation. The previously banned dressing-tables and cocktail cabinets and the new coffee-tables of the 1950s heralded a more consumer-orientated market and a strain of popular design which succeeded in bringing modernity into the domestic interior by offering longed-for meanings associated with youth, conviviality and a younger, more glamorous image of femininity.[19]

Turning back to the DIA slogan 'Fitness for purpose' to reassess one of the central tenets of Utility design, it is necessary to consider its derivation from the biological theory of evolution, based on a belief in the survival of the fittest. In *Design in Civilisation* Noel Carrington wrote:

> By fitness is meant that a thing made for human use should be perfectly adapted for its purpose and made in the most suitable way. This is not only what we call common sense, it is in harmony with what we admire in nature, where animals and plants have adapted their form to fit them in the struggle for existence and in conformity with the laws which govern the world.[20]

He stipulated that the other necessary attribute in defining 'fitness' in design was 'suitability of method of production and material', and that 'The right way of making anything is the way which entails the least expenditure of effort and material consistent with the result required.' In 1939 he expressed his disapproval of the logic of Functionalism, when he wrote: 'The utilitarian basis is not the whole of life, and if we exaggerate it unduly we should have a poor kind of existence',[21] betraying a reluctance towards wholehearted industrialisation that he undoubtedly shared with many of his contemp-

oraries. Carrington's observation is typical of the guarded support given to Modernism by Good Design reformers like the DIA and the group who formed the early Council of Industrial Design in 1944. After the war, aware of the need for a more populist approach to design at the dawning of a consumer-orientated economy, even the firmer upholders of Functionalism confessed to a less confident position. As Julian Holder has pointed out, Anthony Bertram, who in 1937 had written 'if a thing fulfils its purpose … beauty comes in as a sort of by-product',[22] confessed in 1944, criticising the view of the house as 'a machine for living in':

> I prefer, in this dark interim, to be less cocksure that I was in 1935 … I do not, you understand, wish to modify in the slightest degree my attack on the bogus … But I am trying to understand these phenomena better.[23]

This is just a sample from the numerous contemporary commentators and historians since[24] who have offered critical interpretations of debates that surround the instrumental associations of 'fitness' or, as it is often referred to, 'Functionalism'. The intention here is not to redeem it, but to disassociate design from the aesthetic of formal abstraction in order to be able to discuss its social meanings.

Susan Sontag's essay 'Fascinating Fascism',[25] a critique of Leni Riefenstahl's book *The Last of the Nuba* (published in 1973), provides a particularly apposite exemplar of the dangers of attributing beauty of form to the logic of fitness. In this Sontag exposed Riefenstahl, Hitler's propagandist photographer responsible for the triumphalist filming of the Nazi rallies, as attempting to cover-up her fascist sympathies by pleading the transcendence of pure beauty. Sontag's refusal to accept 'the purification of … Riefenstahl's reputation of its Nazi dross'[26] is predicated on her contention that Riefenstahl's aestheticisation of the Nuba tribe was not a departure but 'continuous with her Nazi work'.[27] Sontag describes Riefenstahl's use of the same rhetoric of utopian aesthetics to promote a cult of physical perfection as strong, beautiful and healthy, depicting the ritual Nuba wrestling-match to celebrate the triumph of the strong over the weak. Riefenstahl's declaration that she was not interested in 'What is purely realistic, slice of life, what is average, quotidian'[28] is very revealing in its refusal to engage with what Esther Leslie, in a more recent essay referring to the same period, has called 'the exotic of the everyday', referring to Benjamin's 'materialist hand dirtying' in his acknowledgement of the 'thing–world'.[29]

The recognition of the over-controlling dark side of the Fitness philosophy of Good Design is apparent in the critical writing on design during the Reconstruction period. It provides evidence that in the reassessment of Utility to adjust it to peacetime conditions the commentators themselves were aware of the dangers in their fascination with Fitness. This could be

said to mark the beginnings of a new stage in the history of design when the consumer was no longer necessarily perceived as a homogeneous malleable mass, but as intelligent, discriminating and potentially amenable to reform.

It is significant that today there is a growing fascination with Fitness of a different kind to that which fuelled the Utility period, but arising out of disillusionment with 1980s 'designer' aesthetics, with the waste and profligacy engendered by unnecessary product clutter, and when industrial design courses are beginning to include units on ethical design practice. But the danger is still there, the enticing fascination with an aesthetic which stands in for the actual sacrifice necessary to effect a change of priorities in a genuinely *social* policy on design.

Notes

1 Although the physical rebuilding of the nation did not take place until after the end of hostilities, in this context Reconstruction refers to the period that commenced during war when plans for peacetime started to be discussed, as evident in the plethora of publications that appeared from about 1942, a considerable proportion of which dealt with forward planning design-related issues.

2 Foreword to *Four Lectures on Design delivered at Meetings of the Design and Industries Association*, Hutchinson, 1943.

3 See Chapter 12 of this volume.

4 H. Strauss, 'Design and Mass Production, in *Four Lectures on Design*, p. 5.

5 J. Attfield, 'Design as a Practice of Modernity: a Case for the Study of the Coffee Table', *Journal of Material Culture*, Vol. 2, No. 3, 1997, pp. 267–89.

6 A. Jarvis, *Indoors and Out* (The Things We See), Penguin, 1947, pp. 30–1.

7 J. Gloag, *Design in Modern Life*, Allen and Unwin, 1946; see his Introduction (unpaginated).

8 See J.M. Woodham, 'Managing British Design Reform I: Fresh Perspectives on the Early Years of the Council of Industrial Design', *Journal of Design History*, Vol. 9, No. 1, 1996, pp. 55–65.

9 J. Attfield, 'The Role of Design in the Relationship between Furniture Manufacture and its Retailing 1939–1965, with initial Reference to the Furniture Firm of J. Clarke', PhD dissertation, University of Brighton, 1992, chapter 1: 'The History of J. Clarke: Furniture Makers'; 'Introduction to the List of the J. Clarke archive: J. Clarke, furniture manufacturers, High Wycombe 1920–1986', AAD/1986/11, Archive of Art and Design (Blythe Road), Victoria and Albert Museum.

10 Attfield, 'The Role of Design', p. 160.

11 Board of Trade, *Furniture*, Board of Trade Working Party report, HMSO, 1946, p. 113.

12 U. Franklen-Evans, 'A Redefinition of the Popular through a Case Study of the 1951 Exhibition "Black Eyes and Lemonade"', MA dissertation, Winchester School of Art, University of Southampton, 1997.

13 For example, C.D. Edwards, *Twentieth-Century Furniture: Materials, Manufacture and Markets*, Manchester University Press, 1994, p. 186.

14 For example, J. Attfield, 'Inside Pram Town: a Case Study of Harlow House Interiors 1951–1961', in J. Attfield and P. Kirkham, eds, *A View From the Interior: Women and Design*, The Women's Press, 1995, pp. 215–38.

15 J. Attfield, 'Good Design by Law: Adapting Utility Furniture to Peace Time Production – Domestic Furniture in the Reconstruction Period 1946–1956', in P.J. Maguire and J.M. Woodham, eds, *Design and Cultural Politics in Post-war Britain*, Leicester University Press, 1997, pp. 99–109.

16 Advertisements in the trade press like *Cabinet Maker* attest to the eager shift manufacturers made into the new 'Freedom of Design' era.

17 J. Pritchard, *View From a Long Chair*, Routledge, 1984, p. 146.

18 P. Reilly, 'Glamour, Glitter and Gloss', in the *Daily Mail Ideal Home Book*, 1957, pp. 88–9.

19 Attfield, 'Design as a Practice of Modernity'.

20 N. Carrington, *Design In Civilisation*, The Bodley Head, [1935] 1947, p. 10.

21 N. Carrington, *The Shape of Things*, Nicholson and Watson, 1939, p. 2.

22 A. Bertram, the *Listener*, 6 October 1937, p. 710.

23 A. Bertram, *The House: a Survey of the Art and Science of Domestic Architecture*, Penguin, 1945, pp. 109–11.

24 For example, T. Benton, 'The Myth of Functionalism' in P. Greenhalgh, ed., *Modernism in Design*, Reaktion, 1990, pp. 41–52.

25 S. Sontag, 'Fascinating Fascism', in her *Under the Sign of Saturn*, Writers and Readers Press, [1974] 1980, pp. 75–105.

26 *Ibid.*, p. 84.

27 *Ibid.*, p. 86.

28 *Ibid.*, p. 85.

29 E. Leslie, 'The Exotic of the Everyday: Critical Theory in the Parlour', *Things*, No. 4, 1996, p. 97.

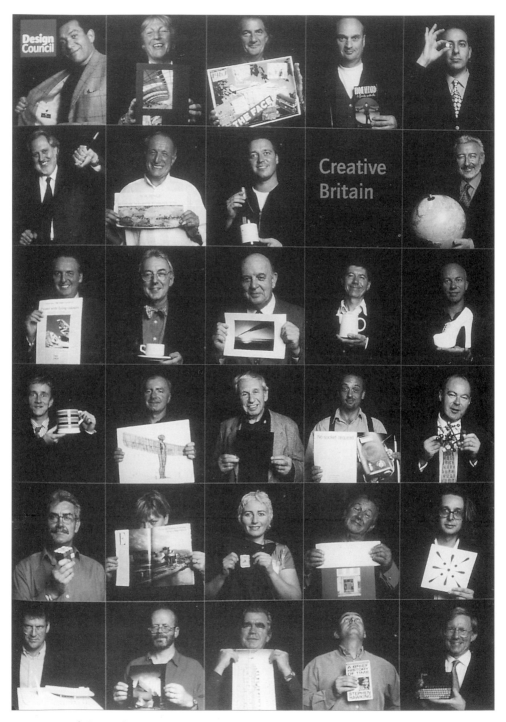

53 Cover of *Creative Britain: a Design Council Report on behalf of the Prime Minister*, 31 March 1998

16 ✧ Design and the state: post-war horizons and pre-millennial aspirations

Jonathan M. Woodham

The ultimate purpose of the Council [of Industrial Design] is to create a new tradition of British design. We must lead the world in the full utilisation of the design potential of the machine. (Notes for the President's Visit to the Council of Industrial Design, 14 May, 1948).[1]

But, because there is no consensus about what British identity will be about in the future, our institutions have been unable to project a single, coherent, forward-looking image of Britain abroad. Instead, they have often opted for … a 'strong brand equity' based around tradition … (Mark Leonard, *Britain™ : Renewing Our Identity*)[2]

Introduction

In the early years of the Council of Industrial Design (COID) there was considerable optimism among its members and administrative staff.[3] Only a few years earlier, the 1943 Weir Report on *Industrial Design and Art in Industry*[4] – an unpublished document which had been highly influential in the setting up of the COID in 1944 – had clearly assumed that the state was destined to play an important central role in design matters. Those associated with the Council strongly believed that the organisation could influence the adoption of a progressively modern aesthetic by manufacturers, retailers and the general public. However, this was not a view which the manufacturing and retailing sectors shared and, in the tricky political and economic navigational waters of the later 1940s, its own position was far from secure.

This chapter will address the role of design and the state in Britain, contrasting the early activities of the COID during the years of Clement Attlee's Labour Government (1945–51) with the high profile accorded design at the outset of Tony Blair's New Labour government which swept to power in May 1997. Despite such apparent successes as the Britain Can

Make It exhibition of 1946[5] and the Festival of Britain of 1951, the COID had to fight hard to maintain a significant presence during those immediate post-war years. Half a century later the Design Council (formerly the COID), despite a radical restructuring and slimming down of personnel, offices and commercial activities in 1994, once more emerged as an important propagandist force in the re-presentation internationally of a modern Britain characterised by high standards of design and a wealth of creative activity. The tenor of this anticipated national identity shift, away from an overreliance on history and tradition, was reflected in the Design Council/Demos report of 1997, entitled *Britain™: Renewing Our Identity*,[6] which will be more fully discussed below.

The 1948 Queen Anne's Gate debate: design in a planned economy

The broad parameters of the design debate in the middle years of Attlee's Labour government may be gleaned from a meeting on the theme of 'The Place of Design in a Planned Economy' held in Queen Anne's Gate, London on 12 July 1948. Essentially conceived as an informal colloquium, it evolved from a series of conversations between Professor W.G. Holford, Gerald Barry (Director-General of the Festival of Britain), members of the COID staff and members of the Political and Economic Planning group (PEP),[7] all of whom were concerned with reviewing the possibilities and limitations of state intervention in design. Their short-term aim was to consider whether any positive initiatives could be implemented in the period leading up to the Festival of Britain of 1951, with a wider brief to assess the value of, and justification for, all forms of state (or state-sponsored) control over designers and the design process.

Participants in this 1948 symposium were drawn from the design profession, the manufacturing and retail sectors, others noted for their special interest in, and knowledge of, public taste, together with members of the COID and PEP.[8] There were two key themes upon which discussion centred: design and control; the possibilities of design ranged from the macrocosmic scope of town and country planning to the more confined, yet esoteric, realms of abstract art; while the notions of control were concerned with the actual mechanisms of state intervention and assistance and information. The design discussions were largely predicated upon the middle ground of industrial design, while definitions of control were informed by current legislation. This included the Board of Trade's watered-down Utility design regulations. Unsurprisingly, at a time when the government's nationalisation programme was at the forefront of the political agenda and very much in the public eye, participants in the debate were divided as to if and how the state should intervene in design matters.

Given the constituency of contributors to that 1948 discussion, con-
siderable emphasis was placed on the role of the COID, a state-sponsored
body[9] still actively seeking to extend its sphere of influence across a wide
spectrum of design-related activity. Despite unease about the extent to
which public taste should be dictated to in a free market, there was an
apparent consensus that a state-sponsored quango such as the COID could
most effectively promote a modern design aesthetic through nationalised
industries and government departments. It was envisaged that this would
be brought about by the commissioning of corporate identities and by
co-ordinated buying policies.

Design and state departments in the early years of the COID

It had always been assumed by design reformers that the newly-constituted
COID would exert influence on the post-war 'corporate' identity of the
state, through influencing the design of buildings and offices at home and
in British consulates and embassies abroad.[10] It was presumed that such
enterprise would exert a powerful economic influence on British manufac-
turers as producers of such lucrative commissions and alert potential export
markets to robust British health in design matters. Sir Kenneth Clark, a
member of the Weir Committee and Director of the National Gallery,
London, a leading establishment figure in debates on matters of taste and
aesthetics, suggested in October 1943 that 'the proposed Council would
be the central body in the field of industrial design in just the same way
as the British Council is in the cultural field'.[11]

In reality, the COID's aspirations in such spheres were greater than
any significant achievements on the ground, despite optimistic soundings
in the Council's first annual report of 1945/46, where it reported that it
was co-operating both with the Ministry of Works on the design of the
furniture and equipment of government offices and with the Ministry of
Education in the preparation of design standards for school furniture and
equipment. Two years later it reported that such consultation had been
extended to the Admiralty and the British Council[12] and that negotiations
were in hand with the newly nationalised industries. It was in the field
of aviation design that the COID's aspirations were most clearly endorsed.

In its first year the COID had established a Joint Liasion Committee
with the British Overseas Airways Corporation (BOAC) to consider the
design of interior equipment for civil aircraft and ground premises. The
ways in which the British air passenger transport industry could provide a
potent visual expression of modern Britain in the face of fierce international
economic competition had been recognised by Lord Reith who, between
1936 and 1939, had been chairman of BOAC's immediate predecessor,

Imperial Airways.[13] His ideals, modelled along the lines evolved for shaping the modern corporate personality of the British Broadcasting Corporation (BBC) and the London Passenger Transport Board (LPTB), were continued in the work of the BOAC Design Committee, established in 1945. Chaired by F.W. Winterbotham, with Kenneth Holmes and F.H.K. Henrion as Consultant Designer and Art Director respectively, it sought to promote interest in a wide range of British manufactured goods and publicity at home and abroad, on the ground and in the air. Advertising material, publicity and print, uniforms, furniture, crockery and cutlery all received attention from leading companies such as Wedgwood and Minton.[14] Richard Lonsdale-Hands and Associates[15] worked closely with the corporation's project engineering staff and the aircraft manufacturers A.V. Roe and Company on the styling of the first British civil post-war aircraft, the Avro Tudor II. Although the COID's direct input to such realisations was minimal, its related expertise was acknowledged in the invitation extended to Gordon Russell, its director, to become a member of the Airport Furnishing Committee, established by the Ministry of Civil Aviation to consider the provision of the most suitable types of furnishings and equipment in passenger handling rooms at government-owned airports and to provide a design-enhanced gateway to Britain.

Although other consultations were carried out between the COID and members of the British Transport Commission, the British Electricity Authority, the National Coal Board and the General Post Office, the anticipated levels of influence of the state-funded Council on government purchasing fell short of the heady expectations of the 1943 Weir Sub-Committee on Industrial Design and Art in Industry. Just as the later 1951 Festival of Britain had been downgraded to the status of a national display, as opposed to the original conception of an international exhibition intended to re-establish Britain as a major industrial trading nation,[16] the ongoing lack of a significant impact of a co-ordinated modern design policy on government departments continued to reveal the dilemma facing the COID in the late 1940s and early 1950s. Following a debate in the pages of the pro-modernist *Architectural Review* which had focused on the poor aesthetic lead set by the Ministry of Works in the spending of its £67 million budget, a leading article in the *Times Literary Supplement* in early 1953 drew attention to the more adventurous design climate enjoyed in other industrial nations. Conversely, the English style was portrayed as deriving from 'a series of Victorian and Georgian memories', while

> The *Architectural Review*, in its plans for bettering the situation, suffers from apparent schizophrenia. On the one hand it extols the informal elegance of a Swedish Government office, on the other, the quilted cosiness of Queen Victoria's train.[17]

The 1948 Queen Anne's Gate debate rejoined

In line with the reservations of many of those concerned with earlier debates about the actual establishment of the COID, at the 1948 'Design In a Planned Economy' symposium some anxiety was expressed that the organisation might be seen as some kind of design dictatorship which would restrict the scope and creative freedom of designers.

One of the areas of greatest contestation centred upon how 'taste' could be defined. Given the diverse constituency of the participants, this gave rise to a considerable diversity of opinion. One view suggested that

> there was a solid core of bad taste which it would probably be extremely difficult to remove. To attempt to do so by a general campaign in aid of a particular kind of taste would be futile; each type of taste at each economic level needed individual study from the psychological, social and economic standpoints to discover its underlying influences and significance before work could begin with any hope of success on the delicate process of encouraging the growth, in any particular section, of a better understanding of design.[18]

There were others who felt that standards of public taste were 'bad' as a result of 'too little opportunity to form good judgement in the choice of goods'. The optimism of these design reformers was underpinned by an unswerving adherence to the strongly-held belief that their cause was a compelling one, for, 'In spite of all the evidence to the contrary ... it was maintained that underlying [British] ... tastelessness was a native good sense and good taste which could be brought to the surface.'[19] A third, non-interventionist, position was also adopted by those who felt that 'it would be most unwise to take for granted that one particular kind of good taste was good and others bad' and that any attempts at influence would inevitably end in frustration and disappointment.

No doubt prompted by Nikolaus Pevsner, the author of the 1937 *Enquiry into Industrial Art in England*,[20] as well as by the experience gained from the COID's commissioning of the Mass Observation visitor survey of the Britain Can Make It exhibition of 1946,[21] there was general agreement that a more systematic analysis of factors underlying patterns of consumer taste and manufacturers' attitudes to design would inform the debate more fully, that the market research being carried out by the government and by bodies such as the British Export Trades Research Organisation (BETRO) should be scrutinised more closely, and that research should be carried out as to how far industry should go in the employment of designers and what their rates of pay might be.

There was complete agreement that the success of British design for

the export market did not stem from the adoption of any particular aesthetic geared to specific national markets, but from the utilisation of unmistakably British qualities of 'graciousness' and 'elegance'. It was also suggested that the 'equalitarian welfare state' was to blame for the design shortcomings of British goods, since no good standards 'could be hoped for without a leisured class free to develop and indulge their taste – in short, without an oligarchy'.[22]

Fifty years on: moves towards a 'new' Design Council

Almost exactly fifty years after the Council of Industrial Design had been founded, its later *alter ego*, the Design Council, found itself once more at the forefront of national debate. Under John Major's Conservative administration, the Council underwent a radical restructuring following the 1994 Sorrell Review, *The Future Design Council*.[23] This was accompanied by sweeping reductions in staffing, together with the closure of its regional offices and a considerable shift in the percentage of grant-in-aid spent on people and premises. In 1992–93 (the last full year of the 'old' Council's operations) this accounted for 89 per cent, whereas in 1995–96 it was set at 41 per cent, with an increased emphasis on the initiation of projects and activities. None the less, the 1994–95 core strategy of 'improving the UK's competitiveness through the better use of design' was very much in line with the ambitions contained within the COID's first annual report of 1945–46, although there was a far greater emphasis on working 'at the leading edge of change in industry, technology and society'.[24]

Such changes had not come about overnight. Over the first half-century of the Council's life there had been many recommendations which had hinted at the need for a sharpening of its role in the face of comparative indifference to its campaigning on the part of industry. For example, under the chairmanship of Sir William Barlow, a strategy group set up by Mrs Thatcher's first Conservative government produced a report, entitled *Policies and Priorities for Design* in 1984,[25] which underlined the fact that British manufacturing industry had not embraced the economic significance of high standards of design. The report recommended forcefully that the Council should be the main source of advice to the government on all design policy matters, stating forthrightly that funding of the Council had been inadequate for its range of tasks.[26]

Even sharper in tone was a review conducted for the Design Council by SRU Limited in the late 1980s to guide development of the Council's strategic plan until 1992. Completed in November 1988, *The Design Council: Design Council Strategy Development Report* identified the key priority of 'helping British manufacturing industry improve its competitive position

at home and overseas by means of better – i.e. more commercially appropriate products'.[27] Most damning of the findings was the fact that among senior managers in UK industry the Design Council was 'little known' and 'ill-understood', seen as having a 'bureaucratic approach', a bias towards the design 'fringe' and 'insufficient appreciation [of] the functional or manufacturing constraints on aesthetics'.[28] There was also found to be a considerable internal 'clash' between the engineering and industrial perspectives on design (the two principal ingredients of the reformulated Design Council of 1972), where each undertook more or less autonomous activities within the same organisation.

It was suggested that by this time the original 1944 remit of propagandising for a greater awareness of 'good design' among the public was no longer a matter of 'direct concern', except where it had a bearing on 'the attitudes and practices of British industry'.[29] The 'ring-fencing' of the Council's activities shifted emphasis for the future upon the notion of design as part of a multidisciplinary process. The report stated that

> We are in a more complex world than that of the 1940s. It is manifestly unrealistic for institutions or industry to define issues in terms of 'design' in isolation rather than as an interactive part of a development including marketing, quality control, cost control, industrial management ... To this end, the Design Council needs to improve liaison and joint activities with other industry focussed agencies such as the Institute of Marketing and the CBI.[30]

In the 1990s such projected strategic reorientations became even more prominent, culminating in the pronouncements of 23 September 1993 by Tim Sainsbury, the Minister for Industry. These set out the Conservative government's view on the future of the Design Council, laying down some of the key parameters of the 1994 Sorrell Review and, at the same time, they also revealed the extent to which there was relative consensus between government and opposition on the potentially important role of design in the British economy. Sainsbury declared that 'The Design Council, in its new role, should be a powerful voice for effective design, a bridge between industry and the design community and a vital catalyst stimulating initiatives by others.'[31] Such an outlook was further consolidated by the government's White Paper on Competitiveness, *Forging Ahead*, published in May 1995, which once more reiterated the centrality of design in UK competitiveness and the key role which the reconstituted Design Council could play in bringing this about.

The more positive and outward-looking collaborations envisaged by the Design Council came to fruition in many ways in 1996. In order to project a more progressive image of Britain abroad, a consortium of the

Design Council, the British Council and the Royal Society of Arts initiated a programme of Excellence by Design which sought to promote a contemporary view of British culture and industry abroad. This initiative was set against a backcloth of problems relating to national projection and global positioning experienced over the previous decade by state-funded organisations like the BBC in the knowledge of the ways in which the US multinationals Coca-Cola, Disney and McDonald's reflected a powerful endorsement of the American way of life.

New identities – by design

Many of the hopes for projecting a well-designed Britain under the Attlee Labour government had been pinned upon nationalised industries and departments of state. By the time that Blair's New Labour government had come power in May 1997, much of what remained of British nationalised industry had been returned to the private sector and given fresh identities, as indeed had the two major political parties themselves, in an era in which image had become almost as significant as substance. Typifying this trend was the electricity industry, reconfigured prior to its launch on the Stock Market in the late years of Mrs Thatcher's government. Similar lucrative opportunities for the flourishing British corporate design industry were afforded by the denationalisation of British Gas, British Telecom, British Rail, and the water and sewerage authorities.

The potential power of design had not been lost on the increasingly image-conscious New Labour Party of the late 1990s, with its softer red rose replacing the Red Flag. This parallelled the rehabilitation of the Design Council which had been taking place in the two years prior to the general election.

Just as its predecessors had done in the 1940s, the Design Council's *Annual Review* of 1997 drew attention to the state's considerable annual expenditure on goods and services and the opportunities that the expenditure of £40 billion per year offered the British design profession, together with the golden opportunity to influence perceptions of a forward-looking British national identity which stemmed from a commitment to high standards of design in government. This had already been identified in a (pre-New Labour) report of 1996, *Better Government by Design: Improving the Effectiveness of Public Purchasing*,[32] published in conjunction with the Design Council by the Social Market Foundation, an independent think-tank. Accordingly, the Council's Public Sector Advisory Committee had put in motion a plan to promote design and provide a training programme in the effective use of design[33] for civil service purchasing officers.

In the immediate aftermath of the May 1997 general election the

Design Council produced a discussion paper entitled *New Brand for New Britain: the Countdown to the Millennium*. Drawing on the ideas of twenty-eight people from the business, media, public and academic sectors, it sought to present Britain as one of the leading nations in design, built upon a history of invention, innovation and expertise in creative industries embracing such diverse fields as biotechnology, multi-media and fashion. The new Prime Minister, Tony Blair, was quick to tune into such notions. On 22 July 1997, when he hosted a soirée for leading figures in the worlds of British fashion, architecture, product design, advertising, animation and film, he acknowledged them as 'a power in the British economy'.[34] Furthermore, he declared in the *Guardian* that

> Britain was once the workshop of the world. It led the Industrial Revolution. It was defined by ship-building, mining and heavy industry. Even today, if MPs pushed for a debate on ship-building they would probably get one. But if they pushed for a debate on the design industry, they would probably be dismissed as concentrating on trivia.[35]

Shifting determinedly away from the 'Workshop of the World' values enshrined in the British display of industrial showmanship at the Great Exhibition of 1851, Blair sought to recast contemporary Britain as 'the "design workshop of the world" – leading a creative revolution', an outlook evolved from strategies already sown by the Conservative administration. The British Tourist Association also initiated a more positive view of contemporary British strengths through its magazine *British by Design*, self-styled as

> The magazine that celebrates the very best of contemporary design emerging from Britain today ... never before has there been a better time to experience it – by visiting Britain and seeing its fresh, modern and ever changing vision for the future.[36]

Similarly, in the autumn of 1997 the British Council published a booklet on *Promoting British Design* which sought to emphasise Britain's contemporary strengths in creativity. In June 1997, when the London Business School reported on *Research: the Contribution of Design to the UK Economy*[37] it was evident that the design business was of considerable significance for the British economy.

Prominent in the Design Council's thinking was its proposed Millenium Products scheme, a Conservative initiative which New Labour endorsed, seeing it as an opportunity to make an ideological shift of the definition of Britain's national identity alongside the Party's association with socialism. As Tony Blair commented in the frontispiece to the Council's promotional pamphlet, *Millennium Products*:

I believe it is time to show a fresh face to the world and reshape Britain as one of the twenty-first century's most forward thinking and modern nations. We must demonstrate that Britain can lead the world by creating products and services that exemplify our strengths in innovation, creativity and design.[38]

The kinds of innovative products which were seen to reflect this intended shift ranged from the Psion Series 5 hand-held computer to BT's innovative interactive *Touchpoint* multi-media information network, an Oxfam water-container and the prototype of the low-energy office-building.

All such thinking was closely in tune with the autumn 1977 Design Council report entitled *Britain™: Renewing Our Identity*. Commissioned from Demos, self-styled 'independent think tank committed to radical thinking on the long-term problems facing the UK and other advanced industrial societies', its author, Mark Leonard, called for the forging of a new perception of Britain abroad, citing as relative success stories in this field where economies and identities had been transformed over a relatively short space of time the innovative post-Franco dynamic transformation of Spain or the emergence of Ireland as the 'Celtic Tiger'. Unfavourable contrasts were made with the 'confused' identity of Britain, firmly located in the past. Britain's institutions charged with promoting Britain abroad were claimed to be incapable of promoting a forward-looking image of Britain, despite an annual expenditure of £800 million. Seemingly unaware of many of the initiatives already set in place over the previous two years (a number of which have been cited above), the Department of Trade and Industry, the British Council, the Foreign and Commonwealth Office and the British Tourist Authority were all identified as major culprits. However, none of the findings come as a major surprise to anyone who has studied the history of Britain over the past 150 years[39] or the difficulties of projecting the two faces of Britain internationally, one of which has been creative and dynamic, the other rooted in heritage and tradition. The 1997 *Renewing Our Identity* report drew attention to a gulf between 'the reality of Britain [as] a highly creative and diverse society and the perception around the world that Britain remains a backward-looking island immersed in its heritage'.[40]

Post-war contradictions: history, heritage and future

There has been a self-conscious, conspicuous and often officially-sanctioned promotion of British tradition in foreign markets, exhibitions[41] and trade fairs over the decades since the end of the Second World War. However, for many decades there have also been many heartfelt protests at the ways in which the past was pilfered to sell both the present and the future.[42]

The dilemma of simultaneously presenting the projection of Britain in terms of her 'past' and 'present' faces was highly visible at the Brussels World Fair of 1958. The official Government Pavilion displayed both a Hall of Tradition and a Hall of Technology, the latter characterised by models of Zeta, the Douneray reactor and the radio telescope at Jodrell Bank. The British display, organised through the Central Office of Information, was intended to convince visitors that Britain looked forward to a progressive industrial and economic future which matched her earlier distinctive and historic contributions to global civilisation. However, as far as the design of modern consumer goods was concerned, the COID's modest display was relegated to the cramped accommodation of the British Industry Pavilion and received comparatively little media attention.

There is a wealth of evidence over the past forty years and beyond which supports the view that similar contradictions were often conspicuous in the promotion of British products and services abroad, whether by totems of contemporary manufacturing practice, such as the British motor industry, or by equally confused departments of state. For example, the British Motor Corporation building at the Stockholm Exhibition of 1962 was styled in mock-Tudor vein, leading Swedish visitors to infer that it was an English pub rather than a progressive force in British industry;[43] in the same year the Board of Trade's own customised display for promotions abroad, entitled *Britain Past and Present*, continued to feature Beefeaters, thatched cottages and old cathedrals alongside more progressive aspects of British inventiveness.

At this time there was also considerable related debate at the British Travel and Holidays Association (BTHA, now the British Tourist Authority) about the ways in which it was felt appropriate to present a traditional image of Britain. For example, at a BTHA meeting of 28 March 1962, the chair, Sir William Mabane, drew attention to the fact that the main users of a picture of a Beefeater in the world of publicity were the makers of Beefeater gin. Furthermore, it was reported in the minutes that 'Curiously enough it was not the BTHA but others who really advertised the things that some of these pernickety critics did not like, and if those others were in business to make money he [Sir William Mabane] did not think they could be very wrong in sticking to what they do.'[44]

Paul Reilly, the Director of the COID, had earlier been co-opted on to the Council of the BTHA and appeared to be relatively supportive of the organisation's activities. However, he pleaded that examples of exciting modern architectural achievements should be featured in BTHA publicity, such as the London County Council flats at Roehampton, Castrol House and indeed the COID's own Design Centre alongside Madame Tussaud's, the Stock Exchange and the Public Record Office.

Interestingly, when the COID (or its reconstituted *alter ego*, the Design Council) were able to mount exhibitions on their own terms, far more coherent displays of contemporary industrial creativity were achieved. For example, at Moscow in 1964 the theme centred on 'the demonstration of how the work of industrial designers has influenced the quality and sales of industrial products in Great Britain', with displays focusing on such topics as the home, the factory, the office and the street. There, in the USSR, market considerations were rather different from those pertaining at many larger international exhibitions in the economic mainstream of 'Western' democracies where, from Brussels 1958 to Seville 1992, the identity of Britain was confused by projecting an image of a country rooted in tradition and at the same time as a creative modernising force.

Towards the millenium: recasting British identity

In his 1997 Demos/Design Council report, *Britain™ : Renewing Our Identity*, Mark Leonard was clearly seduced by what he saw as contemporary opportunities to recast national identities, arguing that

> Today, nations use new tools – logos and branding techniques, advertising campaigns and festivals, speeches and trade fairs – to project their identity to the outside world ... there are important lessons to be learnt from the business world which now manages corporate identities far more systematically and professionally than in the past.[45]

This envisaged agenda for change was not without its critics. For example, a leader in *The Economist* of September 1997 quoted from an evangelical vision of 'A New Britain' from the Labour Party's Election Manifesto of 1964, in which 'the resources of technology' would be mobilised and our 'national wealth in brains', 'our genius for scientific invention and medical discovery', would 'reverse the decline of the wasted years'. *The Economist* reminded its readers that it was not in fact a recent agenda and warned of the failure to convert a spirit of optimism into genuine achievements. However, it went further, suggesting that

> The most suspect of Mr Blair's four modernisations[46] is the emphasis on British identity. 'Rebranding' a country is rather harder than rebranding a political party – and it is not obviously a desirable thing to do anyway. Changes in countries' images should be built on changes in the real world, rather than on campaigns dreamed up in government offices.[47]

But it was not simply right-of-centre political commentators who punctured the heady rhetoric of New Labour's Manifesto. In the same month, Angela Dumas, who had just completed a three-year assignment as the Design

Council's Research Director, expressed her 'personal view' in the *Financial Times* in an article entitled 'Design: More than Slogans are Needed'. While acknowledging that the New Labour government had already placed a greater emphasis than its predecessors on the importance of design for successful companies and a thriving economy, she drew attention to the economic significance of new product development. She wrote:

> The UK has some of the largest graphic and corporate identity consultancies in the world. But effectiveness in this area, while important to companies, does not necessarily help the long-term performance in the innovation of new products, on which overall economic performance in the end depends ... design is as much concerned with engineering and technology as it is with image and aesthetics.[48]

She also suggested that some of the more optimistic claims made in a recent report[49] cited in *Britain™ : Renewing Our Identity* were not counterbalanced by reference to earlier findings presenting a less robust view by the same investigating organisation. For example, the UK was not identified as an innovation 'hotspot' in the coming decade; furthermore, it was seen to lag behind competitors such as the USA, Japan, France, Germany and Italy in terms of product development. In essence, Dumas was arguing for 'long-term reform, not quick fixes'.

It remains to be seen whether the aspirations of the Demos report and the initial strong advocacy of design and creativity by the New Labour administration is transformed into achievements of substance as the millennium approaches. Many of the hopes of the early years of the COID had centred upon objectives very similar to those expressed in *Britain™ : Renewing Our Identity*, which include a radical change of the image of the state through the aesthetic transformation and modernisation of government departments and buildings, the commissioning of progressive corporate identities throughout the operations of state, the stimulus to the export trade afforded by the provision of dynamic modern consulates and embassies around the world, the advocacy of design-enhanced gateways to Britain at airports and other points of entry to foreign nationals, and influence on the British film industry for the global projection of a fresh, modern face for Britain. Of course, the ambitions of the 1940s COID with regard to the corporate rebranding of nationalised industries are no longer widely applicable, and the creation of a 'digital Britain' electronic website was not technically forseeable. As we stand on the threshold of the millennium the jury is still out on the realities of significantly 'renewing our identity' through design fifty years after the COID was born.

Notes

1 Contained within ID1523, Sir Gordon Russell, Personal & Confidential Correspondence about Council Affairs. (All references beginning ID are located in the Design Council Archive at the Design History Research Centre, University of Brighton.)

2 Mark Leonard, *Britain*™ : *Renewing Our Identity*, Demos/Design Council, 1997.

3 For a fuller discussion of such attitudes in this early period of the COID see Jonathan M. Woodham, 'Managing British Design Reform I: Fresh Perspectives on the Early Years of the Council of Industrial Design', *Journal of Design History*, Vol. 9, No. 1, pp. 55–65.

4 Report of the Post-War Export Trade Committee under the chairmanship of Sir Cecil Weir, confirmed (but never published) on 23 September 1943, BT 64/3384. (All numbers commencing BT are located in the Public Record Office, Kew.)

5 For a full appraisal of this key exhibition see Patrick Joseph Maguire and Jonathan M. Woodham, eds, *Design and Cultural Politics in Postwar Britain: the Britain Can Make It Exhibition of 1946*, University of Leicester Press, 1997.

6 Leonard, *Britain*™ .

7 PEP, along with professional bodies and pressure groups (such as the Next Five Years Group, which had emerged in the inter-war years, had already begun to find some acceptance in government circles before the outbreak of the Second World War. PEP had also been concerned in the publication of the report on *The Visual Arts* of 1946, sponsored by the Dartington Hall Trustees.

8 The design profession was represented by such leading figures as Robin Darwin of the Royal College of Art, the consultant Richard Lonsdale-Hands and Jack Pritchard of Venesta and Isokon, while those considered authorities on public taste included Nikolaus Pevsner, John Gloag and J.M. Richards. Members of PEP included Professor W.G. Holford and Henry Simon, while the COID representation included the Director, Gordon Russell and Mark Hartland-Thomas, the Chief Industrial Officer.

9 It relied on the Board of Trade for its grant-in-aid.

10 BT 64/3384, Report of the Post-War Export Trade Committee, p. 8.

11 BT 60/66/8, Supplementary Report of the Sub-Committee on Industrial Design and Art in Industry (Paper No. 48), 20 October 1943, p. 4.

12 The COID had recommended John Hill as consultant designer for the furnishing and decoration of their reception rooms in Portland Place, London. These were carried out by the Ministry of Works.

13 This has been well considered in Frank Jackson, 'The New Air Age: BOAC and Design Policy 1945–60', *Journal of Design History*, Vol. 4, No. 3, 1991, pp. 167–85.

14 Many of these early initiatives are discussed in K. Holmes, 'Design for Air Travel Service', *Art in Industry*, Vol. 42, May 1947, pp. 130–50.

15 Kathleen Darby and John Tandy.

16 See Board of Trade, *Report to Consider the Part which Exhibitions and Fairs Should Play in the Promotion of Export Trade in the Post War Era* (the Ramsden Report), HMSO, 1946.

17 'Design Problems', *Times Literary Supplement*, 6 February 1953, p. 89.

18 ID 1523, p. 2.

19 *Ibid.*

20 Nikolaus Pevsner, *An Enquiry into Industrial Art in England*, Cambridge University Press, 1937.

21 This may be found in the Design Council Archive in the Design History Research Centre, the University of Brighton.

22 ID 1523, p. 4.

23 *The Future Design Council: a Blueprint for the Design Council's Future Purpose, Objectives, Structure and Strategy*, Design Council, 1994. This review was chaired by John Sorrell, also Chair of the Design Council, and its findings were presented to ministers at the DTI in January 1994.

24 'Chairman's Report, *The Design Council Annual Review 1995*, p. 3.

25 Design Council/Department of Trade and Industry, *Policies and Priorities for Design*, HMSO, 1984.

26 *Ibid.*, Section 4.22, p. 15. In Appendix 2 of this 1984 document a number of comparisons were made concerning the Design Council's less favoured position in comparison to other bodies in respect of increased funding over the previous five years. Such organisations included the Arts Council, the British Film Institute, the Crafts Council, the National Gallery, the Royal Society and the Victoria and Albert Museum.

27 Design Council/SRU, *The Design Council: Design Council Strategy Development Report*, Design Council/Department of Trade and Industry, 1988, p. 4.

28 *Ibid.*, p. 10.

29 *Ibid.*, p. 5.

30 *Ibid.*, p. 57.

31 Annex A: the Sainsbury Statement, in Evelyn Ryle, *Managing Change: the Design Council Restructuring Programme 1993–94*, Design Council, October 1994, p. i.

32 Katherine Raymond and Marc Shaw, *Better Government by Design: Improving the Effectiveness of Public Purchasing*, Social Market Foundation, 1996.

33 Two of the principal shortcomings identified were the emphasis on competitive tendering (and thus price at the expense of quality) and the processes of government accounting, which traditionally focused on the initial cost of products rather than the adoption of a resource model which also took into account their life costs).

34 'Britain Can Remake It', *Guardian*, 22 July 1977.

35 *Ibid.*

36 *British by Design*, Issue 2, 1997, p. 2.

37 Andrew Sentance and James Clarke, *Research: the Contribution of Design to the British Economy*, London Business School/Design Council, 1997.

38 Design Council, *Millennium Products*, 1997. He also wrote in the Design Council's *Annual Review 1997*, pp. 32–3, that 'We will also be putting the UK's future image under the spotlight. Millennium Products is an initiative which will highlight this country's growing strengths in design, technology and innovation. Over the next three years, we will seek out pioneering new British products and services to showcase nationally and internationally, including [sic] as part of the Millennium Experience exhibition.'

39 Eric Hobsbawm and Trevor Ranger, eds, *The Invention of Tradition*, Cambridge University Press, [1983] 1992.

40 Leonard, *Britain™*, p. 15.

41 This can be traced back at least as far as the British Section at the Exposition Universelle at Paris in 1867, a trend which continued through the later years of the nineteenth century to the British Empire Exhibition at Wembley in 1924 and beyond. See also Stephen Tallents's seminal text, *The Projection of England*, 1932.

42 Leonard, *Britain™*, p. 15.

43 Federation of British Industries, *Report on the Stockholm Exhibition*, 7 June 1962.

44 BTHA Council Meeting Minutes of 28 March 1962, p. 3, in File 1748, Pt. 1, *British Tourist Authority*, Design Council Archive, DHRC, University of Brighton.

45 Leonard, *Britain™*, p. 15.

46 The other three were a flexible economy, the welfare state and decentralisation of power.

47 'This Vision Thing', *The Economist*, 27 September 1997.

48 'Personal View. Angela Dumas, 'Design: More than Slogans Are Needed', *Financial Times*, 15 September 1997.

49 Sentance and Clarke, *Research*.

Index

Note: 'n' after a page reference indicates a note number on that page.

The following abbreviations have been used in the index:

COID Council of Industrial Design
CWS Co-operative Wholesale Society
NMV National Motor Vehicle